Dutch
The Age
of Painting
Van Gogh
1880-1895

THE BURRELL COLLECTION,
GLASGOW MUSEUM & ART GALLERIES, GLASGOW
10 NOVEMBER 1990 - 10 FEBRUARY 1991

RIJKSMUSEUM VINCENT VAN GOGH, AMSTERDAM
1 MARCH - 26 MAY 1991

Dutch
The Age of Painting
Van Gogh
1880-1895

Richard Bionda
Carel Blotkamp
(editors)

Rieta Bergsma
Enno Endt
Sanne van Smoorenburg

Waanders Publishers, Zwolle

An Exhibition Sponsored by
Whyte & Mackay Distillers Limited

Contents

Lenders to the Exhibition

Private Lenders
Josefowitz Collection

Belgium
Antwerp, Koninklijk Museum voor Schone Kunsten

France
Saint-Germaine-en-Laye, Museé de Prieuré

Germany
Krefeld, Krefelder Kunstmuseen - Kaiser Wilhelm Museum
Neuss, Clemens-Sels-Museum

The Netherlands
Amsterdam, Amsterdams Historisch Museum
Amsterdam, P. and N. de Boer Foundation
Amsterdam, Joods Historisch Museum
Amsterdam, F.G. Lauwaars
Amsterdam, Rijksmuseum
Amsterdam, Rijksmuseum Vincent van Gogh,
(Vincent van Gogh Foundation)
Amsterdam, Stedelijk Museum
Amsterdam, Henk van Ulsen
Amsterdam, Witsenhuis
Dordrecht, Dordrecht Museum
Ede, Simonis & Buunk Gallery
Enschede, Rijksmuseum Twenthe
Gouda, Stedelijk Museum het Catharina Gasthuis
Groningen, Groninger Museum voor Stad en Lande
Heino, Hannema de Stuers Foundation
Laren, P. ter Berg
Leiden, Stedelijk Museum de Lakenhal
Otterlo, Rijksmuseum Kröller-Müller
Rotterdam, J. van Dijk
Rotterdam, Boymans-Van Beuningen Museum
The Hague, Haags Gemeentemuseum
The Hague, Royal Archives
The Hague, Jan Nieuwenhuizen Segaar
The Hague, Netherlands Office for Fine Arts (RBK)
The Hague, Rijksmuseum Hendrik Willem Mesdag
Utrecht, Centraal Museum
Zwanenburg, Mr and Mrs B. Biesheuvel

United Kingdom
Cambridge, The Syndics of the Fitzwilliam Museum
Edinburgh, National Gallery of Scotland
Glasgow, Glasgow Museums & Art Galleries
Walsall, Walsall Museum & Art Gallery

United States of America
San Antonio (Texas), Walter F. Brown Collection

Director's Foreword

This exhibition is a fitting climax to Glasgow's year as the European Capital of Culture for 1990, since it also marks the centenary of Vincent van Gogh. Fortunately for the thousands of people wishing to view the paintings, the exhibition will extend well into 1991. The Rijksmuseum Vincent van Gogh and Glasgow Museums & Art Galleries are delighted to be working together on this project, and hope to collaborate in other ventures of this nature in the future.

An exhibition on this scale involves a large number of people and requires imagination, generosity and commitment. We are extremely grateful for the enthusiasm shown by all the lenders, and would like to thank the Vincent van Gogh Foundation in particular. Thanks are also due to the staff of the Glasgow Museums & Art Galleries and the Rijksmuseum Vincent van Gogh, whose hard work has made the exhibition possible.

The Age of Van Gogh. Dutch Painting 1880-1895 explores the work of the generation succeeding the Hague School, and follows two previous exhibitions of Dutch nineteenth-century art - *The Hague School* in 1983 and *In Search of the Golden Age* in 1986. Although Van Gogh himself knew few of the artists working in his own time, it is interesting to see how he was influenced by the cultural climate prevailing in the Netherlands during the 1880s, and how, in the 1890s, he in turn inspired some of the most talented painters of the younger generation.

The initiative for this exhibition was taken by Richard Bionda and Carel Blotkamp of the Free University of Amsterdam, and we are indebted to them and to the Working Group 1880-1895, the members Rieta Bergsma and Sanne van Smoorenburg in particular, for their enthusiasm and commitment.

Glasgow Museums & Art Galleries has been fortunate in obtaining major financial support from the business sector. The generosity of Whyte & Mackay Distillers, the sponsors of the exhibition, has no precedent since the opening of The Burrell Collection in 1983. We are indebted to them for their support and would like to extend our special thanks to Michael Lunn, Chairman and Chief Executive of this Glasgow-based company.

JULIAN SPALDING
Director
Glasgow Museums & Art Galleries

RONALD DE LEEUW
Director
Rijksmuseum Vincent van Gogh

ACKNOWLEDGEMENTS

We are grateful to the following persons and organisations for their invaluable help in mounting this exhibition.

The Netherlands
J. Bergwerff, Gouda
P. de Boer Gallery NV, Amsterdam
Borzo Galylery, 's Hertogenbosch
I. Bouwman Gallery BV, The Hague
G.C. Branthas, Zutphen
Christie's Amsterdam BV, Amsterdam
C. Gelein, Aalsmeer
S. Ex, Utrecht
Gerrit van Houten Foundation, Groningen
J.R. de Groot, Arnhem
O.C.V. Hartman, Utrecht
F. Hart Nibbrig, Laren
P.H. Hefting, Haarlem
V. Hefting, The Hague
F. Hendriks, Geldrop
L. Heyting, Amsterdam
L.H. Hoek, Uithoorn
Lili Jampoller, Amsterdam
Kunst aan de Dijk Foundation, Kortenhoef
Library, Amsterdam Free University, Amsterdam
Netherlands Office for Fine Arts (RBK), The Hague
J.W. Nieuwenhuizen Segaar, (Nova Spectra Gallery),
The Hague
P. van Oordt, (Library, Rijksacademie Amsterdam),
Amsterdam
M. Op de Coul (Netherlands Institute for Art History - RKD),
The Hague
A.B. Osterholt, Amsterdam
J. Paalman, Haarlem
F.F.J.M. Pieters, (Artis Library, University of Amsterdam),
Amsterdam
F.A.M. Pietersen, Utrecht
H.G.M. Prick, Amsterdam
W. Rappard, (Netherlands Institute for Art History - RKD),
The Hague
Jenny Reynaerts, Utrecht
C. Roosen, Amsterdam
J.H.H. van Roosmalen, Tilburg
K.E. Schaffers-Bodenhausen, (Iconografisch Bureau),
The Hague

J.P. Smid, (Monet Gallery), Amsterdam
Sotheby / Mak van Waay, Amsterdam
J. Teeuwisse, Amsterdam
M.J.E. van Tooren, (Amsterdam Free University), Amstelveen
H. van Ulsen, Amsterdam
A. Wagner, The Hague
M. van de Wal, Assen
P.B. van Voorst van Beest Gallery, The Hague
G. van Wezel, Amsterdam
C. Will, Everdingen
P.J.A. Winkels, Maastricht
E.J. van Wisselingh & Co., Amsterdam
J. Witsen, Voorburg
Working Group 1880 - 1895, Amsterdam Free University: Rolf
Berentsen, Rieta Bergsma, Mirjam Blott, Solange de Boer,
Berlinda van Dam, Joyce Edwards, Hélène Hartman, Hans
Jonker, Kees Kaldenbach, Erlend Kolk, Angelique Kruip,
Nicolette ter Rele, Mary Smit, Sanne van Smoorenburg, Wiebe
Spek, Carla van 't Veer, Diana Wind

United Kingdom
Celine Blair, Glasgow
Michael Clarke, (National Gallery of Scotland), Edinburgh
Timothy Clifford, (National Galleries of Scotland), Edinburgh
Beth Harding, Glasgow
Frances Hazlehurst, (The Fitzwilliam Museum), Cambridge
Tessa Jackson, (Festivals Office, Glasgow City Council),
Glasgow
Peter Jenkinson, (Walsall Museum and Art Gallerie), Walsall
A.M. Jaffé, (The Fitzwilliam Museum), Cambridge
Robert Palmer, (Festivals Office, Glasgow City Council),
Glasgow
Oscar van Nieuwenhuizen, Glasgow
David E. Scrase, (The Fitzwilliam Museum), Cambridge
Valerie Terrace, Glasgow
Richard Verdi, (The Barber Institute of Fine Arts), Birmingham
Heather Wilson, (Museums and Art Galleries Commission),
London

Switzerland
F. Hart Nibbrig, Dornach

SPONSOR'S FOREWORD

The City of Glasgow has hosted many internationally renowned performances, events and exhibitions during its reign as European City of Culture in 1990. *Whyte & Mackay Distillers* are delighted to sponsor what is surely the highlight of the visual arts programme this year, *The Age of Van Gogh. Dutch Painting 1880-1895*, at its first and only British venue at The Burrell Collection.

A unique exhibition, it is a major display of Van Gogh's work to be shown outside the Netherlands during the centenary year of his death. *Whyte & Mackay Distillers* are proud and honoured to be associated with both Glasgow Museums & Art Galleries and the Rijksmuseum Vincent van Gogh in bringing this major exhibition to the city. A comprehensive selection of the work of Vincent van Gogh together with significant paintings by some forty of his Dutch contemporaries provides a fascinating insight into the revolutionary changes in Dutch painting during the years 1880-1895.

We are sure that visitors will not only enjoy *The Age of Van Gogh* but will find it a challenging and fascinating experience. As a Glasgow company with an international product, we are proud to be associated with an event of such universal appeal in this memorable year in the history of the City of Glasgow.

MICHAEL LUNN
Chairman and Chief Executive
Whyte & Mackay Distillers

WHYTE & MACKAY
DISTILLERS LIMITED

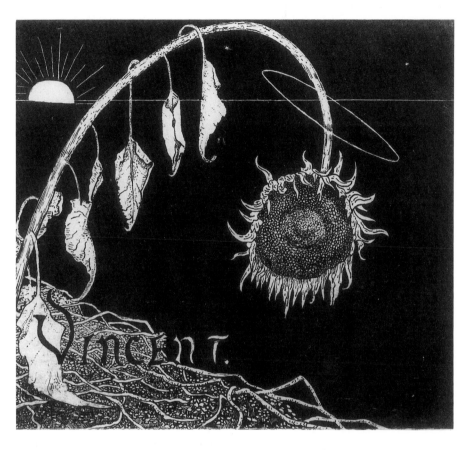

1. R.N. Roland Holst, catalogue cover for the
'Exhibition of the Work of Vincent van Gogh in the Panorama Building',
Amsterdam, December 1892

INTRODUCTION

RICHARD BIONDA AND CAREL BLOTKAMP*

A hundred years ago no-one would have dreamt of calling an exhibition of contemporary Dutch painting *The Age of Van Gogh*. His work would probably not even have passed the selection committee for the Triennial exhibitions – the Dutch *Salons* which were held at the time. Even at the select exhibition of 1892, a grand parade of the modernists organised by young artists to mark the anniversary of the University of Amsterdam, Van Gogh, just recently discovered, was represented by only two paintings, compared to Jozef Israëls's nine, Jacob Maris's twelve and G.H. Breitner's six. Had anyone thought of singling out one painter to lead the parade, the exhibition would without doubt have been called *The Age of Jozef Israëls*.

Times change. In retrospect, it is not the artists of the Hague and Amsterdam Schools who figured prominently in the international developments in late nineteenth-century art, but painters such as Jongkind, as forerunner of the Impressionists, Jan Toorop, as Neo-Impressionist and Symbolist, and above all, of course, Van Gogh. It has now become customary for books and exhibitions about Dutch art to present Van Gogh as either the culmination of the nineteenth century or the starting point of the twentieth. We distinguish one era up to Van Gogh and another beginning with him. His name has become a sort of watershed in the landscape of Dutch art history.

What fascinated people when Van Gogh's work was first exhibited in the early 1890s (fig. 1), as it continues to fascinate us today, is the momentous change it underwent in less than a decade and in the case of the paintings within a mere eight years. His frenetic development became a paradigm for modern art, which elevated individuality, originality and innovation to supreme virtues.[1] This rapid evolution, however, was not an isolated phenomenon: it is reflected in the work of many of his contemporaries abroad and also in his native country, albeit seldom in such an extreme form. This is the point which the exhibition seeks to highlight. It locates Van Gogh in the context of the period 1880-1895 and sets out to show that in this brief span Dutch art was subject to changes which were no less fundamental than the acknowledged 'revolutions' of groups such as De Stijl and Cobra in the twentieth century. One has only to compare Jozef Israëls's *Pancake Day* (cat. no. 47) with Johan Thorn Prikker's *Descent from the Cross* (cat. no. 84), or Anton Mauve's *In the Vegetable Garden* (cat. no. 64) with Vincent van Gogh's *Olive Grove* (cat. no. 34), to see how radically Dutch art changed in this brief period.

The exhibition is thus a profile of the years 1880-1895, with the accent firmly on the art of the younger generation. The first part presents the position at the beginning of the 1880s, with work by artists of the older generation. They fall into two groups: the traditionalists, such as Lawrence Alma Tadema and A.H. Bakker Korff, who were highly regarded in their day, and the painters of the Hague School, such as Jozef Israëls, Jacob Maris, Anton Mauve and J.H. Weissenbruch, who were quite firmly established by 1880 but took surprising new turns in their later work.

The second and largest part of the exhibition is devoted to the younger artists, who consciously cast themselves in the role of the new generation in the course of the 1880s. While recognising the stature of the masters of the Hague School and taking their lessons to heart, they sought new avenues in a free, expressive style of painting and a more cosmopolitan and often emphatically modern choice of subjects, thereby associating themselves with new tendencies abroad. This generation comprised not only painters from the Hague milieu (G.H. Breitner and Isaac Israëls in their early years, Suze Robertson, Willem Tholen, Floris Verster and Willem de Zwart), but also the painters usually referred to as the Amsterdam School (Breitner and Israëls after they moved to the capital, Eduard Karsen, Jacob van Looy, Jan Veth and Willem Witsen).

The third section of the exhibition shows how new trends emerged around 1890, when Van Gogh's remarkable late works became known in the Netherlands, and Jan Toorop's Neo-Impressionism culminated in a highly idiosyncratic form of Symbolism. Many even younger painters, such as R.N. Roland Holst and Johan Thorn Prikker, followed their lead. It was not long before several of these artists turned to a more committed, monumental art with a social or religious slant and to various forms of the applied arts. The year 1895 is thus a fitting point at which to end this exhibition.

About forty artists are represented. This may seem a large number, but such a broad sweep is necessary in order to evoke the age we have in mind. We have, however, differentiated within this group by giving younger painters precedence over older ones. Outstanding figures such as Breitner, Van Gogh and Toorop are represented by a large number of works, lesser gods by only one or two. For the sake of comparison and contrast several artists have been included who, though belonging to the Amsterdam School generation, trod a more cautious path, such as J. Klinkenberg, Wally Moes and Thérèse Schwartze. Many Dutch artists worked abroad for longer or shorter periods (Gabriël, Van Gogh, Jacob Meyer de Haan, Jan Verkade, Willem Witsen) or even spent most of their lives outside the Netherlands (Alma Tadema, Jongkind, Matthijs Maris, David and Pieter Oyens). They have been included here because they generally maintained close ties with the art world in their native country.

The exhibition thus deliberately presents a broad spectrum of work, along the lines, perhaps, of the group exhibitions of the period, the 'Triennials' of living masters, for instance, or the members' exhibitions of associations such as Pulchri and Arti. The exhibition is also organised along the same lines as these events. The works are arranged not so

much by artist as by date, mood, subject matter and format. The profile we present, however, is composed from a contemporary standpoint. The works have been selected for their quality and for the extent to which they are representative of an artist's *oeuvre*, but we have tried also to show the artists' personal preferences or handling of a theme, the emergence of contrasts or, more often, links – between the artists themselves, between them and earlier masters and between them and the foreign painters they so revered, such as Millet, Bastien-Lepage, Whistler and Gauguin. Dutch visitors to the exhibition, at any rate, will find much that is familiar, but perhaps they too will share something of the surprise which the organisers experienced while preparing the exhibition – the freshness of the little-known work of the Oyens brothers and Piet Meiners, for example, the power of W.B. Tholen, the lyricism of Menso Kamerlingh Onnes, the poetry of G.W. Dijsselhof. And although Verster never lacked appreciation, his stature is even further enhanced in this exhibition. By virtue of his great skill as a colourist, he is ranked here on a par with Breitner and Toorop. In other words, the exhibition hopefully has something to offer even those well-versed in Dutch art of the late nineteenth century.

ART IS PASSION

If one were to single out a characteristic that typifies Dutch art in this period it would be the brief, but intense flowering of individualism, the exaltation of personal feeling, summarised in the dictum: 'Art is passion'. This attitude is contained in the idea of artistic vocation and the image of it presented to the outside world by the artists themselves and by those closely involved, such as the critics, both sympathetic and hostile. It would be no exaggeration to say that the modern artist – the artist who, to borrow an earlier French expression, was 'of his time' – made his first appearance in the Netherlands in the 1880s.

Something of this spirit of their times must have touched older painters, such as the Oyens brothers – to judge by the realism of their choice of subject matter (fig. 2) and their style of painting – and the artists of the Hague School who, according to one of their ranks, portrayed the 'modern landscape'. Nevertheless it was only the younger painters who specifically vaunted themselves as modern artists. The painters of the Amsterdam School, in particular, associating closely with the writers and poets of *De Nieuwe Gids*, displayed the hallmarks of an artistic avant-garde of a kind hitherto unknown in the Netherlands: glorification of art for art's sake, the rejection of the social and cultural values of the bourgeoisie, a bohemian lifestyle and a tendency to regard criticism and misunderstanding as proof of artistic greatness. 'Let it be said ...', wrote Witsen under the pseudonym Verberchem in *De Nieuwe Gids* in 1888, 'that we have great artists of the older generation in our country who rank among the best in the world; that there are members of the younger generation who have the greatest admiration for the magnificent works of the great masters but want an art of their own flesh and blood; that these younger artists, scornful of what the masses hold as beautiful, wish to be independent of any system or school; that they roar with laughter at the loathsome taunts and foolish drivel of the band of idiots who call themselves critics; that they are prepared to shoulder the greatest cares in the world for their passion and commitment.'[2]

These artists preached to a small group of converts; they were aware of this and even prided themselves on it. Art should not, in their view, be measured according to rules of

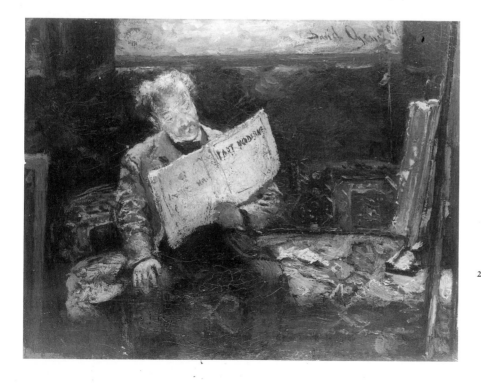

2. David Oyens,
 Kunstenaar in zijn atelier leest l'Art Moderne, 1884.
 Dordrecht, Dordrecht Museum

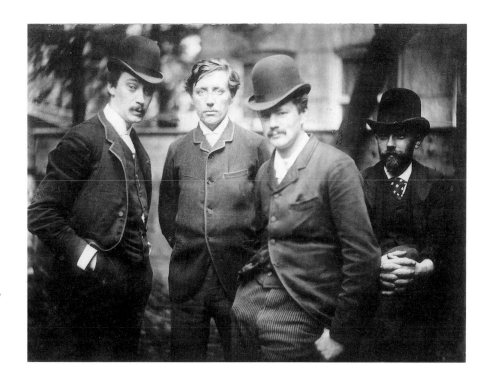

3. (*From left to right*): Willem Witsen, Willem Kloos, Hein Boeken and Maurits van der Valk. Photograph: Joseph Jessurun de Mesquita

aesthetics and morality, as had always been the practice of established art criticism. Sound artistic judgement could only be expected from critics who were themselves artists. True artists did not create for the public or the market, but for themselves and like minded individuals. 'A person who works for honour or money *is no artist*', was how Eduard Karsen summarised their position, consciously or unconsciously challenging a seventeenth-century adage ('honour and profit' as a worthy goal for the painter).[3] Willem Witsen, who, like Jan Veth, would also have distinguished between 'artists, workmen and raconteurs',[4] defined an artist as someone who was 'more than an ordinary mortal (...). He is the privileged being whom Nature has placed above his fellow creatures, who does not exist for their convenience, but should be regarded by them as their superior, from whom they have much to learn, and who can give them pleasure and enrich their lives if they try to understand him.'[5] A telling example is the reaction of Frederik van Eeden in a letter of 1888 to Isaac Israëls' mother, who had expressed grave concern about the life her son was leading in Amsterdam and the work he was producing there, that was so different from the handsome pieces with which, as a sixteen-year-old prodigy, he had caused such a stir at the Paris Salon. In those days he still followed his father's good example: 'Sitting quietly in his studio composing paintings for which people paid good money and taking as his motto *l'art pour l'art*.'[6] But now Isaac had gone astray. Van Eeden, however, fiercely defended the young artist's right to pursue his own course, without worrying about success or status: 'From what you say, you regard any painter who does not secure a comfortable living, marry a respectable woman, raise children and educate them to their proper station in life as an incompetent duffer (...) – come now, Madam! were I to disregard for a moment your wounded feelings of motherly love, I might almost doubt whether it was really the wife of Jozef Israëls I was addressing.'[7]

We gain a vivid impression of bohemian life in Amsterdam from the photographs of Joseph Jessurun de Mesquita and Willem Witsen (fig. 3) and from the correspondence of artists and writers themselves.[8] Their wanderings through the city took them to popular dance halls and houses of ill repute, where they found entertainment and inspiration for their work. They talked and drank the night away in studios and cafés, thrashing out their views on the achievements of soulmates and outsiders alike. A high point in the history of the group of artists who gathered around *De Nieuwe Gids* was the visit of their hero, the poet Paul Verlaine, in 1892 (fig. 4). This coincided with a lecture tour by Sâr Joséphin Péladan, which included a visit to The Hague. Péladan had come to preach the gospel of the Rose and Croix: 'Artist, thou art king (...) thou art prophet (...) thou art priest.'[9] Even outside the ranks of the Symbolists, such exhortations did not fall on deaf ears.

Nevertheless, there were already signs of change around this time. Profound disagreements had arisen in the circle of *De Nieuwe Gids*. Some advocated social commitment instead of absolute individualism, the ideal of an art of the community in place of *l'art pour l'art*. But there were also several prosaic reasons why the group fell apart: growing animosity between individual artists and an increasing tendency for members to move away from the city, get married and start families. The heroes grew weary and others, such as Toorop and Thorn Prikker took over as standard-bearers of the avant-garde.

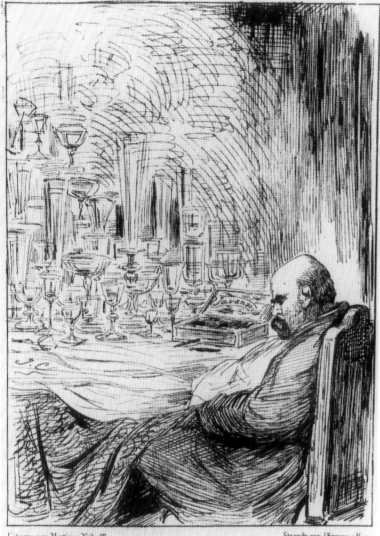

Uitgave van Martinus Nijhoff. Steendr. van J.Krauss, s Hage

En hooger gloeiden zijn wangen,
Als hij sprak van dat klagend gefluit,
En sneller dronk Verlaine
Ontroerd de glazen uit.

PIET PAALTJES

4. Cartoon referring to Paul Verlaine's *Quinze jours en Hollande*,
published in *De Nederlandsche Spectator*,
25 November 1893

The image of the artist, both in his own eyes and in the public view, undoubtedly changed during the period 1880-1895, but the most important changes were those in art itself. In the first half of the 1880s there was still a smooth transition from the Hague School to the younger Hague and Amsterdam artists. Many of them had, after all, been trained or advised by the older generation: Breitner by Willem Maris, Isaac Israëls by his father, Tholen by Gabriël, De Zwart by Jacob Maris, Van Gogh and Witsen by Mauve. The chief genres of the Hague School – landscapes and interiors with figures – were at first taken over and developed by the younger painters.[10] Around 1885, Willem Witsen and Mauve were often to be found working side by side and Witsen, like his mentor, applied himself to painting vegetable gardens, potato pickers and shepherds. Breitner and De Zwart, following in the footsteps of Van Gogh, went to Drenthe in 1885 to paint the landscape there; De Zwart, like other painters of his generation such as Tholen and Voerman, would continue to hold this genre in high esteem throughout his life. And even though Jan Veth was later to claim that the older generation formed a group to look up to rather than to emulate, he also continued well into the 1880s to follow their lead and seek subjects outdoors in the countryside.

In the mid-1880s, at least, there was no suggestion of a clear break with the past, let alone any rivalry between the Hague and Amsterdam Schools. Nor was there any reason for such a schism. One has only to look at the bold, free handling of Mauve's *Fish Market* (fig. 5) or Jacob Maris's misty *View of Dordrecht* in the Burrell Collection in Glasgow (Glasgow Museums & Art Galleries), both dating from around 1884, to understand that the Hague School artists still formed a vanguard that was vigorously supported by some of the younger generation in *De Nieuwe Gids*. In his seminal work, *Amsterdamsche Impressionisten en hun kring*, of 1941, A.M. Hammacher thus rightly avoids the word 'schism', preferring to talk of a 'second' or 'urban' Impressionism centred on Amsterdam, that followed on from the 'natural Impressionism' of The Hague.[11]

Despite the younger painters' admiration for and affinity with their predecessors, their paths began to diverge. This was most apparent at first in the nature and scope of their choice of subject. With the exception of Jozef Israëls and Jacob Maris, the older generation had largely confined themselves to rural landscapes or the outskirts of the cities, with the various facets evidently divided into carefully defined specialisms. The younger artists were more ambitious in this respect. Curious to discover the limits of the possible, they were bolder in their choice of subject matter, more concerned with the world around them and more internationally-oriented. Unlike his father, the eighteen-year-old Isaac Israëls was not interested in the timeless life history of fishermen and peasants, but chose contemporary events such as the departure of a group of colonial soldiers from Rotterdam, which he recorded on a

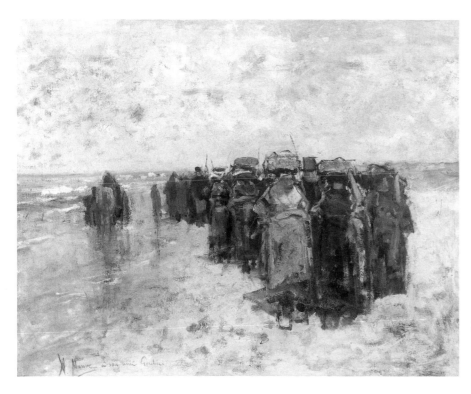

5. Anton Mauve, *Fish Market*, c. 1884.
The Hague, Rijksmuseum H.W. Mesdag

canvas three metres wide (fig. 6). We find no landscapes in his *oeuvre*, though he did some surprisingly handsome portraits and scenes of military life, which perhaps show something of his father's concern for the human and social dimension. The detailed style of painting and the lack of any explicit heroic message placed these pieces in the same category as the documentary works of realistic war artists in France such as Edouard Détaille and Alphonse de Neuville, whose paintings based on the events of 1870-1871 were enjoying great success at the Paris Salons.

Breitner, and occasionally Verster too, showed an early interest in the military genre. Although some subjects were strongly reminiscent of Détaille and De Neuville's paintings (which he knew from illustrations and collections in Rotterdam), his work was significantly different. He was less personally involved and more concerned with the pictorial aspect and with finding interesting solutions to compositional problems – by using an unusually high horizon or cropping the picture to heighten the spontaneity of the image.

Breitner also began to look for a new approach in his handling of other subjects, such as townscapes, portraits and self-portraits, figure pieces and still lifes with flowers. He portrayed his models simply as models, without any trappings or anecdotal touches, and almost always alone. The same was true of his nudes, a genre which the Hague School artists had avoided almost entirely. Breitner's poses and titles are to be taken at face value and do not allude to nymphs, Dianas or abstract concepts such as Innocence. Nor are his nudes seductive. They stare out of the picture with an expression of boredom or lie deliberately unposed on a bed (fig. 7). Breitner, who

kept a reproduction of Manet's sensational *Olympia* in his studio, shared with the French Realist the desire to depict harsh reality without embellishment and a tendency to jot down his images rapidly as impressions. His *Self-Portrait* (cat. no. 8), probably dating from 1882, is a good example of this. As in another early self-portrait with a cigarette in his hand (Rotterdam, Boymans-van Beuningen Museum), he stares out of the picture with a slightly reserved, almost haughty expression, as if he has been caught by the camera quite by chance and come face to face with a stranger. A similar emphasis on informality and a refusal to pose his subject are to be found in Manet's portrait of Mallarmé (also shown smoking), which dates from 1876 (Paris, Musée d'Orsay).

The affinity with Manet and other French Impressionists went further than this. Around 1885, for example, Breitner, Bauer and De Zwart painted ballerinas at the theatre in The Hague; Isaac Israëls found his inspiration in playhouses, cafés and dance halls and De Zwart, like Manet, posed his models in Spanish matador's costume, sometimes with musical instruments in their hands (fig. 8). Reminiscent of Impressionism, too, are the images of life in the bustling metropolis, observed from the midst of the crowd itself or from a window high above the scene. The epithet 'Manetism', used pejoratively at the time, was by no means wide of the mark. The Dutch artists, however, maintained their warmer palette and subtler tones, even after 1890 when their colours became far more intense. Breitner and De Zwart favoured a dark, or on occasion almost black background, thereby continuing, unlike Manet, to acknowledge the illusory space of the painting.

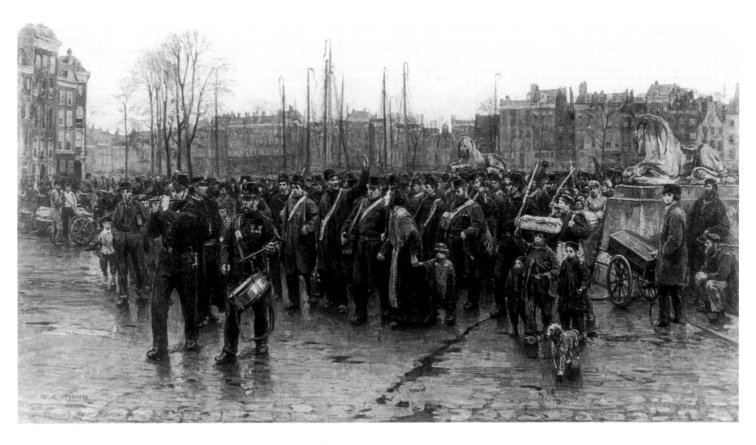

6. Isaac Israëls, *Transport of Colonial Soldiers*, 1883 - 1884.
Otterlo, Rijksmuseum Kröller-Müller

7. G.H. Breitner, *Reclining Nude*, c. 1890.
Utrecht, Centraal Museum

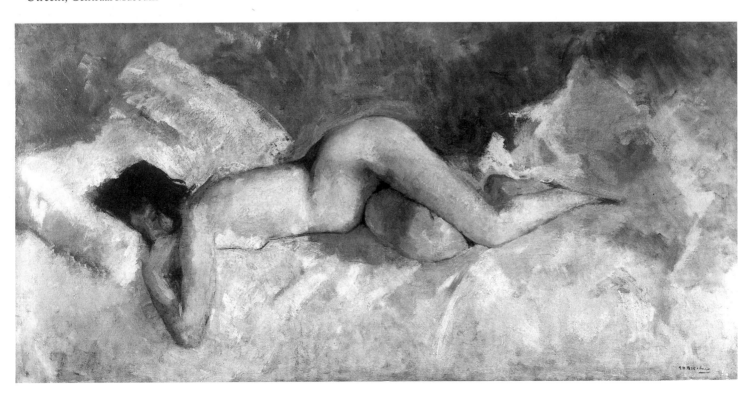

The Parisian élan which many of these works radiate was undoubtedly connected with the artists' reverence for writers such as Flaubert, Michelet, the Goncourts and Zola. Breitner, for example, enthused about *Manette Salomon* by the Goncourt brothers and exhorted all his acquaintances, including his conservative patron Van Stolk, to read this novel of artist life.[12] For him the book was a sort of confession of faith, which strengthened his commitment to the times in which he lived, despite the sacrifices that contemporary life demanded. Millet, too, had stressed this aspect, as Breitner knew from Alfred Sensier's monograph, published in 1881. In the Goncourts' novel, Breitner was particularly drawn to the sympathetic figure of Chassagnol, for whom modern life in all its facets had a special beauty: 'Le moderne, il n'y a que ça...' A second character in the book, the painter Coriolis, also emphasised the beauty of ordinary street-life; he would stroll around Paris, 'étudiant les types saillants, essayant de saisir au passage, dans ce monde d'allants et de venants, la physionomie moderne, observant ce signe nouveau de la beauté d'un temps, d'une époque, d'une humanité.'[13] Breitner's fascination with city life dated from about 1881-1882, when only Van Gogh, then residing in The Hague, shared this interest. In early 1882 the two went out and about together, as we learn from a letter written by Van Gogh a year later [299].[14] Breitner was good company on a walk, he wrote, and the only person he could go on such excursions with, because most others considered the city 'ugly' and took no notice of anything.

We do not know how familiar the younger Dutch Impressionists were with the work of their French counterparts in the 1880s, nor how highly they regarded it. We can assume that Breitner saw quite a lot of what was going on both inside and outside the Salon, the Louvre and the Luxembourg, during his six-month stay in Paris in 1884. He arrived too late for the great Manet retrospective in January that year at the Ecole des Beaux-Arts, but Impressionist work was always on show at Durand-Ruel. In his letters, however, he mentions only Corot and Millet. Isaac Israëls visited Paris with his father almost every year, but here too we can only speculate about what he saw. In his account years later of a visit to Paris with Isaac Israëls in the autumn of 1889, the writer Frans Erens refers above all to visits to writers and critics.[15] Theo van Gogh, whose collection included not only works by his brother but also numerous Impressionist paintings, wrote to Vincent about a visit from Isaac Israëls and Jan Veth, but their impressions of the encounter are not recorded.

Of course, French Impressionists were also to be seen closer to home. From 1884 onwards Monet, Renoir, Pissarro, Morisot, Toulouse-Lautrec, for example, took part almost every year in the group exhibitions of *Les Vingt* in Brussels and the art dealers Goupil exhibited works by Monet and Degas in the Netherlands in 1889, though these were soon returned to Paris unsold. The Dutch Etching Club invited French Impressionists to submit drawings and graphic work, but the Neo-Impressionism of Seurat and his Belgian followers from *Les Vingt* (shown at an exhibition in 1889 in Amster-

8. Willem de Zwart, *Boy in Spanish Costume*, 1889.
Private collection

dam, organised by Toorop) was known here almost earlier and better than the work of the original Impressionists. It was not until 1893 that the Hague Art Circle organised the first, modest group exhibition containing fourteen paintings by Monet, Pissarro, Renoir and Sisley.

The Dutch attitude to French art may be deduced from a long article by Jan Veth in *De Nieuwe Gids*, published in 1890 after a visit to the world exhibition in Paris in 1889.[16] It is clear from the tone of the piece that he still feels a fondness for the masters of the Barbizon School, such as Rousseau, Corot, Daubigny and above all Millet, but he regards Manet as the true revolutionary and precursor of a new era. He was the first to paint modern subjects, 'purely by the accurate and supple juxtaposition of golden outdoor tones, showing a fine sensitivity to the firmness yet openness of colour values'.[17] From Manet, Veth turns to contemporary French art, declaring his intention to ignore the academic painting done purely for financial gain. Bastien-Lepage was certainly important, particularly in developments in Germany and England, but his eclecticism proved not to be viable. Veth is more enthusiastic about the work of Puvis de Chavannes and Gustave Moreau, because of its devout naivety and its erudite, fantastic, visionary quality. He concludes with Degas, Raffaelli, Monet and Pissarro, singling out Degas as the painter of modern life *par excellence*, the best exponent of the Naturalist tendency. In Veth's eyes, Pissarro belongs to the ranks of the Neo-Impressionists, whose achievements he does not fully endorse. He praises their boldness in breaking with tradition; they have explored and discovered a great deal, but they have also imposed a new set of rules on themselves. They lack the personal, passionate element that painters such as Géricault, Rousseau, Monticelli and Monet managed to introduce into their work.

In Veth's view – which was shared by a person of the stature of Derkinderen – Breitner and Verster were by no means on a lower plane in this respect. Monet was for Veth the most passionate French painter, a 'pantheist of Eastern intensity, whose eye is struck by naked colour, wild, turbulent and powerful as a fever'.[18] Shortly after the appearance of Veth's article, Derkinderen described Breitner in similar terms, as the richest among the Dutch artists, someone who could withstand comparison with the greatest French masters thanks to 'the flamboyant, mystical, elegant, extravagant, unsettling richness of an Eastern imagination'.[19] For Roland Holst, Breitner's art in early 1891 was 'more fantastic, (...) more visionary, more sumptuous' than that of his splendid predecessors Jacob and Willem Maris.[20]

NEW AVENUES

It has often been pointed out that the term 'Amsterdam School' is an unfortunate one, given the great differences in outlook and objectives among the younger painters. In fact, they were united only in their desire for complete creative

freedom – freedom from other people's doctrines and freedom to proceed explicitly from their own feelings or ideas. This alone could produce sincere work and every piece that satisfied this criterion was of equal merit. 'A great artist', wrote Jan Veth in the newspaper *De Amsterdammer* (3 March 1887), 'is a man in the grip of an overwhelming obsession. He sees the things around him in a light that only he perceives. Others observe his surroundings too, but the sensations aroused in the artist are unique to him. The essence for him, therefore, lies not in the external world but in his perception of it. In the uniqueness of his perception lies his personality.'[21] Allebé personified this commitment to artistic freedom: as professor and director of the Academy where most of these painters were trained, he exercised restraint in correcting his students' work and was receptive to the different directions they ultimately pursued.

After a period of gradual transition in the early 1880s, these new tendencies became increasingly clearly defined from about 1885 onwards. Breitner's and Israëls's work became more self-confident and betrayed a greater breadth of vision and boldness in handling. The emphasis came to be firmly placed on the artist's expressive 'handwriting' and one has the feeling that they deliberately adapted their motifs accordingly. In scenes of stormy weather, the figures are dashed off with brusque strokes. In techniques where the artist can work with a free hand, such as watercolour or drawing, the results are sometimes distinctly provocative. This is true, for example, of Breitner's smudged watercolours which he intentionally worked on while they were too wet. In his pastels of girls on the street he seems to spoil the faces on purpose, so that they look deformed. Even today we can understand why the public and critics had such difficulty with this 'Young Savage'.

But there were also other ways of looking at the city, which owed less to the French and were more faithful to the native tradition. With the same precision that Jan Veth applied to his portraits, Witsen and Karsen painted townscapes in which the city itself rather than the human figure was the centre of attention. These were quiet, contained paintings, in Karsen's case almost *Andachtsbilder*, in which the artist's handwriting is subordinate to the lyrical mood predominates. On a superficial level they exude the same aura as works of the Hague School. The Hague School masters, however, were concerned above all with atmospheric aspects, with the unique, fleeting moment. For the younger painters the calm was more compelling, sometimes almost symbolic. With their tendency to stage scenes rather than simply record them they had more in common with seventeenth-century masters such as Saenredam and De Hoogh, or the artificial tranquillity of the eighteenth-century painter, Troostwijk.

There were others around 1885 whose choice of subject matter reflected their social conscience. This tendency is most apparent in Jan Toorop, for example in his large figure piece *Respect pour les morts* (fig. 9) dating from 1884. The artist's minute concern with age, tattered clothing and bare feet im-

9. Jan Toorop, *Respect pour les morts*, 1884.
Private collection

mediately calls to mind the demonstrative realism of Courbet and above all his Belgian disciples such as Charles de Groux and Baron Léon Frédéric. Verster's *Stone-Cutters* (Otterlo, Rijksmuseum Kröller-Müller) is in the same category. In 1884 Toorop joined the Brussels association *Les Vingt* and pursued this line further in this socialist-anarchist milieu. At first, under Ensor's influence, he adopted a raw style, modelling the paint with the palette knife (*Brussels Students*, cat. no. 86), but later he applied the more restrained technique of stippling, the hallmark of Neo-Impressionism, which, thanks to *Les Vingt*, made Brussels second only to Paris. In paintings such as *After the Strike* (Otterlo, Rijksmuseum Kröller-Müller) and *Farmer Digging with Wife and Child* (private collection), both dating from 1887-1888, Toorop seems to be referring explicitly to Jozef Israëls and Millet, but his Pointillist style ensures that the effect is not one of epic Naturalism. The frozen expression of the figures gives them a certain dignity that elevates them to symbols of their class or type.

By the end of the 1880s this rejection of Naturalism was leading Toorop (and indeed others, too) to more literary and symbolic themes. His contact with poets such as Emile Verhaeren and Maeterlinck played an important part in this development. New heroes emerged, such as Redon and Matthijs Maris. In *Transport of a Fishing Boat* (cat. no. 90), Toorop positions the bare hull of the boat squarely in the centre of the canvas, where it looms menacingly above the frail anonymous figures on the sand. Not for a moment are we tempted to regard this as an everyday occurrence on the beach at Katwijk: it is clearly a symbol of a collective Calvary.

In paintings such as *The New Generation* (Rotterdam, Boymans-van Beuningen Museum) dating from 1891 and, above all, in drawings such as *The Garden of Sorrows* (fig. 10) dating from c. 1890, Toorop developed an eclectic and highly idiosyncratic symbolism, which combines features of the most diverse art forms (including ancient and non-European art) to create images with a visionary character.

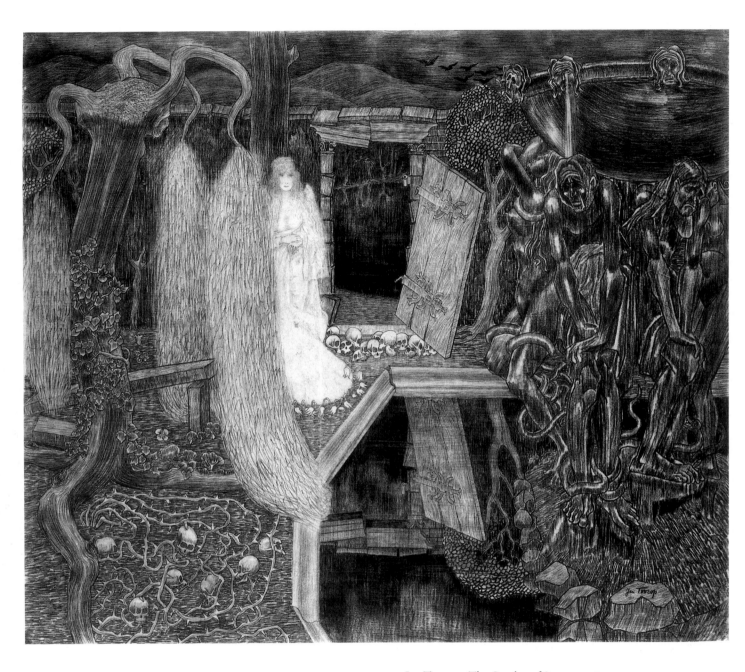

10. Jan Toorop, *The Garden of Sorrows*, 1890.
Amsterdam, Rijksprentenkabinet

Other artists who offered alternative themes and styles to the Hague and Amsterdam Schools followed Toorop's example. In paintings such as *Still Life with Bottles* (fig. 11), Verster abandoned Breitner's technique of using a dark ground tone to suggest space. Instead, colour comes to predominate, it stands out on the canvas. His paintings reek of paint. The flower pieces are fantastic visions in which faithful representation is sacrificed for the sake of the expressiveness of the colour. Around the same time, Johan Thorn Prikker took the linear aspect of Toorop's work a stage further. In almost mystical variations on Christian themes, such as *The Bride* (fig. 29), dating from *c.* 1892, he used line as the most important vehicle for conveying meaning in the picture. It is above all the developments in the art of Toorop and Verster, the most advanced artists at work around 1890, that paved the way for a positive response to the bold distortions and intense colour in Van Gogh's late work, when this became known in the Netherlands in 1891-1892.

Van Gogh himself had wanted to launch the offensive against the Dutch market in 1889. In an interesting letter to his brother Theo [473], he suggested, not without ulterior motive, donating a number of paintings to influential individuals and institutions in the Dutch art world: Anton Mauve's widow was to receive a painting with a dedication and other works were to go to the art dealer Tersteeg of Goupil & Co. and his old friend Breitner, who, as Van Gogh knew, had since established himself as the leading painter of his generation.[22] Finally, two paintings were to be donated to the museum in The Hague which, as the seat of the Hague School and home to various art dealers, was still an important art centre in the Netherlands. This represented a major investment, but Van Gogh was confident that it was the way to establish his name in his native country.

However, recognition came only after his death. In early 1892 Toorop organised the first retrospective exhibition at the Hague Art Circle. It was possible here to follow virtually the entire evolution of Dutch art over the decade – from Hague School to Neo-Impressionism – in the work of a single artist. Van Gogh's work provoked many expressions of admiration at the opening, particularly from artists, wrote Theo's widow, Jo van Gogh-Bonger, in her diary. Even Jozef Israëls, the grand old man of Dutch art, liked many of the paintings, although he remarked that 'there are things that can be painted and things that cannot and Vincent often wanted to paint things that were impossible to paint – the sun for instance'.[23] That remark neatly epitomises the difference between the old lion of the Hague School and the new generation.

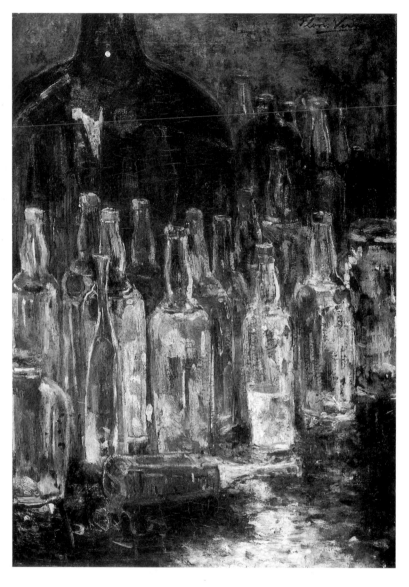

11. Floris Verster, *Still Life with Bottles*, 1892. Otterlo, Rijksmuseum Kröller-Müller

NOTES

* This essay was translated by Martin Cleaver and Andrew McCormick
For the reader's convenience various organisations and events have been rendered in English. A glossary of the original Dutch terms can be found in the Editiorial Note.

[1] The early response to Van Gogh's work is discussed at length in Carol M. Zemel, *The Formation of a Legend. Van Gogh Criticism 1890-1920*, Ann Arbor 1980.

[2] Verberchem (Willem Witsen), 'Tweede Jaarlijksche tentoonstelling van de Nederlandsche Etsclub', *De Nieuwe Gids* 3, 1888, vol. 2, p. 424.

[3] J. Eduard Karsen, *Een droom en een scheidsgerecht*, edited and with an introduction by Rein van der Wiel, Amsterdam 1986, p. 65.

[4] J. Stemming (Jan Veth), 'De stedelijke tentoonstelling van schilderijen', *De Amsterdammer* (daily), 8 October 1886.

[5] W.J.v.W(estervoorde) (Willem Witsen), 'Een boek over kunst', *De Nieuwe Gids* 1, 1886, vol. 2, pp. 463-464.

[6] Letter from A. Schaap-Israëls to Albert Verwey, 12 December 1888, published in Jacob H. Reisel, *Isaac Israëls. Portret van een Hollands impressionist*, Amsterdam 1967, p. 188.

[7] Letter from Frederik van Eeden to A. Israëls-Schaap, 20 June 1888, published in idem, p. 186.

[8] *De beweging van 80* (Schrijvers prentenboek 22), Amsterdam/The Hague [1982]; Charles Vergeer, *Willem Witsen en zijn vriendenkring. De Amsterdamse bohème van de jaren negentig*, Amsterdam/Brussels [1985]; Rein van der Wiel, *Ewijkshoeve, tuin van tachtig*, Amsterdam 1988; Enno Endt, *Het festijn van Tachtig*, Amsterdam 1990.

[9] J.F. Heijbroek, A.A.M. Vis, *Verlaine in Nederland. Het bezoek van 1892 in woord en beeld*, Amsterdam 1985; on Péladan's visit to the Netherlands, see Geurt Imanse, John Steen, 'Achtergronden van het Symbolisme', in exhib. cat. *Kunstenaren der Idee. Symbolistische tendenzen in Nederland ca. 1880-1930*, The Hague (Haags Gemeentemuseum) etc., 1978, pp. 26-28.

[10] Ronald de Leeuw, 'Zijwegen van de Maris-tijd', in exhib. cat. *De Haagse School. Hollandse meesters van de 19de eeuw*, Paris (Grand Palais) etc., 1983, pp. 101-114.

[11] A.M. Hammacher, *Amsterdamsche impressionisten en hun kring*, Amsterdam 1941, p. VII.

[12] P.H. Hefting, *G.H. Breitner in zijn Haagse tijd*, Utrecht 1970, pp. 38-39, 51; *G.H. Breitner. Brieven aan A.P. van Stolk* (etc.), annotated by P.H. Hefting, Utrecht 1970 (letter no. 15, November 1881).

[13] Quoted by P.H. Hefting, *G.H. Breitner in zijn Haagse tijd*, Utrecht 1970, p. 40.

[14] *The Complete Letter of Vincent van Gogh*, New York/London 1958

[15] Frans Erens, *Vervlogen jaren*, published by Harry G.M. Prick, Zwolle 1958, pp. 261-277, 284-297.

[16] Jan Veth, 'Fransche schilders in deze eeuw', *De Nieuwe Gids* 6, 1890, vol. 2, pp. 311-328.

[17] Idem, pp. 323-324.

[18] Idem, p. 327.

[19] A.J. Derkinderen, 'Indrukken op de Arti-tentoonstelling', *De Amsterdammer, weekblad voor Nederland*, 9 December 1890.

[20] Willem du Tour (R.N. Roland Holst), 'De afdeeling schilderijen op de tentoonstelling van Architectura et Amicitia', *De Amsterdammer (weekly)*, 15 February 1891.

[21] G.H.C. Stemming (Jan Veth), 'Tentoonstelling-Vereschagin in Arti', *De Amsterdammer* (daily), 3 March 1887.

[21] Ibidem, note 14.

[23] Vincent van Gogh, *Verzamelde brieven*, published by J. van Gogh-Bonger, Amsterdam/Antwerp 1955, vol. 4, p. 246.

Our Beauty is the Flowering of Desire

Enno Endt*

Amsterdam, 13 April 1887 – 'He was in the capital and the capital was celebrating.' Celebrating because it was the King's birthday.

But this King, William III, was he really so 'well-known and beloved' by his people? Surely he put in only the rarest of appearances in the capital and preferred to hold court in his palaces in The Hague? 'The Gorilla King' they had called him only a short while ago. Admittedly that was in one of those radical left rags, called *Rights for All*, not that it was read *by all*, by any means, nor even by all without rights (in so far as they could read at all). It voiced the opinions of a small handful only, people who could write and also had the unheard-of audacity to write something of the sort. Gorilla King, indeed ...! Fortunately, papers with a larger circulation than *Rights for All* were able to assure their readers that the editor of this seditious organ, Domela Nieuwenhuis, had reaped his just deserts – a year's imprisonment for lèse-majesté.

'Domela is sewing mailbags' howled the crowd as they celebrated the fact that their unloved king had turned seventy. A king who would remain on the throne for some years to come, for lack of any adult heir in the Orange dynasty. Though the popularity of the members of the dynasty might wax and wane over the centuries, the people remained loyal to the House of Orange and knew how to celebrate an Orange festival: for several days and, above all, nights the city was transformed. No longer were the streets a stage for scenes of civic duty, pious respectability and money-making, but were given over instead to the plebs (to use the derogatory term favoured by the grand folk watching from the tall windows of their elegant patrician houses), to the dregs of humanity, the riffraff, the mob, the trash, the rabble, the scum of the earth... there was no dearth of names to convey patrician distaste.

Time was when these fine windows were smashed in the riots and the valuable furnishings tossed out of the canal houses onto the streets below. But now the red-white-and-blue flags – yards and yards of them – hung straight down the front of the houses, orange streamers with an elegant tassel on the end beside them. The patricians liked to honour the royal house: its long and heroic past bestowed an identity and hence a welcome self-assurance on the contemporary nation. And, after all, had the monarchy not only recently submitted to a constitution and the rule of Parliament? (And the right to elect this Parliament was far from being a *right for all*.)

For the time being the rich remained comfortably ensconced in their canal houses, their wealth intact, while in the working-class districts the poor celebrated 'that monstrous feast. A troupe of drunken women, wearing orange breeches, poor folks' underpants, or if you like whores' drawers, dyed orange in a cauldron of boiling cedarwood suds...'
This is how he saw them, when he was in the capital as the capital was celebrating. In these words he recorded his experiences that night as he wandered alone among the hordes possessed with the demon of the festivities. He watched the cavorting masses parading past.

'There were many women among them, whooping and cheering along with the men. For a moment he caught a glimpse of them, their drunken, inflamed faces drawn and distorted by excitement, dirty trickles of sweat dripping down from under their hats, their dishevelled hair sticky and matted, their eyes glittering lasciviously, their mouths as they yelled great gaping holes. Emitting terrifying shrieks, they processed by. Hi! ha! chanted the sweating men, taking the women by the arm and shoving them forward. (...) Then one began to sing, in a sing-song chant which was gradually taken up by the whole crowd: "We won't die, we won't die!" The chant reverberated around him, honest and funny, hoarse and shrill, and then eddied away, the bawling and roaring receding as the crowd passed. "We won't die, we won't die..." the chant stretched in an unbroken chain, repeated endlessly over their heads, under the festoons of lights.'

Even later, as he wandered through the deserted outer reaches of the city in the small hours of the morning, his ears still rang to the distant sepulchral reverberation from the alleyways 'like the lingering plume of smoke from a train crossing the meadows'.

The man caught up in the revelries in the capital in April 1887 was the painter Jacobus van Looy (fig. 12). The capital was in the grip of the Orange celebrations and he was 'driven on tirelessly, with a powerful inner need to see all there was of the merriment'. He describes what he sees in impressionistic terms, with exaggerated use of the literary device of synaesthesia. The contours of the subject he is describing become blurred, in the same way that the outlines of people and objects in the work of contemporary painters tend to fade away. 'All voices rose as one, everything rang with the newest, the most delirious refrain. The pallor of the dawn sky was shot with the joyful roar and shriek of orange, the wild laughter and squalling of red, the whistling and screaming of white and the booming of dark blue, mixed with the inky darkness of the green and purpling shadows.'

The style is copied from his literary friends, the excessive use of the technique was typical of the year in which he wrote his novella, 1887.

The teeming throng of people on the streets of the metropolis, with the sensitive individual in their midst, overwhelmed by the experience, has been a recurrent theme in novels, operas and plays since the age of Romanticism. One has only to think of the final scene of the *Hunchback of Notre Dame* or the closing shots of *Les enfants du paradis*. Similar scenes occur, too, in the late nineteenth century, in an even more powerful form, in the work of the Naturalistic novelists.

12. Isaac Israëls, *Portrait of Jacobus van Looy in a Café*, 1887-1894.
Haarlem, Jacobus van Looy Foundation

Van Looy undoubtedly knew his Zola; like him, he portrays the dancing crowd in language stripped bare, incorporating every bestial and even disgusting detail, without a hint of reprobation: 'They had danced and flocked and enjoyed themselves all through the night, filling the streets with the pleasure of their freedom, and in the lawlessness of the festive spirit they had penetrated into the rich neighbourhoods. And now, full of drink and fun, they clumped and danced the night away, their stockings drooping over their heavy shoes, their feet relentlessly stamping the street. "We won't die, we won't die," they screamed, the chants resounding like the notes of an organ. Shamelessly, as if in the privacy of their own homes, the women threw back their heads to reveal their throats and bosoms and lolled in the arms of their menfolk, who, replete and blissful, drunk as the women, laughed coarsely, their mouths wide open, and fanned them with branches of greenery.

'Banging away savagely, their heads thrust forward, they screamed and roared their cry – hi, ha! hi, ha! – which then rolled away into the distance like thunder. They were swallowed up in an alley; the chant echoed off the walls of the passage; above the reeling throng of orange and white and black hair, the balloons twisted and danced on the end of their sticks and fiery streaks and curls and balls of light stood out against the opening of the alley which was now tinged with blue in the chill of the new day.'

Non-judgemental, certainly, as prescribed by Zola. But not so 'coolly observant' that, emerging from the daze of excitement, Van Looy's wanderer cannot help but feel himself 'in the immense, awful stillness, alive with a distant reverberation, gradually becoming a part – a tiny, disgorged particle – of that monster, giving itself over to the festivities in a burst of flame and an explosion of colour: the city.'

It is this experience which encapsulates that quality peculiar to the best writers and painters of Impressionism, the intense *involvement*, even to the point of pantheistic identification with their subjects. It can be seen as a natural consequence of the creative process: the external world which the artist observes becomes bound up with the inner world of spiritual perception; the impingement of each on the other leads to a momentary impression suffused with emotion (or 'mood'). The senses and nerves do the work while the intellect is suspended. There is nothing resembling an ideological message, a profound allusion to traditional inherited values, nothing but the here-and-now of the external world and the powerful experience of it in one's inner being. In a letter to Van Deyssel, Van Looy wrote: 'What I most want to see in a work of art is:' – followed by three lines heavily scored out – 'well, you see, reasoning isn't really my strong point. I apologise.'

Sure enough, reasoning is often difficult and almost always tedious for the reader. But Van Looy begins a new paragraph and manages to get his ideas off his chest in his straightforward way: 'Unless I see the man who produced it staring at me through the painting, out of the frame, unless I can *plunge* into his *intimate* soul, then such a painting simply leaves me cold.'

In this naive statement, I detect the emphasis on the inner world, the world of spiritual perception. The portrayal of that perception always triumphs over the representation of the external world, the calm, *amicable* Impressionism of the Hague School, which Van Looy himself had once tried. And, of course, such a painting is even further removed from the almost photographic representation plus anecdote-designed-to-set-the-observer-thinking prescribed by Van Looy's training at the Academy of Art.

Nor can one expect to find Van Looy mocking the working class, because he himself was of proletarian origins and never tried to hide it. Because of his background, however, he suffered a lifelong insecurity about his social and artistic worth. Growing up in an orphanage was partly to blame, an upbringing in which he was subservient to the Regents, the 'mothers' and 'fathers' and the Protestant practices they thrust upon him. He was not wild and rebellious by nature, but had a tendency instead to harbour a grudge. He was capable of acute observation and refined sensibility, having an intuitively contemplative disposition. 'I, who am aware every minute of the day of my inability to achieve what I wish to do, I, who want nothing better than to be able to fight with a light heart for some other goal, rather than against my own impotence alone. I, who, like a good child of my time, desire *life*; I, who have already lived through so much, am deeply afraid of the vastness of life and find myself so often staring into the hollow eyes of poverty, drawing nearer with every step and threatening to crush me with its relentless hand. And yet I believe, too, that everyone will do whatever they are fated to do, myself included.'

So what was the chief protagonist of his story – the novelist himself – doing in Amsterdam in the midst of the celebrations? He was looking up his friends from two years before. For two years he had been travelling in Italy and Spain, with a brief detour to Tangier, a trip undertaken more or less out of a sense of compunction, to fulfil the expectations – and obligations – incumbent upon the winner of a Prix de Rome. His prize-winning painting had been a historical work depicting a Biblical scene, *Elijah on Mount Carmel*, kitsch as a romantic picture postcard. During his student years he had shared in the formation of various artistic and literary groups and had followed the development of new ideas in studios, cafés and rented lodgings. And in 1885, just when the developments on both fronts were coming to fruition, with the foundation of the Dutch Etching Club for artists and *De Nieuwe Gids* for writers, just then, he was obliged to set off on his lonely travels, with instructions to *copy*, in meticulous detail, the great masters in the museums – the Uffizi, the Prado – for his own edification, but also to provide reproductions for use by other students at home, at the Academy. Letters from friends provided valuable support, but could also be disquieting:

'Why? Why are you doing this? Why are you shutting yourself away in a museum for four precious months of your life, just when you don't know where to turn for all the ideas filling your head? Is not a single stroke that comes from your own heart more worthy, more valuable for what you want to achieve, than all that reproducing the lines of another painter... enjoy it, fine... but don't pretend that it gives you pleasure to do you such a contemptible job... No, friend, you are a victim of the foolish academic tradition that says the study of great men produces great men;... style... style... well that must come from ourselves, not from museums.'

Now he was back in this circle of friends and he found a rich array of promise and promise already partially fulfilled, 'a tumult of work triumphant'. The poets were revelling in their struggle against an older generation of Biedermeier poets, the essayists were developing a lucid, natural style free from the old rhetorical affectations, the novelists were embellishing their tales of passion with a rich assortment of adjectives. 'All voices rose as one, everything rang with the newest, the most delirious refrain.'

Van Looy, returning from his travels with his own, uncertain efforts – a landscape by the Tiber, subdued, with a view of distant towers, still very much in the tradition of the Hague School – cannot always have felt at ease in such company. But he did find one certainty to cling to, as he was to record a year later, when he was privileged to discover a great work of poetry, written quite unexpectedly by a newcomer to the literary world, which was to become one of the enduring triumphs of the age. Van Looy recorded the event in his diary: 'Gorter will be here soon. Hope he brings his verses with him. *Een nieuwe Lente en een nieuw geluid / Ik wil dat dit lied klinkt als 't gefluit, etc...* (A new spring and a new musical note / May this song ring out like the whistled tune, etc.) Kloos was enchanted yesterday. What a breath of fresh air that Gorter is... Yes, I am right. The greatest deeds will come from silence, alone, soundlessly. Whistle, whistle my lonely birds...'

He had gained this certainty through a silent deed of his own, but not before suffering even greater pain and hurt when his pastel, *Orange Festival*, was rejected for an exhibition in the autumn of 1887 (cat. no. 57). A few years later, in 1890, he was to produce the painting of the same title, a large canvas of 160 x 110 cm, but his first reaction to the disappointment was to record the event in words instead. The result was his novella, *De nachtcactus* (The Night Cactus), quoted earlier in this essay.[1]

The story does not, however, confine itself to a description of the street party. His protagonist relives the celebrations *in his memories* and *at a physical distance* from the action, sitting in the gardener's lodge of a large country house in the wooded dunes outside the city. That evening he has accompanied his host, the gardener, on a visit to the greenhouse to see a cactus which blossoms only rarely and then for just a single night. As

they walk back, one of the gardener's lads points to the pale glow in the night sky to the north. Is there a fire? he asks. 'No, that is Amsterdam, the lights of Amsterdam', explains his boss, a self-styled authority on all things. The reader receives no further explanation, but Van Looy's description suggests that the glow was an atmospheric phenomenon, the result of prolonged drought. The lack of rain preoccupies the gardeners throughout the conversation.

In the silence of the oppressive night that follows, alone while the world is asleep, the protagonist relives first the pain of his early years in an orphanage, the rough life he led among working folk thereafter and the magical sweetness, as he recalls it now, of the Oriental world, briefly glimpsed in Morocco. And then, the two exotic snow-white cactus flowers take possession of him in his dream and speak to him in their mysterious language.

'"We are children of a single night and we parade our beauty for free; of all the flowers that bloom none is our equal, our beauty is the flowering of desire. – And desire is eternal", murmured the flower, turning its face away.'

The reader seeking to explain their dialogue might interpret their single night of life as the night of human existence on earth, in which we know only the light we bring with us from the world before birth. This idea might be contained in the words 'We were born out of light and with the light we are gone'. But it seems more likely that the flowers are to be understood as a metaphor for artistic creation, the sublime flowering which has its origins in the instincts, in 'desire'. A little later in the story, this same passion, but raw and unsublimated, sweeps through the streets of Amsterdam on the night of the festivities, relived in vivid colours by the sleeping figure in the summer house. He wanders through the monstrous tumult, which gradually subsides in the early hours of the morning and finds himself finally on the deserted, empty Dam, where the decorations hang in shreds from the battered makeshift entranceways and blow about the cobblestones. He looks up at the vast town hall, a robust seventeenth-century edifice planted in the square, 'compacted by its own colossal weight. It was enormous, vast, night and day it stood firm.' The chant which had haunted him now rose to his lips like an echo, but it had become a sound of indestructible vitality and in the middle of the Dam he, too, began to sing 'We won't die'.

Waking from his dream, he opens a window and hears 'in the night which amplifies all sound', the rustle of rain falling on the dark garden, bringing relief.

There is more to Van Looy's *Night Cactus* than the naturalistic description of street scenes conveyed in an impressionistic style and with a sense of involvement. There are also snatches of visionary images, as surreal as the work of Redon, or reminiscent of the horrors of Goya, which recur with greater frequency in his later works. Sphinx-like, they suggest secrecy and impending doom and seem at the same time to demand and to defy symbolic interpretation. Van Looy himself said of his pastel *Orange Festival*: 'Perhaps, unconsciously, I pro-

duced something more than the *direct* impression' (the instantaneous quality, the immediacy required by Impressionism), 'perhaps something slipped in, a sort of general impression of that monstrous feast'. Van Looy seems to be formulating for the first time what R.N. Roland Holst was to express more skilfully in 1892, when commenting on a painting by Derkinderen in the influential magazine *De Nieuwe Gids*: 'Reality here is not a goal in itself, but the means of representing the abstract concept that lay behind the reality.'[2] It is not only Roland Holst's comment that shows greater conviction; Derkinderen himself was much more conscious of theory and of having a programme than was Van Looy, with his tentative suggestion that 'perhaps unconsciously something slipped in'. The factors shaping the way in which Derkinderen's work evolved from Impressionism were also completely different from those influencing Van Looy, with the result that their manner of painting was very different. But for all this, they both followed the same tendency, which was apparent in several of Van Looy's contemporaries and many of the younger painters who succeeded him, namely the tendency to devote themselves to a more abstract portrayal of spiritual experiences, more 'general' than the highly individualistic character of art which captured a particular mood only.

What prompted their development in this direction? It may be possible to answer this question by following a particular line in their intellectual development during the 1880s. This generation of painters and writers, born shortly after the middle of the century, was raised in the Christian faith. However, the natural sciences and the materialistic philosophy of their century had sown the seeds of doubt and apostasy just as these young people were reaching intellectual maturity. Many no longer attended Church, were agnostic or even openly atheist. In his literary manifesto of 1882, Willem Kloos, the great editor of the mouthpiece of the younger generation, had derided the God-fearing Christians who clung to their belief in a life after death.[3] Following his example, the young painter Jan Veth took to task a rather less adventurous contemporary in 1886 and confronted her with the closing lines of a sonnet which mocked the 'milk-and-water' Netherlands for the exaggerated praise heaped upon one of the parson-poets of the previous generation[4] (fig. 13). The poem predicts that the younger generation will inflict a harsh sentence on the Almighty and His versifying servants: *Zij zullen eens uw God met al zijn priesters slachten en jubelen bij hun doodskreet, en lachen om hun pijn.* (The day will come when they butcher your God and his priests and rejoice in their death throes and laugh at their pain.)

The author of the poem, who had sent it to Jan Veth, a kindred spirit, was none other than Jacobus van Looy, whom we had thought until now so diffident and insecure. At this early date (1884) he seems to be certain enough about this question of religion. Like his fellow artists, he is fired with pride and contempt, stung by the obtuseness of their pedantic elders who still hold authority, not least because they adhere

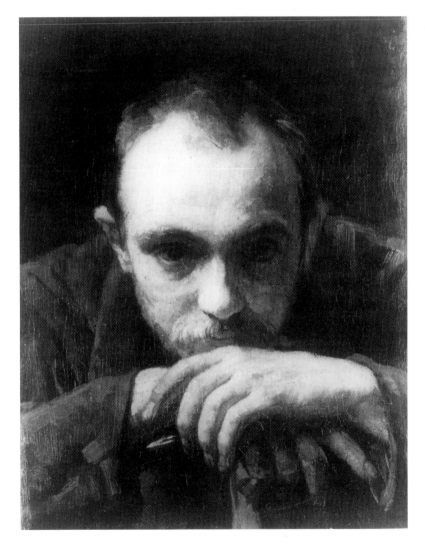

13. Jan Veth, *Portrait of Maurits van der Valk*, 1886.
Dordrecht, Dordrecht Museum

unquestioningly to the socially accepted religion and its empty conventions.

It is this hubris, the vital over-confidence of youth, that keeps them going. They have little else to hold on to, to guide them in their lives and their art, now that they have abandoned a faith so rich in tradition. *L'art pour l'art* became the slogan for artists and poets alike. As far as the content of their art was concerned, this meant no anecdotes or tales with a moral message which might suggest profound (or not so profound) thoughts to the viewer or reader, just an unbiased observation of the real world, as part of the quest for Beauty. The writers held slightly more developed ideas, while the painters had little else than 'mood'. The practices of the Hague School served as their model. It all sounds so simple, as formulated by Van der Valk in the 1880s: 'What is the creation of a work of art but the representation of an impression or the mood evoked by an impression, whether it arises out of lines or colours, direct from Nature or out of the imagination of the artist.'[5] Or his remark that 'the greatest artist is the one who best understands the greatest number of moods'.[6]

And the criterion for art applied to a large extent to criticism. Artistic merit was measured above all by the lyrical effect on the individual, the 'mood'. A subjective criterion of this sort, of course, relied on the critics speaking with the voice of authority. For a while, they could set themselves up against the so-called art connoisseurs of the older generation, but this approach proved unworkable once the first victories had been scored.[7] But as long as the principle held good, each 'soul', with its supposedly unique emotions, feelings and 'spiritual experiences', was left without any clear standard, or any other external point of reference. Only in the company of a few like-minded individuals was support to be found. Such individuals were thus heavily dependent upon one another.

The following passage from Lodewijk van Deyssel's *Nieuw Holland* illustrates all of these elements: the loss of ideology, physical matter as the only enduring certainty and the soul as refuge. 'The world has had its religious visionaries and witnesses of God and for generation upon generation the people have knelt before the powers that dwelt in the skies. Mankind has built on reality and bricked it over with palaces of dreams and temples of prayer, and high in the towers men have seen wondrous sights. But with the collapse of civilisations, the decline and fall of generations, the cleansing storms of the sea of time, we have been washed ashore, poor, naked human beings together. We have looked up and seen the sky, looked in front of us and seen water, looked beneath us and found sand. And we have pondered and questioned whether anything at all exists. Then, suddenly, our eyes met and we saw untold depths in these eyes. And we understood that we existed, human beings, life, everything, with our misery and our bliss.'[8]

And so, Van Deyssel concludes, it is given to us to be 'the witnesses to life, the perceivers of reality, in thrall to fact and enraptured by sensation'.

Only in the last of these four qualities does he refer to the subjective, inner experience of the more external elements of 'life', 'reality' and 'fact'. 'Fact', in particular, suggests something grasped by the intellect, objectively valid, the building blocks of the exact sciences and experimentation. To be 'in thrall' to fact was probably the gift of the modern *artist* and Emile Zola served as Van Deyssel's model in this respect. He was a forceful and eloquent – and successful – propagandist for Zola's work. Looking back on this period, his contemporary, Diepenbrock, remarked: 'Mes Haines and le Roman expérimental held absolute sway over literature and painting around '86'.[9] That Zola was a mentor to others outside the Amsterdam circle, too, should be immediately apparent to any visitor to the great Van Gogh centenary exhibition. This exhibition includes the painting of a large family Bible, standing open on a table. At the foot of the four columns of text lies a battered book with a yellow paper cover on which we can just make out the words: E. Zola. La Joie de Vivre.

'With the great need in him to experience the fullness of their joy' – *la joie de vivre* – Van Looy had mingled with the crowds celebrating the King's birthday. But he who wanted *life*, 'like a good child of my time', could not fail to notice that, painfully, wilfully, the crowd repudiated death in its festive chant, when all along death was plainly and hopelessly visible, as in a canvas by Ensor. A few years earlier, in 1884, driven by 'a thirst for human knowledge', he had sought real life, at this stage in the books which were so warmly recommended to him. The final lines of his sonnet *Na het lezen van Zola*[10] show that even then his reading led him to the same conclusion as he was later to reach in the streets:

> *Als de echo van een stervend reuzenkoor,*
> *Eén lange klacht, zóó, menigmalen, hoor*
> *'k Den strijd des levens langs mij henen gaan*
> *(...)*
> *En al mijn hoop en al wat in mij lacht,*
> *Ik zie het deizen in dien zwarten nacht...*
> *'t Is of Natuur haar luchtig tooisel torst,*
> *Of smachten blijft der menschen kennis-dorst,*
> *Nu alles om mij heen roept: 'wij vergaan'.*

> (Like the echo of a dying giants' choir
> A single endless plaint, time and again
> I hear the mortal struggle pass me by
> (...)
> And all my hope and all that in me laughs
> I see dissolving in that deep black night.
> Now Nature's burdened by her airy beauty,
> And human thirst for knowledge yearns the more,
> For all around me cries 'we have to die'.)

Van Looy was driven by a desire for '*la vie sans phrase*', in other words without religious palliatives, while conscious all the time of the inevitability of '*la mort sans phrase*'.

'I watched them dancing and jumping in the light of a street-lamp and detaching themselves from a group of other people, with a great Orange flag trailing behind them, forming the most colourful spot in the entire spectacle. They emerged from an alley. "We won't die, we won't die." The spontaneous joyful outburst of people irredeemably tied to their miserable earth, but haunted, even when deliriously intoxicated, by the fear of what tomorrow may bring.'

Van Looy expressed all these thoughts in a letter of 20 November 1887 to Van Deyssel,[11] and here too, in a context other than his literary writings, he formulated his despair about the finiteness of human existence, which burns out from the very desire for life.

It was the same with the young poet whom Van Looy had applauded for his 'great deed which arose from silence', the poem *Mei*. For him, too, the 'passion for life' lasted a year only, before the consciousness of death gained the upper hand. In the closing lines of *Een dag in 't jaar*,[12] after a visionary description of Amsterdam by night, Gorter feels at one with 'all mankind's black guilt, all innocent women's woe', with humankind, living according to its instincts and bound to the material world, and he experiences the unconscious pull of death.

> And I, while I stray through their great city,
> Am suddenly aware, I see
> Myself at once in my mind's eye.
> I soar high, high
> Above their very houses,
> I am a tree which rustles to the
> Voice of all the winds,
> It comes and I enfold it,
> With every leaf and bend now here, now there,
> My boughs and branches to its bidding.
>
> For this is how my heart was born.
> I can never hear
> A single sound
> But deep down echoes
> An answering call from my winged spirit.
> Death has no meaning for me
> All shines with vital light
> When I come face to face.

> And all that is greatest
> In human history,
> The great urge and longing
> Has long flamed within
> Me with bright and brittle light.
> Around me the land
> Echoed for years to man's screams.
> Treading with sobs soft as snowfall
> Through the human throng
> I drifted on.
>
> I saw the longing for death's quiet repose
> And the vain hypocrisy.
> Within me burned the fire,
> Around me all was scorched,
> The waves were pounding upon me
> And I sank down beneath them,
> I, too, am proof no more
> Against the passion for life.
>
> The rushing winds all
> Bear down upon me,
> My nostrils sear and scorch with
> All the singeing smells,
> My eyes illuminate
> With all things' lightning flash –
> All mankind's black guilt
> All innocent women's woe –
> Everything together like a great white sea –
> O my white light, white pain,
> White life that's all around me,
> Transitory span
> Of my mortal life
> Wherein I stand bright,
> Bared to your light,
> In longing until death.[13]

The language Gorter uses displays a heightened sensitivity, compared with the 'early beauty' of *May*, the poem with which he made his debut[14] (fig. 14). The works of the Amsterdam School painters showed a similar heightened intensity. The subjects suggest inner torment and are depicted in unusual proportions and lighting. Whereas their landscapes were at first suffused with the 'mood' of the scene itself at a particular time of day, a work such as Veth's painting of a half-submerged wreck in a ditch among the reeds, dating from 1885, in which the palings stand out starkly against the evening sky, has a positively tragic air.[15] Van Looy's café interiors glow with the light of his own inner fire. Breitner, painter of hussars on the dunes and cavalry on the beaches, moved to the city and turned his hand to depicting piles being driven into the clay of a building site or photographing maids walking across a bridge, their skirts billowing in the wind, the

light behind them, images he would later use on canvas. It was no coincidence that Isaac Israëls should have designed the cover of a book entitled *Dances and Rhythms*: 'he loved movement, furious movement, flying hair, billowing skirts, whirling legs, (...) passionate life',[16] and discovered the sort of life he sought in the night cafés, the dance halls, the textile workshops.

However, Van Looy, Breitner and Israëls (fig. 15) did not themselves produce evidence in their work of the radical change in 1890 for which they had paved the way with their exalted ideas. Their Impressionism gradually lost its intensity and came to resemble more closely the work of those painters who had always lived in a more intimate dream world, such as Karsen, Matthijs Maris, Witsen and Verster.

The spirit of the times, which they had for years embodied themselves, now found expression in the work of other artists and painters, mostly much younger, whose concerns had evolved even further. They sought to escape from the isolation of individualism and *relate* to something beyond the mortal self, to discover something other than 'myself and myself alone, again and again, my own immediate surroundings and nothing more' (Gorter, looking back over this period in 1905). Instead they turned 'from a preoccupation with the momentary impression into history, into the flow of time'.[17] They addressed themselves to the 'great works of art of the past', asking themselves 'what gave them their greatness, their richness, their *universality*' (Gorter, ibid).[18] They sought salvation in common experience, shared ideas and beliefs. Given this quest for an earlier world which could serve as a model for the present or even the future, in which there would be a new coherence – a spiritual coherence – and in which it would be possible to divine the meaning of earthly existence, including the meaning of the seemingly incomprehensible *end* of that existence, it was little wonder that artists and intellectuals so often discovered (or rediscovered) an idealised version of the Middle Ages and Catholicism.

In the 1890s, those artists individuals in the Netherlands whom we now refer to as 'Symbolists' did not possess a programme in the form of a manifesto. However, the tendency to spiritualise what had formerly been a feast of the senses is apparent from numerous articles in magazines and periodicals. It is most clearly illustrated in the reviews and essays of Veth and R.N. Roland Holst. The impetus was quickly taken up by those on the fringes of this intellectual circle and publicists alert to the spirit of the times and eager to add their voices to those of the prophets spread the word to a wider public, popularising the new ideas. This tendency is well illustrated by an article in *De Nederlandsche Spectator* of 8 April 1893: 'That giant that goes by the name of the nineteenth century, born into an age of scepticism, raised in a cloud of gunsmoke, fed on a diet of iron and electricity and placed under the guidance of implacable Logos, grew clever and strong in knowledge. But now it recalls that it possesses not only a head but also a heart, that it is capable of feeling too and it sets off in search of

14. Herman Gorter.
 Photograph: Joseph Jessurun de Mesquita
 Laren (NH), Alphons Diepenbrock Archive

beauty. A vain search, mutters Logos. – But it matters not whether one succeeds or fails; the very seeking is itself so fine.

'And now, to everyone's surprise, the grim anvil that had served as the altar of the nineteenth century becomes entwined with flowers which give off a mystical fragrance; while around the steam hammer, elevated to a God, wind clusters of iris and violet.

'This is no renaissance, no rebirth. It is the resurgence of the naive inner life of the Middle Ages, of all the fine ideas and works of that time, produced with a subtlety of which we have almost no conception in this fin-de-siècle. What once blossomed in the confines of the monk's cell or beneath the vaults of a church can now flourish in the open, exposed to the light of day.

'Let us not bind this tender shoot to any religious dogma. The Church has served its purpose and will remain only for those for whom outward form is more important than inner being. But the ultimate faith – not in Jahweh or Allah – the ultimate faith in the ideal that shines far above us like a guiding star, far, far above the soulless pettiness of ordinary deeds, will once again rule the world. The turn of the century will refill the aristocracy of the heart with the naive belief in what Dante so beautifully describes as *L'Amor que muove il sole e l'altre stelle.*'

It is true that this is a rather rough and ready brew of rationalism, aestheticism, symbolism, agnosticism and humanism, but for all that one may laugh at the kitsch image of the steam hammer entwined with garlands of flowers, one cannot ignore the nineteenth-century sense of history which is apparent from the reference to the fin-de-siècle and other signs of 'historical nostalgia' (to borrow a term from Hammacher).[19]

The fact that this change of mentality found so many enthusiastic propagandists is probably also attributable to the absence of any serious opposition to such a noble portrayal of the situation. There was little risk involved in writing pieces of this sort. They did not defend any position which seriously threatened the established order of religion or society (and these institutions in any case did not take seriously the temporary flirtation with anarchism). This vaunting of progressive colours was in effect a call for a return to what Gorter, in his recollections of this period, would summarise as 'metaphysics, in this case: reaction'.

Of course, historical awareness does not necessarily mean conservatism. The third stanza of Gorter's poem, quoted above, for example, also bespeaks historical awareness: 'And all that is greatest / In human history...' But what is referred to here, in this poem dating from 1889, is anything but a sublime spiritual value. It is in fact the same instinctive 'passion for life' which Van Looy recognised as the ground that nurtured the beautiful flower of the night cactus, the silent act of artistic creation.

A purer exposition of the new tendency, a conviction expressed with greater integrity, is to be found in the works of

15. Isaac Israëls.
 Photograph: Joseph Jessurun de Mesquita
 Laren (NH), Alphons Diepenbrock Archive

31

the handful of people who had become imbued with this historical consciousness in the course of their study of the Classics and who had followed the ideas of Classical philosophers and later thinkers on matters of human destiny, prompted by their own concern for 'the state of the world'.[20] Gorter and Diepenbrock's friendship dated back to their student days and it had become their custom to discuss their reading and share their experiences of life in confidence. Gorter would submit drafts of his poems to Diepenbrock for comment. Diepenbrock knew almost all the young writers and painters of the day. He followed the flowering of art and literature in the 1880s with passionate interest, his satisfaction marred only by the fact that the movement rested on materialistic principles.

After the 'early beauty' of Gorter's *May* and his sensitive *Verses* of 1890, which marked both the apogee and the culmination of his *oeuvre*, the baton now passed to Diepenbrock. In his essays he writes with deep satisfaction of the changes taking place, of the new concern with immaterial values, which was also to act as a stimulus to his own creativity as a composer. His reflections on cultural history, which appeared from 1891 onwards in *De Nieuwe Gids*, did not, however, make easy reading. His complex syntax and tentative definitions which avoid any naming of specifics, inspired respect but did not always contribute to a clear understanding or act as a very effective call for vigilance. This is the case, for example, with his warning about taking up fashionable causes at the end of the following passage about Western culture since 1890:

'In the meantime, all of the countries of Europe experienced a deep longing for spiritual renewal and the rebuilding of life according to purer principles and some who had emerged from the desert of the blighted, dead Holland, who had sought Feeling and Passion like the thirsty seek water to quench their longing, understood that, now their youth was passing, they could no longer live by passion alone, nor by simple Feeling, which Van Deyssel had tried to set up in place of Reason and Van Deyssel himself understood it too.

And once again there appeared the names of the ancient powers, capable of moving the earth, which were honoured in the time of the great oneness of life and one person said God and meant himself, another said that God existed, but was unknowable, a third sought peace and calm after the storms of lonely passion and doubt in the philosophy of the one who said that God was in all and everything, a fourth sought to console poor wretched humanity with hymns, for they had lost sight of God and still others looked back to the time of great Faith and sought comfort in their distress and freedom from the chains of Individuality in the contemplation of the images and ideas which had once been the manna of mankind. Many followed the example of barbarians, having captured an old city with vast material and spiritual wealth, who decorated their houses with ancient images of the deities and adorned their ideas and works with ancient, once sacred, symbols.'[21]

This new concern with philosophy and religion once again gave an aristocratic aura to the world of literature and the arts. The knowledge of traditional symbols and myths and religious mysteries which was required could result in elitism and opened the way for intellectual charlatans and raving priests such as Max Nordau or Le Sar Péladan who had struck less of a chord in the age of Naturalism which sprang from knowledge of the earth and earthly things. Reading a passage such as the one from the *Nederlandsche Spectator* about the 'giant that goes by the name of the nineteenth century', with its steam hammer, it is immediately apparent from the tone of the writing alone that there were any number of Victorian ghosts which could still torment the mind in the 1890s and later haunt the pages of the dramatist and writer and the canvases of the artist. Strange hallucinations, decadent fantasies and a fascination with the occult would surface only to disappear again, sometimes as quickly as a delirious dream. In some cases, however, if they were organised into sects and boasted their own rituals, they might stubbornly persist for several decades in the salons of the rich or in imitation temples, where their teachings were blazoned in capital letters, without unduly strict obligations being imposed on the disciples in practice, for example to recognise the rights of all.

It is up to the individual observer today to decide whether he wishes to discern the fashionable tendencies in the literary and artistic products of this period; whether he wants to admire them as a historical curiosity and perhaps also for their sincerity of purpose, or whether he can appreciate them for their intrinsic beauty which still appeals to his senses. At a general level, we can certainly endorse Hammacher's verdict: 'A vision of distant horizons and new heights was opened up, which would turn some into incurable dreamers and stir others to new discoveries'.[22] Diepenbrock was also aware of this exploration of new experiences when he wrote to Veth in 1893: 'Dear Jan Piet. It was a fine piece you wrote about The Three Brides. I saw it in Amsterdam on Sunday and have since reread your piece. It is in fact impossible to describe in words because, fundamentally, it is so completely concerned with the interior. But I do not believe that the *visible* exterior can be more beautifully described than you have done. Your piece has the deep sound and reverberation of a tolling bell. In recent years v. Deyssel and Gorter have managed to make us aware of so much of man's unconscious side, that it comes as no surprise in the end that *this* work, too, should have been produced by Toorop. It seems to me to be full of a wisdom infinitely superior to any artistic technique and springing from intuition and innocence of feeling, as possessed by our Medieval forbears, such as Ruysbroeck (according to Maeterlinck) and which is so unusual in this age. For it does not strike me in any sense as an abstractly conceived symbolism.'[23]

Diepenbrock seems to perceive a link with the great figures of the Eighties, who, for all their differences in orientation, nevertheless paved the way for change.

In the light of this, it is understandable, in my view, that this pent-up metaphysical longing for secrets and mystery, far removed from the lucidity of the present day, should have the effect of restricting artistic activity once again to the circle of a few initiates. The language of art was no longer directed so much to the people as to the cultural connoisseurs. Although they might sometimes refer to themselves as anti-individualistic, and spoke of Community Art, they tended in fact to be much less socially aware than the Impressionists who had claimed to be uninvolved in society. Ten years earlier the slogan 'art for art's sake' may have been fashionable, but it did not breed an élite claiming to be the high priests of art; and artistic endeavour remained firmly rooted in the reality of human existence. Spiritualised art, on the other hand, lost something of the wisdom imparted to Van Looy by the night cactus: that beauty was the flowering of desire, that the artist could not repudiate the life of the passions without the risk of his art becoming rarefied and ethereal.

Van Looy's 'Night Cactus', written in 1887, was published in *De Nieuwe Gids* in 1888. In the same year, Frederik van Eeden wrote an appraisal of the novel *Een liefde* by Lodewijk van Deyssel, the propagandist of Zola. Passages in this novel describing the sexual activities of the frustrated female protagonist are much more explicit than was customary at the time. In his essay entitled 'An Immoral Book', Van Eeden eloquently expounds his objections to the book on aesthetic grounds tinged also with moral distaste.[24] He, too, uses the image of a flower to support his argument: 'You are surely familiar with the great white water lily, which grows in still pools, peacefully, among wide flat leaves with a pale green gloss. The flowers are white, pure white and towards noon the folds and petals gradually open and expose the golden heart to the sun. And so they float, drifting softly backwards and forwards as the wind catches them, or bobbing up and down with the ripples, in their silent white perfection, on the smooth, dark, sparkling surface of the water. Lying on the banks watching the lilies I know that they have risen from the cold black depths of the pond in search of light.

'And lo! they have found it, now it is good, perfect, they are perfect, they rest on the surface and receive the sunlight on their spread and scalloped leaves. And the dark water is content to support them, like pure thoughts of perfect happiness.

'If someone now approaches these flowers to take them, to possess them and reaches under them into the water and pulls them towards him so that far below they break off, with a soft snapping sound and there appears a long, tubular, brownish stem, slack, wet and limp, it is to me as if I were to see a length of intestine drawn out of the white body of a sweet, beautiful woman. Don't do it. Please don't do it. They were fine and perfect, I cannot endure it. I do not want to know what the stem is like, how they are rooted in the muddy depths, how they are nourished by the black soil. Now they are ugly and wretched and unappealing, but it is you who uprooted them that made them so. That ugliness was not there, was not ugly, for I could not see it.

'This is what you do, Van Deyssel, to my mind, when you take the sexuality, that blooms so beautifully purely on the bright surface of my soul and uproot the long, ugly stem which nestles deep in the dark unconscious corners of my being'.[25]

Van Eeden is thus as aware as Van Looy of the mire where beauty germinates and in which the roots grow that nurture it. But the less sentimental Van Looy is more prepared to come to terms with this reality and hence also with the pain of earthly existence.

The awareness of this reality is also apparent in the work of Van Gogh dating from the same period, the 1880s, which reached an impasse at the very point when spiritualisation was gaining momentum, in 1890. Yet this same work was soon to be re-examined and could not be overlooked, so that ten or twenty years later it was to emerge triumphant.

Notes

*This essay was translated by Mary Maclure
For the reader's convenience various organisations and events have been rendered in English. The glossary of the original Dutch terms can be found in the Editiorial Note.

[1] In order not to distract the reader with references in the less factual early part of this essay I have omitted footnotes until this point. Most of the quotes have been from Jacobus van Looy's story *De nachtcactus* (The Night Cactus), which was published under the pseudonym A. Brouwer in *De Nieuwe Gids* 3, 1887-1888, vol. 2, April 1988, pp. 4-29 and August 1888, pp. 326-355. It then appeared in Jacobus van Looy, *Proza*, Amsterdam 1889, pp. 1-72. In the second edition (1894) on pp. 91-161. A third edition was published in 1904. *De nachtcactus* was published separately in 1969 by De Roos Foundation, in an edition containing woodcuts by Gerrit Noordzij.

The quotes beginning 'that monstrous feast...' and 'What I most want to see in a work of art...' are from Jacobus van Looy, 'Brieven aan Karel Alberdingk Thijm', edited by Harry G.M. Prick, in *Roeping* 31, 1955, 4 August, pp. 227-244. Letter of 20 November 1887.

The quotes beginning 'I, who am aware every minute of the day...' and 'Gorter will be here soon...' are taken from Jacobus van Looy, *Een feestdroom. Een keuze uit ongebundeld en ongepubliceerd werk*. Compiled and annotated by Peter J.A. Winkels and Chris Will. The Hague 1982, pp. 56 and 60-61.

Finally, the quotation beginning 'Why? Why are you doing this...?' is taken from Jacobus van Looy, *Gekken*, Amsterdam 1892, pp. 112-113.

Details of Van Looy's life and work are to be found in Christiaan Will and Peter J.A. Winkels, *De dubbelbegaafdheid van Jacobus van Looy*, Haarlem 1988 (Haarlemse miniaturen, 14) and in the *Schrijvers Prentenboek* devoted to him, no. 26, The Hague 1987.

[2] R.N. Roland Holst, 'De beteekenis van Derkinderens nieuwe muurschildering in onze schilderkunst', in *De Nieuwe Gids* 7, 1891-1892, vol. 1, February 1892, pp. 321-324.

[3] Willem Kloos, 'Inleiding' in Jacques Perk, *Gedichten*, Sneek 1882. Reprinted in Kloos, *Veertien jaar literatuur-geschiedenis*, vol. 1 (1894 and later); more recently in H. Michaël, *Willem Kloos, zijn jeugd, zijn leven*, The Hague 1965.

[4] For this incident see Fusien Bijl de Vroe, *De schilder Jan Veth 1864-1925. Chroniqueur van een bewogen tijdperk*, Amsterdam-Brussels 1987, pp. 92 and 113.

[5] J. Stemming (pseudonym of M. van der Valk). Quoted from the newspaper *De Amsterdammer*, by J. Staphorst (pseudonym of Jan Veth) as a motto above his article 'Odilon Redon', in *De Nieuwe Gids* 2, 1886-1887, vol. 2, April 1897, pp. 64-72.

[6] J. Stemming (pseudonym of M. van der Valk), 'Wereschagin in de kunst', in *De Nieuwe Gids* 2, 1886-1887, vol. 2, April 1897, pp. 52-63. The quote comes from p. 60.

[7] A detailed survey of literary ideas adopted by art critics among the painters may be found in Carel Blotkamp's contribution to this catalogue.

[8] Lodewijk van Deyssel, 'Nieuw Holland', in *Verzamelde opstellen*, vol. 1, Amsterdam 1894, pp. 34-35. This passage was written circa 1887.

[9] Alphons Diepenbrock, *Brieven en documenten*, compiled and annotated by Eduard Reeser, vol. 1, The Hague 1962, p. 379, letter to Andrew de Graaf, 14 September 1892.

[10] Jacobus van Looy, *Gedichten 1884-1925*. Leiden 1932, p. 11.

[11] See source given in note 1.

[12] H. Gorter, 'Een dag in 't jaar', in idem *Verzamelde werken*, vol. 2, Amsterdam-Bussum 1949, pp. 486-514. Also in idem, *Verzamelde lyriek tot 1905*, Amsterdam 1966, 1978, pp. 48-78.

[13]

Ik, terwijl ik door hun groote stad ga
ik voel me in eens, ik sta
plotseling voor mijn eigen oog.
O ik rijs hoog
boven hun aller huizen
ik ben een boom waarin kan ruischen
aller winden stem,
hij komt en ik omvang hem
met al mijne bladen en buig mij over
waarheen hij wil met tak en loover.

Want zoo werd mijn hart geboren
ik kan niet hooren
ooit een geluid
of diep in mij fluit
mijn eigen zielsvogel diezelfde toon.
Voor mij bestaan geen doôn
alles heeft levenslicht
vlak voor mijn aangezicht.

En wat het grootste is
in menschengeschiedenis
het groote verlangen
dat heeft al lange
spiegelend in mij gebrand.
Om mij was het land
al zoo lang vol geschreeuw.
Stil ging ik snikkend als sneeuw
door der menschen drom
varende om.

Ik zag het verlangen om te vergaan
ik zag den valschen schijn aan
in mij heeft het gebrand
om mij heeft het gezengd
de golven hebben geklonken
op mij, ik ben in gezonken,
ook ik, ik kan niet meer
tegen het levensbegeer.

Op mij varen saam
aller winden aam,
in mijne neusgaten brandt
aller geuren brand,
in mijne oogen licht
aller dingen weerlicht -
aller mannen zwart
aller witte vrouwen smart.

Dat is alles samen als een witte zee -
O mijn wit licht, wit wee,
wit leven dat om me zijt,
vergankelijke tijd
waarin ik verga
waarin ik licht sta,
voor uw licht bloot,
verlangend tot den dood.

[14] 'It is dead and gone, isn't it, that early beauty' and 'You must half kill yourself producing it, then something comes of it'. 'We all have the feeling that anything that isn't deeply felt does not count', excerpts from a letter by Gorter to his friend Alphons Diepenbrock. In A. Diepenbrock, *Brieven en documenten* (see note 9), p. 231; and in *Herman Gorter Documentatie 1864-1897*, compiled by Enno Endt. Second, enlarged edition, Amsterdam 1986, p. 329. Reflections on Gorter's development in this direction can be found in the edition of his sensitive *Verzen. De editie van 1890*, Amsterdam 1987.

[15] The oil painting and subsequent etching are reproduced in Fusien Bijl de Vroe, *De schilder Jan Veth* (see note 4), pp. 76 and 77.

[16] Gerard Brom, *Hollandse schilders en schrijvers in de vorige eeuw*, Rotterdam 1927, p. 115.

[17] As formulated by Kees Fens in his review of Endt, *Het festijn van Tachtig*, entitled 'De hogeschool van de literatuur' in *De Volkskrant*, 15 March 1990.

[18] H. Gorter, 'Voorrede', in. idem, *De school der Poëzie*, vol. 1, second edition, Amsterdam 1905. Included in idem, *Verzamelde werken*, vol. 2 (see note 12), p. 445; and in *Verzamelde lyriek tot 1905* (see note 12), p. 519; and in *Herman Gorter Documentatie* (see note 14), p. 609.

[19] A.M. Hammacher, 'Symbolisme en abstractie', in exhib. cat. *Kunstenaren der idee. Symbolistische tendenzen in Nederland, ca 1880-1930* (Haags Gemeentemuseum), The Hague 1978. Published earlier (1951) in *De Groene Amsterdammer*.

[20] This description can be found in Herman Gorter's early work, 'Lucifer', in idem, *Verzamelde werken*, vol. 2 (see note 12), p. 456; and in idem, *Verzamelde lyriek tot 1905* (see note 12), p. 24.

[21] Alphons Diepenbrock, 'Lodewijk van Deyssel', in *De Kroniek* 2, 1895-1896, no. 56, 19 January 1896, p. 18. Included in idem, *Verzamelde geschriften*, Utrecht-Brussels 1950, pp. 124-132. Diepenbrock is referring in turn to Van Eeden, Verwey, Gorter, Henriëtte van der Schalk, Antoon Derkinderen and Van Deyssel. The 'many' who 'followed the example of the barbarians' include figures such as Le Sar Péladan, Maeterlinck, Thorn Prikker and Couperus. This explanation is taken from E. Endt, *Het festijn van Tachtig*, Amsterdam 1990, p. 148, which contains more detailed reflections on changes through the period and more extensive references to the literature.

[22] Hammacher, loc. cit. (see note 19).

[23] Alphons Diepenbrock to Jan Veth, 7 March 1893, in Alphons Diepenbrock, *Brieven en documenten* vol. I (see note 9), pp. 439-440. Also in *Herman Gorter Documentatie* (see note 14), p. 465.

[24] Frederik van Eeden 'Een onzedelijk boek', in *De Nieuwe Gids* 3, 1887-1888, vol. 2, April 1888, pp. 61-79. Subsequently in idem, *Studie's* (I), Amsterdam 1890 and in later reprints.

[25] This passage is taken from *Studie's* (I) (see note 24), pp. 47-48.

MAN AND NATURE – THE NATURE OF MAN

RIETA BERGSMA*

In the early seventeenth century, Galileo fundamentally changed man's view of the world by demonstrating that the Earth revolved around the sun and could not, therefore, be the centre of the universe. In the second half of the nineteenth century, Charles Darwin caused a similar radical shift in thinking with his theory of evolution, which altered man's view of himself, his origins and his future. *The Origin of Species* (1859) confounded the traditional teaching of divine creation.[1] Darwin held that a slow transformation had occurred in the plant and animal world and that all existing species had evolved from a small number of basic forms. A violent struggle for life was waged in the natural world which led to the survival and reproduction of the strongest, best adapted species, while the weakest went to the wall and became extinct. The book caused a sensation. Twelve years later, in *The Descent of Man* (1871), Darwin described the natural origins of man as an evolution in accordance with broadly the same natural laws, without divine intervention.[2] Mankind's physical and intellectual characteristics had both developed from the animal world through natural, sexual selection. Darwin's theory no longer treated man as external to or superior to Nature, but returned him firmly to the realm of the organisms. Man, with all his abilities, his propensity for good and evil, was simply the product of mechanical evolution.[3]

The theory of evolution caught on rapidly in the Netherlands, as elsewhere;[4] Darwin's principal works appeared in translation between 1860 and 1874. The issue was evidently a major preoccupation of the day, as may be seen from August Allebé's watercolour entitled *Darwin's Doctrine* (fig. 16), dating from 1873, of which a critic remarked in 1880, 'the apes who are engaged in the study of Darwin were handled beautifully and with great wit...'[5] From the 1880s the theory of

natural selection and man's animal origins was taught in colleges and universities. Catholics and orthodox Protestants continued vigorously to oppose the new teachings, but freethinkers and atheists, such as C. Vosmaer, J. van Vloten and Multatuli, greeted Darwinism with enthusiasm. It found keen support in liberal circles and, after 1875, among the growing ranks of the Socialists. The last decades of the nineteenth century saw the publication of numerous cheap editions and anthologies of Darwin's work and by 1900 the theory of evolution had become widely known throughout society.

The acceptance of evolutionary theory cannot be seen in isolation from other developments in the intellectual climate of the second half of the nineteenth century. Positivism and materialism, philosophies premised upon the unity of mind and matter, were enjoying tremendous popularity at the time. In the view of the leading exponents of this doctrine, such as Auguste Comte and Hippolyte Taine, reality consisted only of what could be perceived and verified by the senses. People therefore placed enormous faith in the new developments in the natural sciences. It was felt that the results obtained in this sphere should be applicable to all other areas. Darwin's theory of evolution was presented in a highly positive light: changes in the human race would necessarily entail a change in human society too.

This was also a period of secularisation. For years the Netherlands had suffered a 'dominocracy' – its intellectual and cultural climate dominated by the Protestant clergy, or 'dominees'. Profound social and economic changes were also under way. The country continued to embroider on the liberal principle of *laissez-faire – laissez-passer* and experienced industrialisation much later than its neighbours, but the pace of change began to accelerate noticeably in the final decades of

16. A. Allebé, *Darwin's Doctrine*, 1873.
Amsterdam, Amsterdams Historisch Museum

the century. At the same time, the less welcome consequences of industrialisation began to make themselves felt. While the road and rail network expanded to serve the economy and the emergent tourist trade, the natural environment paid the price of urban and industrial expansion and agricultural reclamation. The urban proletariat and large numbers of the peasant population formed a new deprived social class.

The enormous changes which occurred in the Netherlands in the second half of the last century could not fail to affect the artistic and cultural life of the country. In this essay I shall consider the question of whether Darwinism, admittedly as part of a complex of phenomena, had any repercussions for the visual arts in this period. My hypothesis is that the relation between man and nature, as reflected in art, is heavily dependent on developments in the natural sciences, theology and philosophy. It is these fields, after all, which supply 'explanations', which determine our relationship with, our feeling for and our understanding of Nature. I shall look in particular at the extent to which Darwin's most shocking revelations – his theories about evolution and man's animal origins – percolated through to the visual arts. As a testing ground for these theories I shall use those genres in which the relationship between man and nature is most explicit: firstly, of course, the landscape and secondly, the portrayal of the individual, particularly the individual at work in his 'natural' environment or performing his 'natural' tasks. This latter category includes works in which women are associated with essential natural attributes such as fertility. It will become apparent in the course of this article that Darwin's ideas were interpreted and applied in rather different ways by successive generations of artists, as they incorporated them into their own view of the relationship between man and Nature.

THE MODERN LANDSCAPE

The landscape only emerged as a genre in its own right in the course of the sixteenth century. The theory is that this was a logical consequence of man's discoveries about the world and the universe. The other-worldly outlook of medieval man gave way to a preoccupation with more mundane matters. The golden age of landscape painting in the Netherlands was the seventeenth century, but it experienced a revival in the Romantic era, with its cult of Nature. The landscapes imbued with Romantic feeling and embellished with Biedermeier flourishes which were still to be found in the first half of the nineteenth century gradually gave way in the latter part of the century to a genre partly modelled on French examples (the Barbizon School), in which artists sought a purer, more realistic treatment of Nature. There was a reaction against the 'landscape arrangers, the composers of trees, mountains and foregrounds with their inevitable little pools, seekers after showers of rain and vantage points, pursuers of the whimsical effect', against the artificial method whereby artists prettified images from Nature or composed them in the studio, after the

style of the seventeenth century.[6] An important phase was the period around 1860, which has been referred to as the incubation period of the Hague School, when artists such as Gabriël, Roelofs and the Maris brothers descended on the village of Oosterbeek in the Veluwe, the Netherlands' answer to Barbizon. In this remote and undeveloped area they worked directly from nature. The decade from 1870 to 1880 marked the apogee of the landscape genre among the painters of the Hague School. Jacob and Willem Maris, J.H. Weissenbruch and Anton Mauve, now working in and around The Hague, recorded their impressions in sketches, drawings or small oil paintings which they might then develop further in the studio. Willem Roelofs, who had experienced at first hand the various stages whereby the landscape genre had been purified, described the process in 1886 as follows: 'In the modern landscape we have tried to get ever closer to Nature and to free ourselves from artifices and accepted theories of composition and effect (...). Impressions of Nature never suspected by earlier generations, moments of effect and colour which they failed to observe, have been pressed into the service of Art.'[7]

Critics and public alike were at first unimpressed by this modern view of landscape painting. As late as 1883 J.A.A. Alberdingk Thijm, Professor of Aesthetics at the Academy in Amsterdam, had the following comment to make on visiting an exhibition of work of the Hague School: 'On emerging from an exhibition of Impressionist paintings, one is thankful to be able once again to draw a breath of fresh air in God's free and wholesome world and happy no longer to dwell on thoughts of suicide.'[8] A reaction of this sort is incomprehensible to us now, a century later, when we look at the picturesque images of the typical Dutch landscape of polders, canals and windmills. Professor Thijm and many like him preferred not only a more detailed representation, but also a more uplifting subject. The individual impressions of the Hague School, in which Nature is portrayed without any ulterior meaning, did not satisfy their demand that art should express a philosophy of life.

IN HARMONY WITH NATURE

Nature, or the natural state, was idealised in the modern Hague School landscape. Artists sought out unspoilt locations; they focused on an image of Nature that was slowly disappearing and shut their eyes to the growing urbanisation. They were irked if the authorities interfered with their 'subject matter'. The painter Mesdag and several of his colleagues protested when the local council in The Hague announced plans to level the Seinpost dunes at Scheveningen in order to build a café-restaurant, and created the Mesdag Panorama to record part of the Scheveningen they saw disappearing. In a letter to a local newspaper in 1886, J.J. van de Sande Bakhuyzen, who did a lot of work in the wooded area of The Hague, the Haagse Bos, expressed his satisfaction that 'the Woods Commission has chosen to ignore the criticism voiced in

17. Jozef Israëls,
 *A Midday Meal in a Peasant Hut in
 Karlshaven near Delden*, 1885.
 Dordrecht, Dordrecht Museum

numerous letters complaining that such and such a decaying tree has or has not been cut down or certain yellowing tufts of grass have been allowed to remain or a few nettles have been left to grow among the trees. Had they heeded all these remarks our beautiful Wood would long since have been converted into a formal park.'[9]

The working man was also incorporated into this idyllic view of 'natural' Nature. In these paintings, farmers and fishermen form picturesque accents in the landscape, without disturbing the overall image. Man, animal and object are all in harmony with their natural surroundings. Roelofs applied the new scientific theories to interpret this unity when he wrote in 1871: 'If people would read the latest work by Darwin... they would understand that the gulf separating us from the lowly animals is not so great...'[10] It is difficult to distil from the 'empty' impressions of the painters of the Hague School any of the deeper feelings or philosophical ideas which artists traditionally associated with Nature.

The image of women in Hague School painting is in keeping with this view of the natural links between men, animals and landscape. Jozef Israëls, Neuhuys and Artz painted mostly humble peasant women or fisherwomen and associated them with all that was untouched and unspoilt. The natural function of motherhood was heavily emphasised. Titles such as *The Cottage Madonna* refer directly to the exalted ideas they embodied. Jozef Israëls's painting of *A Midday Meal in a Peasant Hut in Karlshaven near Delden* (fig. 17) is a case in point. The devout pose of the woman, shown in a stable interior with her husband and child and the cattle, is evocative of the Virgin Mary. The Hague School depicts women as mothers, nurturing their families, as Mother Earth growing and blossoming and bearing fruit. Outdoors we see them working in vegetable gardens, gathering food in the fields or tending cattle and goats, as for example in Van de Sande Bakhuyzen's *Landscape in Drenthe* (cat. no. 77) or Mauve's *Vegetable Garden* (cat. no. 64).

THE DISSECTION OF NATURE

Over the years the landscape art of the Hague School painters reflected a growing interest in specific atmospheric phenomena, a tendency which emerged around 1875 and came to be known as the 'grey period'. Places where such phenomena were particularly pronounced, where land and water met, such as Noorden, Nieuwkoop, Kortenhoef, Kampen and Scheveningen, were especially popular with artists. Typical products of this period are *In the Month of July* (cat. no. 20) by Gabriël and *Beach View* by Weissenbruch (fig. 18). Landscapes produced elsewhere (Drenthe was extremely popular until reclamation work began in 1885) also reveal a related interest in the different seasons of the year or times of day. Artists were seeking to capture the interplay of light and space in the fleeting moment when a cloud passes by or the fading outlines of a boat as evening falls. 'Nature must be seen in action', to quote Weissenbruch, while Roelofs, for his part announced

that he was concerned with 'moments of effect and colour'.[11] Much of their work is roughly composed and painted with a loose touch. A dominant tone, usually grey, yellow or green, links the various visual elements and brushstrokes.

Their almost clinical approach to atmospheric phenomena reflects an intense fascination with Nature. Like scientists trying to fathom the truth by experimentation, they sought to capture a particular moment or phenomenon that could enhance their understanding of Nature. The masters of the Hague School thus inaugurated a process of dissecting nature which would be taken a step further by the next generation.

LANDSCAPE AND THE YOUNGER GENERATION

Almost all the young Hague and Amsterdam painters began as landscape artists. In the Dutch Etching Club and the journal, *De Nieuwe Gids*, both founded in 1885, they presented themselves to the outside world as a group and aligned themselves with the avant-garde *Tachtiger* movement, the writers of the Eighties. Their common articles of faith were '*l'art pour l'art*', 'art is passion', 'form and content are one'. In fact, however, the painters were in search of an artistic formula of their own. The 'mood' which they sought to express in their art – an ill-defined concept – was thus associated in the first instance with the landscape. For J. Stemming (pseudonym of the painter M. van der Valk and the Dutch word for 'mood') an impression was 'the feeling one gets at a given moment from one aspect of nature, in the specific circumstances, as it appears then and then only...'[12]

The venerable legacy of the Hague School weighed heavily on the shoulders of the younger generation of painters. 'I *must* have a grey day (...). Give me a week of grey weather without rain and I will give you a painting with authentic tones', sighed Jan Veth in 1885, wandering around the outskirts of his native Dordrecht and trying his hand at landscapes for the first time.[13] The same year found Willem Witsen at his family's country estate Ewijkshoeve, in the company of the doyen of the Hague School, Anton Mauve, painting figures, draining moorland, tending sheep and gathering wood. Jacobus van Looy, winner of the Prix de Rome, was in Italy, but even there found remarkable associations with the Dutch landscape, as we learn from a letter to Witsen: 'Michelangelo has more in common with heathland than with a filthy city full of bourgeois citizens and stinking theories.'[14] The influence of the Hague School is clearly visible in his painting *On the banks of the Tiber* (fig. 19), which he produced on his travels. The same is true of the engravings which appeared in the first portfolio of the Dutch Etching Club in 1886, such as *Evening* by Willem de Zwart, *Trees* by Jan Veth and *Shepherd* by Willem Witsen. The outlook of the younger generation was still very much 'coloured' by the atmospheric impressions of the older painters. It is thus hardly surprising that Jan Veth later remarked: 'Because of the authority it exerted, the eminent work of those we refer to as the great Hague artists, for whom we have never shown anything but the highest respect – art which will remain the great glory of its age and to which we owe the culture of our own age – nevertheless weighed heavily on many of those still seeking their way in this period.'[15] Veth, who tried at first to cast himself in the role of 'a child' in order to 'coax Nature's secrets from her'[16], abandoned his efforts at landscape painting in 1888 and concentrated instead on portraits. From about the same time onwards Witsen devoted himself primarily to townscapes, while Van Looy, Isaac Israëls and Breitner had already shown a preference for figure pieces. Each thus tried in his own way to escape the pressure of the Hague School, which had imprinted a particular image of Nature on their retinas.

18. J.H. Weissenbruch, *Beach View*, 1887.
The Hague, Haags Gemeentemuseum

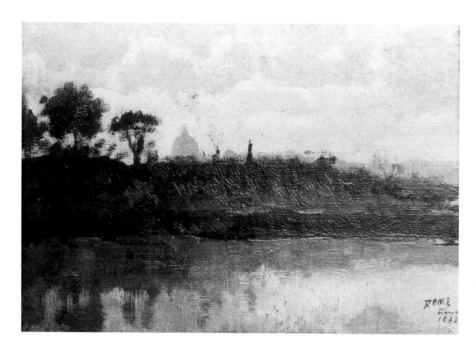

19. J. van Looy, *On the Banks of the Tiber*, 1885.
Private collection

It is always difficult to introduce something new because it means displacing what has become familiar. In a relatively short space of time the Hague School had won a large following, both at home and abroad and a great deal of the work produced in imitation of the great masters was riddled with clichés. As Hammacher rightly observes, nothing suffers so much from repetition as art: 'A different temperament, a seemingly minor shift in feelings or moods, can cause changes in form and associated changes in method.'[17] Feeling and temperament would indeed set the young Amsterdam painters on a new course. If one had to single out the common thread linking the complex range of subjects, ideas and styles that was poised to achieve its breakthrough at this point it would have to be the loss of faith in the direct visual registration of Nature which was characteristic of the painters of the Hague School.

NATURE IS OUR SOUL

'Nature – Nature is our soul with its perceptions and sentiments. That is what a painting must resemble. It must not be true to Nature, but true to feeling – *Märchentreu*, as Heine puts it. What you call Nature is your feelings and if you will pardon my saying so, they are usually uglier than artists' feelings – for that is, after all, why they are artists, is it not?'[18] This impassioned declaration, which appeared in *De Nieuwe Gids* of June 1888, came from the pen of Frederik van Eeden, a member of the *Tachtigers*, and epitomises the change in attitude among the younger generation, to which I am referring. Albert Verwey had predicted this development two

years earlier, in 1886. 'Zola's personal passion, the Goncourt brothers' substitution of sensation for reality, will be two major elements of art based on perception in the years to come.'[19] Unlike the artists of the Hague School, the young Amsterdammers no longer gave themselves up to the landscape, to Nature external to themselves, but saw themselves as the all-important reality. Nature was subordinated to the personal feelings of these individualists, in accordance with Van Eeden's pronouncement, which echoes Emile Zola's famous statement that 'Une oeuvre d'art est un coin de la création vu à travers un tempérament.' This outlook finds its clearest expression in the late 1880s. Not only writers such as Van Deyssel, Prins and Aletrino, but also painters such as Witsen, Van Looy, Isaac Israëls and Breitner, were all admirers of the French Naturalistic novelists, Flaubert, De Goncourt and above all Zola. Well into the 1890s the painters remained in thrall to the novels in the series *Les Rougon-Macquart* (1871-1893), such as *Nana*, *La Terre*, *La Bête humaine* and *Le Rêve*, and to the anthologies *Mes Haines* and *Mon Salon*. For the artists of this generation, Zola's Naturalism represented not only the external side of existence, in which everything was equally important and equally suitable as a subject for a painting – the love of the material world – but above all the passion with which this was experienced. This attitude was perfectly summed up by the painter/writer Jacobus van Looy: 'For me, looking is a process of imbibing rather than probing. A true *Tachtiger* can never rise above the passive and self-indulgent drinking in of moods, bathed in colour...'[20] In this state of intoxication 'Nature' was replaced by 'life'. The landscape genre lost its hegemony, or rather, the distinction between city and countryside ceased to exist. For the younger generation the

modern city and its inhabitants formed a single, gigantic, picturesque, organic machine. Atmospheric moods were now experienced above all in the urban setting: the grey shroud of rain in Witsen's *Montelbaanstoren, Amsterdam* (cat. no. 104), the pale light of early morning or dusk in Karsen's *Begijnhof in Amsterdam* (cat. no. 53), the nocturnal darkness of Van Looy's *Orange Festival* (cat. no. 57). Artists such as Witsen and Van Looy replaced natural light sources such as the sun and the moon with artificial gas and electric lighting. For Breitner, the maids' white aprons and the rain-drenched paving stones took the place of polder landscapes in the snow. Nature had had its day as the criterion of beauty, as Witsen wrote in *De Nieuwe Gids* in 1888, 'For naturalness is synonymous with beauty for most people, because Nature for them is a sort of criterion for passing judgement; (...) and they cling to Nature, to the natural like a drowning man...'[21] This also opened the door to subjects which had previously been regarded as unaesthetic or uninspiring. The impression made on these painters by the animal carcasses in Tholen's *Slaughterhouse* (cat. no. 79) or the wilting flowers and weeds in Verster's *Flowers and Foliage* (cat. no. 96) was as powerful and memorable as that produced by a duckling on a pond or roses in bloom for the previous generation. Breitner introduced the genre of the nude in a harsh and unflattering way in paintings such as *The Seated Nude with a Blue Scarf* (cat. no. 10). The feverish urgency of their approach to life was also apparent in the way painters were often content to depict just a single detail or fragment. Choosing an unusual angle, the artist would zoom in on his subject as if with a camera (Witsen's *Montelbaanstoren*, for example). The subjects were also sometimes blown up to gigantic proportions, as in Verster's still lifes with flowers.

MAN AS A FRAGMENT SEVERED FROM NATURE

It was after 1890, in particular, that the Naturalism of artists such as Isaac Israëls and Breitner, nurtured in the 1880s, reached its apogee. Their interest in the life of the metropolis focused primarily on the seamy side of society: their depiction of the reality of the life of the urban proletariat became increasingly grim, as they adopted Zola's philosophy of passionate involvement in the real world and the Naturalist belief that human life is determined by race, heredity and environment.

Zola had based his series of novels *Les Rougon-Macquart* on the laws of heredity, drawing on the ideas of Taine, Claude Bernard and Charles Darwin. He wanted to found his novels as firmly as possible on scientific knowledge, though now and again a metaphor will slip in. Van Buuren concludes that in *Les Rougon-Macquart*, Zola compares Nature (the countryside) to the Great Mother who produces the sap, the vital substance which the author associates with mother's milk. The city (Paris) is the Terrible Mother who produces poisoned sap.

A person who leaves his land to move to the city loses his plant-like nature and degenerates into an animal.[22]

The theme of man uprooted also features in the art of the Amsterdam painters. A case in point is Van Looy's painting, *Orange Festival* (cat. no. 57), depicting the festivities in the Jordaan quarter of Amsterdam. He describes the atmosphere in a passage in his novella *De Nachtcactus* (The Night Cactus): 'the lines of their bodies writhed in the bestial fury of their insatiable desire (...) The hairs on their heads sprang up like apemen's.'[23] Van Looy's painting effectively captures the fervour with which the revellers abandon themselves to the dance. In a preface to *A Rebours* (Against Nature), the gospel of the 1890s, J.K. Huysmans describes Zola's characters as follows: 'He was superb at suggesting the illusion of movement and life; his characters had no soul. They were driven purely by passions and instincts...'[24] This view of humanity is also apparent in the art of the younger generation; people in the city are ruled by implacable laws and animal compulsion. Israëls and Breitner cram their canvases with houses, canals and people. Messenger boys, labourers and passers-by are mere fragments in the busy life of the city. Early examples are *Noordermarkt* by Isaac Israëls (fig. 20), dating from 1887, and his later drawing *Leliegracht Amsterdam* (fig. 21), or Breitner's *Three Women on a Bridge* from 1887 (fig. 22), *Kalverstraat by night* (cat. no. 11) and *Dam Square in the Evening* (fig. 23), the latter two from the 1890s. Man in the city is locked in a frantic struggle for life, it is the 'survival of the fittest'. One critic caught the mood of this sort of image by Breitner when he wrote in 1894 'but here, here is knowledge of good and evil, here is consciousness of blind passion, here man is no longer a being that sees Nature and is happy or afraid, here man is a fragment severed from Nature itself, bleeding from birth, his eternal birth, an unfettered beast, and cities are the dens which animals have made for themselves, where they go about their lives, work themselves to death, drone on, with their horses and carriages.'[25]

WOMAN AS ANIMAL

Obviously, this fatalistic and deterministic view of human nature precluded the idyllic image of women generally favoured by the Hague School painters. In his *Idols of Perversity*, Bram Dijkstra gives a fascinating and yet terrifying account of the way in which women were perceived in the *fin de siècle*.[26] His thesis is that Darwinism, as a 'scientific' explanation, had repercussions for the entire intellectual climate and hence also for the art of the closing decades of the nineteenth century. Dijkstra cites the Impressionist painter Degas as an example. Looking at Degas' apparently innocent women bathing, a contemporary critic, for instance, immediately recognised the 'bestial' and 'frog-like poses' of a degenerate woman.[27]

20. Isaac Israëls, *Noordermarkt*, *c.*1887.
Private collection.

21. Isaac Israëls, *Leliegracht Amsterdam*, *c.*1890-1894.
Private collection

22. G.H. Breitner, *Three Women on a Bridge*, 1887.
Amsterdam, Stedelijk Museum

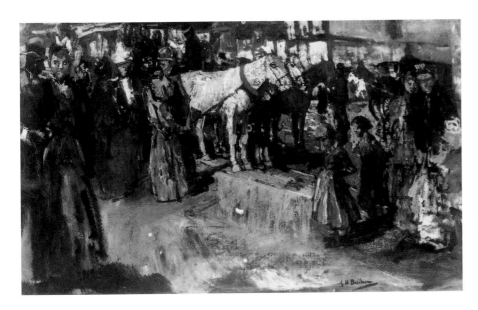

23. G.H. Breitner, *Dam Square in the Evening*, c.1890.
Private collection.
Photograph: Lichtbeeldeninstituut, Amsterdam

Darwin's view of women is expounded most clearly in *The Descent of Man and Selection in Relation to Sex*. After eighteen chapters devoted to fish, crustaceans, ringworms, insects, birds and finally mammals, he concludes that the evolution of woman is slower than that of man. 'Man is more courageous, pugnacious and energetic than woman and has a more inventive genius.' He achieves 'a higher eminence in whatever he takes up, than woman can attain.'[28] Woman possessed the maternal instinct, and some of her attributes, such as intuition, perception and imitation, though more developed than man's, were not valued particularly highly. Woman remained at a more primitive stage of development. She was regarded as a sub-group of Nature; men were intellec-

tually superior, or, to quote Mondrian's astonishing remark at a much later date: 'man is mind, woman beast.'[29]

The bestial and instinctive side of woman is clearly evident in the image of women projected by the younger Amsterdam painters. Israëls sought his models in sailors' bars, dance halls and cafés-chantants on the Zeedijk, the Nes and in the Jordaan. In his *Dance Hall on the Zeedijk* (cat. no. 42), the setting and the two working-class women dancing are magnificently portrayed: the women convey the sense of solidarity, which the painters of the period found embodied in the working classes. At the same time Israëls alludes to woman as a sexual object in the lascivious glances being cast by the man in the background. Van Looy does the same in his *Tango* of 1886

24. J. van Looy, *Tango*, 1886.
Haarlem, Frans Halsmuseum
(Jacobus van Looy Foundation)

(fig. 24). The woman is dancing a provocative tango while a young man, clearly relishing the spectacle, looks on and the guitarist at his side sings along apparently entranced. The clapper of the bell oscillating above his head seems to be an obscure symbol of the underlying passions of the scene. Van Looy describes the same evening in his story 'Tango', in the collection *Proza* (Prose): 'Carmen was dancing; large and dark she moved in front of the shimmering wall (...) now with a bounding upward movement, swaying like a cat that purrs contentedlyáas it flexes its claws (...) His eyes and heart fixed on the dancing woman, he drank in the writhing red body, the swaying and twining of her arms and the turning of the hands and wrists. Rooted to his chair, craning forwards, he followed the artiste, and in her movement and the display of her pure body, saw the embodiment of passion, the desire of one individual for another...'[30] Both Israëls and Van Looy draw a connection between dance and sexuality and emphasise the primitive instincts unleashed by women dancing.

Painters were not alone in linking woman with the world of the instincts; critics drew the same inference, as may be seen in the animal metaphors, the comparisons with dogs, monkeys and cats, which occur in the reviews. Israëls painted numerous street girls, such as the shy figure racing by in *Girl in the Street* (fig. 25). Describing a watercolour of a street girl submitted by Israëls for Arti's spring exhibition, Jan Veth wrote in 1890: 'the superb expression of a stray cat, of one of those perverse and misunderstood beggar children, ripened before its time, like a soft, bruised, green fruit. (...) those small, dull eyes, peering out from beneath a narrow forehead, on either side of a snub nose that is almost pretty, while the coarse monkey's jaws below bespeak the wild greed of the pariah.'[31] The critic G. described Breitner's working-class women in similar terms: 'He sees the silhouettes of figures and peoples his squares in the evening light with them, figures of depraved women, ugly, screaming women whose eyes and mouths tell of crude longing, born as they were in the mire, devastated at an early age, their faces destroyed by a life that reduced them to the level of dogs from the start...'[32] Breitner's work justifies such a characterisation. The faces in his *Two Maids* (cat. no. 14), for example, are grotesque; the women indeed look as if they have been 'destroyed' by life. In his *Tram Horses on the Dam* (fig. 26) he positions the head of a young woman just in front of the animals. The woman looks more primitive and more animal-like than the horses. These artists not only emphasised the bestial, instinctive side of woman, but also believed that the environment affected the physical characteristics of an organism, in line with Darwinian theory. It is thus no coincidence that they sought their models in the seedier quarters of the city.

With the rise of the *Tachtigers*, the nude enjoyed a resurgence of popularity. Whereas Jozef Israëls's *Nude at a Spring* (cat. no. 48), by its title alone, alludes to exalted symbolic classical ideas and depicts the young woman in a state of perfect innocence and in a natural setting, Isaac Israëls and Breitner stress the carnal, erotic and passionate aspect of the nude. Their women are sexual beings. Female sexuality as a factor in its own right features not only in literature, for example the famous scene of the masturbating woman in Van Deyssel's

25. Isaac Israëls, *Girl in the Street, c.* 1890-1892.
The Hague, Haags Gemeentemuseum

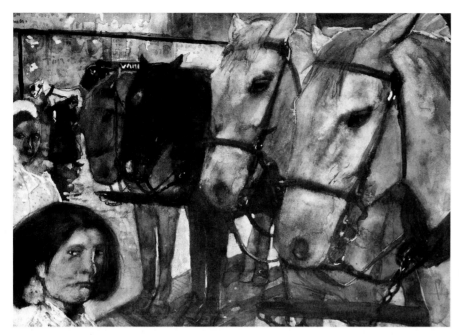

26. G.H. Breitner, *Tram Horses on the Dam*, c. 1894.
Amsterdam, Rijksprentenkabinet

novel *Een Liefde*, but also in a painting such as Israëls's *Reclining Nude with Stockings* (cat. no. 44). With almost voyeuristic self-assurance, the writer shows us a woman who is mentally exhausted, the painter a woman who is physically exhausted. Breitner's reclining figures in kimonos (cat. no. 13) display the same physical weakness and passiveness. Although they are at first sight less disturbing than his nudes or 'street girls', his image of women is essentially the same. Woman's true nature, in his eyes and those of most of his contemporaries, is instinctive, primitive and sexual. In contrast to the Madonna figure of the Hague School, the younger generation presented an image of the Terrible Mother. Woman as the symbol of Nature was not only sheltering but also threatening.

THE REACTION

In 1890, the philosopher G.J.P.J. Bolland wrote a piece in *De Nieuwe Gids* which contains the following passage in his typically convoluted style: 'One of the many foolish and short-sighted lessons inflicted upon us this century by honest but one-sided thinkers is the widely-held view that should, on *purely physical-mechanical grounds*, regard all of Nature beyond human and animal consciousness as completely devoid of anything in the way of plan, providence or intelligence. And should declare all Nature external to ourselves to be meaningless and blind (...). The life of the human intellect, however, with its "subjectivity" which distinguishes it from the physical objects, is just as much a part of Nature as these objective phenomena themselves, and it shows a sad lack of re-

flection that people in Naturalistic circles refer repeatedly to the Universe as if incorporeal thought were not a part of it and we were observing Nature, so to speak, through a looking glass.'[33] Bolland is criticising here the mechanistic view of evolution and claiming that there must after all be a cause or purpose in Nature, something that answers man's spiritual need. Frederik van Eeden, who periodically supplied *De Nieuwe Gids* with psychological reflections on hypnosis and spiritualism, had already propounded a similar view when he wrote: 'This promised land is very dull. The inhabitants claim to have the universe in a weighing scale and all human wisdom on the point of a compass. They react with furious indignation if one questions the possibility of fathoming everything that exists for all eternity with the help of matter, power, mathematics and Darwinism.'[34]

These are clear signals that the generation raised on the theory of evolution longed for something more than the mechanical process described by Charles Darwin and the positivist view of society. In *Het Boek als Nieuwe Kunst*, Braches remarks that the whole tendency to spiritualisation which emerged in the 1890s is connected with the view of the body as inferior to the mind.[35] This idea is repeatedly expressed by the writers and painters of the age. The doctor and writer Arnold Aletrino, for example, corresponded at length with his fellow writer Frederik van Eeden about the 'bestiality' of his sexual feelings and Van Eeden himself found these feelings incompatible with his high-minded ideas about man and society.[36] In the world of art, we see how painters and critics alike projected the base passions onto the weaker members of society: the urban proletariat and women.

Darwin, however, proved to be open to more than one in-

27. J. Thorn Prikker, *Female Figure*, c. 1891.
Otterlo, Rijksmuseum Kröller-Müller

terpretation. 'Tens of millions of years have been spent on these creatures, from which man has developed, and according to the scholars we are the supreme product of all the constituent parts of our planet', wrote the critic J.J. Isaäcson in 1892, perfectly characterising the reaction which consisted of sublimating man's intellectual abilities.[37]

Darwin had reduced spiritual qualities too much to the material level and many saw man as the most highly evolved of all beings whose intellect nevertheless *did* set him apart from animals and the rest of Nature. This probably explains Van Deyssel's famous outburst 'We are the Kings of life. We are the highest natural powers.'[38]

New spiritual qualities were sought in the work of philosophers such as Schopenhauer and Von Hartmann (propagated above all by Bolland), who cast doubt on the perception of the senses, among writers such as Huysmans and Maeterlinck, who gradually took the place of the more 'worldly' Zola, and in mystical and religious movements such as Rosicrucianism and the Catholic faith. Parallel to this was a clear commitment to social melioration. Many artists adopted a political line and became anarchists or socialists. A polemic raged in *De Nieuwe Gids* in 1891-1892 between Van der Goes, Van Eeden and Van Deyssel on the subject of art and socialism, sparked off by Edward Bellamy's *Looking Backward: 2000-1887*. The debate addressed positivist and metaphysical ideas and their implications for art and marked a parting of the ways for the writers of the *Tachtiger* generation. A similar

split occurred in the art of the 1890s. Two new tendencies emerged alongside the more intense Impressionism of Breitner and Israëls: an individually-oriented symbolic art and a socially-committed art of the community. Both of these movements brought with them a new attitude to Nature, including human nature.

THE ESSENCE OF NATURE

Charles Baudelaire's sonnet *Correspondances* (1857), which may be regarded as the foundation of Symbolism, opens with the following lines: 'La Nature est un temple où de vivants piliers / laissent parfois sortir de confuses paroles...',[39] which encapsulate what Nature meant for the artists of the 1890s. They once again turned their attention to the landscape, or to individual elements of the natural environment, such as trees and flowers, but from a different intellectual perspective from that of their predecessors. The Symbolist artist set out to capture the essence of Nature and to translate it into an emblem that had a meaning for humanity. He saw himself as a mediator between the external, transitory reality and a higher, enduring truth. In the words of Sar Mérodack Joséphin Péladan, leader of the mystical Rosicrucian movement to which the likes of Toorop and Thorn Prikker belonged, the artist was priest, king and magician in one. He was also a creator, who no longer imitated Nature but, depending on his own feeling

or conviction, fashioned a new Nature that was the product of his imagination. Unlike Weissenbruch, Thorn Prikker did not have to be physically immersed in the landscape to experience 'the force of Nature';[40] in his view one could experience a snow-covered landscape at the height of summer or a sunrise while sitting in a café or lying in bed.[41] Such natural phenomena could also be expressed by something different. When Thorn Prikker wanted to convey the 'complete whiteness, the awful purity of snow' he symbolised it in a drawing by 'a large form extending from the top downwards, which opened out into a flower, a passionflower; beside this shape at the top of the picture stands a small white figure with long hair, in the centre there is a second female figure, standing perfectly still, at peace.'[42]

Once the artist sets out to capture the essence of Nature he will not only study her more closely, but must carefully consider the eloquence of his means of expression, since this is the medium which must serve to convey the essence.

LINE, FORM AND COLOUR

Earlier artists had of course also tried to adapt their means to the end they were pursuing. The painters of the Hague School, fascinated by atmospheric effects, tried to capture specific moments from Nature. As far as technique is concerned, they did so by adopting a loose touch and a unifying tone that brought the disparate elements together. In the work of the younger generation we see how reality was remodelled according to the artist's will. Artists such as Suze Robertson, Verster, de Zwart, Breitner and Israëls allowed physical mat-

ter to play a more pronounced role, or employed special chiaroscuro effects in their paintings of the city at night to enhance the mood. In Thorn Prikker's early work, *Female Figure* (fig. 27), technique wins out entirely over representation. The means is judged more and more in terms of its expressive quality.

'I understand what painters are trying to achieve by stippling', wrote the critic Jasz in 1892. 'Their argument is that you never see a flat surface with a single, uniform colour, that light shines differently on every tiny particle, that the atmosphere quivers and colours are all dissected. They must try to reflect this as accurately as possible, if they really want to paint properly.'[43] It is interesting to see how Bremmer, in his *Landscape with Windmill* (cat. no. 15), or Toorop in his *Environs of Broek in Waterland* (cat. no. 89), chose a typical Hague School subject but looked at the landscape from a new angle. They applied the Pointillist technique to subject it to an analysis of light and colour. Van Gogh also devoted himself to the study of colour in the last years of his life, which he spent in the South of France. He wrote to his sister Wil in 1888, 'one distinguishes the colours of things at an hour's distance...', but he did not shrink from intensifying colour to an extreme degree (fig. 28).[44] In one of the first articles ever devoted to Van Gogh, which appeared in *De Nieuwe Gids*, Van Eeden specifically stressed this aspect of his work: 'Van Gogh exaggerates greatly. He paints blood-red trees, bright green skies, saffron-yellow faces. I had never seen them like that, yet I understood him. After seeing his paintings I began to see his colours in the things around me, just as he had done, the essence of the colour which he extracted.'[45] Other Dutch painters working in France, such as Meyer de Haan and Verkade, also

28. Vincent van Gogh, *Undergrowth*, 1889.
Amsterdam, Rijksmuseum Vincent van Gogh

used overstated colours. Influenced by the synthetism pioneered by Gauguin and his followers, they produced works such as *Décor for Les sept princesses* (cat. no. 94), in which nature is radically distorted and reduced to a few planes of bright colour which often bear no relation to reality.

For the Dutch Symbolists, such as Toorop and Thorn Prikker, line was as important as means of expression as colour. The critic W. van Tricht had prophetic words to say on the subject: 'I believe that we shall see in Pointillism – and very soon, too – the transition from the art of colours in the nineteenth century to the great art of lines in the twentieth, which is already under way, for those able to see it.'[46] Discussing the work which Thorn Prikker exhibited in 1892, he wrote: 'He has abandoned any attempt to imitate Nature. It is, after all, perverse to try to present Nature and nothing more (...); to reveal his inner soul he does not use images *which contribute to the mood*, his work instead being composed of lines which *themselves* convey what the artist means. Thus the lines of devotion, trance-like, pass through the trees bowed in prayer; the suppliant lines of love pass through the image of the maidens...'[47] In *The Bride* by Thorn Prikker (fig. 29), the line, as an expressive element and symbol, links the Christ figure and the bride. Instinctive, religious and mystical motifs go hand in hand with purely technical innovations as the artist explores the visual media of colour, form and line.

NATURE INVESTED WITH ANIMA: FLOWERS AND TREES

In the 1890s Dutch artists started using rather unrealistic natural motifs to express their personal ideas. In order to determine what symbols were associated with Nature we shall examine in greater detail two specific motifs – trees and flowers – both of which have traditionally had a deep symbolic meaning. The tree, for example, is familiar as a symbol of man's physical or spiritual condition, as a symbol of the power of Nature and as the tree of life. In ancient art flowers represent virginity, humility and suffering, or the transience of life. Some of these allusions reappear in Symbolism, but trees and flowers are also endowed with new meanings.

As the importance of the landscape genre declined among the painters of the *Tachtiger* generation, the flower piece began to attract greater interest. The traditional, cleverly arranged still life, of which Roosenboom's *Poppies* (cat. no. 76) is a late example, gave way to bouquets in which the emphasis was placed on the naturalness of flowers and plants. Fanciful and colourful, they dominate their surroundings. Vases, base and background are subordinated to the whole. Verster took this furthest in his *Roses after a Banquet* (cat. no. 97). He did not confine himself to cultivated flowers, but also incorporated wild plants and weeds, sometimes already faded, withered or dead, as in *Flowers and Foliage* (cat. no. 96). It is impossible to establish exactly what symbolism Verster intended to attach to the images in each work individually, but he occasionally the title provides some indication in the title, as for exam-

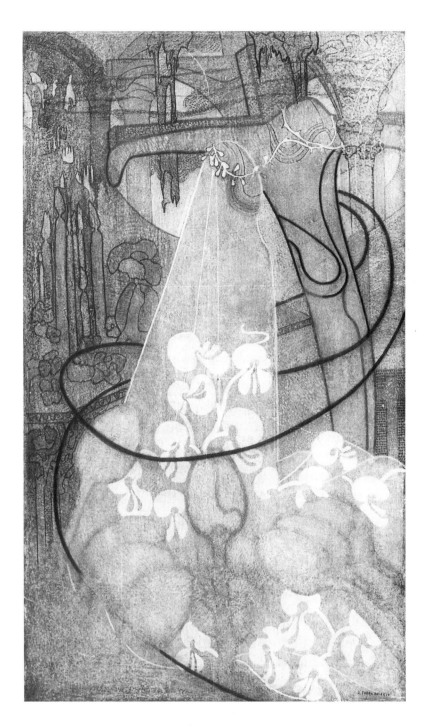

29. J. Thorn Prikker, *The Bride*, 1892-1893. Otterlo, Rijksmuseum Kröller-Müller

49

ple in *Roses after a Banquet*, which represents the melancholy that follows in the wake of a joyful event.

It is perhaps possible to draw a connection between these unaffected still lifes with flowers and the pictures of vegetation outdoors, such as *The Garden* (cat. no. 58) by Van Looy. The reaction when Van Looy exhibited this work was one of shock. He had 'quite simply cut out a chunk of Nature.'[48] However, *The Garden* is a superb depiction of the untamed, capricious, rampant side of Nature, embodied here by the nasturtiums. Vincent van Gogh, more than any other artist, was fascinated by this phenomenon. Ivy features in many of his *sous-bois* pictures, thickly carpeting the ground and entwined around the trees (fig. 28). It is not always possible to pinpoint the exact feelings that artists were projecting in these works, but Nature is clearly represented as a power with a will of its own.

The art of this period links human and natural concepts together. Nature is depicted as animate – invested with a spirit. Kamerlingh Onnes referred to his still lifes with flowers as 'flower portraits' and attributed human traits to them. A bunch of faded tulips with toadstools in the background is given the title *Les Fleurs du mal* (cat. no. 52), a reference to the anthology of poems by Charles Baudelaire, published in 1857, in which flowers symbolise '*luxure*' and '*volupté*', woman and sensuality and evil. The analogy between flowers and women is a recurrent theme in the reviews. When Jan Voerman exhibited a still life with flowers in 1891, the critic Jan Lievensz wrote, in a much more kindly vein, 'Voerman sees flowers as chaste maidens, to be treated with tenderness.'[49]

Trees were regarded in a similar manner, above all by Vincent van Gogh, who wrote in the early 1880s, 'in all of Nature, in trees for example, I see expression, a soul, as it were. A row of pollard willows can sometimes resemble a pro-

cession of orphans.'[50] Even the trees from his early years in the Netherlands bear a certain resemblance to people, as we see in his *Garden of the Parsonage in Nuenen in Winter* (Amsterdam, Rijksmuseum Vincent van Gogh). In his famous *Starry Night* (New York, Museum of Modern Art), a cypress, like a tree of life, forms a link between heaven and earth. Though different interpretations have been ascribed to the work, most of them centre around the conflict between religion and nature (Christian faith and Naturalism).[51] Van Gogh saw Nature not only as a force against which he 'pits himself' with colour and line, but also a power onto which he projected his religious feelings. When his work was exhibited in 1892 Jan Veth astutely observed that 'he attributed human qualities to what we conceive as inanimate and natural phenomena acquired a powerful inner life.'[52]

Verster's trees, too, are anthropomorphic. In his *Garden Path with Willows* (fig. 30), for example, an engraving he produced in 1890, trees rage over the landscape like witches and seem to be locked in combat with one another. Verster was influenced by both Van Gogh and Toorop. Verster's *Evening* (fig. 31), from 1895, might even be seen as an ode to Van Gogh's intriguing canvas *Roots and Tree Trunks* (fig. 32), with its blue tree trunks, roots and green shoots. *Evening* is executed in much greater detail, but the subject and use of colour, different though they may be, show a striking resemblance to Van Gogh's painting. Both artists draw our attention to the ground, to the tenacity of roots and sprouting shoots and to decay – a symbolic allusion to the struggle between life and death.

The connections between man and Nature are presented more explicitly than simply in these veiled allusions and in some cases the two even merge into one another, assuming each other's forms. As early as 1882, Van Gogh had drawn his

30. Floris Verster, *Garden Path with Willows*, 1890. Amsterdam, Rijksprentenkabinet

31. Floris Verster, *Evening*, 1895.
 Leiden, Stedelijk Museum de Lakenhal

32. Vincent van Gogh, *Roots and Tree Trunks*, 1890.
 Amsterdam, Rijksmuseum Vincent van Gogh

33. R.N. Roland Holst, *Old Peasant in the Country*, 1892.
Whereabouts unknown

friend Sien seated naked on the stump of a tree, in such a way that the lines of her body and hair are echoed in the vegetation in the foreground and background (*Sorrow*, cat. no. 37). She is shown sitting naked on a tree stump. He sent a larger version of *Sorrow*, together with a drawing of tree roots, to his brother and wrote: 'I have tried to invest the landscape with the same sentiment as the figure. To be rooted tenaciously, passionately, as it were, in the soil and still to have been half wrenched from it by the storms. The woman's pale, slender figure and those gnarled, twisted black roots are meant to convey something of the struggle of life.'[53] Sien is thus like an uprooted tree. Some ten years later, Roland Holst, a great admirer of Van Gogh, produced a drawing of an *Old Peasant in the Country*, which is also known by the titles *Mourning the Year* and *The Death of the Year* (fig. 33). The curious siting of the head in the foreground, with the hair repeated in the severely deformed trees in the background, gives the work an unrealistic air. The old man and the bare trees are fused into a symbol of the approaching end – their death.

Man and Nature are woven together even more closely in Thorn Prikker's work and are completely integrated in his large *Moine épique* (cat. no. 85). The drawing was inspired by an anthology of poems entitled *Les Moines*, by the Belgian Emile Verhaeren, but the visual stimulus came from the rock formations near Visé in the Belgian Ardennes. Thorn Prikker sought images in the rocks which he then used as a symbol in the definitive drawing. Prikker himself wrote of the work: 'It is no longer a figure or a proportion. What I have produced is the giant, as Verhaeren describes him "... et seul, et seul toujours avec l'immensité". Well, anyway, a giant, a person who is like a rock or a tree...'[54] The drawing shows the figure of a monk, bearing a cross, stepping out of the frame like a living rock.

The examples I have given show how complex and, above all, how personal the symbolism of natural elements is in these works. The same is true of Toorop, whose Symbolist drawings are veritable enigmas. Even sympathetic critics had difficulty with them. Jan Veth, for example, described the weeping willow behind the young child in Toorop's *Younger Generation* (fig. 34) as a tree of life, a 'great natural symbol', while the wood in which it grew was a 'mystical tropical forest'. According to his account, the old woman who appears in the doorway is holding a faded flower.[55] Years later Toorop himself provided the following interpretation of the work: 'The child in the chair is the new era: the woman behind the door – the older generation – is giving the child a pot of flowers as a symbol, passing on tradition. The telegraph and railway – the speed with which everything happens nowadays. Then there is the wood of beauty: faith, colour and life, a beautiful bird – the beauty that dispels the ugliness of the crows. The snake is eating whatever is rotten, mouldy, old.'[56]

To sum up, in a relatively short space of time trees and flowers were transformed from random picturesque elements in the landscape to symbols with meanings of their own. They form part of a personal system of symbols which the artist em-

ploys to express a variety of abstract concepts such as the vitality or power of Nature, his view of man, the purity of the human soul, ideas about life and death and the position of man in modern society. The artist sees in Nature the manifestation of the great scheme of things. The work of the Dutch Symbolists reflects a pantheism, a feeling or belief that everything is connected and invested to the same degree with divine properties, that man and Nature are inextricably bound up with one another.

MIND OR BEAST

As with the Hague and Amsterdam Schools, there is good reason in the case of the Symbolists, too, to examine the image of women in our discussion of the theme of Nature. The conflict between mind and body, sensuality and asceticism, were crucial. In his 1892 lecture tour of the Netherlands, the misogynous Rosicrucian Joséphin Péladan had once again expounded on woman's inferiority to man. A critic summarised the argument in bald terms: 'He sees in women only the ideal of the least developed.'[57] Péladan believed that all true artists were hermaphrodite: 'Physical sensuality cannot and must not exist among those who seek the Ideal – or the artist, which is the same thing. If the intellect is sufficiently developed in pursuit of the Ideal the artist will experience a spiritual sensuality that is infinitely superior to the painful longings of the body.'[58]

In the art of the 1890s women represent two poles: the *femme fatale* versus woman pure and chaste. Matthijs Maris, a representative of the older generation of painters, was regarded by the Symbolists as a pioneer in this respect, since he had long before rejected working from reality as a perceivable phenomenon. 'It must come from the artist himself, Nature obstructs me, it pains me.'[59] Interestingly, the women born of his imagination are almost always represented as organic or plant-like. They grow out of the ground, as in his etching *Ciska*, or blend in with their surroundings, like the recumbent figure in the etching *Under the Tree*, which is also known as *The Lady of Shalott* (fig. 35). In *The Shepherdess* (cat. no. 63) we can just discern a gigantic female figure, leaning over backwards and sinking into the ground. For all their differences, Maris's women generally display the same sort of passiveness as Breitner's nudes. Whereas his female figures in the 1870s were still romantic, realistically portrayed fairy princesses, from the 1880s onwards he made them increasingly incorporeal, thus sublimating their eroticism. The hazy images 'blended in' with the painter's canvas.

Thorn Prikker's early *Female Figure* (fig. 27) shows a marked similarity to Matthijs Maris's images: the woman has become completely fused with the earth and is almost unrecognisable by her physical traits. Both artists seem to associate women with the receptive, fertile soil.

Artists such as Veth and Roland Holst placed the emphasis above all on the ideal of purity which they found embodied in the peasant girls of staunchly Protestant villages such as Laren and Huizen. They saw them as living close to Nature and idealised their state of innocence, representing them almost as Madonnas, a surrogate for the Virgins of the Middle

34. J. Toorop, *The Younger Generation*, 1892.
Rotterdam, Boymans-van Beuningen Museum

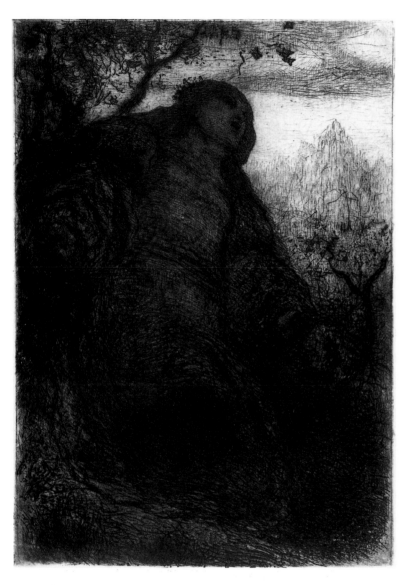

35. M. Maris, *Under the Tree (Lady of Shalott)*, c. 1882.
The Hague, Haags Gemeentemuseum

Ages, when art and faith, man and Nature were still closely related. The young woman in Holst's only partly successful *Woman from Huizen* (cat. no. 75) is more or less flattened against a tree. The stylisation applied by the artists gave the figures an unreal and incorporeal air.

Thorn Prikker took the identification of woman with Nature significantly further in *Spring* (fig. 36), in which a stylised female head rises like a plant in a setting of flowers and in *The Bride* (fig. 29), which is regarded as one of the finest representations of purity by an Symbolist painter. He selected two obvious symbols – the bride's virginity and the innocence of the crucified Christ. The woman, no more than a silhouette enveloped in a veil, is devoid of physical substance, the effect being enhanced by the seemingly thin, glazed surface of the canvas. Rounded buds press in on her body from all sides, white flowers weave up beneath her robe. It is tempting even here to see a sublimated eroticism in the picture, the buds representing phallic symbols and the white flowers, sperm. The Christian symbols link woman and Nature in an obliquely erotic way with higher spiritual ideals. The oneness with Nature is located in the mystical tradition of union with the godhead through purity and asceticism.

Toorop's image of women seems considerably more complex, but no less stereotyped. They signify purity one moment – usually accompanied by flowers – and a force of corruption the next, mostly associated with bare dead branches, bizarre trees or certain animals. One of his earliest Symbolist drawings, *Vil Animal (Woman with Parrot)* (fig. 37), dated 1890, shows a fashionably-dressed woman seen from the back next to a hog, a parrot and a snake. Inscribed on a pillar is a quotation from Baudelaire's *Les fleurs du mal*: '- De Toi, vil animal, – pour pétrir un génie? O Fangeuse grandeur! Sublime ignominie!'[60] We know that Toorop was referring to the untimely death from venereal disease of an artist friend and has therefore portrayed woman as a base and impure creature, a '*Vil Animal*'.

The image of women in the 1890s thus displays a certain duality. The associations drawn between earth, flowers, trees and women are positive and negative by turns. On the one hand women are elevated to an ideal and their bodies are dematerialised, on the other they are seen through Darwinian eyes as a passive element of Nature, often subject to dark desires. If we compare the Symbolist image of women with that of Breitner and Israëls we find a similar denial of female identity. 'You idealists reduce men to *spirits*, you naturalists reduce them to *animals*', to cite a certain Mr Constantijn, writing in *De Nederlandsche Spectator*. If we replace the word 'men' in this quote with 'women' the statement neatly encapsulates the bipolar image of women in the *fin de siècle*.[61]

Darwinist thought not only impinged on the subject matter and, to a certain extent, the form of art in the final decades of the nineteenth century, but also had repercussions for the way people thought about art and the artist in relation to society. Symbolist art was both cryptic and highly individualistic, yet even the work of Thorn Prikker and Toorop and certainly that of Roland Holst and other artists of the 1890s, reflects a certain sympathy for a more practical, socially-oriented art. The acknowledged prophet of this tendency was Derkinderen.

Artists once again descended to the realms inhabited by ordinary mortals. Some, inspired by religious faith, pursued the ideal of a perfect community, others, such as Roland Holst, put their art to the service of socialism. All, however, were united in their desire to model themselves on the Middle Ages, when art had a real function in society. It had lost this status in the intervening centuries and the aim was now to reclaim the role it had previously fulfilled.

Developments in England and in particular the work of socially-committed artists such as William Morris and Walter Crane exerted a powerful influence on ideas about community art and the associated *Nieuwe Kunst* (Art Nouveau), the movement for change in the applied arts in the Netherlands. Various Dutch artists, including Toorop, Veth and Roland Holst visited England to investigate the new developments for themselves. English influence also penetrated the Netherlands via Belgium, through the medium of the artists' association Les Vingt, journals such as *L'art moderne* and *Van Nu en Straks* and individual artists such as Henry van de Velde. Here, too, Darwinism played a part.

'The high priest of Evolution adopted a device for the cover of his book, showing a plant springing upwards from earth and putting forth leaf, bud and finally flower; a caterpillar among the leaves, a chrysalis pendent from the bud and a butterfly hovering over the open blossom. Nothing could well be more tersely and at the same time comprehensively, expressive of perhaps the greatest and most far-reaching theory of our time.'[62] The quote is from Walter Crane's *The Claims of Decorative Art* (1892), which was translated and edited for the Dutch market by Jan Veth. This work, beautifully illustrated by G.W. Dijsselhof (fig. 58), became a manual for Art Nouveau in the Netherlands. Crane expounds the relationship between art and society, based largely on Darwin's theory of evolution as set out in *The Origin of Species*.

Braches has pointed out that Crane conceived of art as a 'natural' consequence of society. A healthy non-capitalist society will allow popular arts and crafts to flourish, which in turn will automatically enable higher forms of art to emerge, as a process of evolution from the lower, material forms to the higher, abstract expressions of art. The great cultures of the past produced immortal art. In the beauty of the Parthenon Crane found convincing proof of the validity of Darwin's theory of the survival of the fittest.[63] Looked at this way, the

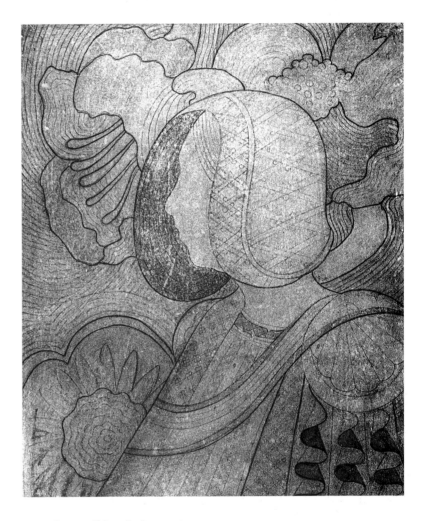

36. J. Thorn Prikker, *Spring*, c. 1890.
Otterlo, Rijksmuseum Kröller-Müller

55

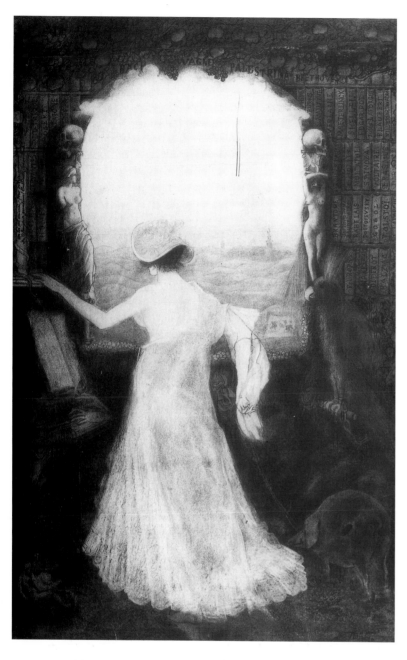

37. J. Toorop, *Vil Animal (Woman with Parrot)*, 1890.
Private collection

artist is no longer a priestly figure who produces his art independently of the community, but a member of society who exposes the feelings of that society. Art and society are seen as a single large living organism. A similar view of society as an organism filtered across the border from Belgium, notably via the work of Henry van de Velde.[64] Darwinist influence is apparent not only in the realm of theory, but also at the practical level in Art Nouveau. As well as studying Nature, artists followed the latest developments in the natural sciences. They studied the works of Charles Darwin, while *Kunstformen der Natur*, by Ernst Haeckel, a follower of Darwin, enjoyed a tremendous vogue after 1895.[65] The floral motifs which were extremely popular in the decorative arts in the Netherlands in the 1890s reflect a marked interest in the constructs and basic shapes of objects in nature, although without detriment to the portrayal of the natural form: organic growth remained an essential feature in design. However, Nature is stripped of any symbolic significance in these two-dimensional stylisations, which have become purely ornamental.

SUMMARY

In a mere two decades, the attitude towards Nature underwent a fundamental change. The external manifestations of Nature ceased to exert such a hold on the imagination. Having been the focus of artistic attention for several centuries, the landscape genre receded largely into the background. Many artists turned away from the superficial appearance of material objects and concentrated instead on the infrastructure. The *Tachtigers* played a crucial role in this development in that they put a premium on personal experience of reality. However, the emphasis on the instinctive, the deterministic and fatalisticáview of reality left many unsatisfied and the artists of the 1890s sought a more philosophical and idealistic view of Nature. Throughout the various phases of this process and through the different, sometimes conflicting opinions, Darwinist thought runs like a constant refrain, albeit interpreted in different ways and with different emphases.

NOTES

*This essay was translated by Mary Maclure

For the reader's convenience various organisations and events have been rendered in English. The glossary of the original Dutch terms can be found in the Editiorial Note.

1 Charles Darwin, *On the origin of species by means of natural selection of the preservation of favoured races in the struggle for life*, London 1859.

2 Charles Darwin, *The Descent of Man and Selection in Relation to Sex*, 2 vols., London 1871.

3 J.G. Hegeman, 'Darwin en onze voorouders. Nederlandse reacties op de evolutieleer van 1860-1875: Een terreinverkenning' *Bijdragen en mededelingen betreffende de geschiedenis der Nederlanden, Ned. Historisch Genootschap*, Utrecht 1970, vol. 85, pp. 261-314. For the introduction of Darwinism into the Netherlands, see also I.N. Bulhof, 'The Netherlands', *The comparative reception of Darwinism*, London 1974, pp. 269-306; P. Smit, 'Houding en reactie van het katholieke volksdeel ten aanzien van de evolutiegedachte', *Annalen van het Thijmgenootschap*, 68 (1980) 2, pp. 223-240.

4 I.N. Bulhof, *Darwins Origin of Species: Betoverende wetenschap*, a study of the relationship between literature and science, Utrecht 1988, pp. 25-46.

5 Anonymous, 'Kunstbeschouwing', *Het Vaderland*, 22 March 1880. In this print, Allebé also shows that Darwin's theory was not new. According to W. Loos and C. van Tuyl van Serooskerken, exhib. cat. *Leven en werk van August Allebé, 'Waarde heer Allebé'*, Haarlem (Teylers Museum) 1988, p. 195, the two monkeys are poring over Petrus Camper's book *Verhandeling over het natuurlijk verschil der wezenstrekken in menschen van onderscheiden landaart en ouderdom*, 1791. It is true that the idea of evolution was not a new one, but until Darwin no-one had assembled so much data to support the hypothesis of evolution or, more importantly, formulated a scientifically acceptable 'natural law' of evolution. Nobody had provided such a 'natural' explanation for the evolutionary mechanism, according to J.G. Hegeman, *op. cit.* (note 3), p. 265.

6 Remark by the critic and essayist J. Kneppelhout in 1850; quoted in L. van Tilborgh, 'Introduction', exhib. cat. *Op zoek naar de Gouden Eeuw, Nederlandse Schilderkunst 1800-1850*, Haarlem (Frans Hals Museum) 1986, p. 24.

7 *Ibid.*

8 Quoted in G. Brom, *Hollandse schilders en schrijvers in de vorige eeuw*, Rotterdam 1927, p. 71.

9 J. van de Sande Bakhuysen, 'Het Haagsche Bosch' *Dagblad van Zuid Holland*, 25 January 1886.

10 Letter from W. Roelofs to H. Hymans, 30 October 1871; quoted in J. de Gruyter, *De Haagse School* (The Hague School), vol. I, Rotterdam 1968, p. 31.

11 Exhib. cat. *Schilderijen en aquarellen door J.H. Weissenbruch*, Amsterdam (Frans Buffa & Son art dealers) 1899. Roelofs quoted in L. van Tilborgh, *op. cit.* (note 6), p. 24.

12 J. Stemming, 'De stedelijke tentoonstelling van schilderijen', *De Amsterdammer*, 13 October 1886.

13 Quoted in F. Bijl de Vroe, *De Schilder Jan Veth 1864-1925, chroniquer van een bewogen tijdperk*, Amsterdam/Brussels 1987, p. 124.

14 Letter from Jacobus van Looy to Willem Witsen, 6 April 1885.

15 Jan Veth, 'Van enkele hollandsche teekenaars in Arti', *De Nieuwe Gids*, 7 (1892) vol. 2, p. 142.

16 Quoted in F. Bijl de Vroe, *op. cit.* (note 13), pp. 119, 121.

17 A.M. Hammacher, *Amsterdamsche Impressionisten en hun kring*, Amsterdam, n.d., p. 43.

18 F. van Eeden, 'Over schilderijen-zien', *De Nieuwe Gids* 3 (1888) vol. 2, pp. 296, 297.

19 A. Verwey, 'Toen de Gids werd opgericht', *De Nieuwe Gids* 1 (1886) vol. 2, p. 175.

20 Brom, *op. cit.* (note 8), p. 151.

21 Verberchem, 'Expositie van Wisselingh in Arti', *De Nieuwe Gids* 3 (1888) vol. 2, p. 299.

22 M. van Buuren, 'Mythen in de Rougon-Macquart', *Ongebaande Wegen, Opstellen over literatuur*, Baarn 1985, 95-115, p. 104.

23 C. Will, P.J.A. Winkels, *De dubbelbegaafdheid van Jacobus van Looy*, Haarlem 1988, p. 62. See also the article by Enno Endt in this catalogue.

24 J.K. Huysmans, *Tegen de Keer*, Amsterdam 1977, p. 9 (translated by J. Siebelink, original edition *A Rebours*, Paris 1884; reprint ed. 1929).

25 P. Tideman, 'Van Israëls tot Derkinderen', *De Nieuwe Gids* 9, (1894), vol. 2, p. 292.

26 B. Dijkstra, *Idols of Perversity, Fantasies of Feminine Evil in Fin-de-siècle Culture*, New York/Oxford 1986.

27 *Ibid.*, pp. 286, 287.

28 Charles Darwin, *op. cit.* (note 2), vol. 2, pp. 312, 313, 321.

29 M. van Donselaer-Middelkoop, 'Herinneringen aan Piet Mondriaan', *Maatstaf* 7 (1959), p. 278.

30 C. Will and P.J.A. Winkels, *op.cit.* (note 23), pp. 57, 58.

31 J. Veth, 'Aquarellenkunst van Isaac Israëls', *De Nieuwe Gids* 5 (1890) vol. 2, p. 297.

32 G, 'Arti et Amicitiae', *De Nederlandsche Spectator*, 21 July 1894, p. 235.

33 G.J.P.J. Bolland, 'De wereldbeschouwing der toekomst, eene wijsgeerige studie I, wereldnood en werelddoel', *De Nieuwe Gids* 5 (1890) vol. 1, pp. 210, 212.

34 Quoted in M.G. Kemperink, *Van Observatie tot Extase, sensitivistisch proza rond 1900*, (dissertation, Groningen), Utrecht 1988, p. 267.

35 E. Braches, *Het Boek als Nieuwe Kunst, 1892-1903. Een studie in Art Nouveau*, Utrecht 1973, p. 19.

36 R. van der Wiel, *Ewijkshoeve, tuin van tachtig*, Amsterdam 1988, p. 80.

37 J.J. Isaäcson, 'Artiestenvereniging', *De Portefeuille*, 19 March 1892, p. 1260.

38 Quoted in E. Endt, 'Kunstenaarslevens: Tachtigers omstreeks 1880 (8), Wisselwerkingen in een literaire generatie (II), *De Revisor*, 7 (1980) no. 5, p. 39.

39 Quoted in B. Polak, *Het fin-de-siècle in de Nederlandse Schilderkunst. De symbolistische beweging 1890-1900*, The Hague 1955, p. 8.

40 *op.cit.* exhib. cat. Amsterdam 1899 (note 11).

41 Letter of 20 March 1894: J.M. Joosten, *De Brieven van Johan Thorn Prikker aan Henri Borel en anderen 1892-1904*, Nieuwkoop 1980, p. 172.

42 *Ibid.* p. 91 (letter of 10-12 January 1893).

43 Jasz. 'De Tentoonstelling van den Haagschen Kunstkring', *De Portefeuille*, 23 July 1892, pp. 169, 170.

44 M.G. Kemperink, *op.cit.* (note 38), p. 183.

45 F. van Eeden, 'Vincent van Gogh', *De Nieuwe Gids*, 6 (1891) vol. 1, p. 266.

46 W. van Tricht, 'De XX in den Haagschen Kunstkring', *De Portefeuille*, 30 July 1892, p. 174.

47 *Idem*, 'Tentoonstelling van teekeningen der Werkende leden van den Haagschen Kunstkring', *De Portefeuille*, 10 October 1892, p. 220.

48 *Nieuwe Rotterdamsche Courant*, December 1894, no author or date. Cutting from the Press Documentation Department of the National Art History Documentation Service, The Hague.

49 J. Lievensz., 'De tentoonstelling te Utrecht' (The exhibition in Utrecht', *De Portefeuille*, 18 July 1891, p. 857.

50 Letter no. 242: J. van Gogh-Bonger, *Verzamelde brieven van Vincent van Gogh*, Amsterdam/Antwerp, 1955, vol. 1, p. 61 (the same numbers in The Complete Letters of Vincent van Gogh, New York/London 1958).

51 Tsukasa Kōdera, *Christianity versus Nature, A study in the Thematics in Van Gogh's Oeuvre* (dissertation, Amsterdam), Amsterdam 1988, pp. 142-149.

52 J. Veth, 'Tentoonstelling van werken door Vincent van Gogh in de Amsterdamsche Panoramazaal', *De Nieuwe Gids* 8 (1893) vol. 1, p. 430.

53 J. van Gogh-Bonger, *op.cit.* (note 50), p. 362, letter no. 195.

54 J.M. Joosten, *op.cit.* (note 41), p. 187 (letter of 3 July 1894).

55 J. Veth, 'Jan Toorop op de keuze-tentoonstelling te Amsterdam', *De Nieuwe Gids* 7 (1902) vol. 2, p. 453.

56 Unpublished manuscript by A. Plasschaert, 'Verklaringen van de symbolische teekeningen enz. van Toorop door hem met mij samen opgemaakt, zondag 2 maart 1902', National Art History Documentation Service, The Hague, file 2, no. 12.

[57] P.B.v.H., 'Sar Joséphin Péladan', *De Nederlandsche Spectator*, 19 November 1892, p. 377.

[58] W. van Tricht, 'Paul Verlaine en Joséphin Péladan', *De Portefeuille*, 19 November 1892, pp. 304, 305.

[59] Quoted in W. Arondéus, *Matthijs Maris, de tragiek van den droom*, Amsterdam 1939, p. 102.

[60] Quoted in I. Gerards and E. van Uitert, 'Jan Toorop. Een fabuleuze bevattelijkheid: het symbolistische scheppen', *Jong Holland* 5 (1989) no. 1, p. 17.

[61] Meester Constantijn, 'Twee uitersten', *De Nederlandsche Spectator*, 26 June 1886. p. 219.

[62] Walter Crane, *The Claims of Decorative Art*, London 1892, p. 29.

[63] E. Braches, *op. cit.* (note 35), pp. 63, 64.

[64] L. Tibbe, 'Art Nouveau en Socialisme, Henry van de Velde en de Parti Ouvrier Belge' *Kunsthistoriese Schriften* 5, Amsterdam 1981, p. 48.

[65] E. Braches, *op. cit.* (note 35), p. 21.

THE MARKET FOR CONTEMPORARY ART IN THE NETHERLANDS

RICHARD BIONDA[*]

Anyone who wished to see contemporary art in the Netherlands a century ago went not to a museum, but to the large Triennial exhibition of living masters, or to one of the many sale exhibitions organised by dealers and artists' associations. The amount of art on the market had increased considerably in the course of the previous twenty or thirty years. In centres such as The Hague and Amsterdam exhibitions changed so quickly that critics complained they could no longer keep up with them.[1] Large associations such as Pulchri Studio and Arti et Amicitiae not only mounted annual exhibitions of their members' work, but also held loan and lottery exhibitions, preview exhibitions scheduled to go abroad, invited other artists to show their work, and organised similar events to raise money for charity. After 1885 these activities also included solo exhibitions and, following the British example, exhibitions of privately owned works.

The supply was as varied as it was great. There were associations for special techniques, such as watercolour, graphic art and drawing, and after 1891 associations like the Hague Art Circle (Haagsche Kunstkring) added applied art and even architectural design to what was already a wide range. The emphasis, of course, was on Dutch art, but most exhibitions, whether organised by associations or art dealers, included work by foreigners. The public was kept well informed of all these activities through reviews, announcements and advertisements in newspapers and periodicals. The Hague newspaper *Het Vaderland* ran a separate column entitled 'Letters from Amsterdam' which was devoted to such events, and periodicals such as *De Portefeuille* printed extensive calendars of international exhibitions, sometimes complete with addresses and opening times. Collectors and museums had more than enough from which to choose, and those who were still not satisfied could, especially after 1885, increasingly find superior Dutch art abroad. Some Dutch galleries had separate branches or exhibition space in Great Britain, while recently established associations sought more contact with colleagues in other countries where they were regularly invited to exhibit their work.

The following account of the Dutch art market will thus concentrate primarily on associations and dealers. What possibilities did they offer artists, what role did the critics play, what was the focus of commercial interest, and how did collectors, the state and the museums respond? This essay offers a provisional answer to these questions on the basis of exhibition catalogues, annual reports issued by museums, gallery sales records and press reviews.[2]

38. P. van der Velden, *Portrait of A.C. Loffelt*, 1888.
Dordrecht, Dordrecht Museum

Membership of an artists' association was of social but also economic importance to painters. Once accepted – after first being nominated, in most cases – artists had the opportunity to exhibit their work and thus make a name for themselves. More than social clubs, they promoted their members' interests by organising exhibitions to help them sell their work. It is no coincidence that the foundation of the largest and most famous of the associations – Arti et Amicitiae in Amsterdam (established in 1839) and Pulchri Studio in The Hague (established in 1847) – coincided with the nearly complete withdrawal of state support. More recently established associations, too – such as the Dutch Society of Watercolourists (Hollandsche Teeken-Maatschappij), the Dutch Etching Club (Nederlandsche Etsclub) and the Hague Art Circle – sought not only to focus attention on undervalued or new techniques, but also to increase sales. The statutory aim of the Etching Club was indeed the promotion of the art of etching, but it also provided space for its members to exhibit their chalk drawings. And though the rules obliged each member to submit etchings every two years, Breitner's name was not struck from the rolls for failing to meet this requirement; the interests of members apparently outweighed whatever bureaucratic decisions were reached during the founding meeting of the Club.

A further advantage of membership in an association was that submissions tended to be judged less harshly. In fact, after all the resistance with which they had met, younger associations such as the Etching Club and the Hague Art Circle did away with special selection committees altogether. Sales were usually handled by the board or by a separate administrative committee; private sales were forbidden in theory, but common in practice. Price lists published in connection with exhibitions should not be taken as cast-iron indications of prevailing prices or, for that matter, an artist's reputation. Rarely fixed, these prices were usually discounted.[3] This sort of bargaining continued even after 1887, when it was announced that the Society of Watercolourists had introduced fixed prices, an 'excellent measure' considered worthy of imitation in the Netherlands.[4]

Besides terms of sale, an organising committee was also responsible for determining where works submitted would be hung. Throughout the 1880s this regularly led to complaints from both artists and critics. A committee, it was argued, was morally bound to hang whatever work it accepted favourably; that was surely the least they could do for artists, after all?[5] Questions such as lighting and height, but also who or which work was entitled to a place of honour (at eye-level and preferably in the middle of a wall) sometimes led to heated discussion. As far as overall appearance was concerned, the crowded Triennial received the worst marks. The low standards of this annual *salon*, held alternately in Amsterdam, The Hague and Rotterdam, meant that some found the exhibitions, especially those organised by Amsterdam and Rotter-

39. *Pulchri Studio, Exhibition Room*. The photograph may have been taken during a group exhibition, when various artists were allocated a section of the exhibition area. Breitner's work can be seen on the back wall. The painting on the far right-hand side of the left wall is presumably Kamerlingh Onnes's portrait of Jenny Kamerlingh Onnes (cat. no. 51).
The Hague, Municipal Archives (Pulchri Studio Archive)

dam, nothing more than a 'prosaic wilderness,' a tawdry bazaar of fourth-rate art. According to the critic A.C. Loffelt (fig. 38), the only way to make a display of some five hundred items attractive was to ensure that each wall provided 'mood as well as variety.'[6] He was equally unimpressed by most other group exhibitions. As late as 1889 he described most of them as 'cures for any aesthetic sense or development of taste. Anyone threatened with such a wall of paintings in his house would have a fit. Exhibitions of this kind are detrimental to art, the artistic development of the public and the financial welfare of artists'.[7]

The Pulchri Studio exhibitions tended to receive the highest praise, owing, in part, to their splendid, well-lit space (fig. 39). As usual, the work was arranged as symmetrically as possible by subject and size, with the most important masters in the middle. In 1895 one critic wrote that he was 'very fond of a single room, like the one at *Pulchri*, where the masters dominate the centre of the long walls, with the younger artists gathered round them. It creates a pleasing whole, like those royal banquets of old, when the king dined at the same table with his entire entourage, from the highest of all to the very humblest.'[8] In 1893 Pulchri introduced another innovation: the *groepen-tentoonstelling*, or group exhibition, whereby different groups of members were each given the opportunity to fill a wall with their most recent work.[9] The idea may have originated in Paris, where starting in 1891 alternating groups of artists had had the chance to organise something akin to retrospectives in the Salon. At Pulchri retrospectives were rare, but now artists were occasionally given the opportunity to hang a selection of their own works however they wished, without the threat of fellow exhibitors. The exhibitions changed rapidly, to the satisfaction of both artists and critics. After all the rivalry between schools everyone was finally able to show his or her work under optimal conditions so that the public could 'gain a more accurate impression of younger artists who are often difficult to judge at ordinary exhibitions.'[10] Individuals such as Eduard Karsen, whose modest paintings were simply eclipsed at large events, were often discovered thanks to this new approach. And Loffelt pointed out an advantage to collectors: those who were not too concerned about established names could pick up inexpensive works by younger artists on such occasions. These tended to be of high quality, since those involved were generally anxious to do their best.[11]

During the winter months associations such as Pulchri would supplement their normal programmes with additional opportunities to view watercolours and drawings. The work exhibited derived from three sources: working members, the Hague gallery Goupil & Co., and private collectors.[12] There was a great deal of interest, among painters as well as dealers and collectors since most of the work was for sale. Up till 1883, when it was decided that more space was needed if the public were to move about more freely, these viewings could be quite hectic, having little in common with the agreeable gatherings of the previous century.[13] Critics found the quality of the

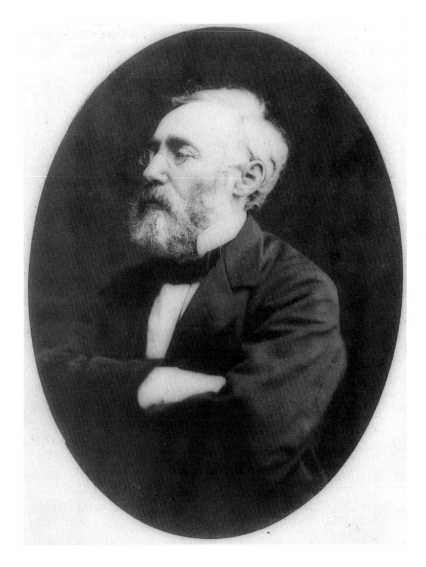

40. Jozef Israëls, *c.* 1880.
The Hague, Netherlands Institute for Art History (RKD)

work on a par with the universally respected exhibitions organised by the Society of Watercolourists. An obvious difference between the two was that the viewings were more accessible to younger artists. Breitner and Suze Robertson, for instance, were already showing watercolours at these venues in the early 1880s, long before they became members of the Society of Watercolourists. But besides work by established artists of the Hague School, the portfolios of Goupil & Co. also contained a great deal by those 'who hope to serve art for many years to come, or still have to find their way.'[14] In 1886 Pulchri organised an interim viewing of Arti members based in Amsterdam; the initiative seems to have been successful, as six months later Arti itself organised its first exhibition of nothing but watercolours, pastels, chalk drawings and etchings.

These viewings were important to artists not only as an extra opportunity to show their work but also because they served to cultivate a taste for draughtsmanship in the most general sense. There is no question that many purchases were made, prompting one critic to remark rather testily that 'art viewings, which are expensive to attend, must not degenerate into art fairs. This would seem to be the case when, out of five viewings, two are organised by working members and one by the dealer Goupil. Such an approach to these events is wrong.'[15]

One of the best places to sell watercolours during the first half of the 1880s, at least, was at the annual exhibitions organised by the Society of Watercolourists at the Academy in The Hague. This association was founded in 1876 by several prominent members of the Hague School and modelled on the Belgian Société Belge des Aquarellistes. The board, which comprised the likes of Jozef Israëls (fig. 40), Mauve and Jacob Maris, was highly selective in order to safeguard the association's reputation,[16] which was further enhanced by honorary members from Belgium, England, France and Italy. In comparison to other exhibitions the number of works shown was fairly small, amounting on average to some 100 to 130 items.

In their heyday, up till 1885 or thereabouts, there was also considerable foreign interest in these exhibitions. Loffelt describes them as 'successful almost without exception, and their reputation abroad was so good that some connoisseurs and dealers took pains to be present on the day of the opening to assure themselves of one or another important work.'[17] The primary focus of interest was the Hague School, which increasingly set the tone at other group exhibitions as well. Even at the Colonial Exhibition in Amsterdam in 1883 one critic found they compared favourably with most foreigners, because they breathed new life into the simplicity and integrity of seventeenth-century Dutch motifs.[18] The average age of the members being about forty-two at that time (except Israëls, who was some fifteen years older), most had already earned their spurs abroad. Jozef Israëls had been particularly successful in this respect; when the Paris gallery Petit organised an exhibition in 1882 of work by the most outstanding artists from various countries, he alone represented the Netherlands.[19]

This good reputation is reflected in the sales figures of the Society of Watercolourists. Of the 129 works which the thirty members and thirty-six honorary members submitted in 1880, an annotated catalogue shows that thirty-eight were sold. The prices – though here, too, these were presumably only what was asked – were respectable, varying from around 80 guilders for a Bilders-van Bosse or Stortenbeker to somewhere between 800 and 1,000 guilders for an Artz, Blommers, Albert Neuhuys or Jacob Maris. Maris sold all four of the works he had submitted. J.H. Weissenbruch, Mauve and Willem Maris fetched slightly less, while Jozef Israëls was the most expensive of the Dutch artists by far: his cheapest watercolour was 1,200 guilders at the time, but another was listed for no less than 2,500.[20]

By the second half of the 1880s the image of the Society of Watercolourists was becoming tarnished. Jozef Israëls, who succeeded Mesdag as chairman in 1885, scarcely managed to sell anything more at its exhibitions, which may also have had something to do with the high prices he asked (4,000 guilders for a watercolour was no exception). After even Loffelt had complained in 1889 about the monotony and the uninspired, hackneyed work submitted by the older exhibitors,[21] De Amsterdammer announced two years later that the Society of Watercolourists was getting old, and that the annual exhibitions, which had formerly been considered important events, had sunk to the humdrum level of most of the rest.[22] Jan Veth had noted this decline as early as 1887, and put his finger on a weakness: 'The Dutch Society of Watercolourists' eleventh exhibition has proved a disappointment to its loyal public. People have grown accustomed to coming here every year expecting to see the best Dutch artists have to offer. (...) When the older generation lost interest it was up to this association to recruit young blood. Where are the younger artists? (...) why do Breitner, Tholen and Witsen not join? Why not De Zwart and Van der Maarel? The answers people whisper to this last query are odd. And Miss Schwartze was accepted? Unbelievable!'[23] Veth's criticism was well founded. Why were there so many Italians – including Biseo, Bucchi, Cipriani, Maccari, Passini and Tusquets – rather than the broadest possible representation of what the Netherlands had to offer in this field? One gets the impression that economic considerations heavily influenced the selection process, and that the outside world was presented with varied but select works which did not spark much competition. Compared to the numerous historicising genre scenes the Italians produced, the content and execution of the Dutch contribution distinguished them as a clearly recognisable school; it was difficult for younger artists to make their mark if they deviated from this image in any way.

In 1881 the closed character of the Dutch Society of Watercolourists prompted a number of older artists such as H.F.C. ten Kate, Charles Rochussen and Cornelis Springer to

establish a new association: the Royal Society of Dutch Watercolourists. The flexible selection criteria of this Society, which received the 'Gothic Hall' in The Hague as its permanent exhibition space, gave a wider range of artists a chance. The list of those invited to join was long; it included the members of the Dutch Society of Watercolourists, whose nearly unanimous refusal did not go unnoticed by the press.[24] The Society's initiative to make more room for younger, lesser-known artists was praised. Toorop, Josselin de Jong and Isaac Israëls exhibited there in September 1884, alongside such artists as Ten Kate and Klinkenberg. The Dutch Society of Watercolourists did, ultimately, take the criticism to heart, and perhaps also the advice Jan Veth proffered in 1887. Once T. de Bock and Isaac Israëls had been admitted in 1883, others joined up as well: P. Zilcken (1885); W.B. Tholen and N. Bastert (1887); Breitner, Geo Poggenbeek and Josselin de Jong (1888); M. van der Maarel and Jan Voerman (1889); Marius Bauer and Suze Robertson (1891); Wally Moes and Haverman (1892). Veth himself and Floris Verster did not become members until 1896, while Willem Witsen joined even later, in 1898.

The best indication that this new enlistment also functioned as a cohesive group was the establishment in 1885 of the Dutch Etching Club, a joint initiative by young artists of The Hague and Amsterdam.[25] With Derkinderen, Jan Veth and Witsen on the first board, and P. Zilcken as an important impetus in The Hague, the Club sought to promote the art of etching among younger Dutch painters by organising exhibitions and annually publishing a portfolio (fig. 41). In 1891 the Club numbered twenty-three working members, including almost all the promising young artists of the day, such as Bauer, Breitner, Derkinderen, Isaac Israëls, Eduard Karsen, Van Looy, Suze Robertson, Toorop, Verster, Veth, Voerman, Witsen and De Zwart.

Though some members went no further than a few experiments, it was important for the group to establish an identity in the outside world and, through its acceptance of foreign guests, to show it belonged to an innovative, international movement. For the second annual exhibition in 1888 Whistler, Camille Pissarro, Rops and Buhot were among those invited to participate, and works by artists such as Corot, Degas, Seurat, Odilon Redon, Millet, Mary Cassatt and Raffaelli were borrowed from private collections or galleries in Holland and France. The scope of the exhibition was broadened further in the course of the following years with

41. (*From left to right*): P. Zilcken, Marius Bauer and Jan Veth at Mouton in The Hague, 1886.
They are probably examining the proofs of the first annual portfolio, published in May 1886.
Reprinted from R.W.P. de Vries Jr., *M.A.J. Bauer*, Amsterdam 1944, p. 36

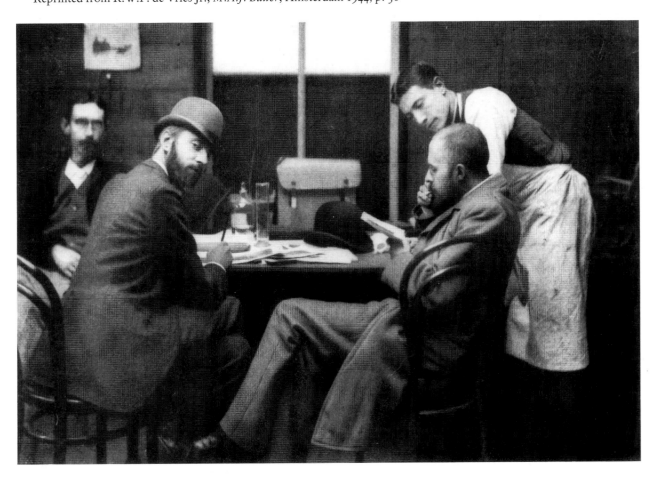

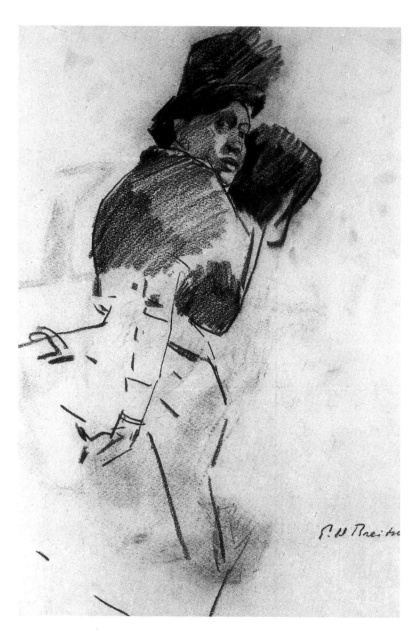

42. G.H. Breitner, *Lady with Muff*, c. 1885.
Otterlo, Rijksmuseum Kröller-Müller

names such as Bresdin, Khnopff, Rodin, Lemmen, Seymour Haden, Bracquemond, Fantin Latour and Klinger. Those who wrote for *De Nieuwe Gids*, established the same year as the Etching Club, addressed the world with conviction; in 1888, for instance, Willem Witsen proclaimed 'that we have great artists of the older generation in our country who rank among the best in the world; that there are members of the younger generation who have the greatest admiration for the magnificent works of the great masters but want an art of their own flesh and blood; that these younger artists, scornful of what the masses hold as beautiful, wish to be independent of any system or school; that they roar with laughter at the loathsome taunts and foolish drivel of the band of idiots who call themselves critics; that they are prepared to shoulder the greatest cares in the world for their passion and commitment.'[26]

The Club stood not only for etching; they also raised other forms of art to exhibition level. For the group exhibition in 1887 the eleven members and nineteen guests were free to submit not only prints but also chalk, charcoal and pen-and-ink drawings, an opportunity they relished. The following year Breitner even exhibited 'four frames with scribbles from my sketchbook' (fig. 42), presumably the first time such material was exhibited as works of art in their own right. To the public, accustomed to 'finished' work, the description alone must have seemed provocative, while to the initiated, combining etching with other media must have seemed less strange. The Club's primary concern was the spontaneous, free expression of the artist as an individual, the best vehicle for which, besides etching, was the sketch or 'scribble'. The artist M. van der Valk emphasised this once again in *De Nieuwe Gids*,[27] by characterising Rembrandt as an artist 'who could capture an entire life in a sketch of ten lines, who sometimes expressed his entire soul in an etching no larger than your thumb.' Van der Valk saw drawing as the expression of feelings and experiences in lines, which is why drawings were sometimes so difficult to grasp. Whether this positive revaluation yielded any financial benefits is difficult to determine after the fact.[28] It was certainly of artistic importance, as it helped eradicate hierarchical thinking with regard to genres and techniques, and ultimately cleared the way – Toorop and Thorn Prikker being the best examples – for new sizes, techniques and supports.

Around 1890, when Impressionism and the *stemmingskunst*, or 'mood art' of the younger generation had been more or less accepted, the tide turned once and for all. A new, more militant movement emerged with its own associations with which to address the outside world. Now that the members of the Hague School were old and saving their energy for the Anglo-Saxon market, someone like Breitner could excel. At the age of 33 he was almost 'classical', as reflected by the prices his work fetched. The true revolutionaries of the day such as Toorop (fig. 43) and Thorn Prikker had more room to manoeuvre, and they met with less resistance from art critics (partly due to a change of guard within the press). *De Nieuwe*

Gids was the first valiant defender of the new art; after 1890, other journals and newspapers began printing what were sometimes quite lengthy reviews which sought to clarify the place and significance of some of the innovators. The favourable reviews of artists such as Eduard Karsen, Kamerlingh Onnes, Derkinderen and Toorop written by J.J. Isaäcson for *De Portefeuille* are a good example of this.[29] The mood had become more tolerant. In large cities such as Amsterdam, The Hague and Rotterdam, artistic circles formed which sought closer ties with kindred associations in other countries. The most famous of these was the Hague Art Circle, founded by T. de Bock in 1891 and, because of its reaction to the more conservative policy of Pulchri Studio, popularly described as 'that association of the young and the young at heart.'[30] In contrast to Pulchri, which was predominantly for painters, the Art Circle sought closer cooperation with other branches of art and provided more scope for modernists – without, however, severing its ties with the older painters of the Hague School. In 1893, for instance, when the autumn exhibition of members' work included fourteen paintings by Sisley, Monet, Renoir and C. Pissarro, an exhibition devoted to the Maris brothers was organised, later followed by tributes to Weissenbruch and Mauve.

The Art Circle's prominence within the avant-garde was largely thanks to Toorop who, despite his initial refusal to preside over the painting section in 1892, was involved in numerous events. Through his connections with Belgian associations such as *Les Vingt* (Brussels) and *L'Association pour l'art* (Antwerp) he played a crucial role in the introduction of neo-Impressionism in the Netherlands. Such foreign contacts were also important for the sale of work by young Dutch artists abroad. Invitations to the first exhibition mounted by *L'Association pour l'art* in Antwerp in May 1892 were sent not only to the members of *Les Vingt* but also to Breitner, Isaac Israëls, Bauer, Witsen, Voerman, Karsen, Verster, Thorn Prikker, Roland Holst and Veth.[31] Toorop himself submitted numerous works to the first exhibitions of the Art Circle in 1892/93, as did Thorn Prikker, W. de Zwart, Bauer and T. van Hoytema. On the whole these events were well received. The third group exhibition in 1892, at which Toorop showed his *Hell and Doubt* (cat. no. 91), among other things, was hailed as a 'new triumph for younger artists in Holland.' Many older artists also expressed their support. Alma Tadema, for instance, donated a drawing with an appreciative dedication to benefit the lottery. The Art Circle was thankful for such gestures, the more so because it had 'found that some – fortunately very few – great artists had refused to support a circle which aims to provide nothing other than a sociable and useful association of artists of all kinds and persuasions. There can be no art without freedom!'[32]

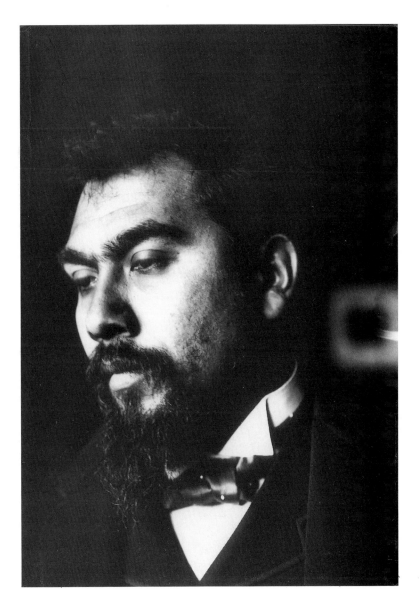

43. Jan Toorop in Willem Witsen's studio.
Photograph by Willem Witsen, November 1892.
Leiden, University Print Collection

44. Interior of art dealers Boussod, Valadon & Co.
(formerly Goupil & Co.),
Plaats 20, The Hague, c. 1900.
The Hague, Netherlands Institute for
Art History (RKD)

THE ART TRADE

In addition to artists' associations, the art trade played an important role at that time in disseminating contemporary art. Most dealers were based in The Hague and Amsterdam, where renowned firms such as E.J. van Wisselingh & Co., Goupil & Co., F. Buffa and Sons, and C.M. van Gogh regularly presented work by prominent living artists, both foreign and Dutch. The works themselves were displayed not only in dealers' showrooms, but also elsewhere. This was sometimes done with a view to testing a particular market,[33] or at the invitation of an artists' association, with which such firms usually enjoyed good relations. The viewings organised at Pulchri by H.G. Tersteeg of Goupil & Co. have already been mentioned; however, the same association also showed selected works owned by the Amsterdam galleries Preyer & Co. and Van Wisselingh & Co., as did Arti et Amicitiae in Amsterdam.[34] The quality of the work shown was usually high and there were many surprises, especially by foreign artists. Shows organised on the premises of the galleries themselves were no less enthusiastically received by the press. Their great advantage over other venues is that they were well maintained and intimate: the works usually had more space and looked well among the statues or decorative art objects with which these salons were furnished (fig. 44).

Most of the dealers who bought contemporary art naturally preferred the work of artists with established reputations. As of the early 1880s the strong demand from Britain and America made it increasingly clear that the great names of the Hague School were the most lucrative. Firms such as Goupil

and Van Wisselingh, who maintained good personal relations with these artists (some of whom were under contract to Goupil) were quick to respond by organising separate group exhibitions in, for instance, London, Edinburgh, and, after 1890, the United States, where there was more demand for them.[35] Galleries organised such events (including solo exhibitions) in Holland primarily after 1890, a number of associations having preceded them.[36] The market had also received a considerable boost from numerous commemorative exhibitions. Prices had risen sharply in the meantime. Anyone still in the market for a good Jozef Israëls, who was the subject of an elegant French monograph in 1890 and whose *Good Neighbours* (fig. 45) was sold in the Post auction in 1894 for 10,100 guilders, had either to pay a pretty penny or, like the director of the Boymans Museum in Rotterdam, visit the artist's studio in person and humbly entreat him to reduce the price. Sometimes this method worked; at that time a place in a Dutch museum was still something rather special, even for Israëls.

The growing fame of these artists, and especially of Jozef Israëls, Jacob and Willem Maris, Blommers and Neuhuys (Mauve had died in 1888), led to a reduction in both the quality and quantity of their work on the Dutch market. The founding members had not sent their best work to the Society of Watercolourists exhibitions for quite some time, while they often submitted nothing at all to the Triennial. Demand for them had grown so great that they managed to sell their work outside the exhibition circuit – with or without the assistance of an international firm like Goupil – or reserved their best paintings for more prestigious exhibitions abroad.[37] By about

1890 critics noticed that artists preferred to show their faces in Paris, Munich, Chicago 'or wherever.'[38] Partly on account of the insatiable appetite of Anglo-Saxons – by 1900 the great English collector John Staats Forbes had amassed no fewer than 175 works by Jozef Israëls – some younger artists gave in to temptation and began freely interpreting and repeating the work of these masters. Jan Veth found this cause for concern: 'this sort of demand poses a serious threat to the dignity of Dutch artists. The ignorant hunger for art, which blindly accepts immaturity, imperfection and insincerity for the sake of acquiring a particular artist or school, is the greatest subversion of art today.'[39] His remarks were an implicit criticism of dealers, but according to Loffelt they were not entirely at fault. Who could blame them for preferring popular works, and for encouraging younger artists 'to produce over and over again' a subject favoured by the public? The British called them potboilers, but they kept the wolf from the door, and what could anyone have against that?[40] Plenty, apparently. The painter and critic J.J. Isaäcson saw art dealership as a vocation, the more so nowadays when the ideas of the young – meaning artists such as Breitner, Verster, Toorop – tended to clash with the conventional notions of the public and the state. People needed an advisor who could not only distinguish the wheat from the chaff but also clearly explain how he did so. Like Theo van Gogh in Paris, this had to be someone 'who is to painting what a dramatic reader is to poetry. The latter interprets the poet's feelings by reciting the poem with due regard for the metre and, wherever necessary, by accentuating the sounds; the former elucidates the painting with carefully chosen words. Both must be intellectually sophisticated and artistic.'[41]

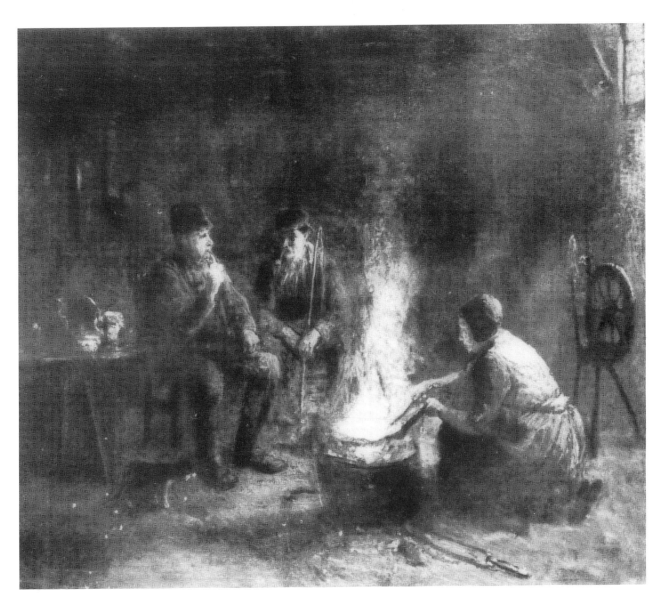

45. Jozef Israëls, *Good Neighbours*, c. 1885.
Whereabouts unknown

46. Mr and Mrs E.J. van Wisselingh in London, *c.* 1900.
The Hague, Netherlands Institute for Art History (RKD),
Van Meurs Collection

Although Isaäcson did not mention him by name, Elbert Jan van Wisselingh (fig. 46) was presumably the Dutch art dealer who most closely approximated this ideal. Van Wisselingh was highly regarded, especially by artists. Some, like Matthijs Maris, were his close friends, and regarded him as 'no ordinary thieving merchant, whose sole aim is to feather his own nest.'[42] Van Wisselingh maintained Maris for a long time in London, but supported others as well, like Marius Bauer, whose first trip to the Near East in 1888 Van Wisselingh financed personally. His taste and daring were admired, for in addition to established masters he also purchased work that was still of little or no commercial interest. Besides Dutch art, Van Wisselingh focused on French masters, following in the footsteps of his father who had first introduced the Netherlands to the Barbizon School. The names Corot, Courbet, Diaz, Millet, Troyon, Decamps, Ribot, Vollon and Bonvin constantly recur in reviews, as well as, around 1890, Swan, Whistler and Carrière. The works were nearly always exceptional. 'He never tried to sell popular paintings which, too easily grasped, seem to entice buyers by virtue of their mediocrity,' wrote a critic in 1894, when Van Wisselingh himself had already been in London for three years.[43] He was one of the few who owned work by Matthijs Maris, which he regularly lent for exhibitions, such as one held in Edinburgh in 1886, to which he sent 'five extremely remarkable pieces,' or the first two group exhibitions of the Dutch Etching Club, where he exhibited seven etchings, two drawings and a photograph Maris had retouched. Like early works by Breitner, they probably belonged to his private collection, as would appear from a visitor's report of 1884.[44]

In 1888 Willem Witsen characterised this exemplary dealer as follows: 'It is true: Mr van Wisselingh lacks entirely that banal taste which would seem to be an indispensable attribute of other art dealers; he is sensible enough not to concern himself with the requirements which the public, with its ingrained bad taste, is so anxious to impose; he does not even have a marked preference for a particular kind of art; the paintings he shows indicate that he is simply searching for beautiful, that is to say genuine art, art which he is able to appreciate even if its expression is deficient.'[45] The confidence with which he made these early purchases of work by younger artists (together with Tersteeg of Goupil & Co., Van Wisselingh was the only dealer who was an 'art-loving member' of the Dutch Etching Club) must have greatly encouraged them. Nor did he force artists to make corrections before accepting a work in commission, as other dealers are known to have done. On the other hand he certainly did take commercial viability into account. When Jan Voerman approached him with some watercolours in December 1889, after being rejected by the dealer J. Buffa, he returned them with the comment that he preferred an oblong format, along the lines of the still lifes with violets that Voerman had exhibited successfully at the Society of Watercolourists.[46] Six months hence he did accept a few, but a year thereafter 'preferred to wait for new work which was somewhat better expressed and more harmonious.'[47] Remarks such as these from someone whose livelihood depended on the sale of art were of course logical; unless an artist lacked self-confidence they would not have inhibited his creativity.

Besides the solo exhibitions he mounted in the 1890s of great names such as Jacob Maris (1898) and Albert Neuhuys (1899), Van Wisselingh was the first to organise important retrospectives of Eduard Karsen and Willem Witsen in 1895. Several other dealers did likewise. The Amsterdam dealer Buffa, for example, showed works by Van Gogh as early as February 1892 (before the large-scale Van Gogh retrospective organised by the Hague Art Circle in May that year) and, starting in 1894, regularly exhibited work by Voerman, whose more or less permanent agent he became. In 1891 the Oldenzeel Gallery offered Toorop ample opportunity to show his work, and a year later devoted an exhibition to Van Gogh. The courage to exhibit Toorop prompted Isaäcson to rank Oldenzeel amongst those who 'may consider themselves called to promote art indirectly, either by exhibiting good art or by supporting the pioneers of an emergent new art.'[48]

PRIVATE COLLECTORS

In light of the preceding it should be clear that collectors and museums at that time had every opportunity to start or expand a collection in whatever direction they preferred. Contemporary art was no bargain, however, unless one bought works from artists who were still unknown. The annual salary of an instructor at secondary or university level varied in 1880 from 1,500 to 2,000 guilders, which was sometimes not even enough to buy a watercolour. At the Society of Watercolourists exhibition of that same year, we have already seen that Jozef Israëls asked 2,500 guilders for a watercolour he sold to J. Verstolk Völcker and, according to a published account, thirty-four items were sold altogether for a total of 16,000 guilders. Including the expensive works by Israëls, this comes to an average of 470 guilders each, or the equivalent of two to three months' salary. One could also buy at the viewings of working members of Pulchri, which was apparently convenient, judging from the early decision to hold these events on two different nights of the week; prices there averaged about 150 guilders in 1881, but for many this sum, too, represented a month's work. And yet one critic still found these prices low. In his opinion, collectors who complained of high prices could enlarge their portfolios 'on very reasonable terms'; whoever could afford to spend one to two thousand guilders a year could quickly accumulate an 'interesting and tasteful collection (...), the value of which capital would do nothing but grow.'[49]

Whether this sort of advice was taken to heart is debatable. The Netherlands did not boast many watercolour collectors of any consequence. As far as the most important collectors of the more modern (Hague School) masters are concerned, the list extends little further than J. Verstolk Völcker, P. Langerhuizen and the painters Taco Mesdag, H.W. Mesdag and P. Stortenbeker, though the first four also regularly bought work by foreigners, particularly Italians, at the exhibitions of the Society of Watercolourists.[50] There was even less

interest in ordinary chalk drawings and prints, except among a few enthusiasts such as J.J. Tiele and the graphic artist P. Zilcken. As Veth wrote in 1892, 'Drawing is considered commonplace, inferior by nature to painting.'[51] Important private painting collections in Holland were equally rare. There were at most several dozen, the majority of which were of a far more modest scale than those in Great Britain or the United States.[52] The exhibitions of works from private collections which associations such as Pulchri Studio and Arti et Amicitiae held from time to time therefore depended heavily on these collectors.[53]

The most important collectors tended to belong to the world of trade and industry. They profited from the country's growing prosperity, thanks in part to the improved commercial climate following the termination of government monopolies in the Dutch East Indies. The growth potential of the ports of Amsterdam and Rotterdam had also been considerably enhanced by the construction of the North Sea Canal and the New Waterway, which linked these two cities with the sea. The second half of the nineteenth century witnessed the rise, particularly in these port cities, of an affluent, culturally minded upper class. It was not without pride that a large exhibition was organised in Rotterdam in 1880, featuring 'modern paintings' belonging to that city's collectors, the most important lender being J. de Kuyper.[54]

A glimpse of the catalogues is sufficient to realise that, like their fellows in England and Scotland such as James Staats Forbes, Alexander Young, Sir John Charles Day and John F. White, Dutch collectors preferred French and Dutch art. Italian art was also relatively popular, as shown by the Rotterdam catalogue of 1880 and the annotated ones published by the Society of Watercolourists, but Belgian and German art was no better represented in Dutch than in Anglo-Saxon collections. The most popular French artists belonged to the Barbizon School – such as Corot, Daubigny, Diaz, Dupré, Jacque, Rousseau and Troyon – besides such varied figures as Bouguereau, Decamps, Delacroix, Henner, Millet, Bastien-Lepage and De Neuville. The Dutch names which occur most frequently in the 1880s are Bosboom, Bakker Korff, Bles, G.J. van de Sande Bakhuyzen, Jozef Israëls, Rochussen, Verveer, Gabriël, C. Bisschop, H.W. Mesdag and Jacob Maris.

In the early 1880s average buyers were primarily interested in visible craftsmanship. Besides landscapes they preferred finely finished figure studies and genre pieces that captured a particular atmosphere or told a story. The Hague School was reasonably well accepted in the Netherlands by about 1885, somewhat later than in other countries, though given the negative connotation of Impressionism the term had to be somewhat redefined for them. Loffelt ascribed a depth of vision and a clarity of perception to the Impressionists, who sought to represent nothing other than what they closely observed. He deplored the fact that others had accused them of superficiality, colourlessness and sloppy draughtsmanship. 'All artists are, by the grace of God, Impressionists,' he wrote. 'The old masters were Impressionists

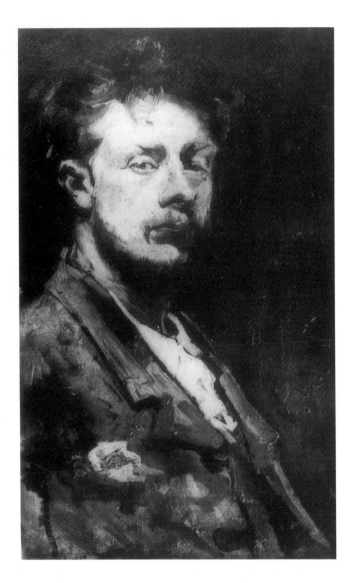

47. G.H. Breitner, *Self-Portrait*, 1882-1883.
Private collection

just as much as Corot, Courbet, Millet, the Breton brothers, Dupré, Rousseau, Diaz, Israëls, A. Neuhuis, the Maris brothers, Mauve, Mesdag and many others are today.'[55]

For the occasionally unconventional subject matter and more daring, looser technique of younger Impressionists such as Breitner and Isaac Israëls (figs. 47 and 48), however, there was little tolerance. Not even major collectors of the Barbizon and Hague Schools such as J. Verstolk Völcker, F.H.M. Post, Rudolf Kijzer, J.C.J. Drucker and W.J. van Randwijk were interested in them.[56] Art critics, scathing and cynical in their opposition, gratefully seized upon the low sales of their work as ammunition. With reference to a group exhibition in 1884 in The Hague, the same Loffelt remarked: 'The young Impressionists must remember that art collectors and connoisseurs are not artists. Only artists will take the will for the deed and want a study for their studio for the sake of a single quality felicitously expressed in it. By contrast a collector with an independent mind is not likely to purchase a piece in which colour and movement have been successfully rendered while the drawing is poor or still undeveloped.'[57] Others, too, seized on the commercial failure of these artists as evidence that Impressionism was doomed (fig. 49). Taurel, for instance[58], made some calculations following the international exhibition in Antwerp in 1885, where Breitner showed his three-metre wide canvas *Charge of the Hussars* (The Hague, Haags Gemeentemuseum): the Belgians and Italians managed to sell one out of every thirteen paintings they exhibited and the Germans one out of every twenty, but the Dutch (with a total of 203 items) only one out of twenty-five, well below the average! He wondered facetiously whether the Impressionists were entirely blameless.

For Breitner and his patron, the Rotterdam grain merchant A.P. van Stolk, this was a constant bone of contention. The merchant was keen to see the painter start turning out marketable works so that he could make ends meet.[59] Breitner, however, stood his ground and attempted in turn to convince Van Stolk that he should resist the ideas and bad taste of dealers and collectors in Rotterdam, to whom the merchant tried in vain to sell Breitner's work. 'You must believe,' he wrote to his patron in October 1883, 'that amateurs must be taught, must be forced to like something, that is to say connoisseurs who buy art, for the others are not usually in a position to do so. Do you think, for instance, that somebody like F. Smit [Fop Smit, a Rotterdam shipowner and collector; R.B.] buys a painting because he likes the look of it, regardless of whether or not it was painted by the greatest of artists, or because it has been painted by a great name and costs a lot of money? He himself said he never buys a painting under 1,000 guilders, after all. Anyone who would say something like that or be thought to have done so is not for me. I have more respect for someone who buys rubbish because he likes the look of it than for someone who, under the guidance of dealers, puts together a collection of work by the greatest names in Europe because they are so expensive.'[60]

In about 1885, the year that seems to foretell danger in the person of Toorop, the tide of opinion began to change regarding Breitner's 'sloppy' work. It is striking to see how, with the exception of critics such as Alberdingk Thijm, the mood became more tolerant with every passing year. Some had already voiced admiration for his nerve and talent, but the exaggerated characterisation of his figures and his sacrifice of 'drawing' on the altar of colour were still much criticized. His emotional, 'fantastic' approach to watercolour was the greatest stumbling block. By 1885, when Breitner had reached the age of twenty-eight, doubts about his talent and leadership among younger artists had been all but dispelled. Without ceasing to harp on the dangerous influence of his work, critics could no longer afford to ignore him, especially not after the 1886 purchase of *In the Dunes* (fig. 57) for the Rijksmuseum. That event more or less forced critics to take sides once and for all. In 1884, for example, Loffelt was still referring to Breitner's work as 'studio decoration,' but two years later he praised the artist's 'desire to capture the breadth and freedom of reality and to convey them within the limits posed by a work of art'; it was certainly a noble cause to banish in such a fashion the conventions which held sway over all art, even if it was hopeless, since art without convention was simply unthinkable.[61] Not long afterwards he defended the Rijksmuseum's acquisition on the basis of qualities he had previously deplored. Whether or not the horses were well drawn was irrelevant; the sense of speed that emanated from the painting was so overwhelming that one simply had no time for that![62] By 1890 or thereabouts Breitner's reputation had approached the stature of a classic, especially among his younger colleagues.[63] According to R.N. Roland Holst, however, there was an element of fashion in the more general recognition he achieved. Breitner was indeed the man of the hour, but that did not mean the public had really learnt to appreciate his art. It was rather 'because by being quick to affirm whatever seems eccentric in artistic matters as in daily life, the public seeks to demonstrate its aristocratic liberality (...), an urbane tendency that acknowledges in excess only that which is not bourgeois. (...) Breitner's art punches holes in any wall it hangs on, like blue and gold fireworks in a deep purple night sky, and it is precisely this passionate character which so alienates the public.'[64]

Roland Holst was probably not far off the mark. Though exact figures are hard to come by, the sale of Breitner's work at that time was still anything but brisk. The same presumably applies to most other young artists, and thus also to Roland Holst himself (cat. nos. 74 and 75). Every now and again they managed to sell something to dealers like Goupil, Van Wisselingh, Buffa or C.M. van Gogh, but beyond that they were dependent on the handful of amateurs who recognised the significance of their work. Unless one was reasonably comfortable – as Witsen, Kamerlingh Onnes, Van Rappard, Verster or Meyer de Haan were – or, like Toorop, had a wealthy wife, it was often hard to survive without other employ-

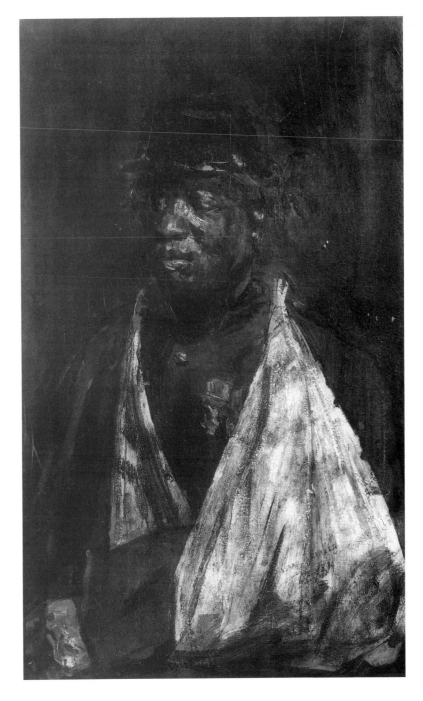

48. Isaac Israëls, *An Atjeh Hero*, 1882.
Private collection

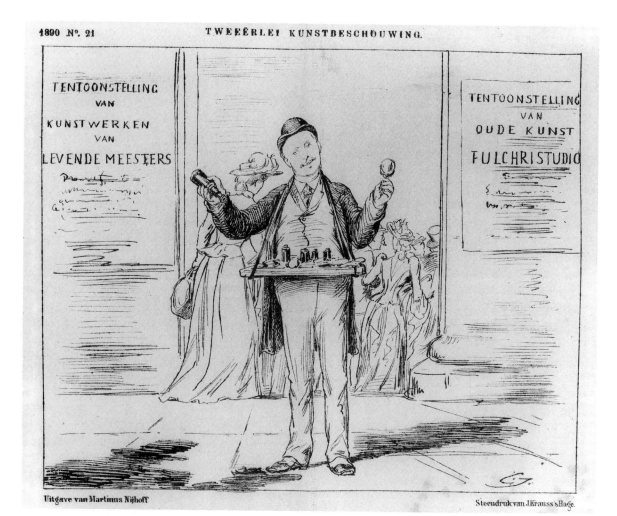

TENTOONSTELLING VAN KUNSTWERKEN VAN LEVENDE MEESTERS

TENTOONSTELLING VAN OUDE KUNST PULCHRI STUDIO

Uitgave van Martinus Nijhoff

Steendruk van J.Krauss 's Hage.

49. *Two types of exhibition*. Caricature in *De Nederlandsche Spectator* of 24 May 1890, referring to an exhibition of seventeenth-century art at Pulchri Studio and the Exhibition of Living Masters held concurrently at the drawing academy. The caption reads: '...Magnifying glasses and telescopes!... Academy of Drawing, Sir? A nice telescope! -- Pulchri Studio, Miss? You'll need a magnifying glass!'

ment. Suze Robertson had saved as much as possible of her substantial annual salary of 2,500 guilders while teaching drawing before attempting to live from her art. Though she lived in Amsterdam she was still enrolled at the Rotterdam Academy, which meant she could exhibit watercolours at the viewings they organised. Breitner regularly wrote to his patron Van Stolk that he was 'terribly in need' of money, and at the beginning was unable to manage – like Tholen and Haverman, incidentally – without also teaching drawing in Rotterdam. As late as 1885 he accepted a commission from an American to paint a copy of Rembrandt's *Anatomy Lesson* (The Hague, Mauritshuis); when he found he was getting nowhere with the commission, he passed it on for half the agreed 1,200-guilder fee to his younger friend Willem de Zwart, who had more experience with this type of work and needed the money just as desperately. During the same period the two artists also occasionally painted tiles for the Rozenburg Delftware

Factory in The Hague at 50 cents a piece, as Toorop and Pieter Josselin de Jong did as well.[65] Though such jobs were of some intrinsic interest (like the illustrating these and other artists did in the early 1890s for books and periodicals), the main point was probably extra income.

Mesdag, formerly a banker and, thanks to his wife Sientje van Houten, a wealthy man, was one of the first in Holland to buy one of Breitner's 'hussars' in 1881, for which he even paid the asking price of 300 guilders (including the 41-guilder frame). But this was after all a 'quiet piece' compared to the imposing cityscapes and figure studies Breitner painted after 1885, which Mesdag – perhaps because of the 'passionate' character to which Roland Holst referred – remarkably enough failed to buy. Nor did he buy any Isaac Israëls besides his early, more academic work, ignoring his spontaneous, impressionistic period around 1890, despite the fact that many of Mesdag's contemporaries thought his 'museum,' which in-

cluded works by Bauer, Dijsselhof, Haverman, Suze Robertson, Voerman and De Zwart, aspired to present a representative cross-section of contemporary art.

Mesdag was one of no more than thirty people in Holland who regularly bought the work of younger Dutch artists, not counting other fellow painters such as Mesdag's brother Taco. With the exception of individuals such as Hidde Nijland and C. Hoogendijk,[66] most of these collectors – including E.V.F. Ahn, J.J. Tiele, J.D.C. Titsingh, P.F.L. Verschoor, J.W.M. Roodenburg, H.G. Samson, A.S. van Wezel and L.C. Enthoven, to name but a few of the more important ones – have been largely forgotten. Ahn regularly bought work from Toorop; as early as 1884 he submitted a *Javanese Girl* to the exhibition of the Royal Society of Watercolourists. The two men were close friends, as is also evident from the double portrait that Toorop painted around 1886 of Ahn together with the artist's wife Annie Hall (fig. 50). Toorop was greatly indebted to him at the beginning. Ahn brought him into contact with Willem Maris, Mauve and Jozef Israëls, and wrote to Toorop's father insisting that his son enter the Amsterdam Academy. Ahn was an 'art-loving member' of the Dutch Etching Club and lent work by De Zwart, among others, for the first group exhibition. He did so again in 1891 for the first exhibition of the Hague Art Circle, this time watercolours by Bauer, Breitner and De Zwart.

Together with Suze Robertson, Breitner and De Zwart were among the artists most prized by the Rotterdam tobacco merchant J.J. Tiele; in the 1880s Tiele's was undoubtedly one of the more progressive collections in the Netherlands. The Association for the Promotion of Fine Arts devoted special attention to it in a series of descriptions of contemporary collections published in 1897. P. Zilcken – himself the owner of one of the most extensive collections of contemporary international graphic art, alongside collectors such as Enthoven of Voorburg – wrote the introduction. Zilcken saw Tiele as one of the 'truly passionate collectors' of modern Dutch art, who with their taste and willingness to lend to art viewings constantly tried to set the right tone for others. According to him Tiele bought almost nothing but 'artists whose work has no market value, whom hardly anyone yet appreciates.' This distinguished him from the vast majority of other collectors: 'Whereas most of them only buy what dealers or the public consider valuable, Mr Tiele buys only what he likes, exercising unusually good taste, sometimes even ignoring the advice of committee members and dealers.' He owned numerous paintings, watercolours, drawings and etchings by Bauer, Breitner, De Zwart, and Suze Robertson, deemed by Zilcken representative of their best work.[67] In an interview she gave in 1912, Suze Robertson called Tiele a 'patron of the arts' who was the first to buy her watercolours during her difficult early days; the collector offered her 60 guilders for one of them, whereas she had been prepared, after the unfavourable reviews she had received in the press, to settle for 10.[68] Like Mesdag, he must have bought not only from the artists themselves, but also at

50. Jan Toorop, *E.V.F. Ahn and Annie Toorop-Hall*, c. 1886.
Dordrecht, Dordrecht Museum

the viewings of working members of Pulchri and Arti as well as the annual exhibitions of the Dutch Etching Club. As appears from an annotated catalogue, at any rate, he purchased more than anyone else at the Etching Club in 1888, and we see his name listed along with those of Jan Veth, E.S. Witkamp, Willem Witsen and De Zwart for a total sum of 325 guilders. He later replaced the French works he had also purchased in the 1880s with ones by Dutch artists, the result being that in 1897 his collection 'was one of the most remarkable, instructive and exciting' in the Netherlands.[69]

In the early 1890s many collectors did indeed tend to prefer paintings and watercolours which 'expressed a mood'. For the majority – excepting individuals such as J.D.C. Titsingh and L.C. Enthoven – the modern movement centring around Toorop, Thorn Prikker and Veth was still too new and lay outside their field of vision. Such provincialism irritated Jan Veth intensely, as did the totally misguided tendency to underrate drawings and prints.[70] At the very least a work of art had to have a bit of colour, otherwise it was considered incomplete. Veth spoke of 'textural idolatry,' which completely ignored the artistic and spiritual worth of line drawings. 'Only recently a journalist – a third-rate journalist, admittedly, but someone whose opinions can be considered representative of prevailing opinion, to some extent – provided a comic example of this crazy narrow-mindedness, when he referred to drawings in flat, concise lines exhibited by Thorn Prikker at the Hague Art Circle as work that might conceivably benefit the 'art industry', but that had no place in an exhibition of serious art.'[71]

MUSEUMS

When A.C. Loffelt visited the Paris Salon of 1891, he was surprised that the French government and all kinds of municipal authorities bought and commissioned so much art there; every major town hall had some modern art, in fact.[72] If he thought things were very different in the Netherlands, he was right. Much earlier, in 1873, Victor de Stuers had expressed regret in *Holland op zijn smalst* that artists such as Jozef Israëls and Bosboom, whose work was already in great demand elsewhere, were not represented in Dutch public collections.[73] Afterwards it is true that a few museums cautiously acquired their first Jacob Maris or Anton Mauve, but as has already been said rightly elsewhere, the purchase by the Boymans Museum of Jacob Maris's *Nurse* in 1889 was still so bold that it prompted the likes of the artist Charles Rochussen to resign from the Supervisory Committee after twenty years of membership.[74]

Jan Veth took stock of the situation again in 1891. Under the heading 'Museum and Art' he raised the question in *De Amsterdammer* whether Dutch museums, like those elsewhere, 'did indeed have the best interests of art and the purification of taste at heart.' Did people there buy work unsullied by commercialism? 'Does the Boymans Museum in Rotter-

dam possess work by that capital artist, Breitner, which one would expect to find in his own birthplace, or is there anything by Jongkind there, who was also active in the area? Does one travel to Haarlem to see the very best Mauves in Teylers Museum? Is the museum in Middelburg worth the trip? Can one find a single good contemporary painting in the Museum van Kunstliefde in Utrecht? And was there rejoicing in the Lakenhal in Leiden when local artists took up their brushes again? Are Bosboom's finest drawings and the work of our greatest watercolourists to be found in Dutch museums? Did anyone take advantage of the recent opportunity on behalf of the State Collection when there was a splendid Thijs Maris which was completely 'comprehensible' for once at Mr Tersteegh's in The Hague?'[75] These questions were, of course, rhetorical, since everyone knew the answers. Anyone interested in contemporary Dutch art was better off visiting James Staats Forbes, the English collector, who on his death in 1904 left over 1,100 paintings and watercolours produced by the Dutch – or rather the Hague – School.[76] With respect to younger artists Veth found the museums even more deplorable, if possible. Anyone who knew of a public collection that included work by Voerman, Bastert, Karsen, Derkinderen, Witsen, Isaac Israëls or Bauer could raise his hand.

Advice, meanwhile, was not in short supply. Critics repeatedly cited works they deemed suitable for the Rijksmuseum, the Boymans Museum or the Amsterdam Association for the Acquisition of a Public Contemporary Art Collection. It was not yet too late; before long this work would doubtless leave the country, and most of it would not return again. The government suffered much abuse, some of which focused on the lack of an acquisition policy at the recently opened Rijksmuseum. The purchase of Breitner's *In the Dunes* for 500 guilders (fig. 57) in 1886 seemed to herald a change, but Jan Veth rightly criticised the random character of the painting's acquisition and the lack of a suitable context for it.[77] As De Stuers had done twenty years earlier, he pointed out the absence of a coherent vision, given the fact that Breitner's precursors who had 'sown the seed' – artists such as the Maris brothers and Anton Mauve – were still not included in the collection. In 1894, two years after the Musée de Luxembourg had bought a Pissarro and a Monet and were negotiating the purchase of an Emile Bernard and an Eugène Carrière,[78] Veth still found the situation in the Netherlands a disgrace: 'Too many of our museums, I have so often felt, are collections which have been assembled according to no guiding principle, like warehouses where things are stored that no one wants and to which someone else, independent of any central authority, adds whatever he sees fit. These public collections have thus come to resemble unchaired meetings of people who have gathered for no apparent reason, each with a different agenda.'[79] According to Veth, the Rijksmuseum bought work which had come to its attention by chance, and failed to attend important auctions. Matthijs and Willem Maris were not represented in the collection, nor were Jongkind, Allebé or Alma Tadema. The situation with respect to Bosboom,

Neuhuys and Rochussen was not much better, and there could have been more of Maris and Jozef Israëls. Compared to the work of previous generations, the purchases were indeed negligible: between 1886 and 1895 a grand total of five paintings (not including the Breitner), by Hilverdink, Termeulen, Blommers, Jacob Maris (fig. 51) and Gabriël (cat. no. 20). Watercolours formed another lacuna, according to Veth, a medium in which some modern masters excelled. In short, there were numerous holes in the collection, and thus a complete discontinuity between the care the architect had taken in designing the various rooms and the museum's carelessness in furnishing them.[80] The drastic reforms for which Veth pleaded never materialised, partly because of the newly constructed Stedelijk Museum, where the collection of the Association for the Acquisition of a Public Contemporary Art Collection found a home. It was thanks to a few prominent collectors, such as the Drucker-Frasers, J.B.A.M. Westerwoudt and A.S. van Wezel, that after 1900 the Rijksmuseum ultimately did house an important collection of the Hague School, including watercolours.

The Rijksmuseum was not the only one to be found wanting. Though every purchase of a Hague School master by the museums of Dordrecht, Middelburg or The Hague was loudly applauded, these choices were rarely made with much forethought. The reputation of the Boymans Museum was downright notorious in this respect; this was not so much due to the director, P. Haverkorn van Rijsewijk, who 'only hung some slick modern paintings when absolutely driven to it,'[81] but to the incompetence of the committee responsible for the Rotterdam Triennial, who preferred to buy a Haaxman or a Bles rather than an Israëls or a Maris. This committee received an annual subsidy of 500 guilders from the municipality, the result being that 1,500 guilders could be spent on every triennial exhibition of living masters, excluding 'monies contributed by city residents' and a certain amount of funding that originated from the former Kunstmin Association. This was far from adequate given the dramatic rise in the price of the great names. As early as 1890 Jozef Israëls had hung a 14,000-guilder price tag on the painting he submitted to the Arti exhibition. The 1,500 guilders that Boymans could spend was thus hardly sufficient to buy anything more than a small Jacob Maris or a good Breitner, both of whom asked 1,500 guilders for a painting at the same exhibition. In the 1890s, one of the ways we have already noted that Haverkorn van

51. Jacob Maris, *Urban Scene, c.* 1885.
Amsterdam, Rijksmuseum

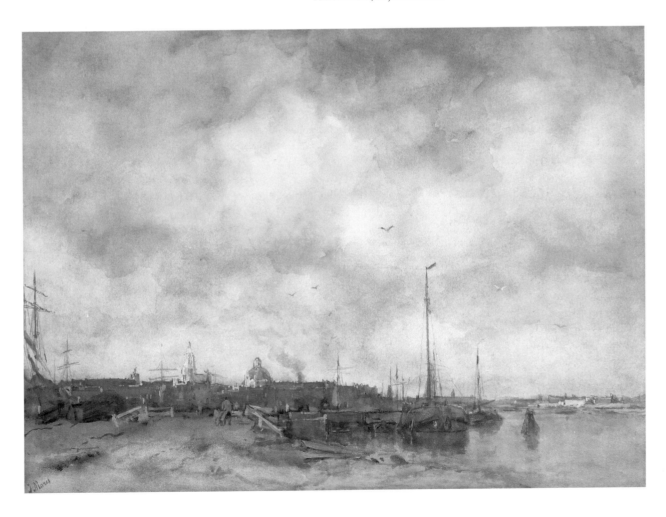

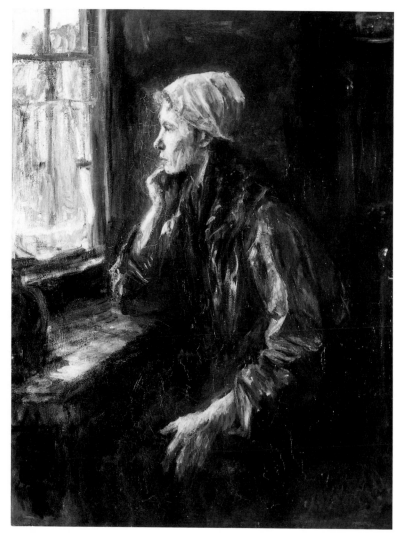

52. Jozef Israëls, *Woman at the Window*, 1895-1896.
Rotterdam, Boymans-Van Beuningen Museum

Rijsewijk attempted to compensate for his paltry acquisitions budget was to pay a personal visit to Jozef Israëls in the hope of acquiring his *Woman at the Window* (fig. 52) for the museum at a discount.[82] Van Rijsewijk was on reasonably friendly terms with contemporary artists, and in 1899 invited many of them to give work to the museum free of charge. Most responded positively; others, including Breitner, were contemptuous of what they saw as panhandling on the part of the museum.

Private attempts to establish municipal collections included the Association for the Acquisition of a Public Contemporary Art Collection mentioned earlier, which was founded in Amsterdam in 1874; similar initiatives were subsequently launched in The Hague and Rotterdam. Though their acquisitions did fill glaring lacunae, on the whole their financial resources were modest, especially since the Amsterdam association earmarked most of its annual budget of some 2,000 guilders for more established names. When the collection was transferred to the Stedelijk Museum in 1895 it included most of the Hague masters, but there was still no trace of Breitner, Witsen, Van Looy or De Zwart, to say nothing of the young Symbolists.[83]

Eduard Karsen, a figure who subtly linked the old and the new (fig. 53), was given a comprehensive exhibition by Van Wisselingh & Co., also in 1895, which brought together nearly his entire painted *oeuvre* at that time – some seventy works in all.[84] The average price of his work in 1890 of around 450 guilders placed him in the same category as Bauer, Isaac Israëls, Witsen, Tholen, Kamerlingh Onnes and Verster. The list of lenders shows that about 38% of his paintings were sold. With the exception of H.G. Samson, A.S. van Wezel and C. Hoogendijk, those who lent items (nineteen altogether) were not well-known collectors. The list also includes his twin brother, who paid for his academic training, and writers and painters of the *Tachtiger* Movement, such as Frederik van Eeden, Albert Verwey, Jan Veth and Etha Fles, who were friends of his. They were not compulsive collectors with either the ambition or the capital of individuals such as Mesdag, but were prepared to pay for quality, provided it was based on integrity and true artistry.[85] This, too, was a 'sales outlet' of a sort, not the most lucrative, perhaps, but certainly an indication that they were on the right track.

53. Eduard Karsen, *At the Zuyder Zee, c.* 1892.
Private collection

*This essay was translated by Jane Hedley-Prôle
For the readers' convenience various organisations and events have been rendered in English. The Editiorial Note contains a glossary of the original Dutch terms.

[1] G., *De Nederlandsche Spectator*, 6 January 1894 ('Over kunst') and 10 February 1895 (concerning the fifth *groepen-tentoonstelling* in Pulchri Studio, The Hague). The situation was not much different abroad; see, for example, Frits Lapidoth's account of a trip to Paris in *De Nederlandsche Spectator*, 21 May 1892.
[2] The study of the contemporary art market in the Netherlands is still in its infancy. A certain amount of work has been done on the Hague School and the Barbizon School: see, respectively, Charles Dumas, 'Haagse School verzameld', exhib. cat. *De Haagse School. Hollandse meesters van de 19de eeuw* (ed. R. de Leeuw *et al.*), Paris (Grand Palais) etc. 1983, pp. 125-136, and Hans Kraan, 'Barbizon en het verzamelen in Nederland', exhib. cat. *De School van Barbizon. Franse meesters van de 19de eeuw* (ed. J. Sillevis and H. Kraan), Ghent (Museum voor Schone Kunsten) etc. 1985-86, pp. 70-88. See Diana Wind's exploraty disertation, *De afzet van de hedendaagse kunst 1880-1895 in Nederland,* Amsterdam (Vrije Universiteit), 1989. I am grateful for her useful statistical data on State acquisitions in this period; see her annex I. The Netherlands boasts few collectors or dealers, such as Ambroise Vollard or George A. Lucas, who wrote their memoirs; the closest equivalent is J. Tersteeg, *Een half eeuw met Jozef Israëls* The Hague, (Boussod, Valadon & Cie) 1910. Even more lamentable is the wholesale destruction of large portions of the archive of one of the most renowned Dutch art dealers, E.J. van Wisselingh & Co., for lack of space! No less disheartening is the disappearance of two potentially very interesting files – 'Correspondence concerning requests for the purchase of artists' work, 1875-1913' and 'Material concerning exhibitions of contemporary artists in the Netherlands, 1877-1917' – from the Algemeen Rijksarchief in The Hague.
[3] Willem Roelofs, for example, accepted an offer of 350 guilders for a watercolour priced at 500 guilders in an exhibition organised by the Society of Watercolourists in 1884, while on the same occasion Mauve agreed to accept 400 guilders instead of the asking price of 750; the buyer in both cases was the noted English collector James Staats Forbes. At the same exhibition Mesdag was prepared to pay asking prices of up to 200 guilders without any further discussion, but beyond that even he, as chairman of the board, would haggle for a lower sum. He paid Blommers not 300 but 200 guilders, for instance, while Gabriël, E. van der Meer and P. van der Velden willingly accepted half of the prices they had asked. The Italian members of the Society of Watercolourists apparently had no objection to this method of doing business. The collector P. Langerhuizen paid Cipriani 1,650 for a watercolour priced at 2,500 guilders, which admittedly was still a considerable sum.
[4] See *De Nederlandsche Spectator*, 20 August 1887: 'An excellent measure, introduced for the first time at this exhibition (of the Society of Watercolourists), calling for adherence to fixed prices; others are recommended to follow suit.' Art dealer Tersteeg of Goupil & Co. in The Hague noted in his copy of that year's catalogue that Mesdag had paid 200 rather than 250 guilders for a Weissenbruch. Van Wisselingh, too, paid less than the asking price, as did the collector J.J. Tiele, who bought two watercolours by Breitner. Nor did the situation change later on; in 1896, for instance, Mesdag paid a lower price for work by Akkeringa and Arntzenius, who both joined the Society of Watercolourists, while Jozef Israëls bought a watercolour by Suze Robertson 100 guilders below the asking price of 250 guilders.
[5] E.G.O. (A.C. Loffelt), *Het Vaderland*, 6 June 1889 (concerning the Pictura exhibition in Groningen).

[6] In 1882 Loffelt listed his conditions: 'The great art of exhibiting seems to be: assembling a harmonious entity on every wall, so that the eye can pass from one item to the next without shocks or jars. A second requirement is to hang less successful and poor items where they need not be seen. I was struck by the fact that above-average work, work that showed promise in any case, was hung either in corners or too high.' E.G.O. *Het Vaderland*, 6 July 1892 (concerning the Triennial in Rotterdam).
[7] E.G.O., *Het Vaderland*, 14 June 1889 (concerning the Pictura exhibition in Groningen).
[8] G., *Het Vaderland*, 4 October 1895 (concerning the Triennial in the Stedelijk Museum, Amsterdam).
[9] The second group exhibition, held in December 1893, included, for example, L. Apol (6 items), F. Arntzenius (10), Suze Robertson (7), Blommers (2), Breitner (6), J.M. ten Kate (10), Konijnenburg (6), B. Mesdag-van Houten (6), Gerard Muller (10), H.A. van Oosterzee (7) and C. Storm van 's Gravesande (14). It would seem that any connection between the artists was nearly or entirely irrelevant; only the established masters of the Hague School were presented more as a group.
[10] *De Nederlandsche Spectator*, 2 December 1893.
[11] E.G.O., *Het Vaderland*, 25 November 1893.
[12] Known and less-known collectors, such as Van den Bronkhorst, Verstolk Völcker, H.W. Mesdag, Taco Mesdag, A. van Naamen van Eemnes, J.H. Tutein Nolthenius, R. Kijzer and P. Langerhuizen, sometimes lent their portfolios more than once.
[13] 'One must be seriously devoted to art,' wrote a critic in 1881, 'if one is not to be angered by the viewings organised by Pulchri Studio of late. Besides the fact that the throngs of people make it physically impossible to see the drawings properly, for the greater part of the evening the air one breathes is nothing short of poisonous.' *Het Vaderland*, 21 February 1881.
[14] *Het Vaderland*, 21 November 1882.
[15] *Het Vaderland*, 18 December 1889.
[16] In order to preserve the identity of the group and to keep the standard high, especially in the beginning, artists such as Jacob Maris or Taco Mesdag submitted work which was already in private hands. New members also tried (or were advised?) to look their best the first time they exhibited. T. de Bock borrowed a piece from Mesdag for his debut, for instance, and younger artists such as Tholen, Bauer and Suze Robertson also felt a need to borrow from collectors who had bought their work.
[17] E.G.O., *Het Vaderland*, 12 August 1890.
[18] E.G.O., *Het Vaderland*, 28 June 1883.
[19] *De Nederlandsche Spectator*, 15 April 1882 ('Berichten').
[20] Three years later the price range was narrower though the overall level had risen somewhat, especially as far as watercolours by Jacob Maris and Jozef Israëls were concerned.
[21] E.G.O., *Het Vaderland*, 15 August 1889.
[22] 'D...g', *De Amsterdammer* (weekly), 13 September 1891.
[23] J. Staphorst (J. Veth), *De Nieuwe Gids* 3, 1887, vol. 1, pp. 91, 93-94.
[24] 'One would be wrong,' opined *Het Vaderland* on 17 August 1882 regarding the first exhibition, 'to see this exhibition as a rejection of a particular artistic movement, the so-called Impressionists, who are supposed to exhibit only at the Dutch Society of Watercolourists. (...) There are drawings in both collections which excel either with respect to their careful technique or to the lively impressions of nature they convey. One can even admire the work of the same brush in both places.'

[25] For the history of the Etching Club see J. Giltay, 'De Nederlandsche Etsclub (1885-1896)', *Nederlands Kunsthistorisch Jaarboek*, 27 (1976), pp. 91-125. Even earlier, in 1880, a number of young students at the Academy in Amsterdam formed the St Luke's Artists' Association, whose members included Derkinderen, Van Looy, Witsen, Karsen and Toorop. The Association's objective was to promote self-development through the 'provocative exchange of ideas' between members; after only a few years Witsen, Veth and Van Looy left the Association, however, which for a long time accomplished little. See Peter J.A. Winkels et al., *Ten tijde van de Tachtigers. Rondom de Nieuwe Gids 1880-1895*, The Hague 1985, pp. 31-32.

[26] Verberchem (Willem Witsen), *De Nieuwe Gids* 4, 1888, vol. 2, p. 424 (concerning the second annual exhibition of the Etching Club).

[27] J. Stemming (M. van der Valk), 'Juiste en onjuiste begrippen over kunst', *De Nieuwe Gids* 4, 1888, vol. 1, p. 263.

[28] The prices at annual exhibitions were not published in the catalogues. According to a concisely annotated copy of the second 'annual' in 1888, De Zwart asked 40 guilders for a drawing; nor did others generally ask more than 100.

[29] See, for example, his review of the exhibition in Arti published in *De Portefeuille*, 24 and 31 October 1891.

[30] Flanor, *De Nederlandsche Spectator*, 15 August 1891, ('Vlugmaren').

[31] Jan Veth, *De Amsterdammer* (weekly) ('Aanteekeningen schilderkunst'), 20 March 1892.

[32] B.v.H. (P.A.M. Boele van Hensbroek), *De Nederlandsche Spectator*, 21 March 1893.

[33] Van Wisselingh, for example, showed Dutch and French art in 1893 in 's Hertogenbosch and in 1894 in Rotterdam's Maashotel; if there was sufficient interest on the part of the Rotterdammers, a larger exhibition was planned. See *De Nederlandsche Spectator*, 14 April 1894.

[34] Sometimes these viewings appear to have had no particular theme, while on other occasions they focused on specific masters or, like the one organised by Van Wisselingh at Pulchri in 1894, on work by French painters of the Barbizon School. See *Het Vaderland* 3-4 July 1894.

[35] The fact that H.G. Tersteeg, manager of Goupil & Co.'s Hague branch, noted all amounts in pounds sterling in his copy of the Society of Watercolourists' exhibition catalogue of 1888 is indicative. That same year the Goupil Gallery organised a separate exhibition in London of Jacob Maris's work, supplemented by a few pieces by his brothers Willem and Matthijs. In 1890 an exhibition was devoted to Anton Mauve, who had died two years earlier, while the Hannover Gallery, also based in London, held a sale exhibition of work by Jozef Israëls. Concerning the arrival and activities of other galleries in London – such as the Holland Fine Art Gallery (which belonged to the Amsterdam art dealer C.M. van Gogh) and the Dutch Gallery (a branch of Van Wisselingh's) – Scotland and the United States, see Charles Dumas, op. cit. (note 2) pp. 130-131 and M.H. Hurdalek, in exhib. cat. *The Hague School: Collecting in Canada at the Turn of the Century*, Toronto (Art Gallery of Ontario) 1983. In New York in 1895 Goupil (which had since become Boussod, Valadon & Co.) organised the First Annual Exhibition in the United States of the Society of Painters in Watercolors of Holland (that is, the Society of Watercolourists), to which Jozef Israëls contributed no fewer than eight items, considerably more than he had shown in a group exhibition in the Netherlands in a long time. See also Jan Veth's comment concerning the 1897 Triennial in Amsterdam (*De Nieuwe Gids* 3, 1887, vol. 1, p. 295): 'When work by the Maris brothers was exhibited (in 1886) in Edinburgh recently and some Dutch newspapers reprinted the praise of the British press, most Hollanders were surprised to hear so much about artists whose names they had never before heard mentioned, or at least not favourably. It is the same old story: our people have to learn from foreigners that they are great artists.'

[36] As early as 1884 Arti et Amicitiae organised a solo exhibition devoted to 'sketches and studies' by Willem Roelofs. That same year solo exhibitions devoted to C. Rochussen (watercolours and drawings) and H.W. Mesdag were held in the Amsterdam Panorama Building and at the Rotterdam Art Club respectively. The following year Mesdag's work was again on view, this time at the International Art Association in Amsterdam. There was a large retrospective of Jozef Israëls in the Panorama Building at the time.

[37] Concerning the Triennial held in Rotterdam in 1891, on 24 May 1891 Loffelt wrote in *Het Vaderland* that the most important Dutch artists – such as Jozef Israëls, the Maris brothers and Bosboom – were not to be seen, and that Mesdag was not well represented. 'There have been better examples of his [Mesdag's] talent in the Parisian Salons of recent years. The numerous foreign exhibitions which on the whole are more attractive to our painters as far as profit and publicity are concerned than the exhibitions held in the Netherlands, have been detrimental to the latter. We cannot compete with Munich and Berlin. Germany promises to become a good market for Dutch art and it goes without saying that our artists and dealers grab Fortune by the hair (...).' On the works submitted by Dutch artists to the Paris Salons see Jaap W. Brouwer, 'Hollandse kunstenaars en de Franse Salons 1879-1899,' *Tableau. Tijdschrift voor beeldende kunst* 6 (summer 1984) no. 6, pp. 84-90.

[38] *De Nederlandsche Spectator*, 11 May 1889 (concerning the Triennial in Groningen) and 5 August 1893 (by 'G.'): 'This year the Hague Academy has the honour of hosting the Triennial. This sounds impressive, but is merely a hollow phrase (...). There was once a time when even the greatest artists would submit their best work to the Triennial, especially when it was held in The Hague, but owing to the blinding fame they have won at foreign exhibitions the emphasis has now shifted. If foreigners who harbour the vain hope of seeing Dutch masters in their own country wish to spare themselves a disappointment, they would be well advised to go to Munich, Chicago or anywhere else.'

[39] *De Amsterdammer* (weekly) 25 December 1892 ('Een zaak van eer').

[40] E.G.O., *Het Vaderland*, 21 July 1894 (concerning the World Exhibition in Antwerp).

[41] J.J. Isaäcson, *De Portefeuille, Weekblad, gewijd aan Kunst en Letteren*, 23 May 1891 ('Aan mijn lezers', etc.), p. 776.

[42] Quoted by W. Arondéus, *Matthijs Maris. De tragiek van den droom*, Amsterdam 1945, p. 143. The artist's regard for Van Wisselingh is also evidenced by the fact that Maris designated the dealer's widow his sole heir.

[43] G., *De Nederlandsche Spectator*, 14 April 1894 (concerning a sale exhibition in the Maashotel, Rotterdam).

[44] 'Mr van Wisselingh's own collection comprises several very beautiful and highly original works by Jacob Maris, and especially by Matthijs Maris. Furthermore there are drawings and paintings by *Breitner*, Van der Maarel and Mauve which are among their best works and very important.' *De Nederlandsche Spectator*, 27 December 1884 (concerning Van Wisselingh's new branch on the Buitenhof in The Hague).

[45] Verberchem (Willem Witsen), *De Nieuwe Gids* 4, 1888, vol. 2, p. 298 (concerning Van Wisselingh's exhibition in Arti).

[46] Anna Wagner, *Jan Voerman IJsselschilder*, Wageningen 1977, pp. 30-31.

[47] *Ibid.*, p. 31.

[48] J.J. Isaäcson, *De Portefeuille, Weekblad, gewijd aan Kunst en Letteren*, 7 November 1891 ('Jan Toorop I').

[49] *Het Vaderland*, 20 December 1881 (concerning the art viewing of working members of Pulchri).

[50] The 'Exhibition of Several Drawings from Private Collections', held in Arti et Amicitiae in 1887, focused on the Hague and Barbizon Schools. No fewer than 41 of the 58 items exhibited were from the collections of the Mesdag brothers and Stortenbeker.

[51] V., *De Amsterdammer* (weekly) ('Aanteekeningen schilderkunst'), 6 November 1892.

[52] Dutch buyers who were prepared to pay 500 to 1,000 guilders for a painting could be counted on the fingers of one hand, according to Loffelt: 'The Netherlands produces much, but buys very little art.' E.G.O., *Het Vaderland*, 29 July 1890 (concerning an international exhibition in Arnhem). See also his commentary on the viewing of the portfolio lent by the young collector P.J. van der Burgh of The Hague, which he published in *Het Vaderland* on 20 January 1891.

53 The response to exhibitions of this type was usually very enthusiastic. In the summer of 1881 the Academy in The Hague showed fifty-one works by members of the Barbizon School, most of them French (including ten works by Corot, eight by Diaz and five by Daubigny), from the collections of Verstolk Völcker, H.W. Mesdag, Taco Mesdag, F.H.M. Post and H.J. van Wisselingh (the father of the dealer Elbert Jan). Carel Vosmaer considered the exhibition a service designed to educate and improve the taste of the public and artists alike, especially since one seldom had the opportunity to see so many of these works in one place, even in France. *De Nederlandsche Spectator*, 24 June 1882. See also A.C. Loffelt's review in *Het Vaderland*, 26 June 1882.

54 Catalogue of the 'Exhibition of Modern Paintings assembled from Existing Private art Collections of this city', Academy of Visual Art and Technical Science, Rotterdam 1880. Ten years later a similar type of exhibition was held in Rotterdam, to which the most important lender was De Kuyper once again. For his collection see: *Catalogue des Tableaux, Aquarelles & Pastels composant la collection de feu M.-J.R.C.H. de Kuyper de La Haye*, sale Frederik Muller & Cie, Amsterdam (30 May) 1911 (124 nos); see also P.H. Hefting, *G.H. Breitner in zijn Haagse tijd*, Utrecht 1970, 106-107 (and his note 8).

55 E.G.O., *Het Vaderland*, 28 June 1883 (concerning the Colonial Exhibition in Amsterdam).

56 See Charles Dumas, *op. cit.* (note 2), pp. 129-130.

57 *Het Vaderland*, 29 May 1884. This was in fact a reiteration of a view Loffelt had expressed some four years earlier, when he wrote that 'some works of art are for art experts and connoisseurs and others more for artists themselves. Artists are not concerned whether a work is finished or completely successful, but continue to elaborate on the subject which may be merely suggested by a few short brushstrokes (...).' A.C. Loffelt (E.G.O.), *Het Vaderland*, 30 August 1880 (concerning the 5th Society of Watercolourists Exhibition). Typical of the turn-about Loffelt eventually made was his appeal in *Het Vaderland* of 6 October 1894 (concerning the exhibition of the Hague Art Circle): 'When will our art collectors finally show more appreciation for De Zwart? His colours are so warm and light, his drawing and composition so broad.'

58 C. E. Taurel, *De Nederlandsche Spectator*, 12 December 1885.

59 See P.H. Hefting, *G.H. Breitner. Brieven aan A.P. van Stolk*, Utrecht 1970, p. 11.

60 *Ibid.*, p. 42 (letter no. 41).

61 E.G.O., *Het Vaderland*, 24 February 1886 (concerning the viewing of watercolours and drawings from the Mesdag Collection).

62 *Het Vaderland*, 10 October 1886 (concerning the Triennial in Arti). By 1886 even such conservatives as Alberdingk Thijm and Jan ten Brink seem finally to have changed their colours. The former did not quite give up the fight, but after seeing an exhibition at the International Art Association in Amsterdam was able to say that 'while Impressionism leads to much abuse and constitutes a real threat to the breadth and rich diversity of art, its principles are irrefutable, and the application of such principles with moderation and equilibrium deserves our love and respect.' A 'phalanx of five young Hague artists' at this exhibition appealed to him 'clearly and in many respects royally.' He referred to them by name: De Bock, Breitner, M. van der Maarel, Zilcken and De Zwart. The manner in which Thijm dated his contribution, however, is significant: 'Anniversary of the death of Michelangelo, 1886' (*De Amsterdammer* (weekly), 21 February 1886, 'Impressionisten'). Jan ten Brink, too, admitted that the Impressionists were 'fundamentally' right; no one could object to the triumph of truth. *De Amsterdammer* (weekly), 17 October 1886, ('Kunst-ten-toon-stelling').

63 His colleague A.J. Derkinderen described him as 'the richest among us'; 'None of our other painters renders his forms with such aristocratic grace, can see and distil such regal distinction from our prosaic Dutch surroundings, can so closely approximate the technical perfection and the wonderful brushwork of some Far Eastern magician of colour.' *De Amsterdammer* (weekly), 9 December 1890 ('Indrukken op de Arti-tentoonstelling').

64 *De Amsterdammer* (weekly), 15 February 1891 ('De afdeeling schilderijen op de tentoonstelling van Architectura et Amicitia').

65 See Richard Bionda, *Willem de Zwart 1862-1931*, Haarlem 1984, pp. 20-21.

66 Nijland is primarily known for his large collection of Van Gogh drawings, but he owned many watercolours by J.H. Weissenbruch as well. Besides work by young Amsterdam artists such as Voerman (17 items) and Karsen (4 items, including *At the IJ*, cat. no. 55), Hoogendijk also had an important collection of French Impressionists and Post-Impressionists, including work by Caillebotte (4 items), Monet, Renoir, Van Gogh, Cézanne (2 items), Gauguin and Vuillard; his collection was sold on 21/22 May 1912 at Frederik Muller & Cie, Amsterdam ('Tableaux Modernes, Aquarelles, Dessins, Pastels').

67 See his auction catalogue *Collection T... (= J.J. Tiele). Aquarelles, dessins et pastels*, Amsterdam (Frederik Muller & Cie.), 19 March 1907, which lists, among other things, 4 works by Bauer, 9 by Breitner, 8 by Suze Robertson and 5 by De Zwart.

68 The interview with M.J. Brusse was published under the heading 'Onder de Menschen: Suze Robertson' in the *Nieuwe Rotterdamsche Courant* of 5-6 October 1912; for the complete text of the interview see exhib. cat. *Suze Robertson*, The Hague (Haags Gemeentemuseum) 1984, pp. 29-35. In the course of the interview Robertson states (p. 32) that she sold most of her work initially in Rotterdam, where she was still enrolled at the Academy and regularly participated in viewings. She also sold 'to a gentleman, a civil servant in The Hague. Though his financial resources were modest, he did have an excellent eye for art and regularly visited the ateliers. Thus he occasionally managed to buy a good work of art for a modest sum, while at the same time lending a helping hand to a struggling young artist.' On p. 43 of the exhibition catalogue on Robertson just cited, Herbert Henkels suggests that the civil servant to whom the artist referred was probably M.J. Tiele, brother of J.J. Tiele, whose sale catalogue (Amsterdam, Fred. Muller & Cie., 28 Oct. 1925) lists no fewer than 13 items.

69 On Tiele see also G. in *De Nederlandsche Spectator*, 14 April 1894 (concerning the exhibition organised by E.J. van Wisselingh & Co. in the Maashotel, Rotterdam): 'Some years ago, Mr Tiele showed that he not only appreciated young artists such as the Maris brothers, Breitner and Suze Robertson, but was also prepared to risk buying their work at a time when Breitner and Robertson in particular were neither known nor regarded very highly. In general, collectors are perfectly prepared to pay thousands of guilders for a famous name, but very few of these so-called connoisseurs are brave enough to spend a few hundred on a fine painting by an unknown. Mr Titsingh of The Hague, who has a highly developed love of art, is one of the few exceptions (...).'

70 Referring not only to critics but probably also to collectors he wrote in *De Amsterdammer* (weekly), 6 November 1892 ('Aanteekeningen schilderkunst'): 'the notion that everything must be seen in terms of atmosphere is so thoroughly drummed into the heads of many people nowadays that anything that focuses on something other than aspects, ebbing tints, the music of colours or the poetry of hazy tonalities – that is, any other kind of attempt to achieve a definite character, or to employ a distinct style (...) is condemned.'

71 *Ibid.*

72 E.G.O., *Het Vaderland*, 9 July 1891.

73 *De Gids* XXXVII (1873), vol. 4, p. 347.

74 Cf. P.H. Hefting, *Breitner in zijn Haagse tijd*, Utrecht 1970, p. 8 (and his note 30).

75 *De Amsterdammer* (weekly), 6 December 1891.

76 See Charles Dumas, *op. cit.* (note 2), pp. 125-126.

[77] 'Breitner has now taken a great step in the eyes of the world. His painting has been bought for the Rijksmuseum! Well well! If the rumour is true that it was the Minister's own initiative entirely, then this proves that those who claimed one must always be prepared for surprises from this statesman were right. With the exception of the work by Hilverdink (...), at least the paintings purchased thus far do not resemble those disagreeable products with which the Rijksmuseum prefers to cover the walls of its large modern art rooms. The purchase is unreasonable in one respect. (...) The acquired items will look peculiar in the national collection, which would have benefited much more from a single painting of another type than from these three. There is now a missing link. Those who sowed the seed are not those who are now reaping the benefit. People have always refused to accept the Maris brothers and Mauve, and now that they can no longer do so they buy... Ter Meulen and Breitner. This is extremely unfair. A much better work by Blommers should have been bought some years ago. But the fact that the Maris brothers and Mauve are not yet represented in our museum remains above all a *national disgrace*.' J. Staphorst (J. Veth), *De Nieuwe Gids* 3, 1887, vol. 1, p. 298 ('Nabetrachting Driejaarlijksche Amsterdam').

[78] Cf. Jan Veth, *De Amsterdammer* (weekly), 3 April 1892 ('Aanteekeningen schilderkunst'); according to Veth this was a 'good' step on the part of the director.

[79] Jan Veth, *De Amsterdammer* (weekly), 24 June 1894 ('Museumbeheer'). In a separate series on the Rijksmuseum Veth again made a savage attack ('In het Rijksmuseum II,' 11 February 1894). The modern art department was 'if possible even more garish, unattractive, incoherent and characterless than any commercial exhibition. Our objection, therefore, is not that this collection would appear to have been assembled in accordance with a philosophy of which we disapprove; our objection is rather that it does not reveal any philosophy, any intention or any plan.'

[80] J. Veth, *De Amsterdammer* (weekly), 18 February 1894 ('In het Rijksmuseum III').

[81] E., *Het Vaderland*, 2 June 1891.

[82] The correspondence concerning this acquisition is preserved in the P. Haverkorn van Rijsewijk archive at the Rijksprentenkabinet, Amsterdam. According to the annual report on the Boymans Museum's collection and acquisitions in 1896, Israëls declared himself willing 'in the interests of Rotterdam and as a gesture of appreciation for the exhibition of his work held by the Rotterdam Art Circle, to allow Boymans to have this work for a significantly lower price than that already asked by a dealer (...).' Boymans was in fact one of the first museums to find room for a travelling exhibition of work by masters of the Hague School; typically enough, these items had not been selected from Dutch collections, but from the collection of James Staats Forbes.

[83] It was not until 1907, nearly twenty-five years after its foundation, that the Rembrandt Association financed the purchase of a modern work of art, though the work in question was very important, being a drawing by Matthijs Maris entitled *Ecstasy*, which was bought for the Boymans Museum in Rotterdam.

[84] See exhib. cat. *Tentoonstelling van schilderijen door Eduard Karsen*, art dealers E.J. van Wisselingh & Co., Amsterdam, 11 November-7 December 1985.

[85] Many other artists also possessed work by fellow painters whom they knew personally or admired. Saar de Swart, for instance, owned work by artists such as Thorn Prikker and Breitner; Breitner, work by Jacob Maris, Bauer and Dijsselhof; Jacob Maris, work not only by his brothers but also by De Zwart; Jozef Israëls, work by Suze Robertson; T. de Bock, work by Toorop; H.J. van der Weele, work by Breitner, Tholen and F. Arntzenius; and Ary Prins, work by Redon and Bauer. This list is far from complete, and serves merely to illustrate the fact that the artists themselves largely ignored the commonly accepted division of art into 'groups' or 'movements'.

PAINTERS AS CRITICS:
ART CRITICISM IN THE NETHERLANDS, 1880-1895

CAREL BLOTKAMP*

54. Jan Veth.
 Photograph by Joseph Jessurun de Mesquita

'In reviewing the Arti Exhibition, our annual *Salon*, Dutch art criticism eloquently demonstrated its ineptitude once again.' This sentence introduced the first contribution in the field of fine arts to appear in the first volume of *De Nieuwe Gids* in 1885.[1] The author of this withering comment on the standard of art criticism in Holland was Jan Veth, a young man who, judging from photographs taken that year, had just managed to grow a beard (fig. 54).[2] He was twenty-one.

There was no lack of nerve on the part of the young Amsterdam writers and painters who formed the circle of friends who launched the new journal. The editors – Frederik van Eeden, Frank van der Goes, Willem Kloos, Willem Paap and Albert Verwey – were all about twenty-five when they founded it. Despite their relatively tender years, neither the editors nor the writers hesitated to mop the floor with the reputations of every established name in the fields of literature and art. Their goal was to become the arbiters of Dutch cultural life, a responsibility they were not willing to entrust to older journals such as *De Gids*, *De Nederlandsche Spectator* or *De Dietsche Warande* and certainly not to the daily or weekly press.

The press had been infiltrated by militant youth, as well. Several painters and writers connected with *De Nieuwe Gids* also worked for the daily or weekly editions of *De Amsterdammer* for varying periods of time during the 1880s and 1890s. But it was primarily in *De Nieuwe Gids* that they could unite against 'the spirit of Jan Salie' (sc. mediocrity) which they felt dominated the Dutch cultural scene. The purpose of the journal, which existed in its original form from 1885 till 1894, was twofold.[3] On the one hand it served to disseminate the new literature appearing in the 1880s – Kloos, Verweij and later Herman Gorter published many of their best poems in it, Frederik van Eeden, Arij Prins and others their novels and novellas – while on the other it acted as the mouthpiece for the critical views of a new generation. The latter may have been the more important of the two roles. In the prospectus of the new journal which was distributed in August 1885, Frank van der Goes wrote that 'The editors of *De Nieuwe Gids* propose first and foremost to develop the principles of aesthetic and historical criticism.'[4] Those who wrote for it passionately defended youthful endeavours in the fields of literature and the fine arts, as well as politics and the sciences, contrasting them with the older generation.

Often, if not always, the authors themselves were actively involved in innovations taking place in the fields they were reviewing. Just as Kloos, Verwey, Van Eeden and Lodewijk van Deyssel wrote literary reviews alongside their poetry and prose, so Veth, Maurits van der Valk and Willem Witsen wrote art criticism and painted. They regarded this combination of theory and practice as self-evident, if not essential. One

of their greatest objections to older critics was that they were not themselves creative, but at best mediocre, such as the writer Carel Vosmaer and painter David van der Kellen. The judgement of such dilettantes could not be trusted. This rekindled the old discussion as to whether critics should receive practical training or theoretical – a debate as old as art criticism itself.[5]

The principled standpoint of these young people provoked widespread reaction. In *De Nederlandsche Spectator* of 3 July 1886, for instance, a certain Dr J. de Jong stood up for critics who are dilettantes; he found them more objective and open-minded than, say, a critic who paints. A year later, J.A. Alberdingk Thijm, who taught aesthetics at the Academy in Amsterdam and had once numbered the angry young Amsterdam painters who wrote for *De Nieuwe Gids* among his students, fended off their attacks by accusing them, in turn, of partiality and poor judgement.[6] As early as 1890, a certain 'Francesco' raised the question in the weekly *Amsterdammer* whether readers were interested 'in the criticism of the Impressionists (...), in their fierce guerilla war against anyone who disagrees with them'[7] – which comment was, of course, rejected out of hand. 'Our only prejudice is against the unsightly, the bogus and anything that is not genuine but learnt from another', retorted Van der Valk laconically.[8] His youthful cohorts also complained that older critics judged art according to aesthetic criteria which went far beyond the limits of fine art, or according to a view of the world that acknowledged the importance of art, but relegated it to a secondary position. This charge was primarily aimed at the classically oriented Carel Vosmaer and also at Alberdingk Thijm, the champion of Catholic emancipation. These men approached all art in the light of their own aesthetic preoccupations, whereas their young detractors wondered if they ever asked themselves what art's specific attributes and expressive potential were.

Neither the literary nor the art critics who wrote for *De Nieuwe Gids* espoused any basic theory of criticism, let alone aesthetics. And they denied that their own art or that of those they admired was based on any theoretical system, something they considered incompatible with the creative process. Creating or understanding art was not something that could be learnt, if one lacked the requisite feeling for it. According to this pragmatic, individualistic approach every work of art should be judged on its own merits. The focus of the critic should be what the creator of a given work had felt and observed and how he expressed it. As things then stood, critics thought that they had the right to judge someone else's expression of feeling based on their own artistic experience, an experience to which neither their fellow critics nor the majority of the audience was privy. The literary criticism which appeared in *De Nieuwe Gids* was not explicitly but certainly implicitly by artists for artists and the same is true to a certain extent of the art criticism in the journal, except possibly that of Witsen and Van der Valk.

It must be said that the literary outshone the art criticism in the journal. Not only is there more of it, but the quality is better. The contributors were experienced writers who could build on the critical tradition established in Holland by such distinguished authors as Multatuli and Conrad Busken Huet. There was no such tradition of art criticism and the artist-writers of *De Nieuwe Gids* certainly did not consider what little art criticism their country had produced to be worthwhile. On the other hand, the art critics pointed out that for about twenty years, without adequate recognition from either critics or the public, the Hague School had been producing work of the highest quality which had served as a standard for critics and as an example for young artists in The Hague and Amsterdam. The Dutch art criticism of the 1880s had a remarkably chauvinistic tone. The great masters of the Hague School led by Jozef Israëls and Jacob Maris were ranked alongside if not above the best French painters, such as Millet and Daubigny, and Breitner was sometimes rated higher than Manet.[9]

ART CRITICISM IN *De Nieuwe Gids* and *De Amsterdammer*

Jan Veth's first contributions to *De Nieuwe Gids*, published under the pseudonyms Samuel and J. Staphorst, were, as we have already seen, largely polemical, aimed at the critics whom he was convinced only had a theoretical knowledge of painting without any real understanding of or feeling for the *métier*. Veth quickly won the support of Witsen and Van de Valk. Their attacks were directed at their old teacher Alberdingk Thijm (fig. 55), whom they claimed was not qualified to discuss painting.[10] 'I have never read such an accumulation of presumptuous professorial ignorance', wrote Veth, no less presumptuously, in his 'Reflections on the Triennial Exhibition' in 1886.[11] They also took Thijm to task repeatedly; when, for instance, he equated Bastien-Lepage, Meissonier and Manet in a review and even called Bastien-Lepage an Impressionist, Witsen pointed out that Lepage and Manet were actually polar opposites.[12] Other Dutch critics were hardly any better in the eyes of the angry young men who wrote for *De Nieuwe Gids*. Whatever sensible remarks about good art they made were outweighed by an abundance of empty words they spouted and their revealingly bad judgements. As Veth summed up the situation, 'One not only rejects their analysis because of their conclusions, but also their conclusions on account of their analysis.'[13]

Our young critics not only vilified the reviews written by these dilettantes, however; they also made an attempt to provide an alternative, both in *De Nieuwe Gids* and in the daily newspaper *De Amsterdammer*. They cleverly used these publications to toss the ball back and forth to one another using pseudonyms. In his 'Reflections', quoted above for instance, J. Staphorst proclaimed the reviewer of *De Amsterdammer*, J. Stemming, one of the few capable Dutch art critics.[14] J. Stemming was Van der Valk's pseudonym and, as mentioned ear-

55. J.T.J. Cuypers, *In Memoriam J.A. Alberdingk Thijm*.
Published in *De Katholieke Illustratie*, 1889

lier, Staphorst was Veth's. Veth went on to say that Van der Valk had taken to heart what W.J. van Westervoorde (Witsen) had just written about criticism in *De Nieuwe Gids*, that the critic should dictate nothing to artists, but rather analyse works of art and make them accessible to the public.[15] Veth called this 'important, but not the only task of criticism.' He endeavoured to write art criticism which did not lower itself to the level of the audience but which was an art in its own right – *la critique pour la critique,* as it were – at least in *De Nieuwe Gids*. Art criticism in journals, he felt, should distinguish itself from that in newspapers. Writing for a journal, he believed it was his responsibility 'to focus attention on grand phenomena, to do justice to our great artists, to defend the rights of the young and to warn against the *bêtise* of official criticism.'[16]

Veth's ideal of art criticism as an art is comparable to what Kloos and later Van Deyssel were trying to do in their occasionally brilliant literary criticism. It also may have been inspired by a remark on the subject of literary criticism which Frans Netscher had recently made in *De Nieuwe Gids*.[17] Netscher distinguished 'exact criticism' – which should be analytical and make full use of the new psychological insights of the day – from a form of criticism that was a work of art in itself, 'the impressions of an impression', the response of one artist to the work of another, in which critical judgement and information have no importance.

Veth was the only one ever to realise his ideal. His later reviews in *De Nieuwe Gids*, in so far as they had to do with art and were not polemics on organisational and art historical issues, were lyrical pieces of prose, highly personal and suggestive. The title of his series of 'Impressions' speaks for itself. One example is the review he wrote of the work of a Belgian painter at an exhibition of *Les Vingt* in 1889: 'The clear colours gush like a clarion call between the more thickly congealed pigments in luxurious profusion.'[18] Such effusive prose suggests that Veth had sacrificed analysis to literary self-indulgence. Not surprisingly, his exuberance was occasionally ridiculed in journals such as *De Nederlandsche Spectator*.

In late 1886, using the pseudonym G.H.C. Stemming[19] – a humorous allusion to Van der Valk – Veth started to write reviews for *De Amsterdammer* with a different tone. Though his verbal revelry had not abated, his writing was much calmer and less didactic than in *De Nieuwe Gids*. It took the form of group exhibition reviews, focusing on particular submissions which he described and evaluated. For extensive analysis or judgement there was usually no space and yet Veth managed to point out strengths and weaknesses concisely. His criticism was not unlike that published in other papers, the main difference being the amount of attention he paid to his peers; led by Breitner, they were still controversial at that point. Veth's admiration for these artists was not blind, however; even in the work of such talented individuals as Haverman, Van der Waay and Witkamp, he sometimes detected superficial, bourgeois tendencies or a certain lack of character.[20]

On a few occasions, Veth addressed the same subject in both *De Amsterdammer* and *De Nieuwe Gids*, including, for instance, the three paintings by Whistler submitted to the 1889 Triennial exhibition, held in Amsterdam. In the newspaper he complained about the critical reaction to the work in the Dutch press, which apparently had not learnt anything from deriding gifted artists in the past who were now famous,[21] whereas in the journal he wrote evocatively about the three exhibited paintings, which included the acclaimed portrait of the artist's mother, and concluded that Whistler was 'the unrepentant priest of the goddess of inviolate beauty.'[22] Thus Veth obviously adapted both the substance and the tenor of his remarks to the medium.

Jan Veth is generally regarded as the most prominent Dutch critic of the late nineteenth century and rightly so, given the quality of his insights and judgement. He was so prolific that his many contributions eventually formed a coherent critical corpus. During the polemical, early stages of Dutch art criticism in the 1880s, however, the criticism of Witsen and Van der Valk was equally important. In fact, they made an even greater contribution than Veth to the theoretical foundation of the field in the Netherlands. It is therefore to be regretted that they did not do more.

Witsen (fig. 56) published a dozen articles in *De Nieuwe Gids* between 1886 and 1888.[23] When he moved to London, however, he stopped writing art criticism. By the time he returned to Amsterdam early in 1891, the situation within his circle of friends had changed so much that he did not take up his pen again. An inexperienced writer, he needed the constant stimulation and support of others. His first and possibly also his later contributions were thoroughly edited by Jan Veth and in fact the pseudonym under which he wrote (W.J.v.W.) comprises the initials of both men. Even so, Veth's editorial assistance was not enough to satisfy Witsen. Following the appearance of the first review on 4 August 1886, he wrote to Veth: 'I read *De Nieuwe Gids* this evening. You made the piece half-way readable and, above all, threw out a lot. That was a great improvement, Jan, but I had expected more. You should have made it more spirited, put more, if not all of yourself into it. You could have used my piece as simply a point of departure. As it is, I recognise my shortcomings in it all too well.'[24]

We can be thankful that Veth did not make even more changes than he did, because this first piece clearly shows that Witsen had very different ideas about the nature of the task at hand.[25] The two men unanimously rejected what they considered dilettante criticism; like Veth, Witsen also thought critics should themselves be artists if they were to judge painting competently. He insisted that critics should approach artists through their work. The essence of any artist is embodied in his work, which is 'remarkable in direct proportion to the strength and greatness of his temperament.' Witsen detested critics who squandered their energy on 'biographical trivia' and judged the artist 'according to conventional little

56. Willem Witsen, c. 1892

theories.' But unlike Veth, he believed that it was the critic's responsibility to inform and serve the public and that his personality should therefore be subordinated to that aim: 'We, who stand outside the work of art, who must rationalise our emotions, who love less exclusively and hate less personally, [than the artist under review, C.B.] we should take the specific qualities of the work into account and set our own ideas aside in order to determine whether the work is felt and expressed personally.'[26] A following article was aimed primarily at the conservative critic Johan Gram, but might also have been a reaction to what Veth had said about his concept of criticism as art, not public service. It reiterated Witsen's conviction that the analysis of a work of art, based on sound judgement, is more important than an opinion that happens to be held by a private individual.[27]

Like Veth, Witsen believed that the manner in which the painter expressed his observations was paramount. This did not mean, however, that form was everything for him and content nothing: 'A work of art becomes more complete to the extent that it portrays a life richly and intensely.'[28] The subject should thus be experienced by the artist and not learned. The intellectual aspects of a work of art as manifested in the representation, though indispensable, should not predominate. In those days, Witsen was generally subtler and more objective than Veth, for whom one's own feelings were everything and, in *De Nieuwe Gids*, at least, an admired work of art mainly a pretext for artfully expressing oneself.

Van der Valk (fig. 13) was a few years older than Veth and Witsen, but only started writing for *De Nieuwe Gids* in April 1887. His career as a critic, however, had started earlier than theirs, for he had published a lengthy review of an exhibition in *De Amsterdammer* as early as 1883.[29] In October-November 1886, he wrote another newspaper review, this time of the Triennial exhibition in Amsterdam, which was published in no fewer than seven instalments.[30] His friends and colleagues responded enthusiastically. We have already seen how Veth praised his friend in *De Nieuwe Gids*; Witsen wrote to Jacobus van Looy, moreover, that though Van der Valk's criticism was biased, it was nonetheless 'better than it has ever been.'[31]

Van der Valk's criticism does indeed have a clear, sharp ring. In the first instalment, he set forth his view of the critic's task: 'To stand between artists and laymen, to provide the public with whatever they need to know in order to understand a work of art, confronting them with a beautiful work – something most cannot identify on their own – and dissecting it for them, telling them why it is beautiful and warning them about all things base and ugly which masquerade as the real thing.' Veth correctly equated this didactic approach to criticism with that of Witsen.

Van der Valk also confronted his readers with a number of important considerations. In judging a work, the viewer should remember that neither technical skill nor the subject as such determines its merit and can even distract from or be detrimental to it. The best work of art is one 'which represents the deepest and most beautiful feelings most personally. Ba-

sically, every artist is an Impressionist, because what is the creation of a work of art if not capturing an impression or the mood evoked by one, be it in lines or colours, directly from nature or from the artist's imagination.'

After criticising the poor arrangement of the exhibition, with mature and immature works hanging side by side and some of the best paintings hidden in dark corners, Van der Valk embarked on an extensive discussion of selected works. Though his prose is filled with painters' jargon laymen can understand it. He calmly explained why Breitner's *In the Dunes* (fig. 57) was such a masterful rendering of cavalry, how the incomplete details so effectively suggested movement and all the various elements helped form a perfect whole. He alternated analyses of such good paintings with equally detailed discussions of those he felt were mere froth, such as a genre scene by Thérèse Schwartze who, despite the popularity of her work, was despised by the young critics who wrote for *De Nieuwe Gids*.

With this series of reviews written in 1886, Van der Valk set a standard for criticism which was subsequently attained only by Veth and Witsen. And yet despite its promise, his own career as a critic was short lived, save several important articles he submitted to *De Nieuwe Gids* in 1887 and 1888. These included a commentary entitled 'Correct and Incorrect Ideas about Art', which sharply criticised the reviews of Arti's autumn exhibition in 1887 and defended the opinion also propagated by other critics who wrote for *De Nieuwe Gids* that the artist's own judgement was paramount.[32]

As we have noted, the criticism written by both writers and painters in the 1880s was highly polemical. They campaigned against 'restrictions, bourgeois attitudes, stupefaction and the illegitimacy of fashionable judgements' in favour of 'a more dignified concept of art', as Jan Veth wrote in 1890.[33] And yet in Veth's opinion that campaign was really finished by that time. His self-confident conclusion was that his colleagues had had 'more effect on criticism in our country than they could ever have expected or intended.' Veth also noted that a shift had taken place in the attitude of the established critics in favour of the new generation of painters and praised a few newcomers to art criticism for their skilful and artistic judgement. 'Modern insights' had even reached the provincial papers.

What Veth failed to mention was that the most important critics of the old guard, whom the younger generation had so often attacked, were now dead. Vosmaer died in 1888, Alberdingk Thijm in 1889. Their deaths took the sting out of Veth's criticism and henceforth he thought he could limit himself to 'formulating impressions of what (...) is lofty and beautiful.'

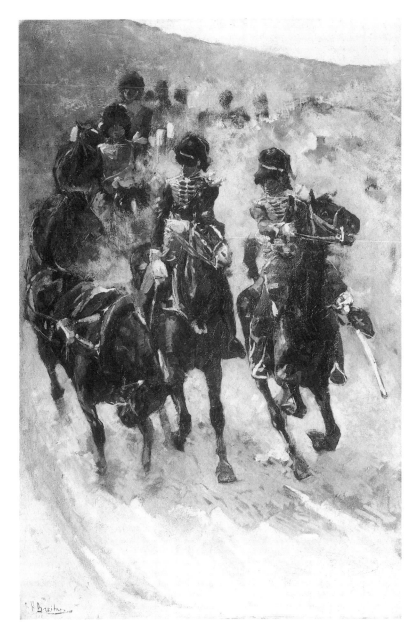

57. G.H. Breitner, *In the Dunes*, 1885-1886. Amsterdam, Rijksmuseum

ART CRITICISM AFTER 1890

Yet even though influential adversaries had disappeared and the art of the 1880s painters had won widespread recognition,

58. G.W. Dijsselhof, cover of the Dutch edition of Walter Crane's
Claims of Decorative Art, translated by Jan Veth, 1893

toward the end of the decade new art forms emerged in the Netherlands which needed to be understood and defended. In 1889 an exhibition was held in Amsterdam of work by the Brussels group *Les Vingt*, that introduced variations on Pointillism and other forms of Neo-Impressionism, primarily by Belgian artists such as George Lemmen and Theo van Rijsselberghe, but also by Jan Toorop, who belonged to the group's Dutch contingent and had organised the exhibition. During the first half of the 1890s, he found himself in the same position as Breitner five years earlier: as the touchstone of the progressiveness or conservatism of criticism. Alongside his Pointillist paintings, after 1890, Toorop showed Symbolist works which could be related to the art of foreigners such as Odilon Redon and Fernand Khnopff. Johan Thorn Prikker, R.N. Roland Holst and other Dutch artists joined Toorop. While Symbolism in the Netherlands in many ways followed the individualistic art of the Hague and Amsterdam Schools, another trend had made its presence felt. This trend could not strictly be separated from Symbolism but was less individualistic and subjected itself voluntarily to the discipline of monumental and applied art. Anton Derkinderen was the great pioneer of this trend, known as Community Art. And finally, in 1891 Van Gogh rocketed onto the Dutch art scene.

All these events created a good deal of excitement during the first half of the 1890s and forced art criticism to take a stance. Critics who wrote for daily newspapers such as Van der Kellen and A.C. Loffelt, who had not even been willing to accept the Hague and Amsterdam Schools, regarded the new art forms as regrettable excrescences. However, critics who worked for the daily *Amsterdammer* as well as various weekly and monthly publications did support them. In the daily *Amsterdammer*, Veth was joined by R.N. Roland Holst and J.W. van Dijckveldt, while the same Roland Holst and, as of 1895, P. Zilcken were among those who wrote for the weekly of the same name. The painter J.J. Isaäcson started publishing reviews and commentaries in *De Portefeuille* in 1889; while not of the highest calibre, they did show that he was open to the latest developments in French and Dutch art. Thanks to a lengthy sojourn in Paris he had first-hand knowledge of the French avant-garde. He focused attention on Monet, Seurat and Signac and was one of the first to write about the unknown Van Gogh just before his death. The prophetic statement written by Isaäcson on that occasion has become famous: 'His name, Vincent, is for posterity.'[34] Even the traditionally conservative *De Nederlandsche Spectator* changed its tune when Frits Lapidoth and a critic simply known as 'G.'

started writing for the paper. G. was especially well disposed toward the new art.

The most important contribution to Dutch art criticism in the early 1890s, however, again came from painter-critics. While Van der Valk and Witsen remained silent, Veth carried on and others joined him. At that stage Veth had no fewer than three periodicals at his disposal with which to propagate his opinions. For the weekly *Amsterdammer* he regularly wrote 'Aanteekeningen', that is, brief notes and comments on fine arts events, while in the daily of the same name he published exhibition reviews. He also continued writing his mainly lyrical prose pieces about artists and individual works for *De Nieuwe Gids*, of which he became fine arts editor in 1890. Veth did not restrict himself to his Impressionistic favourites; he was responsive to changes in art and followed new trends with interest. He had praised Derkinderen's *Procession* as early as 1889 and in 1892 stood up for the same artist's controversial mural in the town hall of 's Hertogenbosch which heralded the birth of monumental art in the Netherlands.[35] Veth also appears to have coined the term 'gemeenschapskunst' (Community Art) which emerged in 1892 and became a source of controversy. He had a very high opinion of innovations being made in the field of decorative art under the influence of the English. He translated Walter Crane's *The Claims of Decorative Art* in 1893, to which he assigned the suggestive Dutch title *Kunst en Samenleving* (Art and Society, fig. 58). Veth wrote pieces, furthermore, in which he revealed his admiration for and understanding of the Neo-Impressionism of *Les Vingt* as well as the Symbolism of Toorop and others. In the work of these innovative painters he detected a need to free themselves from the Hague School, which detested everything 'harsh, sharp and gaunt.' Many showed signs of an 'increasing desire for such a category of pure expressive art', which G.W. Dijsselhof, R.N. Roland Holst and Johan Thorn Prikker acknowledged as well as Toorop and Derkinderen.

Veth did not, however, go along with everything that was new. In an extensive study of French nineteenth-century painting which appeared in *De Nieuwe Gids* in 1890, he pointed out the great importance of Manet, Fantin Latour, Degas, Monet and Pissarro, but expressed reservations about the Pointillists, whose art, to paraphrase J.-K. Huysmans, comprised 'trop de procédé, trop de systèmes, et pas assez de flamme qui pétille, pas assez de vie' (too much method, too much system and not enough fire or life).[37] Nor did Veth know how to react to the work of Van Gogh at first, which he had seen in 1889 on a visit to the artist's brother Theo in Paris. According to the editorial minutes of *De Nieuwe Gids* on 12 November 1890, shortly after Van Gogh's death, he advised Frederik van Eeden not to write an article about the painter.[38] When, almost a year later, Veth announced an exhibition of Van Gogh's drawings at Pulchri in the weekly *Amsterdammer* – the public's first opportunity to see his work in the Netherlands, even earlier than the exhibitions which were to be held

in 1892 in Amsterdam, The Hague and again in Amsterdam – he was sceptical: 'The Hague will be able to see something of the work of this painter, who at least has controversy in common with great masters.'[39] Eighteen months later, after the second Van Gogh exhibition, he publicly recanted his negative opinion of the artist.[40]

Veth was open to Symbolism and Community Art, but not unconditionally. He could not free himself completely from the individualistic approach to art shared by those who had come of age during the 1880s. He remained active as a writer until his death in 1925, contributing regularly to *De Kroniek*, a journal founded in 1895, besides painting portraits and tending to his managerial and organisational obligations. In later life, however, he lacked feeling for the art of younger generations and focused increasingly on art from the past.

The critic most closely linked to the new trends in which he himself was involved was the painter R.N. Roland Holst. In 1890, the year he left the Academy, he started writing for the daily *Amsterdammer*, under the pseudonym Willem du Tour. He was only 21 at the time, the same age as Veth when he made his debut in *De Nieuwe Gids*. A year later, Roland Holst also published in that periodical and in the weekly *Amsterdammer*. At first he respected Breitner and the other members of the Amsterdam School and even followed them in his early work, but he was soon influenced by the ideals of Community Art and the ideas of the Symbolists. He wrote very sympathetically about the new French and Belgian painters such as Redon, Seurat, Lautrec and Henry van de Velde, about Matthijs Maris – whom he rated highest among the older Dutch painters – about Toorop, Dijsselhof, Thorn Prikker and about Van Gogh. As early as February 1892, following the small show organised by the Amsterdam art dealer Buffa, Roland Holst published a piece in which he spoke tellingly of the dangers involved in dealing with Van Gogh's work: in his opinion, appreciation for the artist was too closely linked to his tragic fate and his art was seen as an expression of his mental illness. To Roland Holst Van Gogh's strengths were a strong will, a great love and a childlike delight 'in the essence of colour and expression.'[41]

Roland Holst had a singular respect for Derkinderen and was the most important advocate of his ideas on art. In February 1892, he published a penetrating study in *De Nieuwe Gids* of Derkinderen's mural in 's-Hertogenbosch, which he described as the first real piece of Dutch abstract painting, aimed at representing abstract concepts behind visible reality.[42] Roland Holst defended Abstraction as the essence of reality, the timeless element which ancient and medieval cultures had also sought, as opposed to the ephemeral nature of the Realism and Impressionism of the Hague and Amsterdam Schools. With this important essay, he dissociated himself completely from the views that had been espoused by *De Nieuwe Gids* up till then. In another article on the same subject, A. de Graaf underlined the incongruity between the two camps when he wrote 'We had almost stopped thinking because we felt so

59. T. van Hoytema, cover of the leaflet for *De Kroniek*, 1895

much.'[43] He contrasted the individualism of the 1880s with the new art, which sought to serve the general community and was in fact religious.

This dichotomy smacks of a generation gap, even though the age difference between those involved was small. While Veth tried to bridge the gap and stressed continuity, Roland Holst's opposition to older artists and critics continued to grow. In a letter to Chap van Deventer, who was planning to launch a new journal, he wrote on 28 July 1892 'On the whole I agree with you that it would befit a new journal to adopt an explanatory approach with respect to painting (...), but you should not forget that those who followed Breitner's generation (Toorop, Thorn Prikker, Van Gogh) must now be defended, whom both the critics and the public are against.'[44] The division between Roland Holst and the Amsterdam School is also apparent from a letter he sent Verwey two years later about a painting by Breitner. It was a good painting, he wrote, but compared to the art of Egypt and the Italian Renaissance 'you are only bewildered by his bad taste, his ignoble attention (...), his absolute insensitivity to the fact that the highest art can only be the very purest expression of feelings.'[45]

During the second half of the 1880s, Veth, Witsen and Van der Valk served an important purpose in *De Nieuwe Gids* and the daily *Amsterdammer*, making Dutch and to a lesser extent French Impressionism palatable, while changing the course of art criticism. The utter individualism and almost blind veneration of beauty preached especially in *De Nieuwe Gids* were forced, however, to make way for an art and hence also an art criticism that was not confined to the proverbial ivory tower. In the years that followed, Veth and the even more scrupulous Roland Holst defended a different art according to different criteria, but these were only fully developed in *De Kroniek* (fig. 59), which journal, as noted earlier, was founded in 1895. The social position of the artist and his function in society would be at the heart of the discussion, a fascinating aspect of *fin-de-siècle* European culture, but beyond the scope of this essay.

It is the fate of the critic that his reputation stands or falls with the status of the art for which he has toiled. That applies to the eighteenth century, to which modern art criticism in newspapers and journals can be traced, but even more so to the second half of the nineteenth and twentieth centuries. It is the propagandists of the successive avant-garde movements whose names have been remembered almost without exception, for history has shown that they were 'right'. And yet in the final analysis a supporter of Cubism such as Apollinaire was no better critic than Jacques Rivière who took a dim view of the movement. Judging from Apollinaire's critical corpus, his taste, insight and argumentation were unsteady and probably influenced more than they should have been by his well-known artist friends. There is more to be learned about crucial aspects of Cubist art from a more objective critic such as Rivière.

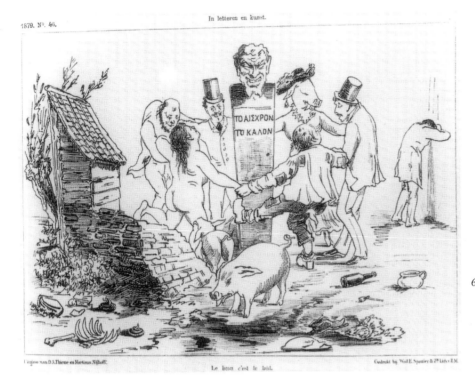

60. Carel Vosmaer,
The Triumph of Naturalism in Literature and Art.
Caricature published in
De Nederlandchse Spectator, 1879

Taking this into account, one might wonder why conservative Dutch art criticism of the 1880s and 1890s is not regarded more highly than it is in Holland, where it has mainly functioned as the musty backdrop to the stunning performance of the younger generation. This contrast is, of course, precisely the impression with which the members of that younger generation wished to leave us. In our present view of the nineteenth century, the avant-garde is less isolated and no longer regarded as only worthwhile artists. Nineteenth-century Dutch critics who supported history painting and Academism, such as Vosmaer and Alberdingk Thijm, to whom a number of recent publications have been devoted, now share in the renewed interest in these areas.[46]

One might also wish to know whether, in their need to distinguish themselves, the young artists we have discussed did not create an image of their elders that is really a caricature. It is true that the older writers based their criticism on a system that was both ethical and aesthetic. However much Vosmaer and Alberdingk Thijm and lesser gods such as Van der Kellen and Loffelt differed, they all agreed that art is governed by certain rules. In the criticism these men produced, the Good, the True and the Beautiful are still alive. They believed works of art should be executed soundly and thoroughly and that the subject should be of interest; to their way of thinking there was surely such a thing as a hierarchy of genres. In 1885 Alberdingk Thijm still thought that Jozef Israël's famous early painting *At the Graveside* was far too large for such a humble subject.[47] These critics did not hesitate to scold even the most reputable artists. The younger critics, however, greatly exaggerated the conservatism of their elders, whose protests were therefore not unjustified. In a letter to the editor of *De Amsterdammer* in 1892, Loffelt accused these brash young men of claiming they had discovered the genius of the Hague School.[48] That recognition had come much earlier, from the distinguished critic J. van Santen Kolff, among others, who wrote for *De Banier* and *Het Vaderland* in the 1870s,[49] and also from Vosmaer, Alberdingk Thijm and Loffelt himself,[50] long before anyone had heard of the youthful rebels. Their reviews of Dutch group exhibitions always opened with an extensive and usually positive look at the work of Israëls, Jacob Maris, Mauve and other masters of the Hague School. The young writers, however, had a retort ready for remarks like Loffelt's: that admiration had come too late – only after the Hague School had won fame abroad – and that it was half-hearted, since these painters had been regularly criticised for their choice of subject and their careless style. But the young critics were most bitter about the fact that the admiration was linked to praise of the work of artistic lightweights, so what was it worth?[51] After reading the work of the older writers, one has to admit that the younger ones were correct in this respect. Their elders seem to assign praise and blame at random, according to criteria that are often suspect. And they were just as blind to the merits of new talent such as Whistler, Redon or – nearer home – Breitner.

Thirdly, it is worth determining whether the older critics might have shed some light on the art they criticised, as Ri-

vière had done to Cubism. For instance, conservative critics argued that Toorop's symbolist work was very illustrative, the symbolism unclear and the explanation of the master and his interpreters confused; the extremely eclectic character of his work is seen more clearly by his opponents than by his supporters. It must also be admitted that the criticism of the Hague School by older critics such as Alberdingk Thijm and Loffelt was not entirely unjustified: their work was, indeed, sometimes repetitive and their choice and treatment of subject hackneyed, probably in part for commercial reasons. Johan Gram was not far off the mark in 1887 when about the heirs of Jozef Israëls and Neuhuys he remarked that 'little passion is evoked by seeing the hundredth bowl of potatoes being eaten or the thousandth stocking knitted.'[52] Even earlier, in 1884, a certain Fred. J. Verheijst had written that 'The fate of the potato in particular has with great sympathy been taken to heart by our artists. Planting and digging, scraping and peeling, cooking and smoking, pecking and picking, biting and chewing, this vegetable has for years been a favourite subject of contemplation for our Colourists.'[53] And these comments were written even before Van Gogh painted his *Potato Eaters*.

Humour was one of the sharpest weapons of critics who resisted new trends in art (fig. 60), which sometimes made their work more readable than the diatribes turned out by the young writers. This humour runs through not only reviews, but also the fictitious dialogues between exhibition visitors by Alberdingk Thijm and poems such as 'For a Painting' which appeared in *De Nederlandsche Spectator* in 1886.[54] Standing before a painted scene he cannot recognise (a topos in late nineteenth and early twentieth-century art) the poet muses: 'And the background... what do we see there? (...) Endless scores of sheaved stalks? The thousand fears of a mother's heart? A host of rag-and-bone men?' and so forth.

The young painter-critics may have exaggerated the faults of their older colleagues but this should not affect our appreciation of their achievement. Between 1880 and 1895 they developed a brand of art criticism that was both expert and committed, an art criticism that called attention to artists who, despite great potential, had not yet been recognised.

*This essay was translated by Martin Cleaver and Andrew McCormick
For the readers' convenience various organisations and events have been rendered in English. The Editiorial Note contains a glossary of the original Dutch terms.

Parts of this essay were first published in my article 'Art Criticism in *De Nieuwe Gids*', *Simiolus*, 5 (1971), pp. 116-136. I have also made grateful use of material collected by Angelique Kruip for a thesis, on art criticism in the Netherlands between 1880 and 1895 for the Free University, Amsterdam.

[1] Samuel, 'Schilderkunst', *De Nieuwe Gids* 1, 1885 vol. 1, pp. 323-324.

[2] Fusien Bijl de Vroe, *De schilder Jan Veth 1864-1925. Chroniqueur van een bewogen tijdperk*, Amsterdam 1987, p. 72.

[3] Owing to conflicts within the editorial staff, the publication of the journal was interrupted in 1894; after resuming later that year, it continued until 1943, largely under the leadership of Willem Kloos (d. 1938) and his wife Jeanne Reineke van Stuwe.

[4] The prospectus was published as an appendix to G. Stuiveling, *De Nieuwe Gids als geestelijk brandpunt*, 2nd ed., Amsterdam 1959, pp. 115-116.

[5] In eighteenth-century France, for instance, this was an important issue. See Diderot, *Salons*, eds. Jean Seznec and Jean Adhémal, Oxford 1957, I, pp. 7-60.

[6] 'Under the guidance of the "Stemming" family (see below, note 19), people are meddling on all sides with the many-sidedness of art', Alb. Th., 'Exclusivisme', *De Amsterdammer* (weekly), 22 May 1887.

[7] Francesco, 'De kunst op de Haagsche tentoonstelling III', *De Amsterdammer* (weekly), 22 June 1890.

[8] J. Stemming, 'Juiste en onjuiste begrippen over kunst', *De Nieuwe Gids* 3, 1887, vol.1, p. 259.

[9] J.V., 'Schilderkunst op de Tentoonstelling van Architectura et Amicitia in de Loods op het Damrak', *De Amsterdammer* (daily), 8-9 February 1891.

[10] J. Stemming and G.H.C. Stemming, 'Prof. Thijm en zijn exclusivisme', *De Nieuwe Gids* 2, 1887, vol. 2, pp. 191-196. This was a response to the article by Alberdingk Thijm (see note 6).

[11] J. Staphorst, 'Nabetrachtingen over de Driejaarlijksche tentoonstelling', *De Nieuwe Gids* 2, 1886, vol. 1, p. 299.

[12] W.J.v.W., 'Jan van Beers in het Panorama', *De Nieuwe Gids* 3, 1887, vol. 1, p. 132.

[13] J. Staphorst, *op. cit.* (note 11), p. 299.

[14] *Ibid.*, pp. 302-306.

[15] W.J.v.W., 'Een boek over kunst', *De Nieuwe Gids* 1, 1885 vol. 2, pp. 461-468.

[16] J. Staphorst, *op. cit.* (note 11), p. 306.

[17] Frans Netscher, 'Het daghet uyt den oosten', *De Nieuwe Gids*, 1, 1885 vol. 2, pp.333-361.

[18] J. Staphorst, 'Tentoonstelling van de "Société des Vingt" in het Panorama te Amsterdam', *De Nieuwe Gids* 4, 1889, vol. 2, p. 310.

[19] Richard Bionda gave the plausible explanation that the pseudonym 'G.H.C. Stemming' incorporates the initials of Breitner, the acknowledged leader of the younger generation and therefore stands for 'G.H. Breitner cum suis'. The concept 'stemming' (mood) is key to the outlook of the Amsterdam Impressionists, for more on which see pp. 130-131 of the article by Blotkamp cited at the beginning of these notes. It is understandable that the young painter-critics made a sort of sobriquet of this, which Alberdingk Thijm mocked by speaking of 'the Stemming family' (see note 6, above). Besides J. Stemming and G.H.C. Stemming, in the daily *De Amsterdammer* and in *De Nieuwe Gids* we also occasionally encounter O.N.T. Stemming (the painter Eduard Karsen; 'ontstemming' means 'ill feeling' or 'resentment') and I.N. Stemming ('instemming' meaning 'assent'). This last pseudonym was presumably used by the scholar and painter Jan Zürcher. When, however, on 15 June 1889, a damning review of the exhibition of Les Vingt appeared in the daily *Amsterdammer* by a certain B.E. Stemming ('bestemming', or 'intention, purpose, use'), Jan Veth responded in the same newspaper on 16/17 June 1889 with a letter to the editor in which he wrote, 'I feel somewhat embarrassed about the childish fashion in which a little brother Stemming, whom I still do not know, felt he needed to attack Les Vingt as a group in yesterday's edition of your paper', whereupon Veth announced that it would only be possible in the future to write for the paper under one's own name or initials.

[20] G.H.C. Stemming, 'Tentoonstelling van teekeningen in "Arti et Amicitiae "II', *De Amsterdammer* (daily), 24 November 1886.

[21] J.V., 'Iets – op de valreep – over de "Driejaarlijksche"', *De Amsterdammer* (daily), 16 Oct. 1889.

[22] Jan Veth, 'Whistler', *De Nieuwe Gids* 5, 1889, vol.1, pp. 133-134.

[23] Completely reprinted in Rein van der Wiel, *Ewijkshoeve, tuin van tachtig*, Amsterdam 1988, pp. 154-179.

[24] *Ibid.*, p. 102.

[25] W.J.v.W., *op. cit.* (note 15).

[26] *Ibid.*, p. 465.

[27] W.J.v.W., 'Een kunstcriticus', *De Nieuwe Gids* 2, 1887, vol. 2, pp. 47-51.

[28] W.J. van Westervoorde, 'Een Hollandsch schilder in Spanje', *De Nieuwe Gids* 2, 1887, vol. 2, pp. 181-187.

[29] On Van der Valk as a critic, see Matthijs Dijkstra, 'Maurits van der Valk', *Metropolis M* 2 (1981), no. 41, pp. 26-29.

[30] J. Stemming, 'De stedelijke tentoonstelling van schilderijen', *De Amsterdammer* (daily), 8, 13, 17-18, 21, 31 October / 1, 4, 7-8 November 1886.

[31] Letter from Witsen to Van Looy, 26 October 1886, quoted by Van der Wiel, *op. cit.* (note 23), p. 111.

[32] J. Stemming, *op. cit.* (note 8).

[33] V., 'Aanteekeningen schilderkunst', *De Amsterdammer* (weekly), 27 April 1890.

[34] J.J. Isaäcson, 'Parijsche brieven', *De Portefeuille*, 17 August 1889.

[35] J. Staphorst, 'Derkinderens "Processie van het H. Sacrament van mirakel"', *De Nieuwe Gids* 4, 1888, vol. 1, pp. 461-467. Jan Veth wrote the brochure *Derkinderens wandschildering in het Bossche stadhuis*, Amsterdam 1892 about the mural. Van Duyl said he did not object to Derkinderen's painting, but to all those explanations of the content and symbolism. Veth was now the target of the same criticism he had heaped on older critics such as Alberdingk Thijm a number of years previously. Roland Holst subsequently defended Veth: Willem du Tour, 'Derkinderen en zijn profeet door A.G.C. van Duyl', *De Amsterdammer* (weekly), 14 February 1892, with a short commentary by Derkinderen. On Community Art from an international perspective, see Bettina Polak, *Het Fin-de-Siècle in de Nederlandse schilderkunst*, The Hague 1955, pp. 206-213.

[36] J.V., 'Van enkele Hollandsche teekenaars in Arti', *De Nieuwe Gids* 7, 1892, vol. 2, pp. 142-144.

[37] Jan Veth, 'Fransche schilders in deze eeuw', *De Nieuwe Gids* 5, 1890, vol. 2, pp. 311-328.

[38] The minutes of the editorial meetings are published as an appendix to Stuiveling, *op. cit.* (note 4), p. 144. Frederik van Eeden ignored Veth's advice and published 'Vincent van Gogh', *De Nieuwe Gids*, 6, 1890, vol.1, 263-270.

[39] J.V., 'Aanteekeningen schilderkunst', *De Amsterdammer* (weekly), 25 October 1891.

[40] Jan Veth, 'Tentoonstelling van werken door Vincent van Gogh in de Amsterdamsche Panoramazaal', *De Nieuwe Gids* 7, 1892, vol. 1, pp. 427-431.

[41] Willem du Tour, 'Vincent van Gogh', *De Amsterdammer* (weekly), 21 February 1892.

[42] R.N. Roland Holst, 'Over Derkinderen I. De beteekenis van Derkinderens nieuwe muurschildering in onze schilderkunst', *De Nieuwe Gids* 7, 1891, vol. 1, pp. 321-324.

[43] A. de Graaf, 'II. Gemeenschapskunst. De wandschildering van Derkinderen', *De Nieuwe Gids* 7, 1891, vol. 1, pp. 325-329.

[44] Quoted in Walter Thijs, *De Kroniek van P.L. Tak*, Amsterdam 1956, p. 27.

[45] Quoted in M. Nijland-Verwey, *Kunstenaarslevens*, Assen 1959, pp. 110-111.

[46] N. Maas *et al.*, *De literaire wereld van Carel Vosmaer. Een documentaire*, The Hague 1989; J.F. Heybroek (ed.), *De verzameling van mr. Carel Vosmaer (1826-1888)*, The Hague 1989; exhib. cat. *J.A. Alberdingk Thijm 1820-1889. Katholicisme & Cultuur in de negentiende eeuw*, Amsterdam (Amsterdams Historisch Museum), Nijmegen (Universiteitsbibliotheek) 1989.

[47] Alb. Th., 'Ten-toon-stelling Israëls', *De Amsterdammer* (weekly), 19 April 1885.

[48] A.C. Loffelt, 'Aan den portretschilder, kunstbeoordeelaar, enz. enz., Jan Veth', *De Amsterdammer* (weekly), 1 May 1892. The same edition includes a lengthy response from Jan Veth, 'Den wel-edelen Heer A.C. Loffelt.'

[49] The honour sometimes also fell to Van Santen Kolff. Frans Netscher said later about him that 'He was the first – in *Het Vaderland* – who dared to defend De Bock, Maris and Mauve, who were ridiculed at exhibitions.' Quoted in E. d'Oliveira Jr., *De Mannen van '80 aan het woord*, Amsterdam 1908, p. 88. Van Santen Kolff had described himself as someone who, whenever possible, 'stands up for the new movement in our school of painting, which still has to struggle against innumerable prejudices on the part of much of the public and many of the critics.' Quoted in 'Een nationale vereeniging ter bevordering van de waterverfteekenkunst I. De Hollandsche teekenmaatschappij en haar tweede tentoonstelling', *De Banier* 3, (1877), p. 326. Van Santen Kolff coined the term 'Hague School' into currency and one of the first to assign the term Impressionism to Dutch painters in a positive sense. See Blotkamp, *op. cit.* (at the beginning of these notes), p. 132.

[50] Loffelt, for instance, wrote in 1883 that the Hague School painters were not inferior to the best foreigners and were worthy followers of the seventeenth-century landscape painters, who had also used 'ordinary' subjects to create elevated art: 'The principle that guides our Impressionists is "look carefully and feel deeply"; paint nothing you have not observed meticulously. The unfavourable connotation some attach to the term 'Impressionism' is totally unjustified (...) By the grace of God all artists are Impressionists.' E.G.O., 'De Schilderijen op de Koloniale Tentoonstelling', *Het Vaderland*, 28 June 1883.

[51] See Veth's response to Loffelt, *op. cit.* (note 48). Many older critics also responded favourably to the work of talented young artists. It is ironic that Alberdingk Thijm wrote with great admiration about Jan Veth's portrait of Frank van der Goes (cat. no. 99) precisely when he was most vehemently attacked: 'He has captured the character completely; the pose is consistent with it.' Quoted in Alb. Th., 'Schilderij-ten-toon-stelling "Arti" II', *De Amsterdammer* (weekly), 13 November 1887.

[52] Quoted by W.J.v.W., *op. cit.* (note 27), p. 49.

[53] Fred. J. Verheijst, 'Kunst-ten-toon-stellingen. Utrecht, Amsterdam, 's-Gravenhage III', *De Amsterdammer* (weekly), 11 June 1884.

[54] Florentijn, 'Voor eene schilderij', *De Nederlandsche Spectator*, 1 May 1886.

Catalogue

EDITORIAL NOTE

The catalogue is presented alphabetically according to the names of the artists. Following the Dutch usage, names with the prefix 'de' or 'van' are listed under the surname proper. Van Gogh, for example, appears as Gogh, Vincent van. Each entry comprises a brief biography of the artist, followed by his or her work in chronological order, with paintings taking precedence over watercolours and drawings. Dimensions are given as vertical measurement by horizontal. Details of provenance are given in full wherever possible. An interrogation mark indicates that the data given is unconfirmed. Details of exhibitions are given only up to 1900.

Literature references are presented chronologically. The select bibliography is in alphabetical order. Shortened references indicate titles listed in the bibliography following the biography of the artist in question.

For the reader's convenience, various organisations and events have been rendered in English in the catalogue. The following is a glossary of the original Dutch terms.

- The Dutch Society of Watercolourists (established in 1876): *Hollandsche Teeken-Maatschappij*.

- The Dutch Etching Club (established in 1885): *De Nederlandsche Etsclub*.

- Amsterdam Academy (established in 1870): *Rijksacademie*.

- The *Tachtigers*. The Dutch term is used in the catalogue to refer to the group of avant-garde writers and poets who established *De Nieuwe Gids* in 1885.

- Association for the Acquisition of a Public Contemporary Art Collection: *Vereeniging tot het Vormen van een openbare verzameling van Hedendaagsche Kunst (VVHK)*.

- Rotterdam Art Circle: *Rotterdamsche Kunstkring*.

- Utrecht Art Circle: *Utrechtsche Kunstkring*.

- Royal Association of Dutch Watercolourists: *Koninklijk Genootschap van Nederlandsche Aquarellisten*.

- Association for the Promotion of Fine Arts: *Vereeniging tot Bevordering van Beeldende Kunsten*.

- Triennial exhibition (a cycle of exhibitions held annually in Amsterdam, The Hague and Rotterdam in turn; hence a triennial event in each of these cities) *Driejaarlijksche Tentoonstelling van Levende Meesters*.

- Art viewing: opportunity for artists to show work informally to a select public: *Kunstbeschouwing*.

- Group exhibition: exhibition of several works by each member of a group of artists: *Groepen-tentoonstelling*.

Alma-Tadema, Lawrence

Dronrijp 1836 - 1912 Wiesbaden

Lawrence Tadema was born in a small village in a fairly remote part of Friesland, but grew up in the provincial capital, Leeuwarden. When he was four years old his father, a notary, died. Lawrence went to grammar school, where it was expected that he would follow in his father's footsteps and study law. He himself, however, wished to develop his artistic talents and was supported in this by his mother. In 1852 he became a pupil at the prestigious Antwerp Academy, which attracted large numbers of students from the Netherlands. One of them was Matthijs Maris, who became a friend of Tadema's. The director of the Academy, Gustaf Wappers, and his successor, Nicaise de Keyser, were noted history painters and the history genre also appealed to Tadema. After graduating in 1856 he continued to live in Antwerp. Around 1860 he acted for a time as assistant to Baron Henri Leys, who was working on a cycle of historical scenes for the town hall in Antwerp.

Like his teachers, Tadema began by painting episodes from the history of his own country, particularly themes from the early Middle Ages. Influenced by the archaeologist Louis de Taye, in whose house he lived, and inspired by a study visit to the British Museum in 1862, he began to paint Egyptian themes, followed shortly after by scenes from Greek and Roman antiquity, which were to become his speciality. In 1863 he spent his honeymoon in Italy, where much of his time was devoted to studying the excavations at Pompeii.

Tadema spent the following years in Brussels and Paris, where he associated with Louis Gérôme and Alfred Stevens. He also visited London on several occasions. His success there, coupled with the threat of war on the Continent made him decide to settle in England in 1870, shortly after the death of his wife. In 1871 he remarried; his new wife was Laura Epps, a young pupil. Two years later he acquired British citizenship. In London Tadema, who now went by the name of Alma-Tadema, developed into a portrait and history painter of high standing. He left the portrayal of major historical events to others, preferring to concentrate on historical genre paintings. He depicted scenes of daily life from classical antiquity, which combined a feeling for atmosphere with meticulous archaeological accuracy. He was especially admired for his convincing rendering of materials and his painting of metal, marble, drapery, plants and flowers is indeed wonderfully realistic.

Alma-Tadema's house in Grove End Road, which had been completely rebuilt and furnished to his design after an explosion in 1874, had rooms in the Pompeiian and Dutch Renaissance styles. Something of a curiosity, it attracted large numbers of visitors. At the height of his fame, in the last decades of the nineteenth century, he was one of the best-paid artists in England, ranking alongside history painters such as Frederic Leighton and Albert Moore. He was admitted to the Royal Academy and knighted by Queen Victoria in 1899.

Although Alma-Tadema felt completely at home in the English art world, he maintained close ties with his native country. His work was exhibited in the Netherlands fairly regularly, often at the Dutch Society of Watercolourists, of which he was an honorary member. He also kept up a close friendship with the critic Carel Vosmaer, with whom he travelled in Italy in 1878 and 1883. Vosmaer wrote several essays on Alma-Tadema's work and made him the protagonist of his novel *Amazone*. However, Dutch collectors and museums were less enthusiastic about Alma-Tadema than their English counterparts. He was not as highly regarded by the young painters of the 1880s and 1890s as his London-based compatriot, Matthijs Maris.

Literature: C. Vosmaer, *Onze hedendaagsche schilders, Lourens Alma Tadema*, The Hague 1882, no. 4; Percy Cross Standing, *Sir Lawrence Alma-Tadema O.M., R.A.*, London 1905; exhib. cat. *Ary Scheffer, Sir Lawrence Alma-Tadema, Charles Rochussen of De Vergankelijkheid van de Roem*, Rotterdam (Lijnbaancentrum) 1974; V.G. Swanson, *Sir Lawrence Alma-Tadema. The painter of the Victorian vision of the Ancient world*, London 1977; Rykle Borger, *Drei Klassizisten. Alma Tadema, Ebers, Vosmaer*, Leiden 1978; F.L. Bastet, 'Carel Vosmaer en Lourens Alma Tadema', in J.F. Heijbroek (ed.), *De verzameling van mr. Carel Vosmaer (1826-1888)*, The Hague 1989, pp. 130-147.

I

L. ALMA-TADEMA
Emperor Hadrian's Visit to a Romano-British Pottery, 1883
Oil on canvas, 159 x 171 cm
Signed and annotated lower right: *L. Alma Tadema Op*
CCLXI B
Amsterdam, Stedelijk Museum (donated by the Association for
the Acquisition of a Public Contemporary Art Collection)

In *De Nederlandsche Spectator* of 4 September 1886, Carel Vos-maer published a lively account of a visit to his friend Alma-Tadema in London in January 1883. 'Tadema produced a large canvas with the beginnings of a composition (...). Gradually sweeping across its surface, he sketched the figures in white chalk as he saw them in his mind. (...) Then, talking and working at the same time, "You see, there is Hadrian now, up on the gallery by the staircase (some lines in white chalk), ...behind him Lucius Verus (ditto)... on the right the potter, who is showing him a vase (a few outlines in chalk)... and there... (chalk outlines)... is where Sabina must come, with her beautiful head, and the wife of L. Verus – etcetera. And here, halfway up the staircase, a naked slave with a tray of pots, (and the contours suddenly appeared) ...and another at the bottom, coming upstairs with a tray of pots (...). And then pots, pots, pots everywhere, all real, from the British Museum, look, I have copies of them here."' Some months later Alma-Tadema consulted Vosmaer, a classical scholar, for historical details relating to Hadrian, and an appropriate Latin inscription.

The scene which Alma-Tadema has reproduced in the painting is typical of his work; it is not a momentous historical event but an everyday moment he has invented, in the life of the Roman emperor Hadrian. To his English public this would have been a significant choice. Hadrian had a special tie with Britain, having spent much time there and having built the famous Hadrian's Wall to protect Roman territory. Alma-Tadema's painting shows various objects found at excavation sites in England, such as the celebrated Colchester pot and a fragment of a mosaic from a villa near Arundel. He based the emperor and his retinue on prints of Roman busts and, in contrast to these Latin figures, portrayed the nameless Britons as blond Nordic types. He was no less meticulous with other details, although his principal concerns were colour and composition. Here he has indeed achieved a coherent composition in pleasing, resonant tones.

To his surprise, perhaps, Alma-Tadema did not find an English buyer for the work when he first exhibited it in 1884. In 1886 it was shown in the Netherlands by Oldenzeel, a Rotterdam firm of art dealers, where it attracted much attention, but once again failed to find a buyer. The painting then underwent an astonishing transformation. Tadema cut it into three smaller canvases, which he subsequently reworked. Two of them were exhibited in Amsterdam in 1893. They are the large section, which belonged to P. Langerhuizen at the time and which is now at the Stedelijk Museum, and a small fragment (The Hague, Royal Collection) showing the pottery with a figure in the foreground, carrying a wooden tray laden with pots on his head. The latter piece was lent to the museum by Emma, the Queen Mother, and the work may in fact have been cut up at her request. Lodewijk van

Deyssel recalls a visit to Alma-Tadema in London in 1894, when the artist apparently told him that the canvas 'could only be deemed appropriate for a place in the palace if the slave were removed from it', (*Gedenkschriften*, ed. Harry G.M. Prick, Zwolle 1962, pp. 421-422). The artist evidently rejected the idea of painting over the figure – which was an essential element in the composition – and opted instead to cut the work into marketable sections. He himself kept the offending fragment with the half-naked figure, which is now at the Musée d'Orsay in Paris.

PROVENANCE: H. Koekkoek Jr Gallery, Amsterdam (before 1893); P. Langerhuizen, Amsterdam, 1893 (*f* 15,500); auction Amsterdam (Fred. Muller & Cie.), 29 October 1918, purchased by the Association for the Acquisition of a Public Contemporary Art Collection in Amsterdam (*f* 10,000); donated to the museum by the Association, 1949.

EXHIBITIONS: *116th Exhibition*, London (Royal Academy of Arts) 1884, no. 245; Rotterdam (Kunstzaal Oldenzeel) 1886; *Moderne schilderijen*, Amsterdam (De Brakke Grond; C.F. Roos & Co. and H. Koekkoek Jr Gallery) 1893 (the canvas was cut into three parts, two of which were exhibited).

LITERATURE: C.V.[osmaer], 'Eene schilderij van Alma Tadema', *De Nederlandsche Spectator*, 4 September 1886; Helen Zimmern, 'L. Alma-Tadema, Royal Academician, his Life and his Work', *The Art Annual*, 1886, p. 24; J. Staphorst, 'Iets over Alma Tadema', *De Nieuwe Gids* 2, 1886, vol. 1, pp. 94-96; J.W.v.D., 'Tentoonstelling van moderne schilderijen in de Brakke Grond', *De Amsterdammer* (daily), 8 November 1893; J.V.[eth], 'Iets over Alma Tadema', *De Amsterdammer* (weekly), 26 November 1893; G., 'Een praatje over schilderijen', *De Nederlandsche Spectator*, 9 December 1893; anonymous, *Eigen Haard* 15 (1893), pp. 172-173; exhib. cat. Rotterdam 1974, p. 7.

Bakker Korff, Alexander Hugo

The Hague 1824 - 1882 Leiden

Like many artists of his day, Bakker Korff first worked as a pupil in the studio of a noted painter (Cornelis Kruseman, as of 1841) before enrolling at an academy. He initially attended the Hague Academy, but completed his education in Antwerp, where he was taught by the celebrated history painters, Nicaise de Keyser and Gustaf Wappers. Bakker Korff subsequently lived and worked in Oegstgeest, Leiden, The Hague and Noordwijk before settling permanently in Leiden in 1856. At first he painted history pieces, mainly biblical and mythological scenes in a romantic-classicist style; his early draughtsmanship is sometimes likened to that of Flaxman and Rethel.

In the latter half of the 1850s he began to paint small genre scenes executed with meticulous precision, which accorded with the taste of the art-buying public. These works brought him tremendous acclaim, both at home and abroad; reviews often referred to him as the Dutch Meissonnier. Bakker Korff must have been an ardent admirer of the seventeenth-century artists of the Leiden School, such as Dou, Metsu and Van Mieris, who specialised in small, minutely finished pictures. Like them, he achieved great mastery in his rendering of texture. He could unerringly reproduce silk or velvet fabrics, or objects made of copper, glass or porcelain, without losing touch of the whole. Despite their colourfulness his canvases are superbly balanced and well composed. The humour of many seventeenth-century genre painters, too, found an echo in his work. He shows a preference for domestic scenes portraying elderly women (modelled on his two

unmarried sisters with whom he lived) in bourgeois interiors. His paintings, however, have a modern, ironic undertone, which is accentuated by the carefully chosen titles, while some of his drawings are uncannily perceptive caricatures.

Bakker Korff's work had little impact on the emerging young artists of the 1880s. An exception may perhaps be made in the case of Floris Verster, who had known his fellow townsman as a member of the Ars Aemula Naturae Society in Leiden. Verster's rich colours and the treatment of material in his work from the 1880s and 1890s suggest a lingering admiration for Bakker Korff.

LITERATURE: C. Vosmaer, *Onze hedendaagsche schilders, Alexander Hugo Bakker Korff*, The Hague 1882, no. 8; anonymous, 'Berichten en mededeelingen', *De Nederlandsche Spectator*, 25 March 1882; Johan Gram, 'A.H. Bakker Korff', *Elsevier's Geïllustreerd Maandschrift* 9 (1899), vol. 18, pp. 389-405; Jan Engelman, *Torso*, Utrecht 1931, pp. 24-28; exhib. cat. *Alexander Hugo Bakker Korff*, Leiden (Stedelijk Museum De Lakenhal) 1958; exhib. cat. *A.H. Bakker Korff, J.L. Cornet, H. Ringeling*, Leiden (Stedelijk Museum De Lakenhal) 1981/82; *Catalogus van de schilderijen en tekeningen*, Leiden (Stedelijk Museum De Lakenhal) 1983, pp. 52-68.

2

A.H. Bakker Korff
Commemoration of the Lifting of the Siege of Leiden (Hutspotdag), 1879
Oil on panel, 17.5 x 23.5 cm
Signed and dated lower right: *A.H. Bakker Korff 79*
Dordrecht, Dordrechts Museum

Bakker Korff's teacher at Antwerp, Gustaf Wappers, owed his reputation largely to the colossal canvas of *An Episode during the Siege of Leiden*, painted in 1829 (Utrecht, Centraal Museum). It portrays with deep pathos the burgomaster of Leiden offering his body as nourishment for his starving fellow townsmen during the Spanish siege of 1574. In 1879, fifty years later, Bakker Korff recalled an event from the same period in the history of his home town. His painting depicts two elderly women sitting in an old-fashioned interior before their meal of *hutspot*, a dish of mashed potato, onion, carrot and beef, which is traditionally eaten on 3 October. The custom commemorates the lifting of the siege of Leiden and the starving citizens' discovery of a *hutspot* in the abandoned Spanish camp. While the dog looks on hungrily, the two women are deep in prayer, expressing their gratitude for the meal, but also, it has been suggested, for the liberation of Leiden some three centuries earlier. The painting reflects not only the gentle irony with which Bakker Korff viewed his own bourgeois milieu, but seems also slightly scornful of history painting, which was then losing its supremacy.

The same scene appears in an undated ink and watercolour drawing, which was probably not a preliminary study but a

drawing made after the painting (Frederik Muller auction, Amsterdam, 19 June 1913, no. 425, whereabouts unknown). It bears the inscription *Leiden 3 oct. Hutspot, den Heer L. Droogleever Fortuijn Rotterdam*, which presumably refers to the purchaser of the painting.

PROVENANCE: L. Droogleever Fortuyn, Rotterdam; H. van Gijn, Dordrecht (before 1897); bequeathed to the museum, 1938.

EXHIBITIONS: *Schilderijen van overleden meesters (werkende leden)*, The Hague (Pulchri Studio) 1897, no. 11.

3
A.H. BAKKER KORFF
Under the Palms, 1880
Oil on panel, 17.5 x 14 cm
Signed and dated centre right: *A.H. Bakker Korff 1880*
Amsterdam, Rijksmuseum

Two elderly women, dressed in old-fashioned costume, are seated next to a plant-stand, gazing admiringly at a potted palm, clearly the product of their own tender care or that of their unseen hostess. In subject and treatment, the panel is a good example of the small genre scenes for which Bakker Korff was famous.

His style hardly changed after he started producing genre pieces of this type in the late 1850s. His later work is somewhat more loosely painted, as can be seen in the sequence of tiny touches of colour which make up the carpet.

He frequently made different versions and replicas of his work. This panel, for example, is a variant of an earlier painting (whereabouts unknown) of two ladies looking up at a fuchsia on a plant-stand. Another painted version and at least two sketches of *Under the Palms* are also known. One of them, a pencil drawing dated 30 August 1879 (Leiden, Museum De Lakenhal), was probably a preliminary study. The other, a pen and ink sketch dated 1880 (Frederik Muller auction, Amsterdam, 20 June 1913,

no. 367, whereabouts unknown) seems to have been drawn after the painting, perhaps because Bakker Korff wished to keep a record of his paintings. The drawing is inscribed *Le tableau appartient à M.L. Droogleever Fortuijn Rotterdam*, which must refer to a different version of the painting, because the Rijksmuseum canvas shown here was sold by the artist to the State of the Netherlands at an exhibition in The Hague in May 1881 for the very considerable sum of one thousand guilders. The 1880 sketch bears the annotation, *Dort wollen wir niedersinken / Und unter dem Palmenbaum. Heine*, which gives the key to the interpretation of the scene. These slightly misquoted lines from the poem 'Auf Flügeln des Gesanges' in Heinrich Heine's *Buch der Lieder*, conjure up an exotic paradise for the poet's beloved. Linking this text with the image of two aging spinsters in a genteel, bourgeois interior is typical of Bakker Korff's humour. Nor was it lost on

his contemporaries. When the canvas was exhibited in 1881, Carel Vosmaer failed to spot the reference to Heine in the title, but he did grasp the artist's intention: '...the two old ladies (...) – et in arcadia ego – they, too, are seated under the palms, their innermost souls perhaps thrilling to the ideals and idylls of Chateaubriand or Bernardin de St Pierre' (*De Nederlandsche Spectator*, 11 June 1881, p. 209).

PROVENANCE: acquired by the State of the Netherlands, 1881 (*f* 1,000).

EXHIBITIONS: *Kunstwerken van levende meesters*, The Hague, 1881, no. 12.

LITERATURE: C. Vosmaer, 'Eene penneschets van de Haagsche tentoonstelling', *De Nederlandsche Spectator*, 11 June 1881; A. Crébas, 'Onder de palmboom in het zonnetje gezet', *Kunststrip* 1 (1970/71) 2.

BAUER, MARIUS

THE HAGUE 1867 - 1932 AMSTERDAM

Marius Bauer grew up in an artistic family, the youngest of ten children. Relatives on both his father's and mother's sides had been house painters or designer-artists for many generations. Three of the children attended the Hague Academy. Marius studied there from 1879 to 1884, at the same time as Marinus van der Maarel, Etienne Bosch and Willem Van Konijnenburg. He must also have met Breitner and De Zwart, who enrolled as students towards the end of the 1870s. After leaving the Academy, Bauer spent several years studying under Salomon van Witsen, whom he considered an important influence on his development. At first he painted still lifes and motifs drawn from fashionable society. His palette was light and colourful and his figures rendered in a sketch-like manner, inspired by the Hague School and the French Impressionists.

Bauer played a prominent role in art circles. A member of the Pulchri Studio Artists' Association since 1886, he was appointed to the board from 1890 to 1892 and organised soirées and *tableaux vivants* on an Oriental theme. He had made his first journey to the Near East in 1888, when he was given the opportunity to visit Constantinople, his expenses paid by the art dealer E.J. van Wisselingh. From then on, the Orient was to be a constant source of inspiration. Bauer became an inveterate traveller. He visited France, Turkey, Egypt, Spain, Italy, India and the Dutch East Indies, discovering motifs for his work in alleyways, courtyards and bazaars, on roof terraces and in mosques, but also finding suitable settings for his history paintings and biblical scenes.

Although his repertoire of subjects remained largely the same throughout his life, his style changed considerably. The range of colours he used, particularly after 1905, was reduced to a few closely related tones, which he applied in ever finer layers, giving some of his work the appearance of watercolour. In later work, his scenes of bustling crowds and festive processions gave way to pictures with no more than one or two figures.

Bauer was especially successful as a graphic artist. Nominated by his etching teacher Philippe Zilcken, he became a member of the Dutch Etching Club in 1888. On a visit to Zilcken, Jozef Israëls is reputed to have said that Bauer 'doesn't have talent – he *is* talent'. And, he added, 'I want to have all those etchings!' His first etchings, on the whole small in scale, are rendered in whirling lines that resemble Matthijs Maris's work. After 1891, Bauer started to produce larger pieces and won praise for his skilful compositions and his characterisation of figures. The stark contrasts between light and dark clearly show the influence of Rembrandt. Around the same time, he also began to make book illustrations in lithograph, as well as etchings and reproductions of drawings. The best known example of his work is the sixteen-volume French edition of the *Tales of a Thousand and One Nights* published in 1912, which contains some 3,000 drawings by Bauer.

LITERATURE: J. Veth, 'Bauer', *De Nieuwe Gids* 7 (1892), vol. 1, pp. 465-468; Pol de Mont, 'Mari Bauer', *Vlaamsche School*, March 1894, pp. 69-74; P. Zilcken, 'Bauers etsen voor Akedysseril', *De Gids*, May 1894, pp. 317-323; P. Zilcken, 'Marius Bauer', *Elsevier's Geïllustreerd Maandschrift* 13 (1897), pp. 1-17; K. Groesbeek and P.C. Eilers, *M.A.J. Bauer. Zijn etswerk*, Amsterdam [1927]; M. Bauer, *Brieven 1888-1931*, Amsterdam 1933; J.H. van Eikeren, *Marius Bauer zoals men hem niet kent*, Bussum 1946; R.W.P. de Vries jr, *M.A.J. Bauer*, Amsterdam 1944; M.F. Hennus, *Marius Bauer*, Amsterdam 1947; exhib. cat. *De onbekende Bauer* (Rotterdam, Boymans-Van Beuningen Museum) 1957.

4

M. BAUER

The Ball, *c.* 1888
Oil on canvas, 30 x 43 cm
Signed lower right: *M. Bauer*
Private collection (formerly P.B. van Voorst van Beest Gallery)

From about 1885 to 1888, Marius Bauer depicted scenes from the fashionable world of opera, theatre, *cafés-chantants* and the horseraces. He was one of the first artists in Holland to tackle these themes, although Breitner and De Zwart also produced several ballet scenes around 1885. Isaac Israëls, however, probably only made his first circus and theatre sketches in the early 1890s.

It is interesting to compare *The Ball* with Israëls's *Dance Hall* (cat. no. 00), a completely different interpretation of the theme. *The Ball* has none of the sultry intensity of Israëls's paint-

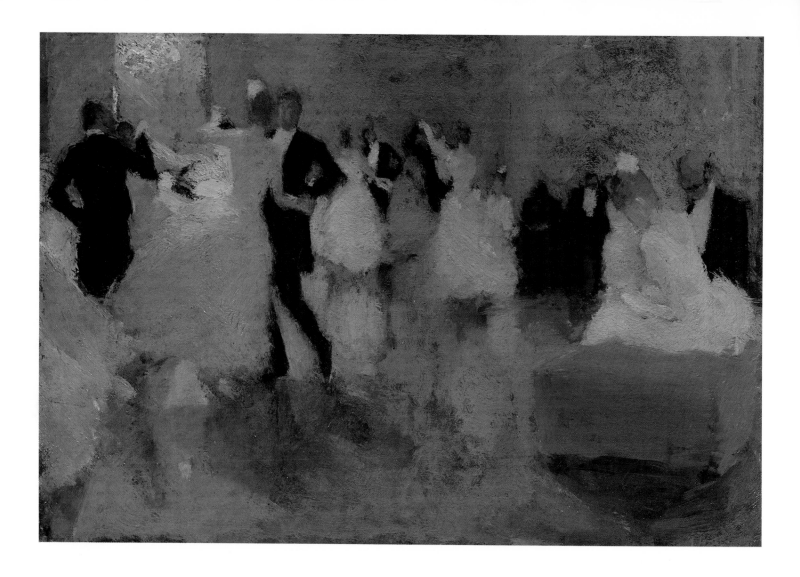

ing. Bauer keeps at a distance, thereby stressing the dignity and respectability of the occasion. His figures glide elegantly on a polished dance floor which subtly mirrors their evening attire. The lady perched on a pouffe to the right shyly averts her gaze from the balding gentleman behind her, who appears to be making a flirtatious remark or is perhaps inviting her to dance. The golden-yellow plane in the left background is probably a mirror.

It is uncertain whether Bauer had visited Paris, London or Brussels before 1888, but the unusually colourful and light palette and the Impressionist style of the brushwork have much in common with paintings by Degas and Whistler, while the elegance of the setting and the subject itself recall work by Alfred Stevens and James Tissot.

A *grisaille* version of the motif (whereabouts unknown) has a slightly different composition. The girl on the pouffe has been moved to the lower left and is sitting under a palm tree with a companion. The dancers are still whirling across the floor, which in this version is made of parquet. There is more movement in the *grisaille* and the figures are smoother. Though it has the quality of a finished work, it was probably made as a study for the version in colour.

5

M. BAUER
The Cathedral, *c.* 1891
Black and coloured chalk, 57.8 x 55 cm
Signed lower right: *M. Bauer*
Groningen, Groninger Museum voor Stad en Lande
(R.J. Veendorp Collection, owned by J.B. Scholtenfonds Foundation)

Although the drawing is a dense network of fine chalk lines, it nevertheless contains sufficient detail to be identified as the fa-

çade of Rouen Cathedral. The sheet can be dated fairly precisely on the basis of a comment made by the art critic Jan Veth in *De Amsterdammer* on 6 December 1891. Bauer, he said, had recently been to northern France, mainly to see the cathedral at Rouen 'which the talented draughtsman of the church at Strasbourg will certainly render beautifully'. Veth might have been alluding to Bauer's habit of working from memory, which he apparently did without even consulting the sketches he had produced on the spot. On one occasion, asked how he was able to remember everything he had seen with such clarity, he replied that

he actually had more difficulty in forgetting. In this case, however, he has evidently succeeded. The drawing is not an accurate representation of the cathedral, but rather like a nocturnal vision. The structure looms up in the dark; small, stooped figures clad in white make their way towards the door; riders on horseback can be seen on the left and right. It is impossible to say with any certainty what Bauer has depicted. It may be an illustration of a scene from a medieval story, since the period fascinated him, as it did many of his contemporaries. Cathedrals were also depicted by Matthijs Maris, whom Bauer so admired (engraving of *The Cathedral in Rouen*, *c.* 1882), as well as by Thorn Prikker (*c.* 1890) and Toorop. Bauer's picture, however, has no deliberate symbolic connotation. He looked for fairy tales and found them in the adventures of the knights and crusaders of the past, in the sophisticated circles of his own time and in the exotic world of the Orient.

PROVENANCE: Hidde Nijland, Dordrecht; R.J. Veendorp, Wassenaar, *c.* 1933; J.B. Scholtenfonds Foundation, 1968; on loan to the museum, 1968.

EXHIBITIONS: *Teekeningen door leden*, Amsterdam (Arti et Amicitiae), March 1892, no. 7 ('Kerk te Rouen'; *f* 275).

LITERATURE: J. Veth, *De Amsterdammer* (weekly), 6 December 1891.

BOSBOOM, JOHANNES

THE HAGUE 1817 - 1891 THE HAGUE

As a boy, Johannes Bosboom was apprenticed to B.J. van Hove, a painter of townscapes. Together with Sam Verveer, he helped his tutor paint stage sets, while at the same time, from 1831 to 1835, he attended the Hague Academy. Bosboom then made several trips to Germany and Belgium, where he exhibited his work and achieved his first success. He gradually started specialising in church interiors, though he also produced several peasant scenes around 1862 and a few beach views and seascapes in 1873. His main source of inspiration was Emanuel de Witte, a seventeenth-century painter who had specialised in depicting church interiors. Around 1865, Bosboom's relatively precise technique became freer, like that of the other painters of the Hague School. His compositions became more austere and ambitious as he moved his subject matter closer to the foreground, often painting only a choir screen or a chancel in its setting. Any figures he added to his paintings were usually in seventeenth-century costume.

Bosboom acquired a reputation both as a painter and a watercolourist and became an honorary member of the Societé Belge des Aquarellistes in Brussels in 1856. From the 1870s on, he concentrated increasingly on watercolour, a technique which the Hague School had done much to promote. He joined the Dutch Society of Watercolourists in 1876 when it was founded and subsequently exhibited there every year. In the last decade of his life, he had increasing difficulty working in oils. His 'impressionistic' paintings, which younger people so admired, were in fact the re-

sult of repeated repainting and endless toil. After his death, his heirs auctioned them as 'uninteresting' or 'only of interest to artists'.

Like Jozef Israëls, Bosboom was highly respected by older artists as well as the younger generation. He was given the honour of unveiling *The Nightwatch* at the opening of the Rijksmuseum in 1885 and two years later, on his seventieth birthday, his bust was placed in the same museum. He also received many medals and awards, both in the Netherlands and abroad. After his death, there were plans to dedicate a museum to Bosboom and his wife, the famous author of historical novels A.L.G. Bosboom-Toussaint, who had died five years previously, but the project was never realised.

LITERATURE: J. Bosboom, 'Een en ander betrekkelijk mijne loopbaan als schilder', exhib. cat. *Bosboom*, The Hague (Pulchri Studio) 1891, pp. 7-17; H.L. Berckenhoff, 'Johannes Bosboom. 18 February 1817-14 September 1891', *De Gids*, 55 (1891) 4, pp. 154-161; Ph. Zilcken, *Peintres hollandais modernes*, Amsterdam 1893, pp. 137-166; P.A.M. Boele van Hensbroek, 'In memoriam Johannes Bosboom', *Elsevier's Geïllustreerd Maandschrift* 1 (1891) 1, pp. 325-337 [reprinted in M. Rooses (ed.), *Het Schildersboek* Amsterdam 1898, vol. 1, pp. 2-21]; H.W.F. Jeltes, *Uit het leven van een kunstenaarspaar. Brieven van Johannes Bosboom*, Amsterdam 1910; G.H. Marius and W. Martin, *Johannes Bosboom*, The Hague 1917; M.F. Hennus, *Johannes Bosboom* Amsterdam (Paletserie) 1940; Jos. de Gruyter, *De Haagse School* Rotterdam 1968, vol. 1, pp. 15-29; exhib. cat. *De Haagse School. Hollandse meesters van de 19de eeuw*, Paris (Grand Palais) etc. 1983, pp. 170-179, bibliography, pp. 336-337).

6

J. BOSBOOM
St Jacob's Church in The Hague, *c.* 1884
Oil on panel, 66 x 49 cm
Initialled and dated lower left: *j.b. 1884*
Amsterdam, Stedelijk Museum (donated by the Association for the Acquisition of a Contemporary Art Collection)

Bosboom first painted the chancel of St Jacob's church in The Hague in 1856, for which – to his gratification – he was appointed to the distinguished Belgian Order of Leopold. Between this immaculately detailed canvas and the later 'impressionistic' version at the Stedelijk Museum in Amsterdam, he produced a whole series of paintings and drawings of the same subject, including those at the Dordrecht Museum, Mesdag Museum, Groningen Museum and in the Dutch Royal Collection. Some depict the north side of the chancel, as in the version reproduced here, which also shows the choir screen; others are of the south side, which is recognisable by the organ and the painting on the wall. However, Bosboom added or omitted elements according to his own taste. In this example, he has replaced the eighteenth-century wrought-iron choir screen that was actually in the church, with a different one. He is known to have had part of a seventeenth-century screen in his studio and he presumably used this

as a model. Similarly, with a view to historicising his pictures, he generally depicted his figures in seventeenth-century costume. In any event, he had a professed dislike of modern clothing. He himself, apparently, had the appearance of a seventeenth-century gentleman and was admired for 'the flair with which he donned his alma-viva cape and wide-brimmed beaver-cloth hat' (*Nieuwe Rotterdamsche Courant*, 19 July 1892).

Bosboom was inspired by Emanuel de Witte's lively and evocative church interiors, as is evident from this painting. The sunlit church has the atmosphere of a hall for social gatherings rather than the solemnity of a place of silent worship. The armorial bearings on the left refer to a secular event – the chapter meeting of the Knights of the Golden Fleece, which was held in the

church of St Jacob in 1456. Bosboom's historical settings and the associations they evoke with Holland's glorious past undoubtedly contributed to the popularity of his work.

PROVENANCE: J.H. van Eeghen; on loan to the museum, 1891 (except 1908-1911); purchased by the Association for the Acquisition of a Contemporary Art Collection, donated to the museum, 1949.

LITERATURE: *Nieuwe Rotterdamsche Courant*, 19 July 1892; Marius/Martin 1917, pp. 41, 111-112, 152; E. van Schendel, *Museum Mesdag. Nederlandse negentiende-eeuwse schilderijen, tekeningen en grafiek*, The Hague 1975, p. 42, no. 38.

BREITNER, GEORGE

ROTTERDAM 1857 - 1923 AMSTERDAM

As a child, George Breitner's ambition was to become a history painter. At the instigation of the distinguished Rotterdam artist Charles Rochussen, he enrolled at the Hague Academy in 1876 and passed his intermediary drawing examination only a year later. In 1879, while continuing his studies at the Academy, he taught evening classes at the Ars Aemula Naturae Academy in Leiden, where Floris Verster was among his pupils. An excitable and volatile personality, he was expelled in 1880. Between 1877 and 1887, Breitner received financial assistance from the Rotterdam grain merchant A.P. van Stolk. Van Stolk, however, objected to his unrestrained technique, and the relationship between them broke down. His lack of precision as a draughtsman troubled both Breitner and his critics and even after leaving the Academy he felt a need to study further. After consulting Rochussen, he accepted a place at Willem Maris's studio in 1880 and a year later was invited to join Mesdag, his wife Sientje van Houten and Théophile de Bock, who were jointly producing a panoramic landscape of Scheveningen (Panorama Mesdag, The Hague).

In the early years of his career, Breitner produced a number of still lifes, landscapes and figure studies, including a few self-portraits. His main interest, however, was in military pieces, a genre also favoured by Isaac Israëls and Verster. Breitner's originality is evident in his loose brushstrokes and unconventional compositions.

In 1882 he met Van Gogh and for a while the two men sought each other's company, often going on excursions to draw together. Breitner spent the summer of 1883 painting in the unspoilt countryside in the province of Drenthe, where Van Rappard and Van Gogh were also at work. In 1884, after renewed efforts to find a good teacher, he spent a month taking lessons at Cormon's studio in Paris, together with Toulouse Lautrec and Emile Bernard, and was followed two years later by Vincent van Gogh. In a letter from Paris, Breitner wrote that one only saw Millets and Corots 'and sometimes very ugly ones'. A few of his ballet scenes and nude studies, however, suggest that he must also have seen work by younger Parisian artists and certainly by Degas. After another stay in Drenthe, in 1885, with De Zwart, Breitner moved to Amsterdam in 1886. He made a fresh attempt to improve his technique, on this occasion under the guidance of Allebé at the Amsterdam Academy. He stayed there for only a short time, but seems to have acquired a better understanding of what 'mastering the métier' meant to him personally. The paintings he had made in Paris were a prelude to the stark reality of the images he was now producing, many in vividly contrasting colours. His repertoire expanded to comprise nudes and city scenes.

For many of his contemporaries, Breitner's work and his attitude to life epitomised the concept of 'il faut être de son temps'. He was a powerful influence on his peers and on Isaac Israëls in particular. From 1888 to 1891, the two men had studios in the same building near the Oosterpark, which later came to be known as the Witsen House. Witsen took up residence there in

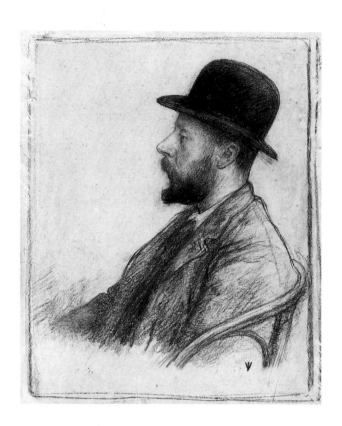

1891 and the friendship which already existed between Breitner and Witsen was nurtured by their passion for photography.

In the early 1890s he painted a superb, almost classical series of girls in Japanese kimonos, followed in 1895 by a series of scenes in neighbourhoods which had been earmarked for demolition. Thereafter, his creative energy seems to have been spent and his work lost its characteristic spontaneity. The exhibition held in his honour at Arti in 1901 represented a turning point in his career. Most of his subsequent paintings were variants of work he had done previously, while ill-health reduced his output to a minimum after 1917. Until his death in 1923, he lived from the proceeds of a fund set up by his friends, who saw him as a man of immeasurable courage and dedication.

LITERATURE: P. Zilcken, 'G.H. Breitner', *Elsevier's Geillustreerd Maandschrift*, 11 (1896), pp. 297-308; A. Pit *et al.*, *George Hendrik Breitner, indrukken en biografische aanteekeningen*, Amsterdam, 1904-1908; J. Veth, 'Breitners jeugd', *Portretstudies en Silhouetten*, Amsterdam [1908], pp. 176-205; A. van Schendel, *G.H. Breitner*, Amsterdam (Paletserie) [1939]; A.M. Hammacher, *Amsterdamsche impressionisten en hun kring*, Amsterdam 1941, pp. 82-98; P.H. Hefting, *G.H. Breitner in zijn Haagse tijd*, Utrecht 1970; P.H. Hefting, *G.H. Breitner. Brieven aan A.P. van Stolk*, The Hague 1970; A. Venema, *G.H. Breitner 1857-1923*, Bussum 1981; exhib. cat. *G.H. Breitner 1857-1923. Aquarellen en Tekeningen* (introduction by P.H. Hefting), Laren (Singer Museum) 1983; P.H. Hefting *De foto's van Breitner*, The Hague 1989.

7
G. BREITNER
Still Life with Arum Lily, *c.* 1884
Oil on canvas, 99.25 x 58.5 cm
Signed upper left: *G.H. Breitner*
Private collection

In the summer of 1883, Breitner wrote to his patron, A.P. van Stolk: 'I have done some flower studies which have turned out well. I shall continue to work on them for a while and I believe I shall produce something good in this genre. My still lifes, at least, have always been the best things I have done.' Breitner had made his début at the Exhibition of Living Masters in 1879 with a still life of vegetables, which quickly found a buyer. Flower still lifes were popular with collectors, which is no doubt why he chose to devote himself to the genre at this time. An added advantage was that they could be painted in the studio, without the artist having to spend money on models or travel. However, the idiosyncratic, asymmetrical composition of his *Still Life with Arum Lily* represents a sharp break with tradition (cf. *Poppies* by M. Roosenboom, cat. no. 76). The assortment of flowers and pot plants he has chosen and the informal way in which they are arranged was highly unusual by Dutch standards. When the painting was exhibited in Utrecht in 1884, the critic Fred Verheyst commented sarcastically in *De Amsterdammer* that 'there is also a certain Mr Breitner from the capital who, according to the catalogue, had it in mind to paint flowers; I can only say that it takes courage to submit something as enigmatic as this...' The flowers themselves, however, are perfectly ordinary. In the foreground is an elegant arum lily (with some overpainting visible to the left of the tallest white flower) and beside it, a roughly sketched cineraria in bloom. A few red and white peonies and an arum lily are arranged in a glass bowl on the table, with a bunch of pink and orange gladioli behind them. The background is painted with bold strokes in a rust-brown tone. The green of the arum lily leaf beautifully complements the brilliant orange-red tints in other parts of the painting. It is tempting to assume that Breitner was familiar with French examples, in view of the striking similarities in the choice and arrangement of the plants between this painting and the early works of Bazille, Monet and above all Renoir, in particular the latter's *Pot Plants* from 1864 (Winterthur, Oskar Reinhardt Foundation).

PROVENANCE: E.J. van Wisselingh & Co., Amsterdam, 1910 (bought from the artist); Huisman, 1917; Lenaertz-Wagner, The Hague; auction Amsterdam (Fred. Muller & Cie.), 19 December 1922, no. 59; auction Amsterdam (Mak van Waay), 23 November 1923, no. 8; C.M. van Gogh Gallery, Amsterdam; auction Rotterdam (Van Marle & De Sille), 21 April 1925, no. 230; J. Nienhuys; A.M. Nienhuys-Versteegh, Aerdenhout; auction Amsterdam (Mak van Waay), 25 April 1966, no. 14; A.B. Osterholt, Amsterdam, 1966.

EXHIBITIONS: Utrecht (Kunstliefde), April 1884.

LITERATURE: F.J. Verheyst, *De Amsterdammer* (weekly), 20 April 1884; S. Segal, *Een Bloemrijk Verleden*, Amsterdam 1982, p. 118.

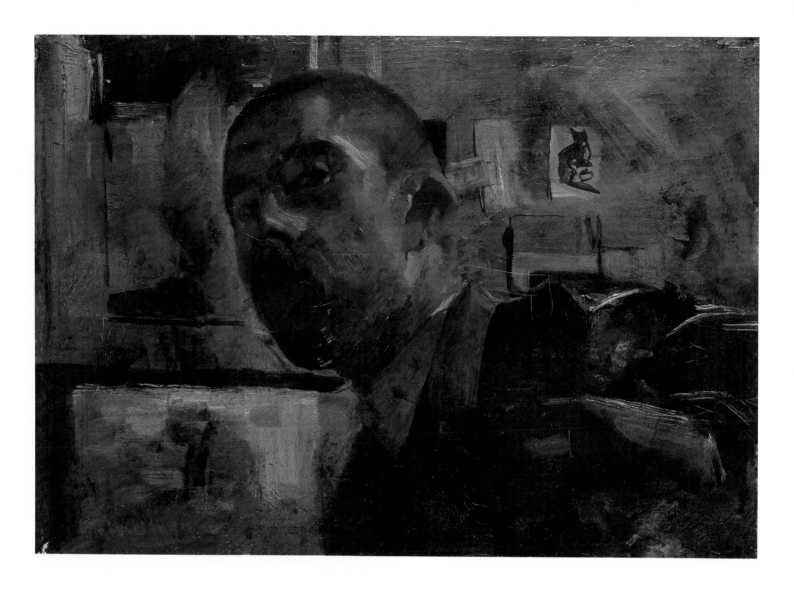

8

G. BREITNER
Self-Portrait, 1885-1886
Oil on canvas, 37 x 52.5. cm
Signed lower left: *G.H. Breitner*
The Hague, Haags Gemeentemuseum

Towards the end of 1881, Breitner wrote to his patron Van Stolk expressing the wish to paint a portrait of his daughter. Van Stolk rejected the idea, but promised to try and interest the art public of Rotterdam in his work. At the same time he urged Breitner to devote more attention to the finish of his paintings. In order to persuade Van Stolk of his competence, Breitner began a self-portrait. In a letter to Miss G. van Stolk, some twenty years later (1904), he confides that he took the portrait to Van Stolk's office, hoping – in vain, as it transpired – to secure a commission by this more direct means. The painting was ultimately acquired by Jan Veth. Breitner painted four more self-portraits in this period, all of them showing the artist with a self-assured, supercilious air, which was in fact the impression he made on others. A.L. Terwen, a drawing master from Dordrecht, described the artist after meeting him in 1882: 'Breitner made a strange impression on me; in appearance something of an Englishman, a bit of a dandy and

for the rest intractably complacent...' He was not the only artist to reveal an arrogant trait. Matthijs Maris presented himself in a similar light in a self-portrait from 1860, which Breitner had probably seen in Jacob Maris's collection (now at the Rijksmuseum Kröller-Müller).

Breitner probably painted the portrait early in June 1882, shortly after being discharged from the hospital where he had spent several months receiving treatment for venereal disease; his head had been shaved there. 'I shall look like a mouse', he joked in a letter to Van Stolk during his stay in hospital – and the portrait indeed proves him right.

This early canvas is in every respect an impressionistic reflection of a specific moment. Breitner portrays himself painting, or perhaps putting on or taking off his overall. In any event, he is engaged in some activity. He looms into the picture from the right, thus heightening the feeling of movement. The rigorously cropped image and broad, sketchy brushwork give the effect of a blurred photograph. The oblong format, too, is unusual and Breitner never used it again for a self-portrait. The studio wall in the background may be an idea borrowed from Manet or Degas, both of whom had painted sitters in front of a wall decorated with Japanese prints or drawings. The only distinguishable work in the background of Breitner's painting, a pencil drawing of a

black cat, could be interpreted as a flirtation with Japonisme. Studies of small animals by the Japanese artists Hokusai and Hiroshige, for example, were well known in the Netherlands. In 1884 Anton Mauve painted a self-portrait in profile, along the same lines as Breitner's, with the same haughty air and a similar background (The Hague, Haags Gemeentemuseum). His version, however, is somewhat more formal.

PROVENANCE: S. de Swart, 1901, Amsterdam; auction Amsterdam (Fred. Muller & Cie.), 18 May 1909, no. 26; E.J. van Wisselingh & Co., Amsterdam, 1909; G.H. Breitner, 1909; E.J. van Wisselingh & Co., Amsterdam, 1916; donated to the museum by the Modern Art Society (Vereeniging van Moderne Kunst), 1916.

LITERATURE: Van Schendel 1939, p. 11; A.M. Hammacher 1941, pp. 44, 48; Hefting, Utrecht 1970, pp. 41, 42, 54, 55; Hefting, The Hague 1970, pp. 24, 65, 31.

9

G. BREITNER
Le coup de canon, 1887
Oil on canvas, 62 x 101 cm
Signed lower right: *G.H. Breitner*
Groningen, Groninger Museum voor Stad en Lande
(R.J. Veendorp Collection, owned by J.B. Scholtenfonds Foundation)

Up until the 1880s, military subjects were the province of history painters and were above all expressions of nationalism and patriotic heroism. Breitner and painters such as Isaac Israëls were not concerned with such sentiments, however, but chose the motif primarily for the pictorial potential of the resplendent, gold-braided uniforms and, in Breitner's case, because of the tremendous impression made on him by the sight of hundreds of galloping horses taking part in a cavalry exercise. He enjoyed the military manoeuvres in Drenthe and Brabant and frequently attended these events during his time in The Hague. He filled many sketchbooks on such occasions and produced numerous watercolours and oil paintings on the same theme. He was successful in this genre – the Rijksmuseum bought *Riders in Yellow* in 1886 – and did not entirely abandon the motif even after moving to Amsterdam, when his interest shifted from cavalry steeds to the dray-horses that drew the city trams. Until 1895 he continued to exhibit scenes of *coups de canon* and other military subjects.

Le coup de canon shows artillerymen with their guns on the ridge of a hillside, silhouetted against the sky. The horizon is slightly higher than the middle of the canvas and divides the picture quite sharply in two; both halves are painted in a rather flat, uniform manner. The strong composition and fluid handling of the paint are in sharp contrast to the energy and exuberance of his other paintings. His palette, on the other hand, with its greys, browns, greens, ochres and black, remains unchanged.

PROVENANCE: E.J. van Wisselingh Gallery, 1896; H. van Beek, Rotterdam; E.IJ. van Beek-Van Hoorn Janssen; E.J. van Wisselingh & Co., Amsterdam; R.J. Veendorp, Wassenaar; J.B. Scholtenfonds Foundation; on loan to the museum, 1985.

EXHIBITIONS: *Kunstwerken door leden der maatschappij*, Amsterdam (Arti et Amicitiae), 1890, no. 20 ('Het Kanonschot')?; World Exhibition, Antwerp, 1894, ('Le Coup de Canon'); *Schilderijen, aquarellen, teekeningen etc.*, The Hague (Haagsche Kunstkring), 1895, no. 13?; *Schilderijen van werkende leden*, The Hague (Pulchri Studio), 1896, no. 22 ('Kanonschot')?

LITERATURE: Zilcken 1896, p. 304; Van Schendel 1939, p. 24.

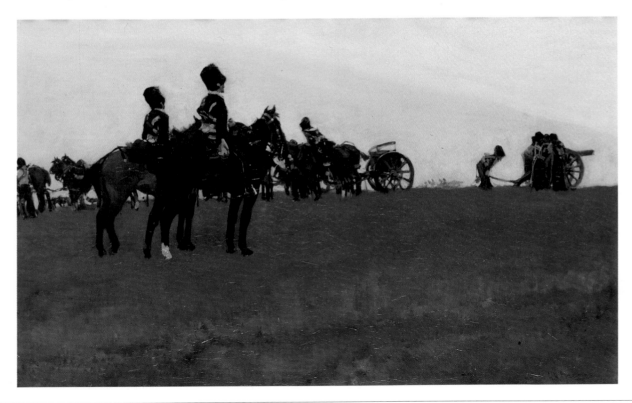

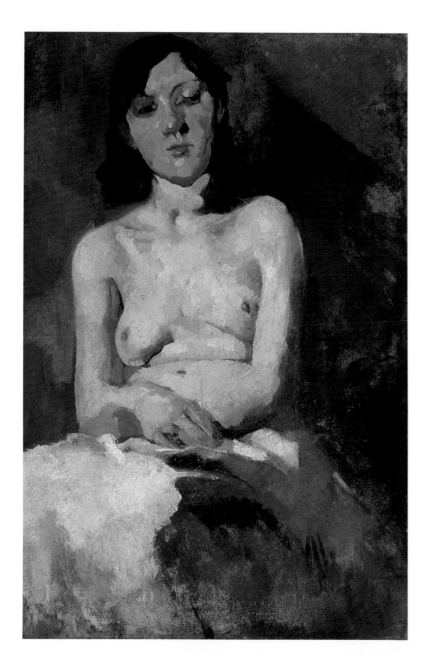

10

G. Breitner
Seated Nude with a Blue Scarf, *c.* 1889
Oil on canvas, 87 x 57 cm
Unsigned
Private collection

Breitner often turned to his photographs when planning and composing his paintings. The unidentified woman portrayed as a *Seated Nude with a Blue Scarf* appears in one of these photographs, albeit in a different pose. Though the photograph is not dated, Breitner only started using a camera in 1889 and it is therefore possible that the painting, which has always been thought to date from around 1887, was in fact made a couple of years later.

Breitner's frontal view of the model shows an angular, less attractive woman than the one in the photograph. Though not particularly beautiful, she did not have the shiny nose, lank hair and sagging posture that Breitner has given her. The work was probably a reaction against the idealised academic interpretation of the nude. He produced a second, almost classical painting of the same woman, with shorter hair, as in the photograph, and with a red cloth draped around her hips (*Nude with a Red Scarf*, Groningen, Groninger Museum voor Stad en Lande). Both paintings are rendered with the same assured brushwork and were probably made in fairly quick succession.

When Breitner first submitted four nudes to the Arti exhibition in 1891, the critics were scathing. The nudes were not considered offensive, as 'they reveal none of the beauty of a shapely woman', but were seen as too unattractive to be sensual. Veth and Roland Holst, however, rose to his defence, describing his work in lyrical terms (*De Amsterdammer* 8/9 February 1891 and 15 February 1891).

Breitner painted a large number of nudes between 1887 and 1891, some of them inspired by artists working abroad. His girls bathing or preparing to bathe reveal his admiration for Degas, while Manet's *Olympia* won his enthusiastic praise. Breitner was the only prominent exponent of the genre in the Netherlands at the time and it is therefore astonishing that the 1901 retrospective of his work did not include a single nude. Commenting on the exhibition, A. Pit observed that Breitner's nudes played 'a crucial role in the development of his talent and are essential to a proper understanding of his temperament as a painter and his objectives as a composer'.

PROVENANCE: Kossmann, 1945; auction Amsterdam (Mak van Waay), 3 April 1951, no. 128; L. Verkoren, 1951; J.G. Verkoren-Gerber, Groet; auction Amsterdam (P. Brandt), 6 June 1961, no. 159; auction Amsterdam (Sotheby-Mak van Waay), 30 October 1979; Van Voorst van Beest Gallery, The Hague, 1982.

EXHIBITIONS: A. Pit, 'G.H. Breitner', *XXste Eeuw* 8 (1902) 1, pp. 244-251; Van Schendel 1939, pp. 52-53.

II

G. BREITNER
Kalverstraat by Night, *c.* 1890
Oil on canvas, 117 x 79 cm
Signed lower left: *G.H. Breitner*
Private collection

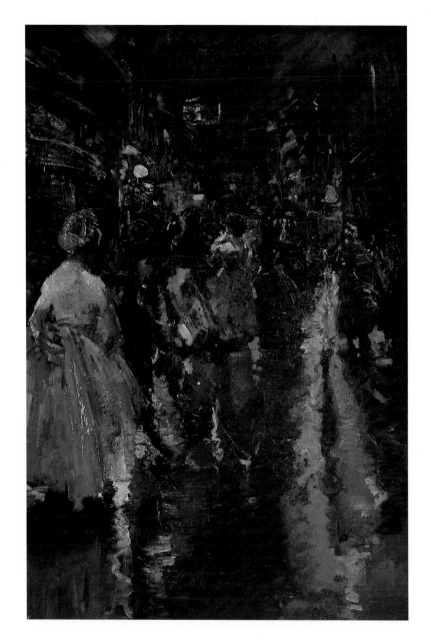

Breitner's move from The Hague to Amsterdam in 1886 at first occasioned little change in his choice of subject matter. He continued to paint figure studies and military manoeuvres, but now added nudes to his repertoire. Though most of his famous impressionistic portrayals of Amsterdam were produced after 1890, earlier in his career, in 1882, he had expressed a desire to paint ordinary people in the streets and at home. He and Van Gogh roamed through The Hague in search of inspiration and produced numerous drawings and watercolours of their impressions. Depicting the sights and sensations of modern life became *de rigueur* for young artists some years later and Isaac Israëls and George Breitner in particular produced superb views of Amsterdam.

Breitner painted numerous pictures of shops and people in Amsterdam's once prestigious Kalverstraat, viewed either from street level or from the raised vantage point of a balcony. Some show the street decorated with festive bunting. *Kalverstraat by Night* was based on a preliminary watercolour study made on paper which had first been washed thoroughly to enhance the effect of sunlight breaking through cloud after a heavy shower (*Kalverstraat, Amsterdam*, private collection; see Hefting 1984, p. 27). The same figures and buildings are shown in the painting, but here, the highlights on the façades and the Munttoren against an otherwise dark background, convey the atmosphere of evening. The vibrating yellow line on the right – a reflection of the light given by the gas lamps – is counterbalanced by the pale dress of the woman on the left, who is shown from the back. The dark figure of a boy can be seen behind her, while further along the street are the barely discernible silhouettes of three maidservants and possibly also a coach.

The picture itself and the exuberance with which it has been executed reflect the almost legendary fieriness of Breitner's temperament. He has used his palette knife to apply thick strokes of paint in some areas and to scratch it away in others to expose the luminous colours underneath. The play of light and handling of the paint heighten the atmosphere of a modern, dynamic city scene – worlds apart from the tranquil views of Amsterdam that Witsen and Karsen were producing in the same period (cat. no. 104).

PROVENANCE: A.P. Nielsen, Amsterdam.

12

G. BREITNER
Dam Square in the Evening, *c.* 1890
Oil on canvas, 93 x 178 cm
Signed lower right: *G.H. Breitner*
Antwerp, Koninklijk Museum voor Schone Kunsten

Breitner first showed a painting entitled *City Square in the Evening* at the Exhibition of Living Masters in The Hague in 1890 and later that year at Arti. Press reviews from that time describe a picture of a rain-swept street, metal rails and horse-drawn trams, possibly the painting now at the Dordrecht Museum. It was extremely well received, which probably encouraged Breitner to explore the theme further. He exhibited a new *City Square* or *Dam Square in the Evening* every year until 1895, the pictures ranging in price from five hundred to five thousand guilders (see fig. 23). The description of *Dam Square in the Evening* which appeared in *De Nederlandsche Spectator* on 16 September 1895 comes closest to the painting at the Antwerp Museum. According to the reviewer, the piece was entirely unlike any he knew. 'It is an empty moment, empty of trams', he wrote, 'while women in light, colourful clothing walk across the deserted square. The

shop windows glowing bright orange at the end of Damstraat evoke a pleasant and unusual atmosphere.' Most of Breitner's views of squares show a horse's head close up in the foreground. Some are flanked by the figure of a servant, or a couple of servants passing by and a considerable number show the vague outlines of a crowd in the background. Although the Antwerp painting does not depict such a busy scene, it is empty only in a comparison with others, for in addition to the women crossing the street, there are children playing, a couple of scruffy dogs and two horses with harnesses highlighted in colours typical of Breitner.

Many of the French Impressionists used their picture space as a frame through which reality passes by. Breitner has employed the same device and this canvas, like other of his works, clearly reveals the influence of Degas.

PROVENANCE: E.J. van Wisselingh & Co., Amsterdam; purchased by the museum, 1931.

EXHIBITIONS: *Studies, Enz., vervaardigd door leden der Mij*, Amsterdam (Arti et Amicitiae) 1895, no. 27 ('Dam bij avond')?

LITERATURE: W. Vanbeselaere, 'G.H. Breitner. Plein bij avond', *Openbaar Kunstbezit* 1970, no. 5.

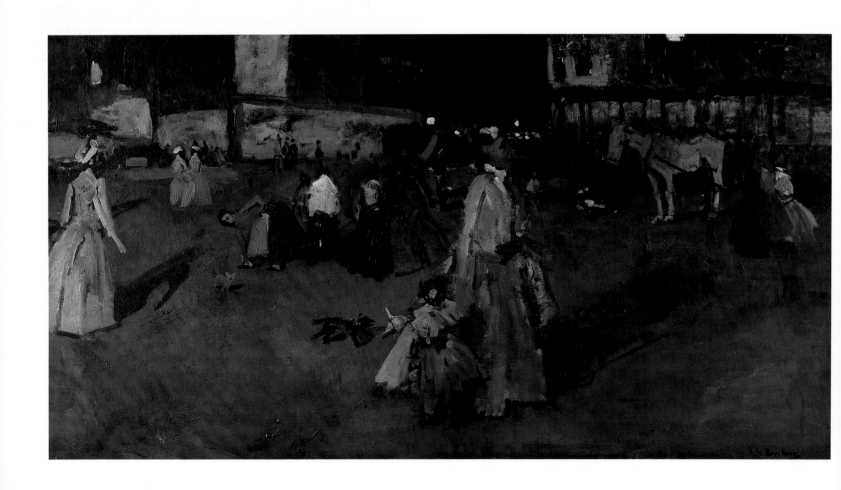

13

G. BREITNER
Girl in a White Kimono, c. 1893
Oil on canvas, 58 x 56 cm
Signed lower left: *G.H. Breitner*
Enschede, Rijksmuseum Twenthe

Breitner painted a series of girls in kimonos in 1893-1894 after re-covering from a serious illness. A letter he wrote from the sana-torium to a Ms Van der Weele indicates that his japonaiseries were conceived in this difficult period. His penchant for the ex-otic may thus have been a form of escapism. The kimono girls are depicted in a more modest manner than his nudes or street girls. Moreover, he introduced a new element by uniting the figure, the Oriental carpet and the Japanese screen into a decorative en-tity, inspired by the Japanese prints which were so popular with European artists in the last decades of the nineteenth century. The Hague Art Circle mounted a special exhibition of Japanese prints in 1892. Though Breitner was not the first Dutch artist to portray his model in a kimono – precedents are known by Marinus van der Maarel and Willem de Zwart (cat. no. 109) – he took the theme a step further, for besides using Oriental at-tributes, he assimilated the decorative composition of Japanese examples. The work that artists such as Thorn Prikker, Dijssel-hof and Theo van Hoytema were producing in the 1890s betrays the same influence.

In addition to Japanese prints, Breitner also used photo-graphs as a basis for his portrayals of girls in kimonos, a fact he neither publicised, nor denied when asked. Another painting in the series, which is very similar to the *Girl in a White Kimono*, is a faithful rendering of a photograph of Geesje Kwak. Breitner traced the image onto transparent paper and then drew qua-drature lines in order to transfer the picture to his canvas. The most significant change he made was to bring his subject closer, virtually eliminating the effect of depth, as he did in the *Girl in a White Kimono*.

The series of girls in kimonos marked the beginning of a phase in which Breitner started to apply his paint with greater care and subtlety. But an anonymous critic in the *Nieuwe Rot-terdamsche Courant* (23 October 1894) could not resist a dero-gatory comment on the model he had chosen. According to the critic, 'the girl's common appearance and misshapen arms and hands clash with the lavish Japanese setting.' Nevertheless, the paintings were better suited to the public taste than the more roughly executed work he had produced previously. In 1895, even the conservative and highly critical A.C. Loffelt published a favourable review of the series.

PROVENANCE: E.J. van Wisselingh & Co., Amsterdam, 1895 (bought from the artist); C.M. van Gogh Gallery, Amsterdam, 1899; W.P. van Ingenegeren; auc-tion Amsterdam (Fred. Muller & Cie.), 19 May 1920, no. 60; E.E. Huisman Gal-lery, The Hague, 1920; J.A.A.M. van Es Gallery, Utrecht, 1920; Lenaertz Wagner, The Hague, 1920; auction Amsterdam (Mak van Waay), 19 December 1922, no. 57, and 23 January 1923, no. 6; E.J. van Wisselingh & Co., Amsterdam, 1923; H.E. ten Cate, Almelo/De Lutte; purchased by the museum, 1966.

LITERATURE: Schendel 1939, p. 33; O. Ter Kuile, *Catalogus van Schilderijen, Enschede* (Rijksmuseum Twenthe Enschede) 1974-1976, p. 32.

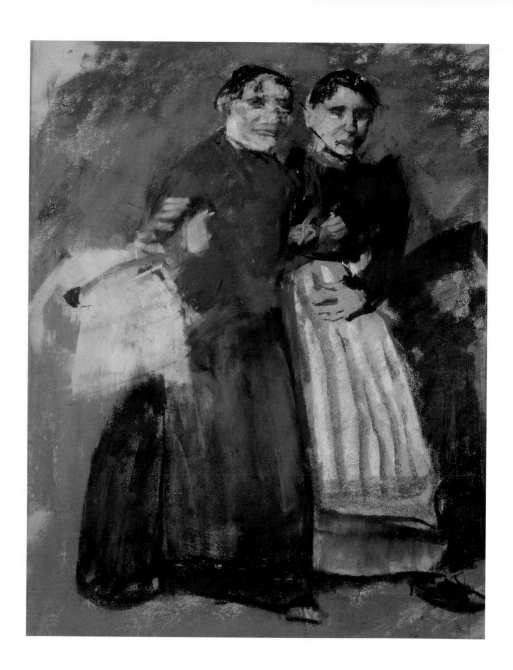

14

G. BREITNER
Two Maids, *c.* 1890
Pastel, 50 x 40 cm
Unsigned
Amsterdam, Rijksmuseum Vincent van Gogh

It is surely impossible to surpass Hammacher's evocative de-
scription of Breitner's street scenes in Amsterdam. 'That unity of
houses and women in the dark city, that vitality and firmness of
step; tense lines, taut shapes – a dark unity of togetherness. Arm
in arm, drawing warmth from each other's bodies in the winter,
sweeping recklessly past in the wide outdoors in summer winds
or pouring rain, like sailors on a ship, sure-footed, rather pon-
derous of gait. This is how Breitner saw the women of Amster-
dam and how, as a painter, he created them, in harmony with the
city, whose darkness is a colour different from any other city in
Europe – bronze like the water in the canals, damp-black like cel-
lar floors. This was his great creation of the Street. The demonic
quality of the city and the reckless, primordial strength of wo-
men' (Hammacher 1941, p. 86).

The pastel of the *Two Maids* is a street scene rather than a figure
study. The two women flit past like sombre shadows, but they
represent the beating heart of the modern city. Breitner chose
working girls to illustrate this, sometimes portraying factory
workers and sometimes, as in this case, maidservants, whom he
captured on canvas or paper in a few rough strokes, in portrait or
full-length. Isaac Israëls (cat. no. 45) shared his predilection for
portraying working women. The two artists undoubtedly in-
fluenced one another when they shared a house in the Ooster-
park in the late 1880s. However, Israëls would allegedly lure
Breitner's models as they passed his door on their way to Breit-
ner's studio, which suggests that the relationship may not always
have been cordial.

PROVENANCE: François Buffa et Fils, Amsterdam; J.P.M. Glerum, Amsterdam,
till 1941; auction Christie's Amsterdam, 10 April 1990, no. 228; donated to the
museum by Christie's Amsterdam BV, 1990.

BREMMER, HENDRIK

LEIDEN 1871 - 1956 THE HAGUE

Hendrik Bremmer was born in Leiden in 1871, the son of a hotelier. From the age of eight to fifteen, he attended boarding school in Roermond, where he subsequently spent a year receiving religious instruction. His fascination with mysticism in boyhood was later to evolve into a passionate interest in philosophy and he became an ardent admirer of Spinoza. He returned to Leiden to attend high school, where he was taught by the little-known painter D.L. Kooreman. In 1889 he left school and enrolled at the Hague Academy. The lessons were far from stimulating and, at the end of the first year, Bremmer decided to establish himself independently. His studio in the attic of his parents' Rijnland Hotel, became the haunt of Leiden artists such as the painters Charles Heykoop, Jan Vijlbrief and Herman van Daalhoff, the writer and journalist Henri Borel and the musicians K. Gripekoven and B.J.F. Varenhorst.

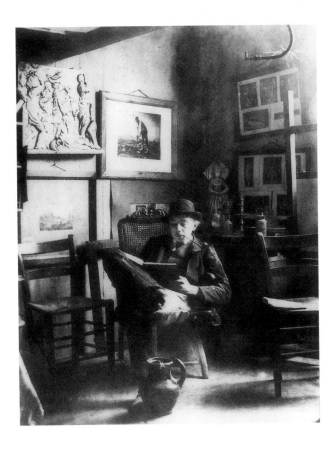

In 1895 Bremmer married Aleida Beekhuis and subsequently earned a living by writing and giving highly successful lectures and courses on art. These activities occupied most of his time and painting became little more than a hobby. From 1903 to 1910 he published *Moderne Kunstwerken*, a journal of contemporary art, and from 1913 to 1938, a similar publication called *Beeldende Kunst*. From 1909 onwards, he also played a significant role as advisor to Ms Kröller-Müller, who was then assembling her famous art collection. The large number of Neo-Impressionist masterworks at the Kröller-Müller Museum reflects the influence of both Bremmer and Henri van de Velde.

Bremmer left a fairly small *oeuvre* of paintings and drawings, most of which date from 1889 to 1895. His earliest studies of heads and still lifes are in a realistic and rather academic style. Influenced by the painters Toorop, Theo van Rijsselberghe and Henri van de Velde, Bremmer tackled Pointillism, while Van Daalhoff, Aarts and Vijlbrief followed in his footsteps. Ms Bremmer-Beekhuis, commenting many years later on Bremmer's years in Leiden, wrote that Rood and Chevreuil's theories on colour had encouraged him to apply the technique. The theoretical principles of Pointillism probably appealed to him as a means of penetrating the essence of matter. He attached less importance to the representation of an object than to its symbolic value. His basic philosophy also influenced his choice of subjects and he continued to paint still lifes and landscapes throughout his life on the grounds that even the most banal could give expression to the absolute. Though a few of his Pointillist canvases came close to achieving O.N. Rood's ideal of 'superior luminosity' (*Modern Chromatics*, New York 1879), much of his work was rather stiff and contrived. Bremmer rarely showed his paintings. He exhibited at the *Derde Leidsche Kunstbeschouwing* (Third Leiden Art Viewing) in 1894 and at the International Exhibition of the Hague Art Circle, but his work was not shown in public again until it appeared in an exhibition on Divisionism at the Boymans Museum in Rotterdam mounted in 1936-1937.

LITERATURE: *Herdenking H.P. Bremmer*, Rotterdam 1956; J.M. Joosten, 'De Leidse tijd van H.P. Bremmer 1871-1895', *Leids Jaarboekje*, Leiden 1971, pp. 79-114; exhib. cat. *Licht door Kleur*, The Hague (Haags Gemeentemuseum), 1977, pp. 23, 27; H.J. Vink, 'Bremmer, Spinoza en de abstracte Kunst', *Jong Holland* 3 (1987) 2, pp. 40-47.

15

H. BREMMER

Landscape with a Windmill, 1894

Oil on canvas, 55 x 65 cm

Initialled and dated lower right: *HPB/MRT 1894*

Leiden, Stedelijk Museum de Lakenhal

The *Landscape with a Windmill* is executed in the Pointillist technique, with fine stippling over the entire surface of the canvas. The bright, contrasting colours and angular shapes give the work a naïve charm, though it is unlikely that Bremmer, who sought clarity and purity, intended to produce this effect. The natural shapes in the landscape are arranged in an almost geometrical manner. Bremmer probably knew not only the colour theories formulated by Rood and Chevreuil, but also the *Essai sûr les Signes inconditionnels de l'Art* (1827) by the Leiden scholar Humbert de Superville, if only from other books such as J. van Vloten's widely-read *Aesthetica* (1865). De Superville's book examines the hypothesis that colour and line can serve to express emotions. Ascending lines are cheerful, for example, and descending lines sad. If this theory is applied to the *Landscape*

with a Windmill, the bright colour combinations, the rising lines of the path and wall, and the elegant verticals of the trees and telegraph poles could be interpreted as cheerful, evoking a spring-like mood. Bremmer's technical and theoretical principles were based on his philosophy of life and art. He subscribed to Spinoza's concept of God as the inherent basis of all reality and, like Plotinus, believed that the significance of a work lies in its ability to reveal the universal (absolute truth or even the divine) through the accidental (the ephemeral, the object). The most direct means of approaching and expressing the essential was through abstraction and geometrical arrangement. The Dutch polder landscape, traversed by an intricate network of canals, is in itself abstract and geometrical, and it was these features that Bremmer took as the starting point for his painting.

PROVENANCE: W.C.F. Collection, 1971; Fijnaut Gallery, Amsterdam 1979; purchased by the museum, 1979.

LITERATURE: *Catalogus van de schilderijen en tekeningen*, Leiden (Stedelijk Museum de Lakenhal) 1983, p. 85.

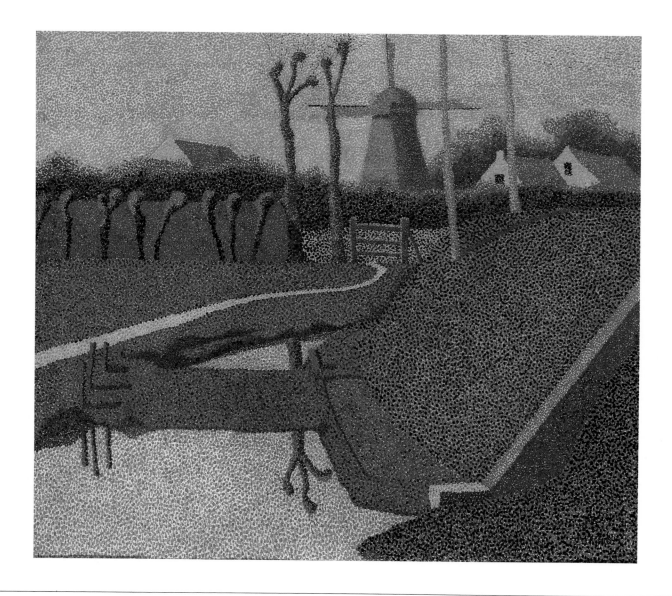

16

H. Bremmer
Still Life with Bottle and Ginger Pot, 1895
Oil on canvas, 40.5 x 51.5 cm
Initialled upper right: *HPB*; dated lower right: *30.4.1895*
Private collection

The quiet harmony of Bremmer's still lifes reflect the artist's contemplative nature, while his sensitive treatment of the simple motifs he chose to depict adds an extra dimension to these otherwise prosaic objects. The colours and textures of the glazed earthenware bowl, the ginger pot and the glass bottle are superb, and the reflections in the glass bottle have been rendered with tremendous skill. Only on closer examination do we notice the stylised folds of a table cloth at the bottom of the picture. The minute, even stippling in vibrant shades of yellow, green and blue generates a resonant force which has almost the impact of an icon.

Bremmer kept the painting all his life. Together with various other pictures it was displayed on his print cabinet, which can be seen in the background of the portraits that his son Rudolf Bremmer made of him (*H.P. Bremmer in his Studio*; drawing 1953, canvas 1955, both in private collections).

PROVENANCE: R. Bremmer.

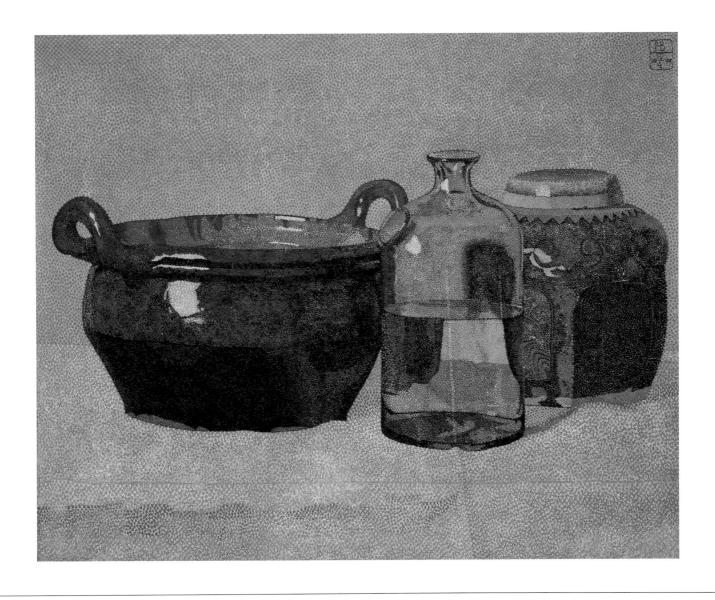

DERKINDEREN, ANTOON

's-HERTOGENBOSCH 1859 - 1935 AMSTERDAM

Antoon Derkinderen, the son of a goldsmith, was the ninth and youngest child in a Catholic family. He trained as a schoolmaster and went on to teach for a short time. From 1878 to 1880 he studied at the Royal Academy of Applied and Fine Arts in 's Hertogenbosch and subsequently from 1880 to 1885 – with lengthy interruptions – at the Amsterdam Academy under August Allebé. He spent the 1882-1883 academic year with Jan Toorop in Brussels, where the two men attended classes under Jean Portaels at the Académie Royale. Together with some of his fellow students from the Amsterdam Academy, Derkinderen helped to establish the St Luke's Artists' Association in 1881 and the Dutch Etching Club in 1885. From early on, however, he produced work which was markedly different from that of his contemporaries. Whereas they aspired to work independently, Derkinderen was more interested in monumental and applied art. He found a kindred spirit in Alphons Diepenbrock, a boyhood friend who was deeply impressed by Wagner's concept of the *Gesamtkunstwerk*. Derkinderen's ideal was to produce an architectonic *Gesamtkunstwerk*, incorporating both art and sculpture.

His first opportunity to pursue this ambition came in 1884, when he was commissioned to produce a large painting of the procession of the Miracle of the Host for the church in the *Begijnhof*, or beguinage, in Amsterdam. He made several dozen preliminary figure and portrait studies for the project, but after a journey to Italy and France in 1887 and his confrontation with Giotto's work and the monumental art of his contemporary, Puvis de Chavannes, he completed the painting in an unnaturalistic, stylised and flat manner. Although the result was much admired by Jan Veth and other of his friends, the commission was rejected and the contract annulled.

From 1889 to 1891 Derkinderen worked on a new project to decorate the town hall in 's Hertogenbosch (*eerste Bossche wand*). In 1893, the year in which he married the painter Jo Besier, he designed his first stained glass window for the staircase at Utrecht University. In the same year he began a new series of paintings for 's Hertogenbosch town hall (*tweede Bossche wand*), which he completed in 1896. The figures and architectonic elements surrounding these paintings, like the figures in the book decorations he was producing in the same period, have a hieratic quality inspired largely by sacred, medieval examples. Derkinderen considered these two-dimensional representations appropriate for the decoration of walls or books. His development from the late 1880s brought him recognition as the founder of a new monumental art, also known as *gemeenschapskunst*, or community art.

After 1895 he received various important commissions, which included murals for *De Algemeene*, a life assurance company in Amsterdam (1898), as well as paintings and stained glass windows for Berlage's Stock Exchange in Amsterdam (1898-1905). These projects were never completed, however, because of conflicts with the architect. From 1903 to 1906 he had his own

stained-glass studio, *De Zonnebloem*, in Laren. After succeeding Allebé as director of the Amsterdam Academy in 1907, he designed several large monumental ensembles, none of which, however, left the drawing board. Derkinderen's influence can be seen in the monumental art in public buildings and churches (particularly Catholic churches) dating up to the late 1920s.

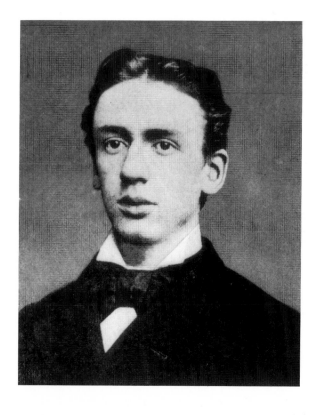

LITERATURE: A.J. Derkinderen, *De jeugdjaren van Antoon der Kinderen door hemzelf beschreven anno 1892*, Bussum 1927; A.M. Hammacher, *De levenstijd van Antoon der Kinderen*, Amsterdam 1932; Bettina Polak, *Het Fin-de-siècle in de Nederlandse schilderkunst. De symbolistische beweging 1890-1900*, The Hague 1955, pp. 187-229, 401-407; exhib. cat. *Antoon Derkinderen 1859-1925*, 's Hertogenbosch (Noordbrabants Museum) etc. 1980-81.

17

A. Derkinderen
The Dead Trumpeter, 1883
Oil on canvas, pasted on panel, 24.5 x 64 cm
Unsigned
The Hague, Haags Gemeentemuseum

The elongated format of this painting and the rendering of the emaciated, outstretched body are reminiscent of Hans Holbein's famous altarpiece of the *Dead Christ* at the Kunstmuseum in Basel. Although Holbein was much admired in the late nineteenth century, it is uncertain whether Derkinderen was familiar with this picture. An inscription, written in a hand other than the artist's – presumably that of his wife, Jo Derkinderen-Besier – appears on the back of the panel: 'A.J. Derkinderen. Study of a dead trumpeter painted at Brussels hospital after completing his studies at the academy in Brussels.' If the information is correct the canvas must have been painted in the summer of 1883. It is not a deathbed scene, a fairly common genre in the nineteenth century, but a figure study of a corpse. According to Hammacher, Derkinderen had been given 'secret permission' to paint in the hospital mortuary. It is not known whether he painted the lifeless figure for any specific purpose, but he probably regarded it primarily as a good exercise. The study is fine in tone and painted fluently in broad strokes, with little detail in the face, hands or feet – an effect painters of Derkinderen's generation increasingly tried to achieve in their finished work. There does not seem to be a narrative context for the painting and only the inscription on the panel indicates that the dead man had been a trumpeter. Another canvas from Derkinderen's Brussels period depicts the half-naked body of a monk, scourged to death, together with a few secondary figures (private collection). However, *The Dead Trumpeter* was not a preliminary study for this work, which is dated 1882.

Provenance: J.H. Derkinderen-Besier; bequeathed to the museum in 1945.

Literature: Hammacher 1932, pp. 23, 123; exhib. cat. 's Hertogenbosch 1980-81, no. 42.

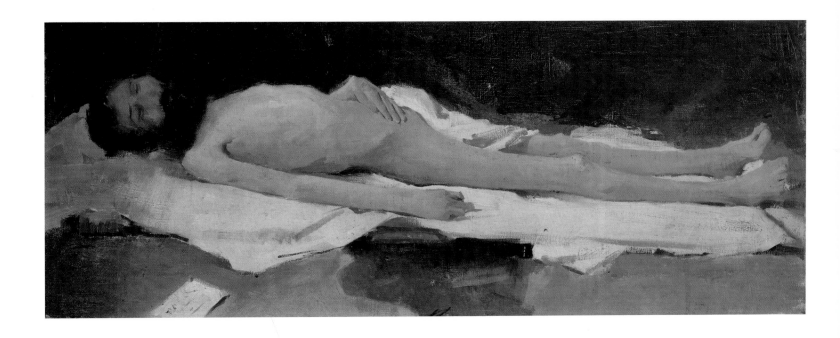

18

A. DERKINDEREN
Paul, Bessy and Arthur Tutein Nolthenius, 1894
Tempera on canvas, 122 x 65 cm (triptych)
Unsigned; annotated lower left: *Paul at the age of 10*; lower
centre: *Bessy at the age of 8*; lower right: *Arthur at the age of
2¹/₂*
Dordrecht, Dordrechts Museum

In 1893-1894 the engineer and art connoisseur R.P.J. Tutein
Nolthenius commissioned Derkinderen to paint portraits of his
wife (private collection) and their three children Paul, Bessy and
Arthur, to mark his wedding anniversary. Seven years earlier,
Derkinderen had painted a fairly realistic portrait of two chil-
dren sitting on a sofa (The Hague, Haags Gemeentemuseum).
Subsequently, influenced by Puvis de Chavannes and by late
Medieval and Renaissance art, he developed an austere and
monumental style which was reflected most clearly in the two
cycles of murals he produced for the town hall in s' Hertogen-
bosch. Tutein Nolthenius's commission came as Derkinderen
was preparing the second of these cycles, the *tweede Bossche
wand*.

In line with his new ideas, he produced a triptych of the chil-
dren, portraying them in a highly formalised manner. According
to a relative of the family, Tutein Nolthenius was not entirely
happy with the result. The children are arranged symmetrically,
with the boys in profile to either side of the girl, who is seen from
the front, in the manner of portraits of late-medieval donors
flanking a central panel of the Virgin Mary. The inscribed pen-
nants at the bottom and the demarcation of the foreground by a
hedge are in the same style as the murals. The triptych, however,
gives an illusion of space, which is entirely absent from the
tweede Bossche wand. Furthermore, Derkinderen has used col-
our – particularly in the landscape – to heighten the mood of the
picture, which recalls paintings by the French artists in
Gauguin's circle and by the Nabis, whose work he knew through
Jan Verkade.

To a certain extent the triptych is a Symbolist painting, al-
though it is less explicit than the work Toorop and Thorn Prik-
ker were producing during this period. The girl's flowers and the
young goat next to the boy on the right signify the innocence of
childhood. However, it is primarily the triptych format and for-
mal arrangement that elevate the work above everyday reality.

PROVENANCE: R.P.J. Tutein Nolthenius, 's Hertogenbosch; private collection;
on loan to the museum, 1956.

LITERATURE: Hammacher 1932, pp. 70, 126; exhib. cat. *Kunstenaren der Idee.
Symbolistische tendenzen in Nederland ca. 1880-1930*, The Hague (Haags Ge-
meentemuseum) etc. 1978-1979, no. 10; exhib. cat. 's Hertogenbosch 1980-81,
no. 57.

DIJSSELHOF, GERRIT WILLEM

ZWOLLERKERSPEL 1866 - 1924 OVERVEEN

Dijsselhof initially received drawing lessons from the seascape painter Jacob van Heemskerck van Beest. He attended the Hague Academy from 1882 to 1885 and the teacher training college in Amsterdam from 1884 until 1886. In the spring of 1886 he became a student teacher at the School of Arts and Crafts, where he took part in the modelling class. He and a number of his fellow students, Theo Nieuwenhuis, Lambertus Zijl and Jozef Mendes da Costa among them, founded the Labor et Ars Association in that same year, which aimed to foster innovation in Dutch arts and crafts. Following the example that had been set in England, Dijsselhof, the driving force behind the project, advocated the merits of craftsmanship and the importance of decoration in its own right. The group disbanded in the autumn of 1887 and Dijsselhof went on to give evening classes in freehand drawing at Felix Meritis in Amsterdam, where he met the painter Maurits van der Valk with whom he later shared a studio.

In April 1888 Dijsselhof and Nieuwenhuis embarked on a journey which was to take them to Berlin, Dresden, Prague, Vienna, Munich and Paris. They returned in June 1889, enthusiastic about the art and, above all, the examples of decorative art they had seen during their travels. Dijsselhof became one of the pioneers in a group of artists concerned with design and new production techniques in the applied arts in the 1890s. Opposed to the proliferation of historicist movements at the time, they turned again to Nature in search of a basis for their art. By studying fauna and flora, they hoped to discover a 'natural' way to a 'New Art'.

Dijsselhof experimented in various fields and in 1890 he and Lion Cachet were among the first in Holland to learn the art of batik. He studied traditional graphic techniques such as woodcut, as well as book decoration and typography. In 1892 he designed a diploma, based on stylised natural shapes, for the book trade, and in the following years he also produced designs for wall decorations, screens, lamps and furniture, while continuing to develop his skills as a painter and draughtsman. 'Discovered' by Breitner, Dijsselhof made his début at Architectura et Amicitiae in 1891, where he exhibited watercolours of fish and flowers, demonstrating his talent for design and decoration. The type of work he produced was little known and caused a sensation at the exhibition. Mesdag and many other artists bought work from him, while the critic Jan Veth lavished praise on it. Like many of his contemporaries, Dijsselhof experimented with Art Nouveau for a relatively short period. In 1898 E.J. van Wisselingh & Co. offered him the opportunity to put his ideas on interior design and furniture into practice together with Theo Nieuwenhuis and Lion Cachet, but the venture was not a financial success. In 1903, Dijsselhof abandoned the attempt and devoted himself to painting. Although he produced several landscapes, he is best known for his paintings of fish.

LITERATURE: J. Veth, 'Dijsselhof op de tentoonstelling van Architectura et Amicitiae in de loods op het Damrak', *Hollandsche teekenaars van dezen tijd*, Amsterdam 1905, pp. 31-34; R.W.P. de Vries, 'G.W. Dijsselhof', *Elsevier's Geillustreerd Maandschrift*, 15 (1905), vol. 30, pp. 362-377; R.W.P. de Vries, *G.W. Dijsselhof. Hollandsche Schilders van dezen tijd*, Amsterdam 1912; N. van Harpen, 'Schilderkunst', *Maandblad voor Beeldende Kunsten*, 1 (1924) 8, pp. 229-236; M.F. Hennus, 'Circusschetsen van G.W. Dijsselhof', *Maandblad voor Beeldende Kunsten*, 11 (1934) 5, pp. 131-134; L. Gans, *Nieuwe Kunst. De Nederlandse bijdrage tot de 'Art Nouveau'. Dekoratieve kunst, kunstnijverheid en architektuur rond 1900*, Utrecht 1960, *passim*; E. Braches, *Het Boek als Nieuwe Kunst, 1892-1903, een studie in Art Nouveau*, Utrecht 1973, pp. 43-50; H. Olyslager and M. Wardenaar, *Ons Amsterdam*, 36 (1984) 2, pp. 47-50; Charles Vergeer, *Willem Witsen en zijn vriendenkring*, Amsterdam/Brussels 1985, pp. 123-126; C. Hekker, 'Kunstenaars in Artis rond 1900', *Holland* 20 (1988) 4-5, pp. 261-270.

19

G.W. Dijsselhof
Lobsters, 1892
Watercolour, 118 x 64 cm
Initialled and dated lower left: *GWD 92*
Heino, Hannema de Steurs Foundation

Six huge lobsters, drawn in careful detail in pen and ink on a watercolour background, zigzag their way forward, using their long antennae to guide themselves as they clamber arduously over the ground. Dijsselhof has managed to capture the clumsiness of their movements. A strong, undulating line leading upwards enhances the rhythm of the work, which is an eloquent example of the artist's talent for decoration. The vertical format and the composition of the piece, as well as the theme, the graphic style and Dijsselhof's superb mastery of the watercolour technique, recall the work of Japanese artists. It resembles a *kakemono*, a vertical painting in ink or watercolour that can be rolled up on a scroll.

In Japanese painting, depth is suggested not by means of linear perspective, but by conflating background and foreground and using colour and fragmentation to create an illusion of space. Dijsselhof has employed a similar technique in arranging the lobsters within the picture space and has in this way managed to achieve the zigzag effect.

The subject of this work was extremely unusual. Dijsselhof found inspiration at the modern aquarium which opened at Amsterdam zoo in 1883. Teachers of art and the applied arts encouraged students to work at the zoo, but while most tended to study predators and birds of prey, Dijsselhof was entranced by the ethereal underwater world of fish, crustaceans, aquatic plants, sea anemones and corals which could be viewed behind four-centimetre thick glass panes. He recorded every position, every movement and every detail of colour in his sketch books and then methodically numbered and catalogued them. He thus built up a system which facilitated his work in the decorative arts, but proved even more important as a source of material for the work he produced autonomously. A photograph taken at an exhibition at Arti in Amsterdam in 1893 shows the watercolour in a white mount with a simple wooden frame. The beautiful frame which now surrounds it is of slightly later date and was designed by Theo Nieuwenhuis.

PROVENANCE: E.J. van Wisselingh & Co., Amsterdam; F. Kranenburg, Amsterdam; F. Bisterbosch, Amsterdam; bequeathed to the museum by Mr H. Hannema, 1965.

EXHIBITIONS: *Teekeningen door leden der maatschappij*, Amsterdam (Arti et Amicitiae) April 1893, cat. no. 26 ('Kreeften'); *Schilderijen, aquarellen, teekeningen, etsen etc.*, The Hague (Haagsche Kunstkring) July/August 1895, cat. no. 101.

LITERATURE: G., 'Tent. van Teekeningen in Arti', *De Nederlandsche Spectator*, 29 April 1893.

GABRIËL, PAUL

AMSTERDAM 1828 - 1903 SCHEVENINGEN

The young Paul Gabriël, who was later to gain a reputation as a landscape painter, contributed towards his mother's meagre income by painting portraits. His father, a sculptor who taught at the Amsterdam Academy from 1820, died in 1833, leaving his wife and seven children in reduced circumstances. Paul took evening lessons in drawing at the Amsterdam Academy from 1840 to 1843 and was later, much to his disappointment, a pupil of the architect and amateur painter L. Zocher. In 1844 he went to study under the landscapist Barend Cornelis Koekkoek at the Kleef Academy in Germany, but Koekkoek was dissatisfied with his progress and Gabriël returned to Holland a year later. He found a place at the studio of Cornelis Liëste in Haarlem, where he again applied himself to portraiture, while he also copied many paintings at the Welgelegen Museum. He met Mauve in Haarlem and the two men became friends. Gabriël's artistic development was slow until he moved to Oosterbeek in 1853. He remained there until 1856 and, with advice and encouragement from Johannes Bilders, set to work diligently from nature. He then moved to Amsterdam, entering into a period of his life marred by financial problems. His paintings were not in demand and in 1860 he decided to move to Brussels, where he found a more conducive artistic climate. Various artists, including Willem Roelofs and the seascape painter P.J. Clays, admired his work and gave him encouragement. In 1866 he became a member of the Societé Belge des Aquarellistes and a year later he married A. Urbain from Liège. In 1875 he was honoured with a knighthood in the Belgian Order of Leopold.

Gabriël remained in Belgium until 1884, but regularly visited Holland to explore the countryside around Amsterdam, Veenendaal, Abcoude, Vreeland, Kampen and Kortenhoef. Blessed with an outstanding visual memory, he continued to paint Dutch motifs throughout the years he spent abroad. On his return to the Netherlands he settled in Scheveningen, but often worked in other parts of the country such as Voorschoten, Broeksloot, Oosterbeek, Kinderdijk and Heeze. In addition to polder landscapes and flower still lifes, he painted landscapes with sheep-folds, ducks' nests and wheatsheaves. Gabriël was often criticised for the excessively bright colours, which distinguished his work from the grey-toned canvases of the Hague School. Although several major museums bought his work (Amsterdam, Rijksmuseum, *In the Month of July*; The Hague, Haags Gemeentemuseum, *Peatcutting, Kampen*; Rotterdam, Boymans Museum, *Landscape near Overschie*, in 1889, 1890 and 1898 respectively), Gabriël was not widely appreciated during his own lifetime. Only after his death was he hailed by Plasschaert and Bremmer as an 'independent talent'.

LITERATURE: L. de Haes, 'P.J.C. Gabriël', *Elsevier's Geïllustreerd Maandschrift*, 3 (1893) 5, pp. 453-473 [reprinted in M. Rooses (ed.), *Het Schildersboek*, Amsterdam 1898, vol. 1, pp. 212-236]; W. Steenhoff, 'P.J.C. Gabriël', *Elsevier's Geïllustreerd Maandschrift* 16 (1906) 31, pp. 79-89; [A. Plasschaert], 'Gabriël', *Kritiek van Beeldende Kunsten en Kunstnijverheid* 3 (1906), pp. 35-43; K. [W.J. Koppius], 'Paul Joseph Constantin Gabriël', *De Vrije Arbeid* 3 (1916/17), pp. 155-166; H.E. van Gelder, 'Brieven uit P.J.C. Gabriël's Brusselschen tijd', *Oud Holland* 42 (1925), pp. 178-180; H.W.F. Jeltes, 'Brieven van Gabriël', *Oud Holland* 43 (1926), pp. 117-127; Jos. de Gruyter, *De Haagse School*, Rotterdam 1968, vol. 1, pp. 76-91; exhib. cat. *De Haagse School. Hollandse meesters van de 19de eeuw*, Paris (Grand Palais) etc. 1983, pp. 180-185 (bibliography, pp. 337-338).

20

P. GABRIËL
In the Month of July, *c.* 1885
Oil on canvas, 102 x 66 cm
Signed lower left: *Gabriël f*
Amsterdam, Rijksmuseum

'Though I might look rather sullen,' Gabriël confessed in a letter to the art critic A.C. Loffelt in 1901, 'I love the sun shining on the water and, apart from that, my country is colourful. What struck me most when I returned from abroad were the rich, succulent colours of our country (...). I have often heard foreigners say that the work of Dutch painters is all grey, whereas their country is actually green.'

These comments illustrate Gabriël's refusal to yield to the influence of the Hague School. His predilection for bright colours elicited a lot of criticism, but it was also regarded as a hallmark of his work. The sun-drenched landscape in the painting shown here is ablaze with colour. The mill is etched against a

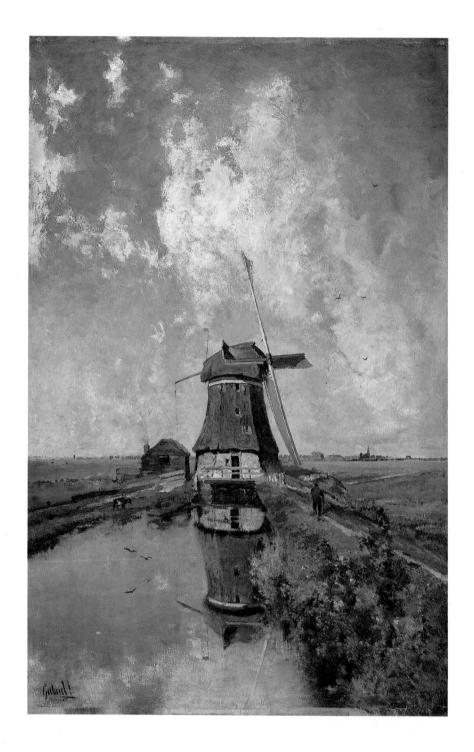

brilliant blue sky with contrasting white clouds drifting by, and the whole scene is mirrored in the smooth surface of the water in the canal. A man is strolling along the path on the right bank, a cow is grazing on the left, and the little village in the background is sweltering under the hot July sun. Gabriël has taken the geometry of the Dutch landscape, traversed by canals, as the basis for his composition. The mill is a monumental structure in the middle of the picture plane (the centre of the picture is under its roof). It is extended to form a central axis with the reflection in the canal and the vane pointing upwards. It is as if Gabriël were seeking laws of nature, while applying mathematical rules of composition to achieve classical balance. No other master of the Hague School produced such resolute compositions. Gabriël used the same composition with a central axis for the *Mill in a Polder* (private collection). Here, the mill has been brought slightly forward, the reflection in the water is less carefully worked out and the painting is much freer and more fluid. The miller's house and the figure of the man are not shown. Gabriël repeated many of his works, generally in order to improve the composition or colouring.

In 1895 Mondrian copied *In the Month of July*, which had been exhibited at the Rijksmuseum since 1889, revealing early in his career his feeling for this type of linear composition.

PROVENANCE: Acquired by the museum, 1889 (f 1,000).

LITERATURE: De Gruyter 1968, p. 85, fig. 102; exhib. cat. Paris 1983, pp. 150, 151.

Gogh, Vincent Willem van

Zundert 1853 - 1890 Auvers-sur-Oise

Vincent van Gogh, his younger brothers Theo and Cor, and his sisters Willemien and Anna grew up in a vicarage in the country-side. Their father was a Protestant clergyman. The family had connections in the art world, as Vincent's mother was a cousin of Anton Mauve and one of his paternal uncles was an art dealer in Amsterdam. Vincent did not complete his schooling, but left in 1869 to take up a position as junior clerk at the Hague branch of the art firm of Goupil & Co. He worked for the same firm in London from 1873 to 1875 and was subsequently transferred to their Paris branch for almost a year. However, it became increasingly clear that he had little aptitude for the art trade and he was eventually dismissed.

Religion became the principal focus of his life during this period. After teaching at a boarding school in England for several months and having failed in his attempt to study theology in Amsterdam, he went to Belgium in 1878 to train as a missionary. He spent a short time in Laken and subsequently moved to the impoverished mining region of the Borinage. He devoted a great deal of time to drawing, both from nature and from reproductions, after prints by Millet and others whose work he admired. In August 1880, he resolved to become an artist and from then until the end of his life, he received financial support from Theo, who had been more successful in the art trade.

After working in Brussels for some time, where he met the young painter Anthon van Rappard, Van Gogh returned to his parents' home in Etten in the province of Brabant in 1881. He applied himself diligently to drawing scenes of peasant life, generally working from models. At the end of the year, however, his difficult relationship with his parents prompted him to move to The Hague. Here he came into contact with other young artists, including Breitner, who shared his interest in motifs illustrating life in the poorer parts of the city. The themes that attracted them were of the type described by Zola and De Goncourt, whose naturalistic novels had made an impact on both painters. Van Gogh also met the Hague School painters. He studied under Mauve for a while, but their views and temperaments clashed. Moreover, his family and friends disapproved of his relationship with a 'fallen woman' and in September 1883, partly under the pressure they brought to bear on him, he decided to leave The Hague. He spent a few months in the province of Drenthe, before returning once again to live with his parents, who had since moved to Nuenen.

The following two years proved extremely fruitful. He gained a great deal of experience in painting and made countless drawings of peasants at work. All his efforts were concentrated in the pursuit of his great ambition to become a painter of peasant life like Millet, for whom his admiration knew no bounds. In 1885 he painted *The Potato Eaters* (Amsterdam, Rijksmuseum Vincent Van Gogh), which he himself saw as the first real test of his competence.

After studying drawing at the Antwerp Academy for a few months, he moved to Paris in March 1886, where he shared an apartment with Theo. He again took lessons and practised life drawing at Cormon's studio, where he also met Toulouse-Lautrec and Emile Bernard. In Paris he met the Impressionists and Neo-Impressionists, whose styles he absorbed. He began to use lighter, more vivid colours and his brushwork became looser. In 1887, together with Signac, he frequently worked *en plein air*, developing a distinctive pointillist technique of his own. It was at this time too, that he met Gauguin.

Ultimately, however, the hectic pace of city life proved too much for Van Gogh and, in the hope of finding a tranquil retreat in the countryside, he left for Arles in February 1888. It was here that he reached artistic maturity. His landscapes, still lifes, portraits and self-portraits are rigorously simplified and the images are distorted; he used strong colours, often combined with their complementaries, and applied his paint with fluent, impasto brushstrokes to intensify the effect.

Van Gogh's dream was to establish a community of artists in Arles. Gauguin arrived in the autumn of 1888, but problems soon arose between them and Gauguin left after a violent quarrel just before Christmas. It was during this frenzied outburst that Van Gogh mutilated his ear. He was admitted to the hospital in Arles on several occasions in the following months, returning home to work when his health seemed to be improving. However, his condition continued to give cause for concern and in 1889 he had himself admitted to an asylum in Saint-Rémy near Arles, where he was to remain for over a year. In lucid intervals, he worked well and productively. He was able to paint in the gardens and even outside the asylum, but he also worked in his room, making replicas of earlier work or copies after Millet, Rembrandt and other artists he admired. He left Saint-Rémy at the end of April 1890 and travelled via Paris to Auvers, where he

spent the last months of his life under the care of Dr Paul Gachet, an art collector and amateur artist. On 27 July 1890, he shot himself in the chest and died two days later.

After he had moved to Paris, his paintings were shown in several exhibitions of Impressionist and Post-Impressionist art. Though his work had always been controversial, he was beginning to acquire some measure of recognition. At the beginning of 1890, the critic Albert Aurier published the first enthusiastic review of his work, in *Mercure de France*. After his death his reputation soared. His work was much in demand in France, but even more so in the Netherlands and Germany. The publication of his correspondence shortly afterwards helped give rise to the legend which surrounds his name and precipitated a tendency to interpret his work in terms of the tragic circumstances of his life.

LITERATURE: Walter Vanbeselaere, *De Hollandsche periode (1880-1885) in het werk van Vincent van Gogh (1853-1890)*, Antwerpen/Amsterdam 1937; J.-B. de la Faille, *The Works of Vincent van Gogh. His Paintings and Drawings*, Amsterdam 1970; *The Complete Letters of Vincent van Gogh*, New York/London 1958, reference numbers in square brackets correspond to the letter numbers in this edition; *Van Gogh in Perspective*, ed. Bogomila Welsh-Ovcharov, Englewood Cliffs (NJ) 1974; Jan Hulsker, *Van Gogh en zijn weg. Al zijn schilderijen en tekeningen in hun samenhang en ontwikkeling*, Amsterdam 1977; Carol M. Zemel, *The Formation of a Legend. Van Gogh Criticism 1890-1920*, Ann Arbor (Mich.) 1980; exhib. cat. *Vincent van Gogh in zijn Hollandse jaren. Kijk op stad en land door Van Gogh en zijn tijdgenoten 1870-1890*, Amsterdam (Rijksmuseum Vincent van Gogh) 1980/81; exhib. cat. *Van Gogh in Arles*, New York (The Metropolitan Museum of Art) 1984; exhib. cat. *Van Gogh in Saint-Rémy and Auvers*, New York (The Metropolitan Museum of Art) 1986/87; *The Rijksmuseum Vincent van Gogh*, Evert van Uitert, Michael Hoyle eds., Amsterdam 1987; exhib. cat. *Van Gogh à Paris*, Paris (Musée d'Orsay 1988; exhib. cat. *Van Gogh & Millet*, Amsterdam (Rijksmuseum Vincent van Gogh), 1988/89; exhib. cat. *Vincent van Gogh*, Amsterdam (Rijksmuseum Vincent van Gogh), Otterlo (Rijksmuseum Kröller-Müller) 1990.

21

V.W. VAN GOGH
Cimetière de paysans, 1885
Oil on canvas, 63 x 79 cm
Signed lower right: *Vincent*
Amsterdam, Rijksmuseum Vincent van Gogh (Vincent van Gogh Foundation)

In 1882 Van Gogh's parents moved to the village of Nuenen in Brabant. Vincent, who was still living in The Hague at the time, replied to a letter from his brother Theo, expressing his interest in the area. Though he had not yet seen it, he suggested that 'a very old little church and a churchyard with graves in the sand and old wooden crosses' might be an interesting motif for a painting [226]. He referred to the theme several times in subsequent letters, and gradually resolved to paint a peasant funeral in the snow. He may have been inspired by Courbet's famous *Burial at Ornans* (Paris, Musée d'Orsay), or Félicien Rops's cynical variant, a lithograph entitled *Walloon Funeral*, as both were artists he admired. Nothing came of the plan, but he depicted the church on many occasions after returning to live with his parents in Nuenen in 1883.

The old Gothic tower, a strangely solitary structure in a churchyard surrounded by fields, appears in almost thirty drawings and paintings. It is shown in various ways and viewed from different vantage points. Sometimes it is a tiny detail in the distance, as in his sketches of the parsonage garden in winter, or it is seen through a window, as in the interiors with weavers at their looms. He also depicted it from close by, showing only a part of the tower, or used it as a backdrop in pictures of people visiting the churchyard or the peasants who came to buy the wooden crosses when the tower was demolished. In a number of works, however, the tower appears in its entirety, and forms the main subject of the piece

The Amsterdam canvas, which dates from May 1885, is probably the last one he made. In a letter to Theo, he reports that 'the old tower is to be demolished next week! The spire has already gone; I am in the process of painting it' [408]. He had originally intended it as an evening scene, but was dissatisfied with the result. He consequently scraped the canvas bare and began afresh, painting the tower from a different angle and in the morning light. He also mentions that he left out many details.

Churches and church towers set in a graveyard had been a particularly popular theme since the Romantics. While many of the countless nineteenth-century examples are free of the underlying connotations they would have had for an artist such as Caspar David Friedrich, Van Gogh's painting is probably more than simply a picturesque spot chosen at random. Though he never adhered to a consistent system of symbols, he tended to relate his subject matter to his personal philosophy of life and to attach literary associations to his work. This is particularly true of the painting shown here, with its literary-sounding French title. He sent it to Theo, with the following lengthy explanation. 'I wanted to give an impression of this ruin, where for centuries peasants have been laid to rest in the very fields where they laboured in life. I wanted to show how very simply they die and are buried, dead easy, like leaves falling in the autumn – no more to it than turning over a bit of earth – a little wooden cross (...). Now, however, the ruin expresses the decline of a faith and religion, no matter how firm its foundations were, while the lives and deaths of humble peasants never change, budding and withering like the grass and flowers that grow in the churchyard. *Les religions passent, Dieu demeure*, as Victor Hugo says – he, too, was buried recently' [411]. The dilapidated church tower was thus a negative image for Van Gogh, and it may likewise signify decay when it is shown in the background of moribund gardens in winter or interiors with weavers languishing at their looms.

Some years later, Dutch Symbolists such as Toorop and Simon Moulijn used Gothic church architecture in a similar, though far more explicit manner, to symbolise the transience of external manifestations of the Christian faith, of the church as an institution in decline.

PROVENANCE: J. van Gogh-Bonger, Amsterdam; V.W. van Gogh, Laren; Vincent van Gogh Foundation, 1962; on permanent loan to the museum, 1973.

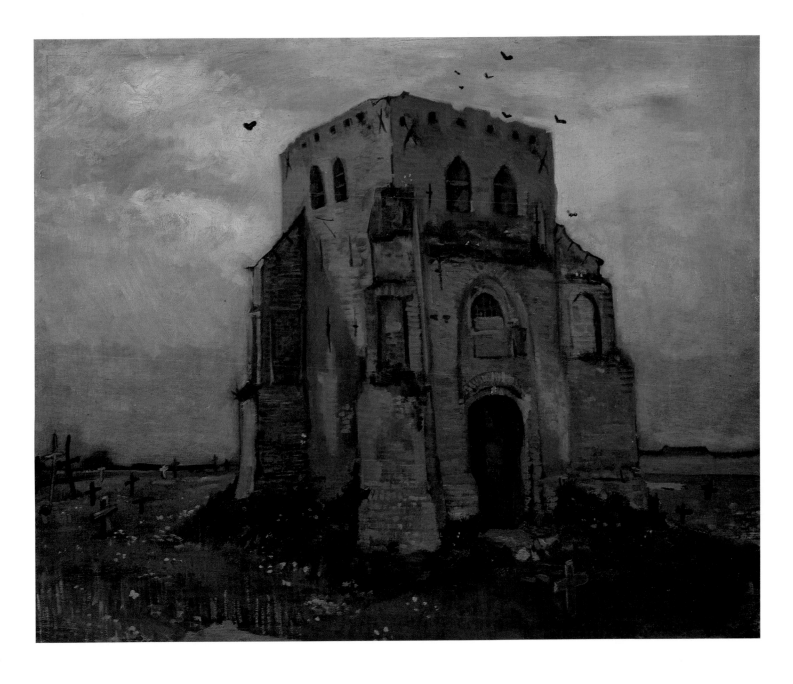

LITERATURE: Vanbeselaere 1937, pp. 297-298, 354, 377, 401, 414; De la Faille 1970, F 84; exhib. cat. Amsterdam 1980/81, pp. 105-109; *Rijksmuseum Vincent van Gogh* 1987, pp. 140-141; exhib. cat. *Van Gogh in Brabant*, 's Hertogenbosch (Noordbrabants Museum) 1987, no. 79; exhib. cat. Amsterdam 1988/89, no. 17; exhib. cat. Amsterdam 1990, no. 9.

22

V.W. VAN GOGH

Birds' Nests, 1885

Oil on canvas, 38.5 x 46.5 cm

Signed lower left: *Vincent*

Amsterdam, Rijksmuseum Vincent van Gogh (Vincent van Gogh Foundation)

In the last few months of his stay in Nuenen, before leaving for Antwerp at the end of November 1885, Van Gogh painted landscapes and still lifes, but practically no figures. This may have been because the local clergy had tried to discourage him from associating with the peasants when he was alleged to have made a woman pregnant. They had likewise used their influence to stop the peasants posing for him. But there were also artistic reasons for turning his energies to still lifes. They enabled him to practise modelling with colour and thus tackle a problem which he often mentioned to Theo at the time. He painted many still lifes of fruit or vegetables, a whole series of baskets of potatoes, and five still lifes of birds' nests. Three of them are set against a very dark, almost black background. Theo was critical of the amount of black he was using, but Vincent drew his attention to the richness of colour that masters such as Frans Hals and Velázquez had managed to achieve. Hals, he remarked, used 'not one, I assure you, but twenty-seven shades of black' [428]. Moreover, he explained, the dark backgrounds in these particular still lifes indicated that the nests were not in their natural surroundings. The

example shown here nevertheless has a relatively light background against which the nests, attached firmly to twisted, broken branches, stand out sharply. The rough outlines of a few tufts of grass suggest that the motif was arranged and painted outdoors.

As he often did, Van Gogh invested his subject, prosaic as it may be, with a personal connotation. Beside a sketch of a nest in one of his letters he noted: 'la nichée et les nids [the clutch of eggs and the nests, perhaps a quote from French literature, C.B.], these touch me, especially *people's* nests – the cottages on the heath and those who live in them' [425]. Van Gogh apparently associated the birds' nests with the humble dwellings in which the poorest members of his community found shelter.

PROVENANCE: J. van Gogh-Bonger, Amsterdam; V.W. van Gogh, Laren; Vincent van Gogh Foundation, 1962; on permanent loan to the museum, 1973.

LITERATURE: Vanbeselaere 1937, pp. 302, 304, 398-399, 415; De la Faille 1970, F 111; *Rijksmuseum Vincent van Gogh* 1987, pp. 132-133.

23
V.W. VAN GOGH
Autumn Landscape, 1885
Oil on canvas, 64.8 x 86.4 cm
Unsigned
Cambridge, The Syndics of the Fitzwilliam Museum

Both the landscapes and the still lifes that Van Gogh painted in Nuenen in the autumn of 1885 enabled him to confront the problem of colour more directly than he had previously done. It is the main theme in his correspondence with Theo during this period. Writing from Paris, Theo had apparently told him about the colours used by Manet and the Impressionists, practically none of whose work Vincent had seen. He also urged him to make his paintings lighter if he wanted to sell them. Vincent resisted at first and in fact it was only when he went to Paris a year later that he was won over to French colourism. He quoted theories on colour from the writings of Charles Blanc, Bracquemond and Delacroix, invoked the work of artists he admired – Delacroix again, and the painters of the Barbizon and Hague Schools – and even referred to his own practice, in an effort to persuade Theo

that a light or dark palette was not, ultimately, the decisive factor. Delacroix had once commented that, even with a colour like mud, Veronese had managed to depict a nude 'so that she *looked* white and fair in the painting' [428]. What it finally came down to, Van Gogh concluded, was that a painter should use 'the colours on his palette, instead of confining himself to the colours of nature' [429]. His autumn landscapes, like the fine painting in Cambridge, represent his first, rather tentative efforts to put this theory into practice. Instead of using the evocative *couleur locale*, he mixed a palette based on a single dominant colour to represent the trees in their exuberant autumn finery. Here he has used a strong orange-brown, with harmonising shades for the tree-trunks and patches of light and shadow on the ground. The scene as a whole is then contrasted against a light, airy sky.

PROVENANCE: J. van Gogh-Bonger, Amsterdam; Tabingh Suermondt, Velp; J.E.E. Yssel de Schepper-Tabingh Suermondt, Aerdenhout; W.H. Yssel de Schepper; Garman-Ryan, London; Lady Epstein, London; auction Christie's, London, 1 July 1980, no. 34; purchased by the museum, 1980.

LITERATURE: Vanbeselaere 1937, pp. 304, 400, 415; De la Faille 1970, F 119; exhib. cat. *Van Gogh in Brabant*, 's Hertogenbosch (Noordbrabants Museum) 1987, no. 84; exhib. cat. Amsterdam 1990, pp. 56-57.

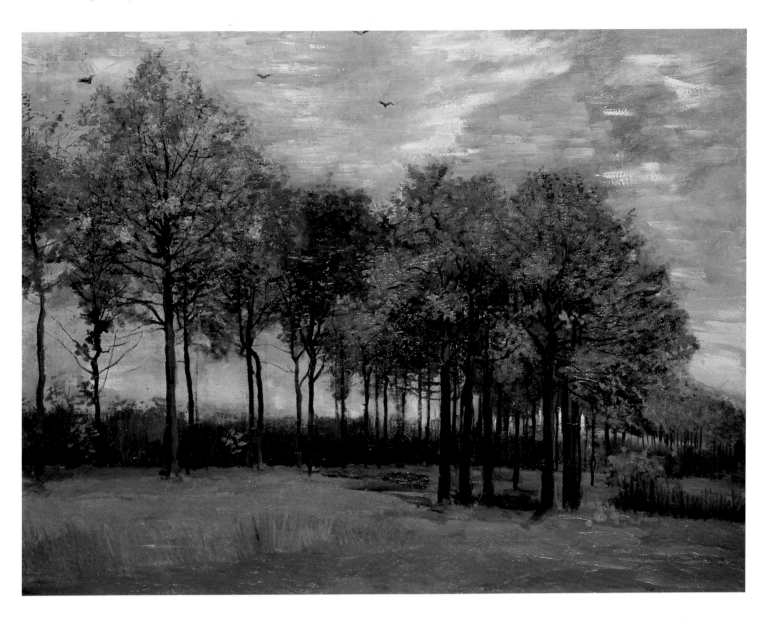

24
V.W. VAN GOGH
Stuffed Kalong, 1886
Oil on canvas, 41 x 79 cm
Unsigned
Amsterdam, Rijksmuseum Vincent van Gogh (Vincent van Gogh Foundation)

This unusual painting of a stuffed bat is executed on an exceptionally elongated canvas of the format Van Gogh generally reserved for landscapes or for the occasional vertical flower still life. He also painted a stuffed parrot (private collection) and a kingfisher (Amsterdam, Rijksmuseum Vincent van Gogh), and made several drawings of owls. Stuffed animals sometimes form part of the inventories of artists' studios, but whether Van Gogh

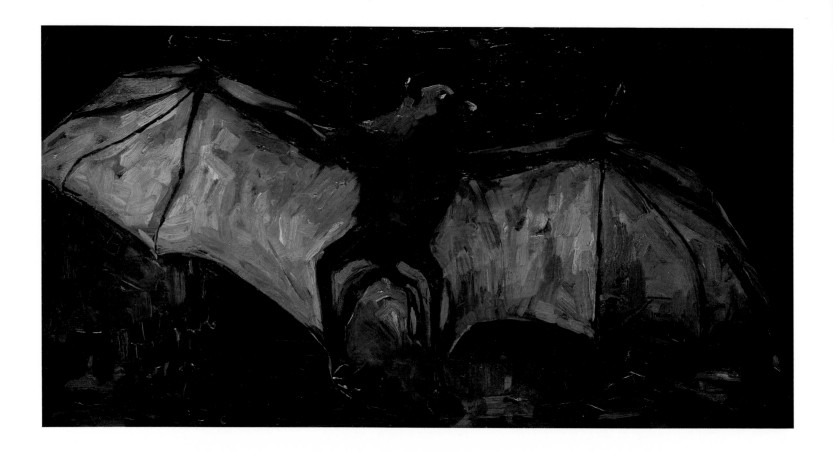

possessed any, apart from the kingfisher (now at the museum) is unknown, and it would indeed seem unlikely for him to have had a bat. The bat he has portrayed here is not a common European species, but a tropical kalong indigenous to Indonesia. Fully grown, they may have a wingspan of up to 150 cm. Van Gogh might have seen the animal in a public zoo or natural history collection, such as the Jardin des Plantes in Paris. The style of the painting is characteristic of the work he was producing during the first half of his stay in Paris in 1886. The canvas is covered with confident, broad, generous brushstrokes, and the colours are brighter and more pronounced than those he had used in previous years. His colour spectrum was still muted, however, and has more in common with Dutch art of the period – Breitner's for instance – than with the French Impressionists. The kalong must have been illuminated by a lamp to heighten the transparency of its wings. They are extended tautly like a Japanese parasol, and contrast with the dark background. It is a strange apparition, though not in the least gruesome; its head and body look more like a toy bear than a monster in one of Edgar Allan Poe's horror stories.

PROVENANCE: J. van Gogh-Bonger, Amsterdam; Oldenzeel Gallery, Rotterdam; A.F. Philips, Eindhoven; A.H.E.M. Philips-de Jongh; purchased by the Vincent van Gogh Foundation, 1973.

LITERATURE: De la Faille 1970, F 177A.

25
V.W. VAN GOGH
Moulin de Blute-fin (*Moulin de la Galette*), 1886
Oil on canvas, 46 x 38 cm
Signed lower right: *Vincent*
Glasgow, Glasgow Museums & Art Galleries

Vincent van Gogh arrived in Paris around 1 March 1886, and found accommodation with his brother Theo. Their lodgings were rather cramped, however, and in June of the same year they moved to a larger apartment at 25 Rue Lepic, in the heart of Montmartre. Montmartre in those days was still quite rural. There were three windmills on top of the Butte, surrounded by allotments and a few, rather tumbledown dwellings, almost like a shanty town on the outskirts of the city. Around the windmills, however, were bars, pavement cafés, a dance-hall and a park, and the Butte was consequently a favourite haunt for pleasure-seeking Parisians. As he had done previously in The Hague, Nuenen and Antwerp, Van Gogh made dozens of drawings and paintings of the area in which he lived. Like the Impressionists, and particularly the young Neo-Impressionists Seurat and Signac, he preferred the outer fringes of the city, where nature and human civilisation were in contrast. Factories and railway bridges, workmen and people out for a stroll gave this no man's land a modern appearance. Van Gogh's landscapes and urban scenes, mostly painted *en plein air*, are topographically quite accurate, judging by old photographs of the sites.

This atmospheric little painting is one such view of the Butte in Montmartre. From a vacant plot to the side of the Rue Lepic, Van Gogh looked past the allotments and small sheds in the fore-

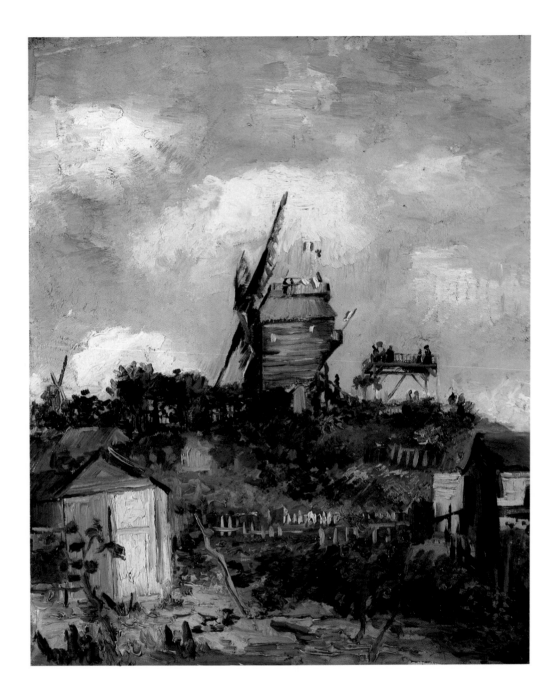

ground to focus on the Moulin de Blute-fin, a seventeenth-century grain mill. The mill was a popular tourist attraction, as both the terrace on its roof and the belvedere in front of it afforded magnificent views of the city below. The flags fluttering on the roof lent an extra note of festivity. The mill is often referred to as Moulin de la Galette, which was in fact the name of the area as a whole – the mills, cafés, and the dance-hall, which features in paintings by Renoir and Picasso.

The mills are the principal motif in several of Van Gogh's works. He may have been harking back to the landscapes with windmills of the Hague School, but at the same time he emerged as a chronicler of his times. As his paintings show, the mills had acquired a new function as tourist attractions. He produced at least three more paintings (two of the same modest format) and several drawings of the Moulin de Blute-fin alone. The mills are viewed from different vantage points and at different times of the year. The canvases with bare trees date from the winter of 1886-

1887. The others were probably painted in summer of 1886.

During his first six months in Paris, Van Gogh absorbed the traditions of modern French art. While his numerous flower pieces are inspired by Monticelli, his landscapes predominantly reflect the impact of the Impressionists. As the Glasgow painting shows, he experimented with a looser touch and a lighter, more colourful palette.

PROVENANCE: J. van Gogh-Bonger, Amsterdam; Bernheim Jeune Gallery, Paris; Alex Reid and Lefevre Gallery, Glasgow; William McInness, Glasgow; bequeathed to the museum, 1944.

LITERATURE: De la Faille 1970, F 274; Pierre Richard, 'Vincent van Gogh's Montmartre', *Jong Holland* 4 (1988) 1, pp. 16-21; exhib. cat. Amsterdam 1990, p. 72.

26
V.W. VAN GOGH
Undergrowth, 1887
Oil on canvas, 32 x 46 cm
Unsigned
Utrecht, Centraal Museum (on loan from the Van Baaren
Museum Foundation)

Van Gogh painted several landscapes similar to this one in 1887. They do not show vistas, figures, or houses, but only a patch of ground and undergrowth with sunlight filtering through. They are like snapshots of nature taken at random. At most, a few tree trunks lend an element of structure. There is little spatial depth, and even this is reduced by the even distribution of brushstrokes and lines over the whole surface. Van Gogh never painted *sous-bois* landscapes of this type in the Netherlands. They can only be explained in terms of the contemporary French art he saw in Paris, such as Monet's landscapes and parks with their luxuriant greenery. A more important influence, however, was Monticelli, whose work he passionately admired. Monticelli applied thick impasto to form an almost abstract crust of colour, and his representations are embedded, as it were, in this surface. As we can see from the Utrecht painting, Van Gogh also experimented with this technique.

PROVENANCE: A. Schuffenecker, Clamart; E. Blot Gallery, Paris; Charles Vincent, Paris; Huinck & Scherjon Gallery, Amsterdam; L.H. van Baaren, Utrecht; Van Baaren Museum Foundation, Utrecht; on loan to the museum, 1980.

LITERATURE: De la Faille 1970, F 306.

27

V.W. van Gogh
Trees on a Slope, 1887
Oil on canvas, 37.5 x 46 cm
Unsigned
Amsterdam, P. and N. de Boer Foundation

This painting is one of numerous studies Van Gogh made in the summer of 1887, when he was exploring Paris and its environs, as many Impressionist painters had done before him. Unlike the landscape painters of the Barbizon School, they sought motifs near or around water. Villages along the Seine downstream from Paris, such as Argenteuil and Bougival, were particularly popular with Monet, Renoir, Pissarro and Sisley. They painted not only the river with its banks and bridges, but also the visitors who came from the city to spend a day boating or at riverside cafés. Van Gogh also painted scenes of this type. Like Signac, Bernard and other young artists, he preferred spots where the rustic atmosphere had almost been obliterated by the encroaching city. He found such places within walking distance of Montmartre, in Asnières, for instance, where Bernard lived. Accord-

ing to Bernard's published memoirs, Van Gogh would set off with a large canvas on his back and return at the end of the day having painted several small studies on it. These he would later cut into separate pieces. The Amsterdam painting may have been made on one of these productive days. With rapid strokes and small dabs of colour, Van Gogh has brilliantly captured the atmosphere of a sunny day. Although there is no water to be seen, the tree-lined slope resembles a river bank. Judging from the buildings in the distance, it is possibly a spot on the Seine near the Pont de Clichy, as there were formerly two similar apartment buildings not far from the access to the bridge. Van Gogh made several paintings of the bridge and the two buildings.

PROVENANCE: E.H. du Quesne-van Gogh, Baarn; M.P. Voûte, Amsterdam; Van Wisselingh Gallery, Amsterdam; P. de Boer Gallery, Amsterdam (1940); P. de Boer, Amsterdam; P. and N. de Boer Foundation.

LITERATURE: De la Faille 1970, F 291.

Van Gogh had previously drawn women beside a cradle or with infants in their arms in 1881, in Etten, as well as in The Hague, when he was living with Sien Hoornik and her children. The genre was popular both in the Netherlands, where it was practised by Jozef Israëls, Albert Neuhuys and their numerous followers, and abroad. The *Woman beside a Cradle*, from Van Gogh's Paris period, shows the influence of these artists he so admired. The woman's pose, and especially her clasped hands, are reminiscent of the young peasant woman beside a cradle in Israëls's large painting, the *Midday Meal in a Peasant Hut in Karlshaven near Delden*, which the Dordrecht Museum purchased in 1885 (fig. 17). Van Gogh might have seen the canvas before leaving the Netherlands in February 1886, or he may have seen the engraving after the painting, published by the Amsterdam art firm Buffa. Compared with Israëls's painting, however, or with Van Gogh's own work in Holland, this canvas is a portrait rather than a genre piece. This is possibly because he had resolved to become a portraitist in Paris in order to earn a living. Inspired by naturalistic novels and figure pieces by the Impressionists, he began to portray his models in surroundings which reflected their social background. The woman in this painting is in the foreground, detached from the cradle behind her. She is sitting with her hands in her lap, apparently lost in thought, her gaze averted from the observer. Her dark, high-necked dress adds to the rather melancholy mood of the portrait. She might conceivably be in mourning. In contrast to this image, the burning candle on the table on the right could symbolise the young life of the infant in the cradle. It serves no purpose as a source of illumination, since the room is evenly lit by daylight.

The sitter has recently been identified as Léonie Rose Davy-Charbuy, a niece of the art dealer P-F. Martin, who was a friend and colleague of Theo van Gogh. She lived with her uncle. The cradle behind her and the paintings on the wall – which include a landscape and a barely discernible portrait of a soldierly-looking man – place her in context as a young mother from a middle-class family. The portrait has often been compared to paintings by the Impressionists; the theme is similar to Berthe Morisot's *Cradle* from 1872 (Musée d'Orsay, Paris), though Van Gogh is unlikely to have seen this work. The style corresponds more closely to portraits of women by Renoir and, more particularly, Toulouse Lautrec (with whom Van Gogh had frequent contact in Paris). Léonie has big, warm eyes, and her upper eyelids are accentuated by a dark line. Her delicate face is rendered in subtle flesh tones, like the women portrayed by Renoir, though Renoir's brushstrokes are blended together to achieve a softer, hazier effect. Like Toulouse Lautrec, who painted similar portraits during this period, Van Gogh's manner is transparent and varied; stippled areas alternate with dashes of paint, which have been applied in varying sizes and directions.

28
V.W. VAN GOGH
Woman beside a Cradle, 1887
Oil on canvas, 61 x 46
Unsigned
Amsterdam, Rijksmuseum Vincent van Gogh (Vincent van Gogh Foundation)

PROVENANCE: J. van Gogh-Bonger, Amsterdam; V.W. van Gogh, Laren; Vincent van Gogh Foundation, 1962; on permanent loan to the museum, 1973.

LITERATURE: De la Faille 1970, F 369; *Rijksmuseum Vincent van Gogh* 1987, pp. 194-195; exhib. cat. Paris 1988, no. 25.

29

V.W. van Gogh
Portrait of Alexander Reid, 1887
Oil on cardboard, 41 x 33 cm
Signed lower right: *Vincent*
Glasgow, Glasgow Museums and Art Galleries

Alexander Reid was the son of a Scottish businessman who had a flourishing frame-making and gilders workshop in Glasgow. Alexander went to Paris in late 1886 or 1887 as an apprentice to Boussod and Valadon, the firm of art dealers where Theo van Gogh was employed. He became friendly with the Van Gogh brothers and shared certain of their tastes, including their enthusiasm for Monticelli. At heart, however, he preferred the Old Masters to modern art, and this created tensions in the friendship. There were business conflicts, too, and it is revealing that Reid did not purchase any of Vincent's work during this period. He posed for him, as Vincent had hopes of making a name as a portraitist, but never bought the finished result.

Besides a number of drawings in Van Gogh's sketchbooks, two oil portraits of Reid are known. One is a full-length depiction of him sitting in an armchair (private collection). The paintings on the wall behind him have been identified as the head of a peasant woman, dating from Van Gogh's Brabant period, flanked by two paintings by the American, Frank Boggs, which belonged to the Van Gogh brothers. Though Reid obviously posed in their apartment, the background was quite appropriate for a man of his profession. This fluent, sketch-like painting is obviously a study. The other picture, which was probably painted a few months later, in the summer of 1887, is a bust portrait of Reid. It is in the same, small format, but it has been worked out in more detail and is also signed. Nevertheless, Van Gogh tried to retain its spontaneity. The fairly evenly-rendered, lighter surfaces of the clothing and the back of the armchair, as well as the red background, are animated by a mass of loose dots and short strokes in different directions, which harmonise with the more subtle and compact pattern of lines in the face. This was Van Gogh's rather free interpretation of the fairly systematic Pointillist style developed by Seurat and Signac, which he had seen and come to appreciate in Paris. His colours, too, are based on Neo-Impressionistic theories of optical colour mixing. He has used a spectrum of colours dominated by complementary reds and greens, with beige-yellow forming a link between them. Reid's portrait was undoubtedly intended as a demonstration of these new ideas on colour, but it was probably also meant as a character study. Van Gogh's rendering of the serious, rather childlike, timid face and the sloping shoulders, reflects his own perception of the sitter, who had been vacillating in Paris between a career in art or commerce. Van Gogh frequently commented on Reid in the letters he wrote to Theo from Arles.

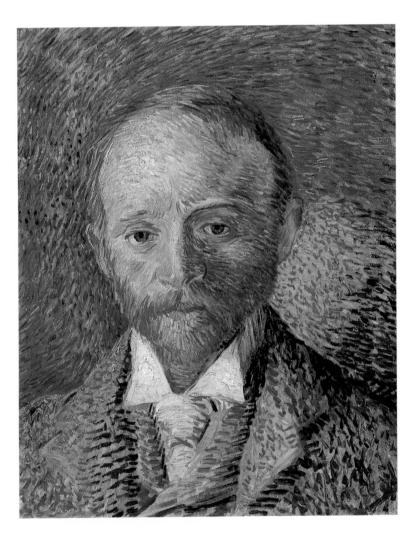

PROVENANCE: J. van Gogh-Bonger, Amsterdam; V.W. van Gogh, Laren; A.J. MacNeill Reid, London; Graham H. Reid; donated to the museum.

LITERATURE: Ronald Pickvance, 'Introduction', exhib. cat. *A man of Influence, Alex Reid (1854-1928)*, Edinburgh (The Scottish Arts Council) 1967, pp. 5-15; De la Faille 1970, F 343; exhib. cat. Paris 1988, no. 38; exhib. cat. Amsterdam 1990, no. 26.

30

V.W. van Gogh
Self-Portrait with Felt Hat, 1887
Oil on canvas, 44 x 37.5 cm
Unsigned
Amsterdam, Rijksmuseum Vincent van Gogh (Vincent van Gogh Foundation)

The numerous self-portraits which both Rembrandt and Van Gogh produced have given rise to considerable speculation about their apparent preoccupation with themselves. It is particularly tempting to interpret Van Gogh's work in psychological terms, as we know so many of the details of his life from his extensive correspondence. He thus became the prototype of the modern, misunderstood artist, whose tragic fate is reflected in his self-portraits. Recent literature has sought to redress the balance and place this romanticised notion in proper perspective.

His prolific output of self-portraits in Paris, for instance, can be explained by the fact that he wanted to become a portraitist, and he himself, of course, provided the cheapest model. The paintings, which are generally small and unsigned, can therefore be seen as technical exercises in both portraiture and colour, especially considering that many of the self-portraits are experiments in colour and brushwork. The *Self-Portrait with Felt Hat* is an excellent example. Applying the Divisionist colour theories, Van Gogh has used sharp contrasts in the entire painting – dashes of green in the red beard, green and turquoise stripes in the shadows on the face, and reddish brown dots against a predominantly blue background. The manner of painting is far less subtle or varied than in the *Portrait of Alexander Reid*, which dates from around the same time. Following the contours of the face, he has added a rhythmic pattern of powerful, dry strokes to the coarse layer of paint in the background, the jacket and the hat.

The work is undeniably both a portrait and a colour study.

Nevertheless, Van Gogh presumably had other aspirations as well. In this case he may have wanted to portray himself as a bohemian, but he wrote very few letters from Paris, and it is thus uncertain what his real intentions were. Most of the self-portraits he made before and after his Paris period are described at length, while any allusions to literature are generally clear. Exploring his own psyche may not have been his principal aim in these self-portraits; he probably regarded them as studies of different character types. He may even have seen them as role playing, as his *Bonze* from 1888 (Cambridge, Mass., Fogg Art Museum) suggests.

PROVENANCE: J. van Gogh-Bonger, Amsterdam; V.W. van Gogh, Laren; Vincent van Gogh Foundation, 1962; on permanent loan to the museum, 1973.

LITERATURE: Fritz Erpel, *Die Selbstbildnisse Vincent van Goghs*, Berlin 1963, no. 10; De la Faille 1970, F 344; *Rijksmuseum Vincent van Gogh* 1987, pp. 188-189; exhib. cat. Amsterdam 1990, no. 27.

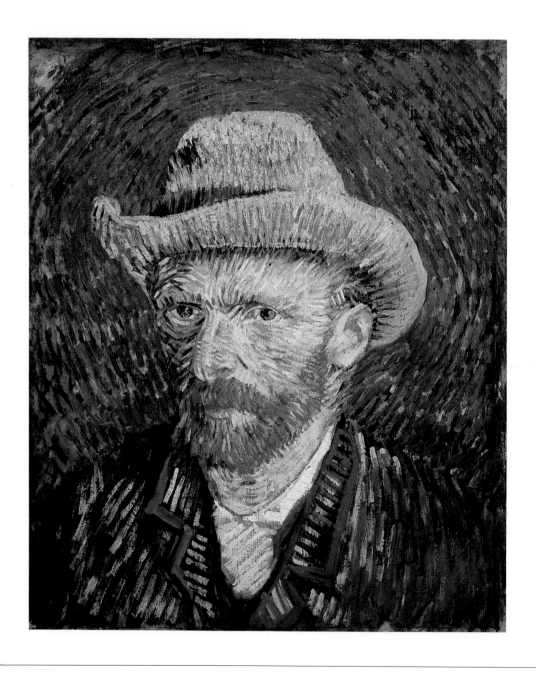

31
V.W. VAN GOGH
Orchard in Blossom, 1888
Oil on canvas, 55 x 65 cm
Signed lower left: *Vincent*
Edinburgh, National Gallery of Scotland

Van Gogh moved to Arles in February 1888. Its rural surroundings enabled him to return to motifs he had painted in Brabant, but also permitted him to explore new ones. He started to paint orchards in blossom in March 1888 and filled one canvas after the other with the distinctive shades of apple, almond, pear, peach and plum blossom. While working on these canvases, he began to envisage them as a *décoration*, or as an ensemble to decorate a room. In a letter to Theo, he sketched three paintings which he had combined to form a triptych, and announced that he was working on two more series of three. In the end he produced a total of twelve orchards. He was dissatisfied with the last few, however, and regretted not having stopped earlier.

Van Gogh had first attempted a project of this kind in 1884, when he designed a decorative cycle representing the seasons for the Eindhoven goldsmith, Hermans. In theme, format and treatment, the paintings were intended to form a series to decorate a room. Some of the Impressionists he had met in Paris, Pissarro and Monet among them, were also interested in decorations of this type. In 1885, for example, Monet had produced paintings for a *salon* in the house of his art dealer, Durand-Ruel. Van Gogh may have had something similar in mind for his brother Theo, although he did not mention where he wanted the paintings hung. A number of letters refer to them as studies for an ensemble of larger format, which he planned to paint in the future. He again raised the subject of a *décoration* a few months later, around the time he invited Gauguin to join him in the Yellow House in Arles. The plan had taken shape by then, and he was intending to decorate one room with a series of sunflower paintings and another with portraits.

Van Gogh conceived of his *décorations* as a series of paintings with a single motif, which no-one before him is known to have done. Monet's variations on a rural theme were separate canvases, and not a *décoration*, although Van Gogh may have got the idea after seeing series of this type at an exhibition in Paris. In any event, a room full of paintings of orchards in blossom, grouped together as triptychs, would indeed have been a remarkable sight. The Edinburgh canvas was meant to form part of the second series of three to which Van Gogh referred in letter 477. Together with another orchard (F 556, private collection), it was probably to have flanked a vertical painting of a pear tree (F 405, Amsterdam, Rijksmuseum Vincent van Gogh), of which he enclosed a sketch in the letter. Stylistically, however, the triptych would have lacked unity. The centre panel, which seems to be inspired by Japanese woodcuts, has heavy contour lines and planes of strong colour, whereas the impressionistic side panels are more muted and rendered with a thin, loose brush.

PROVENANCE: Theo van Gogh, Paris; private collection, Great Britain; William Boyd, Dundee; Alexander Maitland, Edinburgh, 1937; donated to the museum, 1960.

LITERATURE: De la Faille 1970, F 553; Evert van Uitert, *Vincent van Gogh in creative competition. Four essays from Simiolus*, Zutphen 1983, pp. 27-33; exhib. cat. New York 1984, no. 8; exhib. cat. Amsterdam 1990, pp. 104-117.

32

V.W. VAN GOGH
The Zouave, 1888
Oil on canvas, 65 x 54 cm
Unsigned
Amsterdam, Rijksmuseum Vincent van Gogh (Vincent van
Gogh Foundation)

'At last I have a model – a Zouave', Van Gogh wrote to his brother Theo from Arles at the end of June 1888. He appears to have been as fascinated by his model's appearance – his 'small head, bull neck and tiger's eyes' – as by the exotic splendour of his uniform. The Zouave corps, though by then made up entirely of French soldiers, continued to wear the uniform of the North African regiment that had served Berber princes in former times. The uniforms were a pretext for Van Gogh to use colour combinations of unprecedented intensity. Stunning complementaries, which he had usually blended in his Paris paintings in the Pointillist manner, were juxtaposed in large planes in the Cloissonist style which his friend Emile Bernard had developed. In addition to the blue and orange of the Zouave's jacket, he introduced a second pair of complementary colours by painting a green door next to an orange brick wall, with the man's head and red cap in front of it. It was, he wrote to Theo 'a brazen combination of clashing colours, and difficult to control'. He described the re-sult as crude and ugly. Letters to his sister Willemien and to Bernard (to whom he sent a watercolour after the portrait) also stress its ugliness, apparently with some degree of satisfaction, since this had been his intention. He also suggested exchanging the *Zouave* for a work by Bernard. What is most interesting in this letter is that Van Gogh fantasises about the two of them working together. A short time previously, Bernard had made a series of sketches of brothel scenes and sent them to Van Gogh, who now proposed that they both paint a brothel scene (it is unclear whether he meant them to do so together or individually) incorporating the study of the Zouave. He thus envisaged the Zouave in a larger, narrative picture, presumably posing as a client at the brothel. This hypothetical painting might have been a colourful, exotic and more plebeian counterpart of the brothel scenes with middle-class clientèle painted by Parisian Impressionists such as Manet and Degas. Unfortunately, however, the plan never materialised. According to Van Gogh's subsequent letters to Bernard, the painting which came nearest to the idea of the brothel scene was his famous *Night Café*.

PROVENANCE: J. van Gogh-Bonger, Amsterdam; V.W. van Gogh, Laren; Vincent van Gogh Foundation, 1962; on permanent loan to the museum, 1973.

LITERATURE: exhib. cat. 1984, pp. 106-108; *Rijksmuseum Vincent van Gogh*, 1987, p. 240; Juleke van Lindert en Evert van Uitert, *Vincent van Gogh en zijn portretten. Een eigentijdse expressie*, Amsterdam 1990, pp. 67-68.

33

V.W. VAN GOGH

Portrait of Camille Roulin, 1888
Oil on canvas, 37.5 x 32.5 cm
Unsigned
Amsterdam, Rijksmuseum Vincent van Gogh (Vincent van Gogh Foundation)

In November 1888 Van Gogh wrote to Theo saying that he had painted portraits of '*an entire family* (...) the husband, his wife, their baby, their little boy and a son of sixteen, all very French types, though they have something Russian about them, too'. He was referring to the family of Joseph Roulin, the postman in Arles. Van Gogh had at last found patient models and he painted over twenty portraits of the various members of the family. His letters express a deep affection for Roulin, 'a notorious republican and socialist and a well-informed, clear-minded thinker', and no less for his wife. He painted her with her baby on several occasions and repeatedly portrayed her as *La Berceuse*, a symbol of motherhood and of the warmth and safety of family life, which Van Gogh himself missed so deeply. Why he should have associated this French family with Russians is a mystery; it might have been Roulin's huge beard and general appearance, though he describes the Roulin in his portraits as having 'a face like Socrates'. He certainly does not resemble any of the characters in the Russian literature which Van Gogh mentions in his correspondence.

There are two closely related portraits of the eleven-year-old Camille Roulin. They show a boy with a large beret, his eyes cast down as if he is too shy to look at the painter – and therefore the spectator. Whereas the *Berceuse* paintings and various other portraits of the family are in the Cloissonist style, with flat areas of colour separated by strong outlines, Van Gogh has used a range of colours and varied brushstrokes to add interest to the surfaces of this painting. The beret, the jacket and the boy's face are modelled and animated by the brushwork. The technique is similar to his self-portrait from Paris (cat. no. 30), though it is freer and less systematic here.

PROVENANCE: J. van Gogh-Bonger, Amsterdam; V.W. van Gogh, Laren; Vincent van Gogh Foundation, 1962; on permanent loan to the museum, 1973.

LITERATURE: De la Faille 1970, F 538.

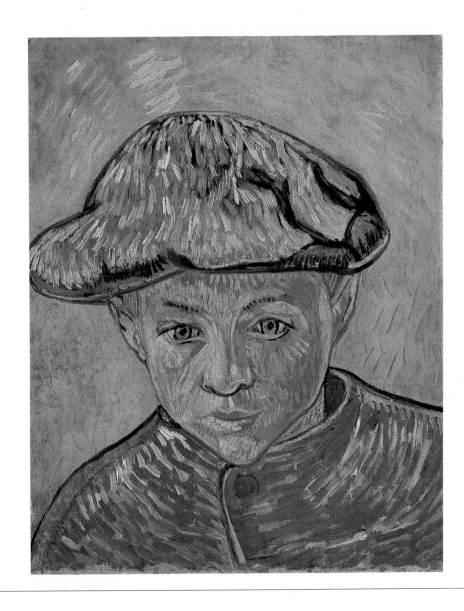

34

V.W. van Gogh
Olive Grove, 1889
Oil on canvas, 73 x 92.5 cm
Unsigned
Amsterdam, Rijksmuseum Vincent van Gogh (Vincent van Gogh Foundation)

speechless [B21]. Bernard, in his view, knew nothing of reality and had probably never even seen an olive tree. Van Gogh considered this type of quasi-religious art (he referred to Gauguin's and Bernard's works as 'abstractions') as unhealthy; he himself had been lured by it when painting his *Berceuses*, but had soon returned to reality. True religious sentiment was not to be found in biblical representations but in careful studies of man at work

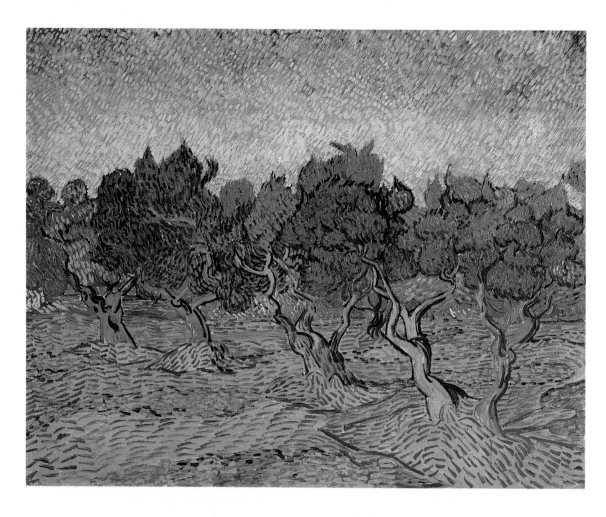

The rugged countryside around Saint-Rémy, where Van Gogh had himself admitted to an asylum in April 1889, was an area of olive groves. There had been no olive trees at Arles in the Rhone valley, and Van Gogh seized this opportunity to paint them. Even during his period in Brabant, he had revealed a sensitivity to the manifestations of the cycle of nature. This is also reflected in the paintings he produced in the South of France, although they were never intended to form a systematic series representing the seasons. He was delighted with the blossoming orchards in spring, the wheat fields and reapers in summer, and he turned to the olive groves in the autumn and winter. The grey and silvery tones of trunks and leaves, and the earthy colours of the arid soil were simply appropriate for the time of year. Moreover, olives are harvested in November and December, and he hoped ultimately to paint the harvest with figures. He mentions this in a letter to Theo in November 1889 [614]. In the same passage, interestingly, he voices bitter criticism of Gauguin, who had recently sent him a sketch of his painting of *Christ in the Garden of Olives*, while Emile Bernard's version of the same theme left him

in Nature. 'If I remain here, I will not paint Christ in the garden of olives, but people picking olives as they still do; and if you get the human figure right, it might serve as an allusion'. Not long afterwards he painted several versions of this subject. Van Gogh made no further comment about any religious connotation in his olive groves, with or without pickers. One might assume from the passage cited above that the strange, contorted tree trunks and the colours of these paintings were meant to convey a sense of tragedy, but his letters refer only briefly to light and colour, and not to their significance.

PROVENANCE: J. van Gogh-Bonger, Amsterdam; V.W. van Gogh, Laren; Vincent van Gogh Foundation, 1962; on permanent loan to the museum, 1973.

LITERATURE: De la Faille 1970, F 707; exhib. cat. New York 1986/87, no. 43; *Rijksmuseum Vincent van Gogh* 1987, pp. 274-275; exhib. cat. Amsterdam 1990, no. 108.

35
V.W. van Gogh
The Plough and the Harrow, 1890
Oil on canvas, 72 x 92 cm
Unsigned
Amsterdam, Rijksmuseum Vincent van Gogh (Vincent van Gogh Foundation)

During his stay at the asylum in Saint-Rémy, Van Gogh painted many views of the surrounding countryside, although he was not entirely free to leave the hospital as and when he pleased. During the autumn and winter of 1889/90, when confined indoors, he produced numerous paintings after prints of masterpieces he admired, including a *Pietà* after Delacroix and a *Raising of Lazarus* after Rembrandt. However, the vast majority were based on Millet, whose work impressed him more than that of any other nineteenth-century artist. Millet, he felt, had succeeded in creating a modern religious art without having to rely on biblical themes or ecclesiastical dogma; his piety found expression in his portrayals of simple peasants going about their everyday chores. At the beginning of his career Van Gogh had made numerous copies of Millet's work, which he regarded as a practical exercise. The copies he made in Saint-Rémy, however, though born of necessity, he saw as works in their own right. In letters to Theo he compared them with translations of literature, or a musician's subjective interpretation of a composition. The personal element in his paintings, he said, lay primarily in the use of colour. The prints he was working from were in black and white, and he was thus obliged to draw on his memory of Millet's work which he had seen at the major retrospective in Paris in 1887.

The model he used for the painting shown here was an engraving by Alfred Delaunay after Millet's composition, *Winter at Chailly*, from 1862-1864. There is an extant oil version and two pastel versions, one of which is in the proud possession of The Burrell Collection in Glasgow.

Van Gogh's copy after the engraving is quite idiosyncratic. He has transformed it into a more wintry scene by adding a fine layer of snow to the bare expanse of field. This was probably due to an erroneous interpretation of the engraving, since a letter he wrote to Theo even before starting on the piece refers to Millet's 'snow-covered field' [607].

Millet's landscape and Van Gogh's even more disconsolate variant of it stem from an age-old tradition of representing the seasons or the months of the year. Ploughing and harrowing were always associated with late autumn or winter. Peasants are generally shown at work in the fields and Millet almost invariably included them. This version, with only the implements left behind, shows the landscape at its most desolate. Van Gogh even managed to go a step further. The landscape in his painting is a kind of God's acre, such as those in the representations of winter in the series of seasons painted by the German Romantic artist Caspar David Friedrich.

PROVENANCE: J. van Gogh-Bonger, Amsterdam; V.W. van Gogh, Laren; Vincent van Gogh Stichting, 1962; on permanent loan to the museum, 1973.

LITERATURE: De la Faille 1970, F 632; *Rijksmuseum Vincent van Gogh* 1987, pp. 254-255; exhib. cat. Amsterdam 1988-1989, no. 43.

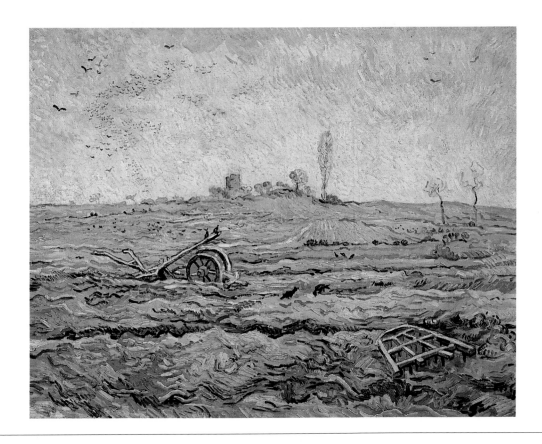

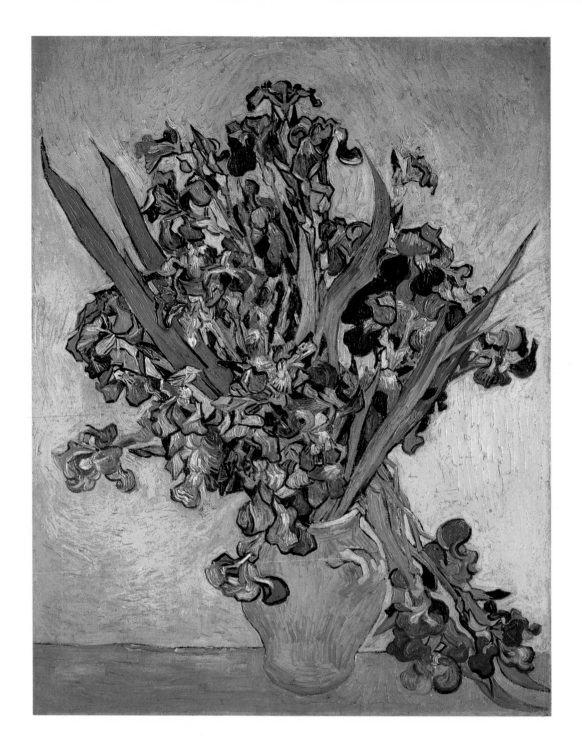

36
V.W. van Gogh
Still Life with Irises, 1890
Oil on canvas, 92 x 73.5 cm
Unsigned
Amsterdam, Rijksmuseum Vincent van Gogh (Vincent van Gogh Foundation)

Van Gogh painted very few flower still lifes in the Netherlands. Apart from the fact that it was considered a genre suitable only for women artists, his interests lay elsewhere. In Paris this changed. Here he emulated Monticelli's flower pieces, using rich impasto brushstrokes against a dark background to create a carpet of colour. Later, in Paris and Arles, Van Gogh developed his own approach to the flower piece, culminating in his many *Sun-*

flowers, which today are almost his trademark. He himself held them in high regard, as they were among the relatively few paintings he considered good enough to exhibit. Moreover, he intended to decorate a room in his Yellow House in Arles with them in honour of Gauguin's visit.

The technical and colouristic brilliance of the *Sunflowers* is equalled, if not surpassed, in the still lifes with roses and irises that he painted in Saint-Rémy in May 1890, shortly before his departure for Auvers. He worked like a man possessed, according to a letter he wrote to his sister Willemien. The Amsterdam painting has extremely bold contrasts between almost complementary colours; purplish blue is juxtaposed with yellow, and green with orange. Many of the shapes have dark outlines, echoing the Cloissonism used by Bernard, Gauguin and Van Gogh himself in his earlier work, although it is free and lightly

applied. The planes of colour are large and contain little detail. The blue irises are quite detailed, but the largest surfaces – the yellow background and the orange vase and the surface on which it stands – are enlivened only by the varied brushstrokes. The whole painting seems to sparkle and quiver with colour.

PROVENANCE: J. van Gogh-Bonger, Amsterdam; V.W. van Gogh, Laren; Vincent van Gogh Stichting, 1962; on permanent loan to the museum, 1973.

LITERATURE: De la Faille 1970, F 678; exhib. cat. New York 1986-1987, no. 51; *Rijksmuseum Vincent van Gogh* 1987, pp. 272-273; exhib. cat. Amsterdam 1990, no. 115.

37
V.W. VAN GOGH
Sorrow, 1882
Pencil and black chalk on brown paper, 44.5 x 27 cm
Signed lower left: *Vincent del*; annotated lower right: *Sorrow*, lower centre: *Comment se fait-il qu'il y ait sur la terre une femme seule – délaissé. Michelet*
Walsall, Walsall Museum & Art Gallery (Garman-Ryan Collection)

From December 1881 to September 1883 Van Gogh lived and worked in The Hague. Intent on becoming an artist, he seized every opportunity to draw from models, favouring elderly men in particular. Not only were their services cheap, but their care-worn features and tattered clothing – which Van Gogh himself sometimes provided – admirably suited the picturesque Realism he was trying to achieve. In this respect he was inspired by French and Dutch artists such as Millet and Jozef Israëls, as well as the British artist Hubert von Herkomer. He collected prints of their works, many of which documented scenes of poverty and hardship. Sien Hoornik, with whom he lived for a while, served as a willing model. There are surprisingly few extant nude drawings of her, since Van Gogh wrote in April 1882 that he was 'eager to [make] many more nude studies' [185].

The drawing shown here looks less like a study than a finished work in its own right. According to Van Gogh it was executed in the style of the British graphic artists he so admired. The figure is presented in a narrative context, which is endorsed by the annotation 'Sorrow' and a quotation from *La Femme* by the French novelist Michelet. Moreover, the sheet is signed and bears the inscription 'del.' (from the Latin *delineavit*, an abbreviation seen on prints or drawings to distinguish the person responsible for the original design from the engraver of the plates for reproduction). Van Gogh may have been hoping to have a print after the drawing published in a journal. He produced a lithograph after the drawing six months later, although only a few prints were made.

The drawing is of a naked woman sitting huddled on what looks like a tree stump. Her sorrow blinds her to the signs of hope around her – the bare, rather Japanese-looking tree in blossom in the background and the snowdrops, crocuses, primulas and other spring flowers at her feet. She is the personification of Sorrow and, more specifically, of the unhappy fate of the abandoned woman in the quotation from Michelet. No more fitting model could have been found: Sien Hoornik, who was pregnant and already had a small daughter, had been abandoned by her husband when Van Gogh started to live with her. He was evidently satisfied with the drawing and was complimented on it by several people, including J.H. Weissenbruch. Shortly afterwards he made a larger version, for Theo's birthday, showing only the figure, but this second drawing has unfortunately been lost. At the same time he sent a large drawing of tree roots, which he called *Les racines* and which, he said, he had tried to imbue with the same sentiment as the female figure. 'Thrusting roots to cling passionately to the earth, as it were, and yet half torn out by the storms'. Both drawings express 'the struggle of life' [195].

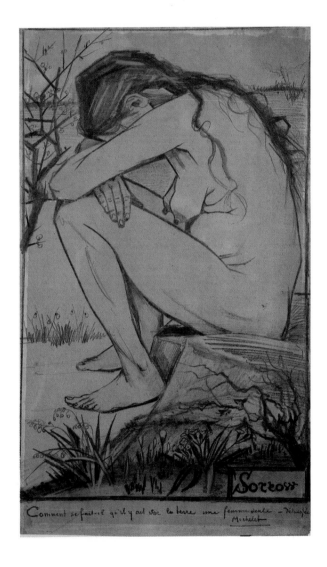

PROVENANCE: J. van Gogh-Bonger, Amsterdam; Montross Gallery, New York; T. Pitcairn, Bryn Athyn USA; auction (Christie's) London, 24 June 1966, no. 48; Lady Epstein, London; Garman-Ryan, London; on loan to the museum.

LITERATURE: Vanbeselaere 1937, pp. 81, 134, 136, 138, 408; De la Faille 1970, F 929A; Carol Zemel, 'Sorrowing women, rescuing men. Van Gogh's images of women and family', *Art History* 10 (1987), pp. 351-368; exhib. cat. Otterlo 1990, no. 35, p. 64.

Haan, Jacob Meyer de

Amsterdam 1852 - 1895 Amsterdam

De Haan was the son of a wealthy Jewish family. Though initially employed at his father's biscuit factory, he was more interested in becoming a painter and consequently relinquished his share in the business to his two brothers in exchange for a fixed monthly income.

He studied art under P.F. Greive for some time and in 1874 passed the entrance examination for the Amsterdam Academy. He suffered from a spinal deformity, however, and poor health forced him to leave the following year. At first he concentrated on portraits and figure pieces, generally favouring Jewish themes, and the early work he produced reflects his profound admiration for Rembrandt. In 1887, prompted by scathing criticism of his painting of *Uriël Acosta* (private collection), he decided to pursue his career abroad. He left for Paris in 1888, accompanied by his pupil J.J. Isaäcson. In Paris he contacted Theo van Gogh and lodged with him for several months. Mainly through Theo, he immersed himself in French Impressionism. At the end of the year he met Gauguin. Together with Gauguin, De Haan continued his studies in Pont-Aven and Le Pouldu in Brittany in 1889-1890. Under Gauguin's guidance, he produced landscapes, still lifes and a number of portraits, and in 1889 the two artists painted frescoes to decorate the walls of an inn in Le Pouldu, owned by Marie Henry. Though interested in Gauguin's synthetist theories of colour and form, De Haan did not adopt them indiscriminately, but continued to use chiaroscuro techniques and essentially realistic colours. He was resolutely opposed to any form of symbolism in painting, and chose his subjects solely for their pictorial qualities.

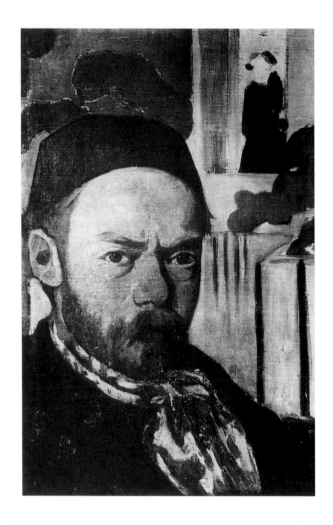

The friendship that had developed between the two men came to an abrupt end when Gauguin, jealous of De Haan's relationship with Marie Henry, incited her family to prevent the couple from marrying (Mari Poupée, as she was affectionately known, had an illegitimate child). In the autumn of 1890, De Haan's brothers summoned him to Paris to account for himself, and from there he returned to Amsterdam. The spring and summer of 1891 saw him in Paris again, by which time Marie Henry had given birth to their daughter. De Haan left Paris for the last time in November. His health suffered badly in the following years, and he was seldom able to paint, although he is believed to have spent part of 1893 working in Hattem. He died in 1895, having bequeathed all his paintings and his personal estate to Marie Henry. The collection remained intact until 1959, when it was auctioned and dispersed.

Literature: F. Dauchot, 'Meyer de Haan en Bretagne', *Gazette des Beaux-Arts* 6 (1952) 40, pp. 355-358; W. Jaworska, 'Jacob Meyer de Haan 1852-1895', *Nederlands kunsthistorisch jaarboek* 18 (1967), pp. 197-225; W. Jaworska, *Gauguin et l'Ecole de Pont-Aven*, Neuchatel 1971, pp. 87-106.

38
J.M. DE HAAN
Portrait of a Young Woman, *c.* 1886
Oil on canvas, 135 x 100,5 cm
Signed lower left: *M. de Haan*
Amsterdam, Joods Historisch Museum

This portrait of a girl from De Haan's early Dutch period contains no hint of the radical shift he was to make to the French Post-Impressionism of Gauguin and his circle. In the early 1880s De Haan was still very much influenced by Rembrandt and other Dutch masters of the seventeenth century. This was one of the major criticisms levelled at his ambitious Jewish history painting, *Uriël Acosta*, in a review in *De Nieuwe Gids* in 1888, which strengthened his resolve to go abroad. The portrait, too, shows the influence of seventeenth-century art, particularly the girl's careful pose, the lighting and the meticulous attention to textural detail. The delicate, immaculately rendered lacework reflects the fall of light from the side and immediately catches the eye. The identity of the girl is not known, but the painting would probably have been commissioned by a Jewish patron. Besides scenes from Jewish history, De Haan also painted a large number of portraits around 1880, a genre in which he excelled even while still a student at the Academy. The Rijksmuseum has a portrait of his teacher, P.F. Greive.

PROVENANCE: Amsterdam, Monet Gallery; purchased by the museum in 1983.

LITERATURE: I.N.S.[temming], 'Meijer de Haan's Uriël Acosta', *De Nieuwe Gids* 3, 1888, vol. 2, pp. 435-436; B. Welsh-Ovcharow, exhib. cat. *Vincent van Gogh and the Birth of Cloisonism*, Amsterdam (Rijksmuseum Vincent van Gogh) 1981, p. 346 (fig. 144).

39
J.M. DE HAAN
Flowers in a Glass, *c. 1890*
Oil on canvas, 35 x 27 cm
Unsigned
Josefowitz Collection

During his period in France, between 1889 and 1890, De Haan's style and palette changed significantly. He interpreted Gauguin's 'leçons d'impressionistes' in a highly personal way, and soon shed the sombre tone and detailed manner of his early Dutch work. Of the twenty-nine paintings which are thought to have been produced in Brittany, no fewer than fourteen are still lifes. They are rather unusual pictures. The often enlarged shapes are contained in small, almost square canvases. The pictorial elements are arranged asymmetrically in some of them, or the composition may contain a forceful diagonal line, such as the one formed by the sloping curtain in *Flowers in a Glass*.

The composition of *Flowers in a Glass* is divided horizontally into two parts, the lower half being painted in cool tones, the upper half in warm tones, while the flowers form a link between the blues of the window-sill and the glass, and the ochre and reddish-orange of the landscape in the background. De Haan has thus ignored the spatial values of the colours ('cool' recedes, 'warm' advances) or perhaps even deliberately reversed them in order to achieve a flattening effect. The colour harmony betrays Gauguin's influence, although De Haan has not paid too much attention to the theory of synthetism. The contours are heavy in parts, and his brushstrokes are more reminiscent of Cézanne than Gauguin. Another version of *Flowers in a Vase* is known; the dimensions are identical (private collection).

PROVENANCE: Marie Henry, Le Pouldu, 1895; Mme M.I. Cochennec, Rosporden; auction Paris (Hotel Drouot), 24 June 1959, no. 85.

LITERATURE: Jaworska 1971, p. 100.

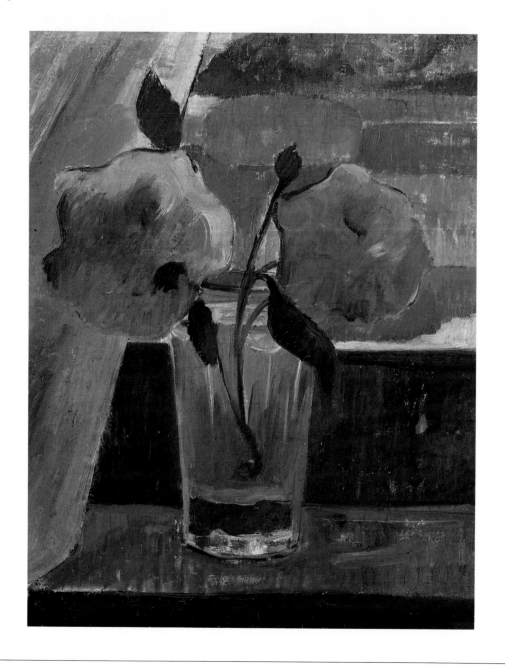

Haverman, Hendrik

Amsterdam 1857 - 1928 The Hague

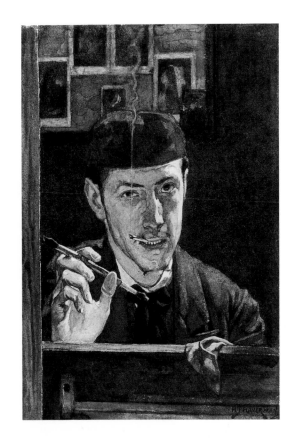

At the age of sixteen, Haverman was apprenticed to the designer-painter H.J. Plaat Jr, though his real ambition was to become an artist. He received drawing lessons from Hendrik Valkenburg and was admitted to the Amsterdam Academy in 1874. After graduating in 1878, he was awarded a royal grant which enabled him to study under Karel Verlat at the Antwerp Academy for a year. He then established himself as a painter in Brussels, where he met De Groux, Braekeleer and Dubois. But Haverman still felt he needed a certain amount of guidance. He returned to the Amsterdam Academy, which had gained prestige since Allebé's appointment as director, and was given the use of a studio at the Academy from 1881 until 1886. During this period he became a member of St Luke's Artists' Association and of Arti et Amicitiae. In order to earn a steady income, he held drawing classes for women at Felix Meritis, where he apparently made 'numerous contacts'. In 1889 he left Amsterdam on a journey to Morocco and Spain, where he adopted a loose, impressionistic style, comparable to that of Breitner and De Zwart. Like Jacobus van Looy, he was inspired by his exotic surroundings, and one of his best known pieces is the huge *Market at Tangier* (The Hague, Haags Gemeentemuseum). In Spain he also painted portraits, including a series of Señora Caramba. Haverman's impressionistic technique was rather unrefined, and he himself ultimately found it unsatisfying. On returning to Amsterdam, he concentrated exclusively on delicately-rendered genre pieces and portraits, revealing Allebé's influence. The 'contacts' he had made earlier proved their worth, and Haverman became a highly successful portraitist.

He married in 1890 and moved to a house in the country near Diepenveen. He was soon bored, however, and returned to The Hague in 1892, where he joined the Dutch Society of Watercolourists. Following the example of Jan Veth, Haverman began making lithographed portraits of well-known contemporaries. He published several plates in *De Kroniek* and *Woord en Beeld*, to which he also contributed a number of art reviews. He received various distinctions for his work as a portraitist, including a knighthood in the Belgian Order of Leopold.

Literature: J. de Meester, 'H.J. Haverman', *Neerlands Roem en Grootheid. Meesterwerken in Woord en Beeld*, 15 (1898), pp. 397-412; G.H. Marius, 'H.J. Haverman', *Elsevier's Geïllustreerd Maandschrift* 1 (1902) 2, pp. 89-99; H. de Boer, 'H.J. Haverman', *Elsevier's Geïllustreerd Maandschrift*, 28 (1918) 56, pp. 361-373; G.H. Marius, *De Hollandsche Schilderkunst in de negentiende eeuw*, The Hague 1920, pp. 241-245.

40

H. Haverman
Old Nurse with Child, 1893
Oil on panel, 49 x 28 cm
Signed lower right: *H.J. Haverman*
The Hague, Haags Gemeentemuseum

Haverman's *Old Nurse with Child*, also known as *Young Life*, is an intimate genre painting by an artist principally known for his portraits. The elderly, wrinkled nurse and the small child are painted as a unity, youth and old age, two phases of life in which it is not outward appearances but the intensity of the moment that is important. The two are taking the air in a garden on a summer's day, with the rhododendron in bloom and the rose displaying its first pale-yellow flowers, obviously a symbol of new life unfolding. In both theme and technique, Haverman is midway between Realism and Symbolism. This small panel bears witness to his years of study under Allebé, not only in the fine style of painting and in his use of natural colours, but also in the choice of an anecdotal motif drawn from every-day life, with a slightly symbolic connotation. Masters of the Hague School such as Neuhuys, Blommers and Jozef Israëls, had also depicted genre scenes of this sort, but their emphasis on their subjects' poverty gave their work a sentimental undertone. The young Amsterdam painters, such as Veth, Roland Holst and Haverman, were more concerned with the psychological element. They also attached great importance to tight composition. Haverman painted numerous versions of the old nurse in the traditional costume of Zeeland. He depicted her in a variety of poses, indoors and outside, with either one or two children. She also appears as the model for the *Burgher of Deventer* in a plate in *De Kroniek* of 15 December 1895.

PROVENANCE: B. Freriks, Utrecht, 1898; J. Jurriaan Kok; donated to the museum, 1913; on loan to Leyenburg Hospital, The Hague, 1971.

EXHIBITIONS: *Teekeningen van leden der Maatschappij*, Amsterdam (Arti et Amicitiae) 1893, no. 39 ('Oude baker met kind').

LITERATURE: De Meester 1898, p. 97; Marius 1902, p. 97; Marius 1920, p. 245.

EXHIBITIONS: *Teekeningen van leden der Maatschappij*, Amsterdam (Arti et Amicitiae) 1893, no. 39 ('Oude baker met kind').

41

H. HAVERMAN
The Orphan, *c.* 1895
Watercolour and chalk, 51.5 x 19 cm
Signed lower right: *H.J. Haverman*
The Hague, Rijksmuseum H.W. Mesdag

The girl gazes straight out of the picture, with an anxious, aloof expression. Her dark-blue skirt, black cape, white jabot and little cap, like a halo around her head, are the uniform of children entrusted to the care of the Dutch Reformed Church. The quiet background shows a pale green lawn with a solitary tree on the left and a row of dark trees along the raised horizon. The frontal view gives the figure an almost hieratic quality, which is heightened by the flatness of the representation and the narrow, vertical format of the canvas. The figure includes too much naturalistic detail to be decorative, but Haverman obviously absorbed the same influences as his contemporaries Veth, Derkinderen, Voerman and Verkade. They had all studied Holbein and the Flemish primitives, the English Pre-Raphaelites and Puvis de Chavannes, and were admirers of Japanese art. These influences in combination produced a 'modern' stylised design. Haverman also made a lithograph of *The Orphan* after the watercolour. It appeared in *De Kroniek* in 1896, showing the figure in reverse. The background here is flatter and the bottom and sides of the composition have been shortened slightly.

PROVENANCE: purchased by H.W. Mesdag at the exhibition of the Dutch Society of Watercolourists in The Hague in 1896, together with the watercolour *Moederweelde* for ƒ 220.

EXHIBITIONS: *21st exhibition of the Dutch Society of Watercolourists*, The Hague (Pulchri Studio), August-September 1896, no. 44 ('Weeze, Nederduitsch Hervormde Gemeente').

LITERATURE: E. van Schendel, *Museum Mesdag. Nederlandse negentiende-eeuwse schilderijen, tekeningen en grafiek*, The Hague 1975, p. 72.

Israëls, Isaac

Amsterdam 1865 - 1934 The Hague

Isaac Israëls was the only son of the painter Jozef Israëls and Aleida Schaap. He had one elder sister. In 1871 the family moved to The Hague, attracted by its conducive artistic climate. Isaac was brought up with a love of the arts, literature and travel (the family toured Europe in 1877) and developed into a child prodigy. From 1878 to 1880 he attended the Hague Academy, where his fellow pupils included Bauer, Verster and Breitner. At the age of sixteen, he made his debut at the 1881 Exhibition of Living Masters in The Hague, to which he submitted *The Fencing Lesson*, which Hendrik Mesdag had bought even before it was completed. A year later, his work was shown at the Paris Salon for the first time, while his *Transport of Colonial Soldiers* (fig. 6) received an honourable mention at the Salon in 1885. He also exhibited work with *Les Vingt* in Brussels in the same year.

Until then, Israëls had concentrated on figure pieces, portraits, processions and especially military scenes, producing some unusually large works in these genres. Breitner shared his enthusiasm for military themes, which were enjoying great popularity internationally. The ensuing period was a time of exploration and experimentation for Israëls. He made brief trips to the provinces of Drenthe, Zeeland and Brabant, to the Borinage in Belgium and to Paris, where he drew landscapes and people at work in factories. Then, like Breitner, he registered at the Amsterdam Academy in 1886-1887. Professor Allebé, however, considered him too advanced to benefit from the course, so Israëls established himself in his father's former studio on the Rozengracht. He joined Arti and became part of the circle around *De Nieuwe Gids*.

In 1888 he moved to the Oosterpark neighbourhood, where Haverman and Breitner lived, and where Witsen took up residence in 1891. For some time his work developed parallel to Breitner's, as the two men encouraged and inspired each other. Together with Frans Erens, he scoured the city in search of contemporary motifs – life on the streets, in bars and in theatres. His choice of subjects was influenced by Zola's books and by Manet and Degas. He was also interested in Redon and Whistler and admired Japanese prints. In his first few years in Amsterdam, Israëls was fascinated by the challenge of capturing the uniqueness of a given moment, and practised doing so by repeatedly sketching the same subjects. At first he scarcely painted or exhibited his work, but he did succeed in developing a style of his own. He emerged in public as a painter again after 1894.

Following the death of his mother, he travelled to Spain with his father and Frans Erens in 1894. On returning to Amsterdam, he applied himself to painting outdoors along the canals and in the parks. He also worked at the seaside, in Scheveningen for example (with his father and Max Liebermann) and on the islands of Marken and Urk. His palette became steadily lighter and he developed a spontaneous-looking and virtuoso painting style. In about 1900, Israëls extended his range of subject matter to include pictures from the world of fashion houses. In 1903 he moved to Paris where he stayed for ten years. He spent the following decade in London, making the occasional journey, in some cases to quite distant parts, before returning to his parents' home in The Hague in 1923.

Israëls was essentially a free spirit. He travelled widely and wanted to keep his material possessions to a minimum. His lifestyle was sober. He never married, and died in 1934 from injuries sustained in a traffic accident.

Literature: F. Erens, 'Isaac Israëls', *Elsevier's Geïllustreerd Maandschrift*, 10 (1900) 20, pp. 1-13 (copy in *Litteraire wandelingen*, Amsterdam 1906, pp. 145-159); G.H. Marius, 'Isaac Israëls', *Onze Kunst* 15 (1916) 29, pp. 141-162; G.H. Marius, *De Nederlandsche schilderkunst in de negentiende eeuw*, The Hague 1920, pp. 205-208; W. Steenhoff, 'Isaac Israëls', *Elsevier's Geïllustreerd Maandschrift* 36 (1926) 72, pp. 1-12; A.M. Hammacher, *Amsterdamsche impressionisten en hun kring*, Amsterdam 1941, pp. 62-65; Frans Erens, *Vervlogen jaren*, The Hague 1982, pp. 261-277 (introduction by A. van Duinkerken, complete edition with notes by Harry M.G. Prick); A.M. Hammacher, 'Isaac Israëls-Liebermann en het Frans impressionisme', *Museumjournaal*, 4 (1959) 8/9, pp. 142, 143; L. Gans, 'Het "onhollandse" in de kunst van Isaac Israëls', *Museumjournaal* 4 (1959) 8/9, pp. 144-149; J.H. Reisel, *Isaac Israëls. Portret van een Hollandse impressionist*, Amsterdam 1967; Anna Wagner, *Isaac Israëls*, Venlo 1985 (with bibliography; first edition Rotterdam 1967).

42

I. Israëls
Dance Hall on the Zeedijk, *c.* 1893
Oil on canvas, 76 x 100 cm
Signed lower right: *Isaac Israëls*
Otterlo, Rijksmuseum Kröller-Müller

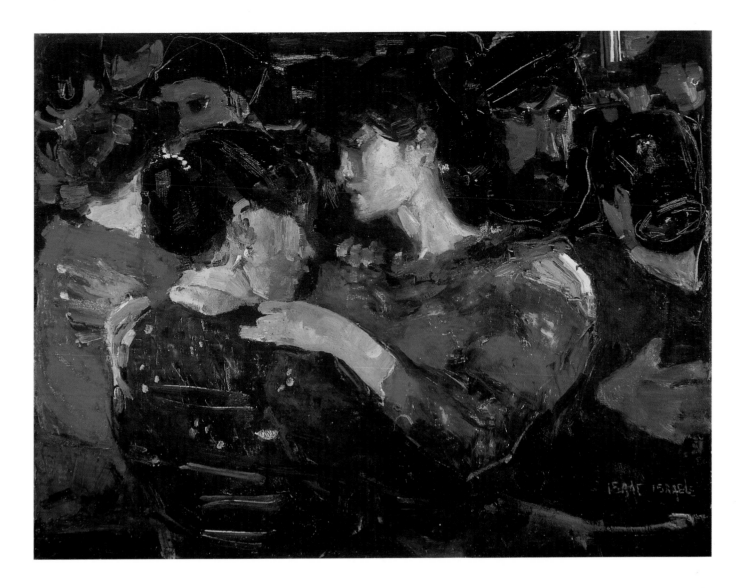

In a review of the 1894 exhibition in Nijmegen, A.C. Loffelt refers to a 'bouquet of dancing street girls' by Isaac Israëls, adding caustically that 'only when we live in a world of Zolas and pimps, will such offensive pictures find their way into our homes. The technique is of the same standard as the subject – coarse and ugly.' Not everyone shared this opinion. An enthusiastic reviewer in *De Nederlandsche Spectator* thought it a superior piece and the finest example of Israëls's work.

Like Zola, Israëls did not shun the seamy side of life, but saw instead its intrinsic beauty. Together with the novelist and poet Frans Erens, or with Breitner or De Zwart, Israëls frequented bars, cafés and other places of public entertainment in Amsterdam. He made many sketches of ordinary people enjoying a night out in the seamen's bars along the Zeedijk or Haarlemmerdijk, and incorporated some of them in his cover design for *Dansen en Rhytmen*, an anthology of fiction by Erens, which was published in 1893. He must also have drawn on this rich store of sketches for *The Dance Hall on Zeedijk*, though the specific example on which it was based is unknown (Wagner 1985, pp. 41-43).

Israëls has captured the sultry atmosphere of the dance hall. His portrayal of the two women, shown close up and almost life-sized, conveys to the viewer the sensation of being in the same, confined space, in danger of bumping into the surly man with the cigarette in his mouth, who is clutching his partner in his huge fist and heaving her around the dance-floor.

Israëls's technique and colours give the work a raw, insistent quality. He has applied much of the paint with a palette-knife, softening the effect slightly in some areas by using a broad brush, while the contours of the heads in the background have been scratched into the paint with the blunt end of the brush. Toorop used a similar technique around 1885, in his portrayal of *Brussels Students* (cat. no. 86). The mask-like heads crowded together also recall his work.

PROVENANCE: H.G. Samson, Amsterdam, 1894; C.M. van Gogh Gallery, Amsterdam; purchased by the museum, 1967.

EXHIBITIONS: *Schilder- en Beeldhouwkunst*, Nijmegen (Sociëteit de Vereeniging), June-July 1894; *Kunstwerken vervaardigd door leden der Maatschappij*, Amsterdam (Arti et Amicitiae) 1894, no. 58 ('Het Danshuis'; H.G. Samson Collection); *Studies enz. vervaardigd door Leden der Maatschappij*, Amsterdam (Arti et Amicitiae) 1895, cat. no. 60 (ƒ 200)?; *Schilderijen van werkende Leden*, The Hague (Pulchri Studio) 1895, no. 46?

LITERATURE: E.G.O. (A.C. Loffelt), *Het Vaderland* 28 June 1894; G., *De Nederlandsche Spectator*, 28 July 1894, 23 March 1895; G., *De Amsterdammer* (daily), 10 November 1894; *Nieuwe Rotterdamsche Courant*, 30 October 1894; Marius 1920, p. 207;.

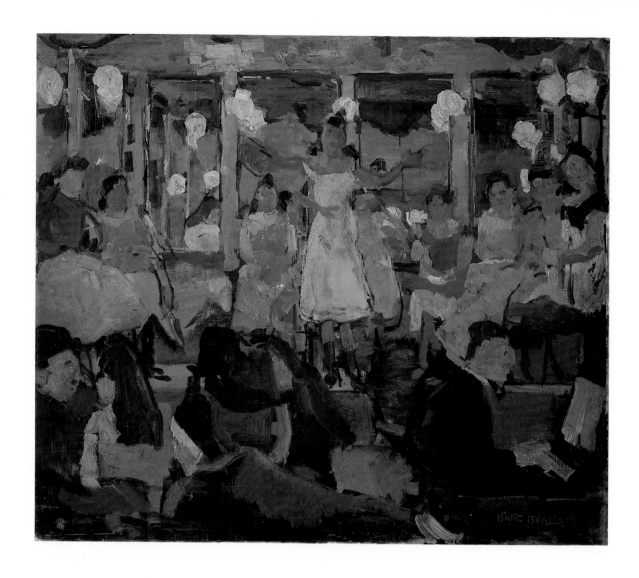

43

I. ISRAËLS

Café Chantant on the Nes in Amsterdam, *c.* 1893

Oil on canvas, 90 x 105 cm

Signed lower right: *Isaac Israëls*

Otterlo, Rijksmuseum Kröller-Müller

The world of variety theatre, cafés and houses of ill-repute provided a source of inspiration for Isaac Israëls, particularly from the 1890s onwards. *Café Chantant on the Nes* probably dates from around 1893, about the same time as his *Dance Hall on the Zeedijk* (cat. no. 42). In contrast to the latter work, Israëls places the viewer at one remove in this painting. We find ourselves at the back of the room, looking over the heads of the audience and the pianist, towards the stage. A young woman is singing, with her fellow entertainers grouped in a semi-circle around her, awaiting their turn. The whole scene has an air of amateurism, an impression which seems to have been deliberately accentuated in certain aspects of the characterisation. It is quite clear that the evening holds no surprises for the waiting artistes, or for the pianist, who, though hammering away enthusiastically on the keyboard, cannot manage without the music. Nor does the audience seem particularly interested in the entertainment. The couple in the left foreground, for example, have eyes only for

each other. Israëls's portrayal of the singer typifies the atmosphere. Her slightly wooden stance, the quasi-dramatic gesture of the hand and the large pink bow in her hair undermine the contrived sense of frivolity.

One of Isaac Israëls's qualities as a painter is his ability to present a diversity of images in an extremely lively manner, within a relatively tightly planned composition. The horizontal and vertical lines of the stage and the large mirrors in the background give the picture a remarkably compact structure. The effect is accentuated by the distribution of colour and the light-dark contrast between foreground and background. A single bold colour accent creates a link between the two.

Similar scenes of women singing or dancing, often against a background of mirrors, feature prominently in the work of the French Impressionists such as Manet, Degas and Toulouse-Lautrec. They, too, tend to give us a glimpse from the back of a room, drawing the eye over rows of figures with their backs to us, to a brightly-lit, colourful stage. Israëls must undoubtedly have seen examples on his visits to Paris. *Café Chantant on the Nes*, however, lacks the cosmopolitan allure of the works of the French artists. Instead, the atmosphere is closer to that evoked by the faintly censorious closing lines of Hein Boeken's poem *Café Chantant*, published in *De Nieuwe Gids* in 1888: *Nu zitten daar die vrouwen op een rij / En zinge 'om beurte' een liedje van*

genieten / En zijn een blijd en vrolijk tijdverdrijf / (There they sit, the women in a line / Rising one by one to sing their happy songs / A gay and merry way to while away the time.)

PROVENANCE: J.M.P. Glerum, Amsterdam; J. Sluyters; H.E. ten Kate, Lonneker; E.J. van Wisselingh & Co., Amsterdam, 1950; purchased by the museum, 1950.

44

I. ISRAËLS
Reclining Nude with Stockings, *c.* 1893
Oil on canvas, 60 x 80 cm
Signed lower right: *Isaac Israëls*
Private collection (formerly P.B. van Voorst van Beest Gallery)

Prior to 1900 Isaac Israëls produced a considerable number of drawings but few paintings of nude models. Nevertheless, he seems very much at home with the motif in his *Reclining Nude with Stockings*. He has approached his subject candidly and executed the work quickly. Indeed, it seems to have been completed in a single session, with a blunt, rapid brush which in some places has barely touched the canvas. He shows the woman slumped to one side from a sitting position. This is a fairly unusual pose in the nude genre, although Breitner used it in many of his portrayals of girls in kimonos from the same period (cat. no. 13). Breitner was, incidentally, the only one of the younger generation of artists to concentrate on the nude.

Although Israëls signed the canvas, he never exhibited it. His uninhibited portrayal of the woman, whose black stockings and red cheeks give her the appearance of a prostitute, would undoubtedly have shocked the public, but Israëls apparently had no desire to challenge bourgeois morality. It was still customary at the time to place nudes in an allegorical context, thus elevating the theme above the purely physical. The *Nude at a Spring* by Isaac's father Jozef Israëls is to all intents and purposes an example of this approach (cat. no. 48). The *Reclining Nude with Stockings* reflects the credo of passion advocated by Breitner and Isaac Israëls. According to Hammacher (1941, p. 65), both sought 'the woman of strong instinct, not the constricted life of the bourgeoisie'.

PROVENANCE: Mrs E.L.J. Kröller-Müller, The Hague; P.J. Nieuwenhuizen Segaar Gallery, The Hague; Ladenius Boersma, Haarlem, 1959; auction Amsterdam (Mak van Waay), 27 June 1973; Van Voorst van Beest Gallery, The Hague, 1981.

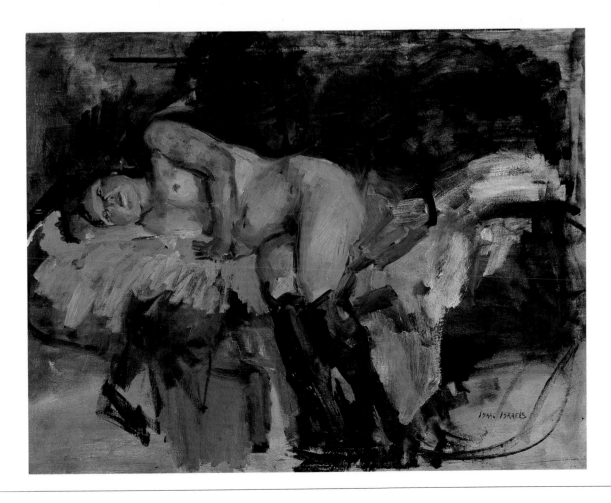

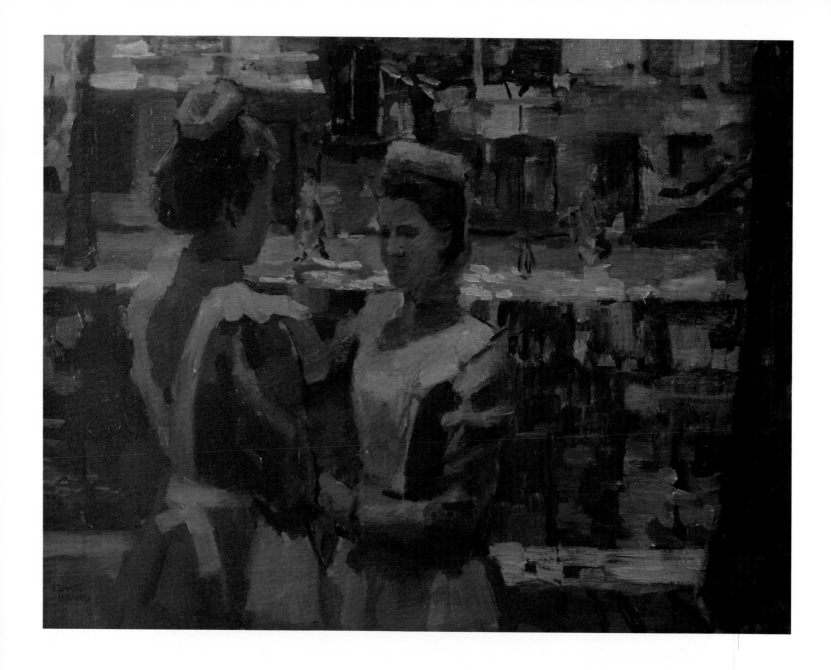

45

I. ISRAËLS

Two Maids on a Canal in Amsterdam, *c.* 1894

Oil on canvas, 60 x 80 cm

Signed lower left: *Isaac Israëls*

Groningen, Groninger Museum voor Stad en Lande

Although Isaac Israëls had obtained permission from the local authorities in Amsterdam to paint out on the streets in 1891, it was not until 1894 that he seriously began to do so. By all accounts, he invariably attracted a crowd of curious onlookers as he worked on the canals and bridges. *Two Maids on a Canal in Amsterdam* was probably executed outdoors. It is suffused with bright clear daylight. The brushstrokes are broad and controlled, and to harmonise with the regular planes within the composition. Israëls favoured this sort of rigid arrangement of the picture. Because the two maids are viewed at such close range – with

the result that the figures are cut off abruptly as if in a photograph – the viewer has the impression of being a witness to the scene, like a passer-by who can catch snatches of the conversation. He used this motif a second time in a similar painting, *Amsterdam Maids* (Amsterdam, Rijksmuseum).

While Israëls's *plein air* studies gain in clarity and virtuosity, they have lost some of the intensity of feeling that characterised his earlier work. This is also related to his choice of subjects from every-day life. Unlike his father, Jozef Israëls, Isaac's mature work lacks any deeper emotion, sentiment or social message. The charm of the fleeting moment and his success in capturing atmosphere, however, save his work from superficiality.

PROVENANCE: donated to the museum by S. Israëls, 1982.

46

I. ISRAËLS

The Rifleman's Funeral, *c.* 1881

Watercolour 37.9 x 67.8 cm.

Signed and dated lower right: *Isaac Israëls 1881*

Amsterdam, Stedelijk Museum

The Rifleman's Funeral, also known as the *Military Funeral*, shows a number of soldiers taking turns to fire into a grave as a last tribute to their dead comrade. The only spectators are two grave-diggers standing to the left. The site is surrounded by a roughly-sketched fence with a dense mass of trees behind it. The funeral is taking place in a corner of the cemetery on Kerkhoflaan in The Hague.

The watercolour is a detailed study for a large painting Is-raëls was to make in 1882. The finished work and a pencil study of the same motif are at the Haags Gemeentemuseum. Israëls was only seventeen when he completed this ambitious painting. He submitted it to the Paris Salon in 1882, where it was favourably reviewed by prominent critics such as Albert Wolff.

The major differences between the painting and the water-colour study are in the setting in which the event is taking place.

The painting shows the funeral in a bare winter landscape. The group around the grave is almost identical to the one in the wa-tercolour, but the motif is set further in the distance. There are also more figures in the painting; an old man is standing a little way behind the riflemen and a couple of inquisitive schoolboys are approaching the scene from the right. Furthermore, the col-ours are quite different, as the two versions depict the episode in different seasons. The watercolour, with its green background, the grey-green and contrasting yellow of the soldiers' uniforms, the grave-diggers' blue jackets and the predominantly ochre foreground, is far more colourful than the painting.

Isaac Israëls was not the only Dutch painter to concentrate on military subjects. Breitner, Verster and Rochussen, the latter representing an older generation of artists, also produced work in this genre around the same time.

PROVENANCE: B. Mendelsohn; purchased by the museum, 1958.

LITERATURE: H.E. van Gelder, 'Isaac Israëls Militaire begrafenis', *Mededee-lingen Dienst van Kunsten en Wetenschappen der gemeente 's-Gravenhage*, March 1939, pp. 61-64; Wagner 1985, pp. 14-15.

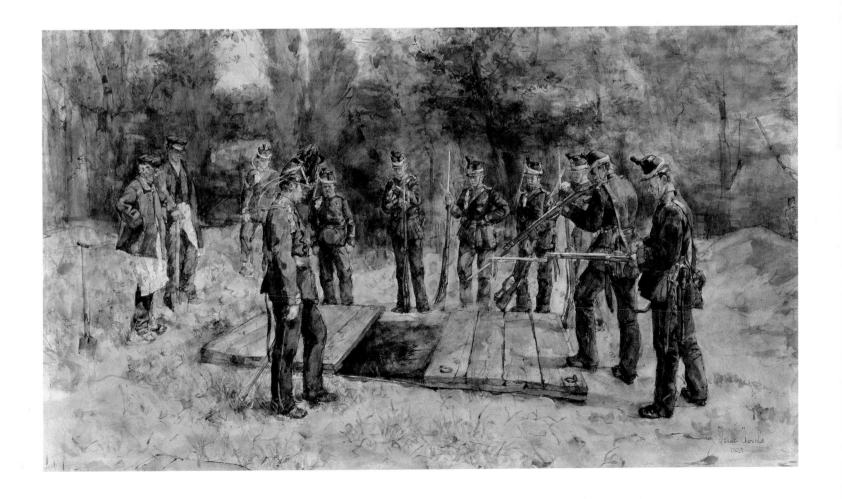

Israëls, Jozef

Groningen 1824 - 1911 The Hague

Practically no nineteenth-century Dutch artist enjoyed as much international acclaim in his own lifetime as Jozef Israëls. Nor, probably, was any other artist so productive and versatile. In a long career, spanning almost seventy years, this prolific artist produced paintings, drawings and etchings, and wrote books, poetry and reviews.

Israëls came from a Jewish family. He enrolled at the Minerva Academy in Groningen in 1835 and at the Academy in Amsterdam in 1842, where he attended evening classes under the renowned history painter Jan Willem Pieneman, while also studying during the day with Jan Kruseman. Admiration for the work of Ary Scheffer took him to Paris in 1845. He was admitted to the studio of F. Picot and studied at the Ecole des Beaux Arts. On returning to Amsterdam he concentrated on portraiture and genre and history pieces. In 1850 he won his first major success with *Ophelia*, or *Meditation* (Dordrecht, Dordrechts Museum), a work with romantic overtones which owed much to Scheffer, whom Israëls in fact only met in 1853.

In 1855 Israëls's art changed direction. Forced to spend some time in Zandvoort for health reasons, he became fascinated by the life of the fishing community. Inspired by the numerous canvases of fishermen and peasant life shown at the Paris World Exhibition, and by the work of foreign painters who visited Dutch coastal villages, he turned his attention to the fishing genre, which had already gained popularity in other countries. His work was widely acclaimed and he gained an international reputation with *Past Mother's Grave* in 1856 (Amsterdam, Stedelijk Museum) and *The Drowned Fisherman*, 1861 (London, Tate Gallery). He painted several romantic-realistic pieces representing death. After his marriage to Aleida Schaap in 1863 he abandoned the motif temporarily in favour of more idyllic domestic interiors such as *The Cottage Madonna*, c. 1867 (Detroit, the Detroit Institute of Arts).

From 1863 to 1871 the couple lived in Amsterdam, where their daughter and son Isaac were born. In 1871 they settled permanently in The Hague. Israëls had a large studio built in the garden of his home at 2 Koninginnegracht, with a special 'fishing corner' where his models posed. During these years he paid regular visits to the village of Laren in the Gooi region, and shortly afterwards Mauve, Neuhuys and others followed his example. He found a kindred spirit in the German painter, Max Liebermann, and maintained contact with him. In 1878 he again took up the deathbed motif after a long interval, producing *Alone in the World* (Amsterdam, Rijksmuseum). This was followed shortly afterwards by other works in which human suffering was the central theme, such as *Nothing More*, 1880-1881, which portrays a man sitting alone at his wife's deathbed (The Hague, Rijksmuseum H.W. Mesdag), and *Growing Old*, 1878 or 1883 (The Hague, Haags Gemeentemuseum), with which he won great acclaim. These are not anecdotal pictures but, as De Gruyter describes them, 'stories without a story'; they have no intrigue or plot, but are solely concerned with the way in which

people perceive the world and experience the harshness of their lives. He uses sharp contrasts of dark and light to heighten the dramatic impact of these images. Israëls briefly outlined the object of his work in a short poem published in *De Nederlandsche Spectator* of 9 September 1882: 'Yes! to capture an idea in a work of art, That can penetrate the human heart, To sing therein of sorrow or delight, For this my muse strives with all its might.'

The 1890s heralded the final phase of his work. His brushwork gradually became looser, contours and shapes grew vague and the chiaroscuro was somewhat muted as he sought to enhance the mood of his pictures. His choice of subjects changed, too. Besides variations on earlier themes, he again sought inspiration from biblical subjects, and after 1900 focused on scenes from Jewish life (*The Jewish Scribe*, Otterlo, Rijksmuseum Kröller-Müller). His work also became more autobiographical, as is evident from the many self-portraits he made (*The Evening of Life*, The Hague, Haags Gemeentemuseum).

After the death of his wife in 1894, he travelled to Spain and North Africa in the company of his son and the writer Frans Erens, publishing a detailed account of this trip in 1899. He enjoyed travelling. After 1878, he and his family made an annual pilgrimage to the Paris Salon, and late in life he was still able to travel to the Venetian Biennale in 1904 and 1910. His fame was unparalleled at the time. He received numerous distinctions and was hailed as a second Rembrandt. He died in 1911 and was given a state funeral.

Literature: Jozef Israëls, *Spanje, een reisverhaal*, The Hague [1899]; Jan Veth, 'De jeugd van Jozef Israëls', *Portretstudies en Silhouetten*, Amsterdam [1908], pp. 86-122; Max Eisler, *Jozef Israëls*, London 1924 (special Spring edition of the Studio); exhib. cat. *Herdenkingstentoonstelling Jozef Israëls 1824-1911*, Groningen (Groninger Museum voor Stad en Lande) etc. 1961-62; Jos. de Gruyter, *De Haagse School*, Rotterdam 1968, vol. 1, pp. 46-59; Dieuwertje Dekkers, *Een visserstragedie groot geschilderd. Jozef Israëls' 'Langs moeders graf'*, Zwolle 1989; bibliography in exhib. cat. *De Haagse School. Hollandse meesters van de 19de eeuw*, Paris (Grand Palais) etc. 1983, bibliography pp. 337-338.

47

J. Israëls

Pancake Day, *c.* 1885

Oil on canvas, 155 x 198 cm

Signed lower right: *Jozef Israëls*

Rotterdam, J. van Dijk

In the 1880s Israëls produced countless scenes with a meal as the focal point of the composition. He shows food being prepared or eaten, or grace being said, in an atmosphere which conveys a sense of gratitude. These large, detailed compositions emphasise the fact that food is obtained through hard toil. *Pancake Day* shows a woman lifting a pancake from the frying pan while her husband and children look on expectantly, and even the cat is alert to the prospect of a rare treat. It must be a special occasion for this humble family, a brief moment of joy in a life which has little to offer.

Contemporaries saw Israëls as a poetic realist, a painter of ideas whose work expressed noble sentiments. His pictures are not stories with a specific narrative line, but reflections of human experience. This work, for example, captures a feeling of intimacy. The identity of the protagonists is irrelevant; 'the thoughts, the moods which they inspire are timeless, eternally human' (*De Nederlandsche Spectator*, 27 January 1894). Although Israëls had many admirers, among them some of the young painters from The Hague and Amsterdam, the public was not unanimously enthusiastic about this kind of work. In a review in 1885, Alberdingk Thijm wondered rhetorically who would want to hang 'such lifesize gloom in their sitting room'. He considered such art an affectation; 'this exploitation of despondency, (...) this constant dwelling on the paraphernalia of poverty – this is all mannerism, and it should be abandoned' (*De Amsterdammer*, April 1885). Thijm, a conservative critic who preferred elevated subjects, was not entirely incorrect. Israëls's work did have a certain affectation. As he did with much of his work, he produced numerous copies and variations of *Pancake Day* in different mediums or in various price ranges. In some, the boy is sitting on the man's right, or the children are replaced by a neighbour, while the man staring somewhat absently appears, with or without child, in numerous other guises, as in *Nothing More*, 1880-1881 (The Hague, Rijksmuseum H.W. Mesdag) or *A Son of the Ancient Tribe*, 1888 (Amsterdam, Rijksmuseum). The same applies to the setting and furnishings. Various large works dating from the 1880s, including *A Midday Meal in a Peasant Hut in Karlshaven near Delden*, 1885 (Dordrecht, Dordrecht Museum, fig. 17), show almost the same arrangement of furniture and a similar wall in the background. Israëls may have recorded certain elements in sketches on his travels, but at home in The Hague he refashioned them into a standard form.

PROVENANCE: J.M. Keiller, 1895; Lord Mount-Stephen, auction London (Christie, Manson & Woods), 19 May 1922, no. 40 with ill.; Eugene Cremetti; auction London (Christie, Manson & Woods), 1 June 1923, no. 110 with ill.; Sampson; auction Amsterdam (Christie's), 9 April 1981, no. 364; P. Lunshof Gallery, Amsterdam; auction Amsterdam (Sotheby's) 25 April 990, no. 20.

48

J. Israëls
Nude at a Spring, *c.* 1885
Oil on canvas, 55.5 x 82 cm
Signed lower right: *Jozef Israëls*
The Hague, Rijksmuseum H.W. Mesdag

Throughout his career, Jozef Israëls painted endless variations on a number of set themes within the fishing genre. Only in later life did he break away from this pattern and select different subjects. Besides biblical themes and scenes from Jewish life, he also produced a number of portraits and even ventured to paint a few nudes.

His *Nude at a Spring*, which can probably be dated around 1885, strongly reflects contemporary international taste, in particular that of Paris, which Israëls visited almost annually. It was an unusual subject for a painter of the Hague School, and he had only tackled the theme as a young man when, like Jacob Maris, he had depicted girls bathing. Nudes are entirely absent from the *oeuvre* of artists such as Mauve or Neuhuys. It was largely younger men, such as Breitner, Isaac Israëls and, occasionally, Floris Artzenius, who, unfettered by the demands of an academic establishment or specific commissions, breathed new life into the genre and portrayed nudes with frankness and without any historical or allegorical context. Jozef Israëls, however, continued to provide a context, as can be seen in his *Eve with the Serpent, c.* 1900 (Amsterdam, Stedelijk Museum). *Nude at a*

Spring, which Mesdag acquired around 1894, originally had titles such as *Baigneuse*, *Au bain*, or *La source*, but in 1905 Philippe Zilcken referred to it in his museum catalogue simply as a *Nude Study*. Whether Israëls worked from a model is doubtful, given the lack of proportion between the woman's head and her exceptionally long legs. The blurred brushwork renders her somewhat sexless. This effect was probably deliberate; because of the dim surroundings, which are only vaguely suggested, the eye constantly returns to the girl's pensive gaze. In this respect, the *Nude at a Spring* is a reworking of the much older theme of *Ophelia*, or *Meditation*, which Israëls painted in 1850 (Dordrecht, Dordrechts Museum), hoping to find 'poetry' in a literary theme. Here he has tried to capture the same mood primarily by pictorial means, an artistic advance undoubtedly influenced by Rembrandt's later work.

PROVENANCE: auction Amsterdam (C.F. Roos & Co) 5 April 1892, no. 44 ('Baigneuse'); mentioned in H.W. Mesdag Collection, 1895.

EXHIBITIONS: *Schilderijen en aquarellen van Jozef Israëls*, The Hague (Pulchri Studio) 1895, cat. no. 22.

LITERATURE: E.G.O. (A.C. Loffelt), *Het Vaderland*, 31 January 1895; M. Hols [ed.], *De Meesterwerken van Israëls. 32 Reproductieën naar zijne meest bekende schilderijen*, The Hague 1906 (Nederlandsche Meesters, vol. 1) ('Aan de bron'); J.E. Pythian, *Jozef Israëls*, London 1912, pp. 49-50; E. van Schendel, *Museum Mesdag. Nederlandse negentiende-eeuwse schilderijen, tekeningen en grafiek*, The Hague 1975, no. 155.

Jongkind, Johan Barthold

Latrop (Overijssel) 1819 - 1891 Grenoble

Before Jongkind was a year old his family moved to Vlaardingen. He grew up there and in neighbouring Maassluis. After leaving school he worked in an office, but his real passion was drawing, and in 1837 he enrolled at the Hague Academy, where he was taught by the romantic landscape artist Andreas Schelfhout. Jongkind's early winter landscapes were clearly influenced by Schelfhout's work. It was at this time that he also met Charles Rochussen, with whom he maintained contact for the rest of his life.

In 1846, after meeting the French painter Eugène Isabey in The Hague, Jongkind settled in Paris where he received an annual royal stipend. He was taught by Isabey, but also visited other studios where he practised drawing from models and studied perspective. In the years that followed, he regularly travelled to the Normandy coast and the Netherlands. He spent much of the latter half of the 1850s in Rotterdam and its environs. When his health deteriorated (he suffered from depression) his friends brought him back to Paris. In 1860 he met Joséphine Fesser, who was to become his lifelong companion. In the 1860s he still paid regular visits to Holland and Belgium, but after 1870 travelled only within France, visiting the south coast and other regions.

Jongkind's town views and rural landscapes, which incorporate both French and Dutch motifs, were much in demand among Parisian dealers and collectors as early as the 1850s. Although he produced his paintings in his studio, using studies which he had in some cases made years earlier, he tried to imbue them with the immediacy of work painted on the spot. His increasingly free, almost vibrating style was not always well received when he sought to exhibit his work. In 1863, a year in which numerous entries for the Salon were rejected, Jongkind's submission, together with Manet's and Whistler's, was turned down. The ensuing outcry led to the organisation of a *Salon des Refusés*. After a second rejection in 1873, Jongkind decided not to send work to the Salon again. In the meantime his reputation was growing steadily. Like Boudin, whose subject matter and loose brushwork were similar to his, he had gained a following among younger artists, especially those experimenting with Impressionism, such as Monet who admired him greatly.

A number of factors, including Jongkind's precarious mental health, caused him to withdraw more and more from Parisian artistic circles. In 1878 he settled with the Fesser family in La Côte-St André near Grenoble. Although he still travelled a great deal and also spent time in Paris, he devoted himself mainly to the landscape of the region in which he lived. He produced fewer paintings, but continued to make numerous drawings and watercolours of remarkable beauty. It was only after his death that his later work became known in the Netherlands through publications and exhibitions.

Literature: Charles Rochussen, 'Johan Barthold Jongkind', *Eigen Haard* 13 (1891), p. 186; Victorine Hefting, *Jongkind d'après sa correspondance*, Utrecht 1969; Victorine Hefting, *Jongkind. Sa vie, son oeuvre, son époque* [Paris 1975]; Marianne Büchler-Schild, *Johan Barthold Jongkind 1819-1891. Seine Stellung in der Landschafts- und Aquarelltradition des 19. Jahrhunderts*, Bern 1979; exhib. cat. *Johan Barthold Jongkind 1819-1891*, Dordrecht (Dordrechts Museum) etc. 1982.

49
J.B. JONGKIND
Grenoble, 1885
Oil on canvas, 33 x 56 cm
Signed lower right: *Jongkind 1885*; annotated and dated lower
left: *Grenoble 2 Juin 1885*
Amsterdam, Rijksmuseum Vincent van Gogh

In the 1880s Jongkind continued to hark back to Dutch motifs such as winter landscapes with skaters, although he had not set foot in his native country since 1869. More often, however, he chose subjects from the area in which he lived, or places he visited, such as the Côte d'Azur. The works he produced on his travels were mainly drawings and watercolours, executed with a minimum of means – a few pencil or chalk lines and a touch of transparent paint – to achieve the maximum impact in atmosphere and spatial effect. His works on paper are often precisely dated and constitute a record, or a diary in images, of his journeys through France.

In the last decade of his life, however, he rarely worked in oil and the quality of his paintings was variable. His unstable physical and mental health seems to have prevented him from mastering the technique, although watercolour did not pose a problem. Sometimes, however, he succeeded, as in this view of Grenoble. The qualities that the younger Impressionists such as Monet and Sisley had always admired in his work are apparent here in the pearly light, the snow-covered mountains in the distance and their reflection in the Isère, and in the fort of Rabot on the hill to the left. The canvas is one of the few that bears an exact date – 2 June 1885 – like the pages of his watercolour diary. This may indicate that the work was completed in a single session. Whether it was painted on the spot is uncertain, as Jongkind was not in the habit of painting *en plein air*. He generally worked in his studio, using sketches made on his trips.

He also produced two watercolours of the same motif, but seen from different vantage points. They are dated 1 and 2 June 1885, which suggests that these must have been unusually productive days. The watercolours measure approximately 16 x 49 cm, and are examples of the panorama format he often devised by using two adjacent pages in his sketchbook. The course followed by the river banks in the oil painting differs conspicuously from that in the watercolours, while the landscape is tighter and more compact, and the sky takes up a larger area. The way in which it is rendered confirms that Jongkind has lost none of his former mastery.

PROVENANCE: Van Voorst van Beest Gallery, The Hague; purchased by the museum, 1990.

LITERATURE: Hefting 1975, no. 786.

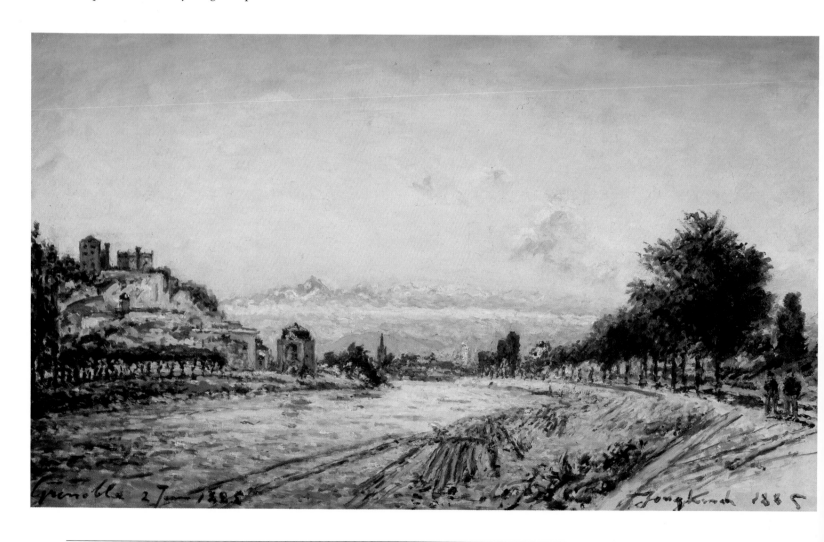

50

J.B. Jongkind
La Côte-St André, le soir, 1885
Black chalk and watercolour, 16.5 x 23.5 cm
Signed lower right: *Jongkind* (studio stamp); annotated and
dated lower left: *La Cote 2 Mars 1885*
Otterlo, Rijksmuseum Kröller-Müller

This watercolour makes a more dramatic impression than one
expects from Jongkind, as if he were trying to compete with the
romantic landscapes and seascapes of Victor Hugo. An oppres-
sive shadow looms over the wide expanse of countryside, and the
dark profile of the village of La Côte-St André is silhouetted
against the sky. The church steeple rises up to form a link with
the stormy clouds. Jongkind's hand has become a little unsteady,
and the shakiness of the inscription is reflected in the work itself,
which is less fluent than his earlier watercolours. Though the
brilliance of his more youthful work has gone, his ability to
evoke moods and associations is as strong as ever. On a piece of
paper little bigger than a hand, he has managed to capture an en-
tire cosmos.

LITERATURE: Hefting 1975, no. 791; exhib. cat. Dordrecht 1982, no. 109.

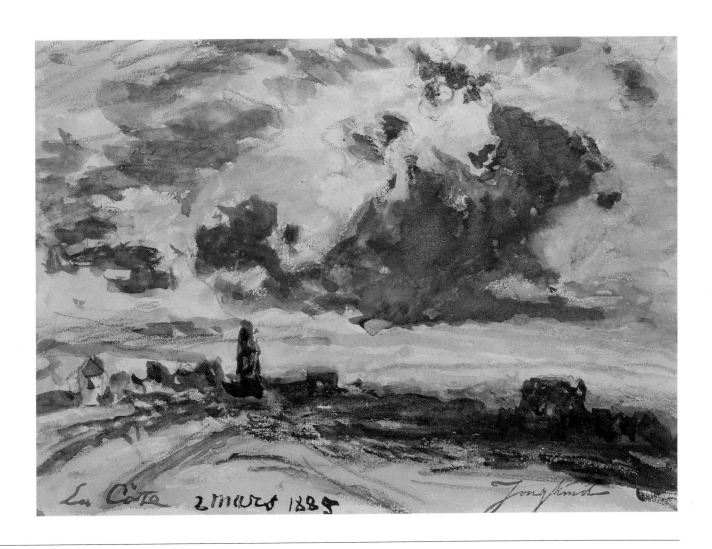

KAMERLINGH ONNES, MENSO

BRUSSELS 1860 - 1925 OEGSTGEEST

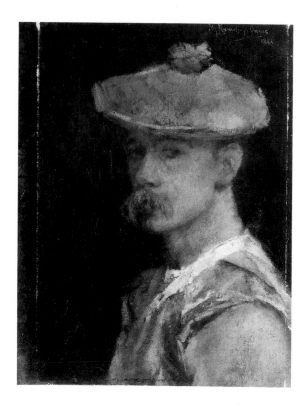

LITERATURE: C. Kikkert, 'Menso Kamerlingh Onnes', *Elsevier's Geïllustreerd Maandschrift* 19 (1909) 38, pp. 361-370; C. Veth, 'Menso Kamerlingh Onnes (1860-1925)', *Maandblad voor Beeldende Kunst* 3 (1926) 7, pp. 197-204; exhib. cat. *Menso Kamerlingh Onnes*, Leiden (Stedelijk Museum de Lakenhal) 1945.

Although born in Brussels, Menso Kamerlingh Onnes grew up in Groningen, where he completed his secondary schooling. Initially interested in the applied arts, he enrolled as a student at the Polytechnic School in Delft in 1880, attending classes under A. le Comte. His teacher, however, advised him to concentrate on painting, whereupon Menso left the school and never received any further formal art training. He decided first to travel and visited Vienna (where he met Hans Makart), Munich, Paris and, in 1882, Capri. On his return to the Netherlands in 1883, he moved back to his parents' house in Leiden, where Floris Verster had a studio. The two artists shared this room until 1892, when Verster married Menso's sister Jenny, and Menso himself married Kitty Tutein Nolthenius. The couple spent their honeymoon in Tunis, and Kamerlingh Onnes returned from the journey with a number of studies of Oriental townscapes and landscapes. These views are somewhat out of place in his *oeuvre*, which consists largely of still lifes and figure pieces. Until 1900 he contributed regularly to exhibitions of members' work, organised by the Pulchri Studio and Arti et Amicitiae, but he submitted less in later years, mainly due to the poor state of his health. Another reason, however, was the fact that he had resumed his old interest in the applied arts. This was particularly evident after a visit to Algiers in 1904, where he was deeply impressed by the Moorish style of decoration. The Moorish influence is apparent in several of his designs for furniture and interior décors. Kamerlingh Onnes also remodelled three villas in Katwijk aan Zee and one in Leiden. He produced a relatively small *oeuvre*. Most of the paintings and watercolours he left behind on his death in 1925 were owned by members of his family. Many of them are now at the Stedelijk Museum De Lakenhal in Leiden.

51

M. KAMERLINGH ONNES
Portrait of Jenny Kamerlingh Onnes, 1888
Oil on canvas, 189 x 137 cm
Signed and dated upper left: *M. Kamerlingh Onnes, 1888*
Leiden, Stedelijk Museum De Lakenhal

In addition to his still lifes of flowers and fruit, Kamerlingh Onnes regularly painted portraits. Being completely self-taught, he had not had the benefit of a proper training in human anatomy, and this is sometimes obvious in his early portraits, which are almost exclusively of members of his family. In this portrait of his sister Jenny, Kamerlingh Onnes emerges as a true colourist of the Impressionist School. His handling of the dress, in particular, is rich and lively. It is painted with strangely angular brushstrokes and in various shades of white, which stand out against the dark background. The profile pose of the sitter is not uncommon in Dutch art of the 1880s. Isaac Israëls's portrait of Nanette Enthoven-Enthoven, 1881 (private collection) is similar in composition and mood. However, Kamerlingh Onnes's arrangement of the figure within the picture space is far more rigorous. His painting recalls the work of Whistler, who was much admired by young Dutch artists of the time. Kamerlingh Onnes has managed to convey something of his sister's character in this portrait. We see a young woman of twenty-five, posing in her grandest attire. Her small, serious face scarcely seems to register our presence and the lacklustre eyes suggest a mood of introspection.

PROVENANCE: on loan to the museum, 1934; donated by the heirs of M. Kamerlingh Onnes, 1946.

LITERATURE: Veth 1926, pp. 101, 102, fig. p. 203.

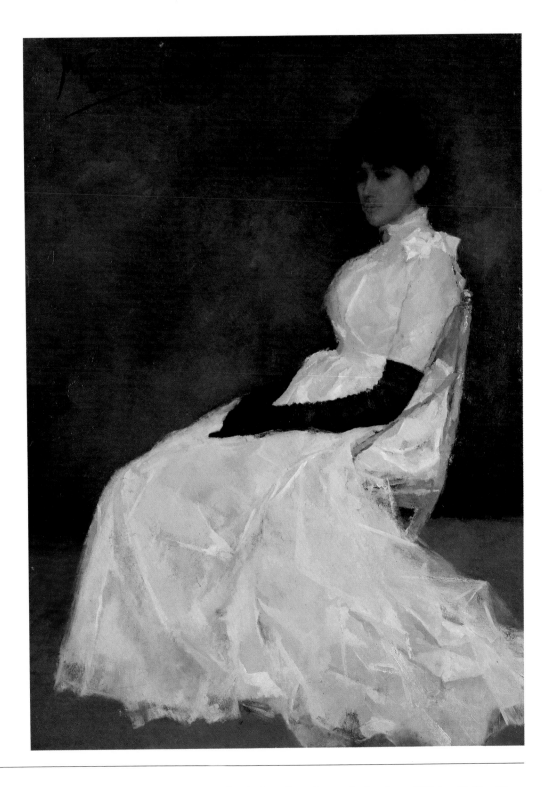

52
M. KAMERLINGH ONNES
Les fleurs du mal, 1883
Watercolour and gouache, 65 x 48 cm
Signed and dated lower right: *M. Kamerlingh Onnes, 1883*
Leiden, Stedelijk Museum De Lakenhal

Menso Kamerlingh Onnes acquired a reputation largely through his watercolours of what he called 'flower fancies'. Some are painted in extremely daring colour combinations and in an exceptionally loose manner. *Les fleurs du mal* is a good example of this type of work. The title of the painting and its meaning have caused confusion over the years. The Lakenhal Museum's cat-

alogue of paintings lists the work simply as *Wilting Tulips*. Since 1945, however, it has been shown in several exhibitions under the evocative title of *False Opulence*, which dates back to an interpretation of the painting published by C. Veth in 1926. He refers to a watercolour of tulips which gives the 'impression of false opulence without inner substance', a still life with roses which represents 'true opulence', and a third flower piece which signifies the onset of decay. He suggests that the three paintings form a symbolic entity, and on this basis, they were subsequently entitled *False Opulence*, *True Opulence* (private collection) and *The Beauty of Decay* (private collection). However, according to an exhibition catalogue of 1893, the title given by Kamerlingh Onnes himself to the painting known as *False Opulence* was *Les*

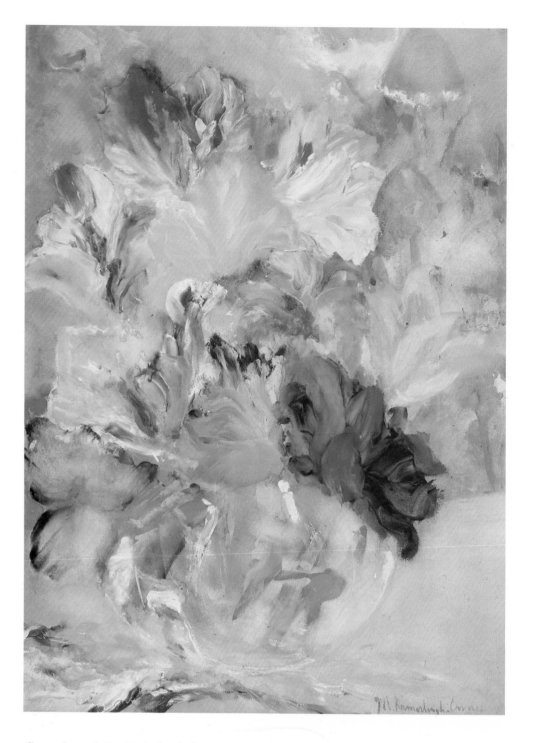

fleurs du mal. De Nederlandsche Spectator of 29 April 1893 described a watercolour of a glass of spent tulips in bright green, dazzling colours and golden tones; in the background, the article continues, were 'fungi in bilious colours: blue-lilac, dirty vermilion and gambogian amber, with hollow, angular caps borne aloft on fragile orange stalks'.

Kamerlingh Onnes's title alludes of course to Baudelaire's volume of poetry published in 1857. The French poet and art critic was held in high regard by the Symbolists. His poem *Correspondances*, which appeared in *Les fleurs du mal*, is a metaphorical formulation of the Symbolist credo that all sensory perception is interrelated. Kamerlingh Onnes's reference to this type of literature suggests that he followed the trends in Symbolist thinking at least to some extent, and perhaps quite closely. Given the source of his inspiration, Veth's interpretation of 'false

opulence' may ultimately be not so far from the truth. Kamerlingh Onnes would indeed have seen the flowers, which are just beginning to lose their splendour, as a symbol of the glorious fullness that precedes the onset of decay – the moment at which life begins to lose its lead over death.

PROVENANCE: on loan to the museum from L.A. Nijpels-Kamerlingh Onnes since 1935.

EXHIBITIONS: *Teekeningen door leden der maatschappij*, Amsterdam (Arti et Amicitiae), 1893, no. 61 ('Les fleurs du mal' ƒ 375).

LITERATURE: Veth 1926, p. 203; Lunsingh, 1945; C. Blotkamp *et al.*, exhib. cat. *Kunstenaren der idee. Symbolistische tendenzen in Nederland, ca. 1880-1930*, The Hague (Haags Gemeentemuseum) 1978, p. 100 (no. 19).

Karsen, Johann Eduard

Amsterdam 1860 - 1941 Amsterdam

Eduard Karsen was an elder twin, and grew up in a large, devoutly religious family. His father, the artist Kaspar Karsen, already had nine children from two former marriages, to which he and his third wife added another six. Eduard was the only one to follow in the footsteps of his father, who gave him his first art lessons at the age of fourteen. In 1878 he enrolled at the Amsterdam Academy, his twin brother Henri paying for his studies. He remained there for seven years. In 1885 he became a member of the Dutch Etching Club, and two years later joined Arti et Amicitiae. During these years he maintained close contact with the *Tachtigers*. He was acquainted with Verwey, Kloos and Witsen, and for a time published art reviews in *De Nieuwe Gids* and *De Amsterdammer* under the pseudonym I.N. or O.N.T. Stemming (puns on the Dutch words for approval and indignation). Despite these contacts he remained something of an outsider in this literary milieu.

A dispute which erupted around 1890 concerning his hopeless relationship with the sculptress Saar de Swart, and which brought a ruling against Karsen when the matter was taken to arbitration, caused him to withdraw further into himself. The dreamy, rather brooding atmosphere that pervades his paintings is sometimes seen as a direct consequence of this unhappy experience. In fact, the same quality is already evident in works predating this episode. Kloos referred to the silence and poetry which he sought in the sonnet 'Evening', written in 1886 and dedicated to Karsen. 'All sound which still spoke from afar, /died away – the wind, the clouds, all pass/ quietly, and yet more quietly – all becomes hushed...'

Soon after being 'discovered' by Jan Voerman, Karsen broke away from his contemporaries in Amsterdam and adopted his own individual style. 'He loved reality, but it was a reality transformed by his imagination', wrote Verwey. Karsen would mull things over and sometimes allow years to elapse before using the sketches he had made in Amsterdam and its surroundings. With him, everything first had to become a memory. He preferred simple subjects, such as views of towns and villages, harbours, farms, yards or gardens, and seascapes of the Zuyder Zee. He succeeded in capturing the intrinsic poetry of such motifs by keeping the human presence to a minimum and, unlike Breitner, by interpreting time as something other than the flash of a camera shutter, prolonging it instead into the deepening twilight of an *Evening* or *Autumn* – titles of many of his pieces. He did not date his canvases, perhaps seeking to stress their timelessness, while his titles likewise offer little in the way of specific detail. By generalising a garden or village scene as *Spring* or *Autumn*, he elevates the theme above the purely local or specific. His compositions and perspectives create a naïve impression. They are unsophisticated, and the brushwork is restrained and unobtrusive. Moreover, the small format of his paintings emphasises their intimate and private nature.

Karsen left a fairly small *oeuvre*. Hammacher estimates the total number of paintings to be just over one hundred, most of them executed before 1900. He painted very few figures or portraits, but referred to a painting (private collection) and a small etching of a desolate house as a self-portrait. After the death of his father in 1896, Karsen moved in with his mother in order to take care of her. He spent the rest of his life in relative seclusion. His death in 1941 marked the end of a generation.

LITERATURE: Caroline Beeloo, 'Eduard Karsen', *Elsevier's Geïllustreerd Maandschrift* 17 (June 1899), pp. 485-497; Albert Verwey, 'Jan Eduard Karsen', *Proza* 10, Amsterdam 1923, pp. 39-44; A.M. Hammacher, *Eduard Karsen en zijn vader Kaspar*, The Hague 1947; exhib. cat. *De verstilde wereld van Kasper en Eduard Karsen*, Schiedam (Stedelijk Museum) etc. 1976-77; J. Eduard Karsen, *Een droom en een scheidsgerecht* (edited and introduced by Rein van der Wiel), Amsterdam 1986.

53

J.E. Karsen

Beguinage (*Begijnhof*) in Amsterdam, 1893
Oil on canvas, 36.5 x 45 cm
Signed lower left: *Ed. Karsen*
Otterlo, Rijksmuseum Kröller-Müller

The critic A.C. Loffelt, who regarded Karsen's work as 'too child-like and naïve' and much too dark, wrote in 1895 that Karsen reminded him of 'a little beguine, who has never ventured beyond her courtyard or dared to lift up her eyes to the free, warm sun and the lustrous, radiant firmament (...) She has only seen nature through her net curtains and over the fence at the bottom of her little bleaching yard.' This seems to be an ironic allusion to Karsen's painting of the *Beguinage in Amsterdam*, which is painted primarily in shades of grey and thus gives the impression of looking through a gauze blind or net curtain. H.P. Bremmer dates this work to 1893, which was perhaps the date given by Karsen himself.

There are two earlier, more naïve versions of the beguinage, both in private collections. The contours are sharper, and closer attention has been paid to details such as window frames, kerbs and lamp-posts. One, entitled *Beguinage in the Autumn*, is probably not a view of the courtyard itself, but of its exterior wall, with a few figures passing by in the bright sunlight. The other version also shows a number of figures, but the composition is closer to the Kröller-Müller canvas. The canvas reproduced here radiates more atmosphere and is imbued with a rather melancholy air; there are fewer details and activity is confined to the small figure of a beguine walking towards the church. The bare trees bend as if in sympathy with her, as though emphasising the bowed posture of old age.

Karsen seems to be telling us that it is always autumn in the beguinage. On the lower right he has painted water, although the little canal had already been filled in. He allowed himself similar forms of artistic licence in other works.

PROVENANCE: purchased by the museum from Huinck & Scherjon Gallery, Amsterdam, 1945.

EXHIBITIONS: *Schilderijen door Ed. Karsen*, Amsterdam (E.J. van Wisselingh & Co.) cat. no. 32.

LITERATURE: Caroline Beeloo, 1899, pp. 495-496; *Moderne Kunstwerken* 8 (1910) vol. 5, no. 38.

54
J.E. KARSEN
Garden with Blossoming Fruit Trees (Katwijk-Binnen), *c.* 1893
Oil on canvas, 37 x 48 cm
Signed lower left: *Ed. Karsen*
Otterlo, Rijksmuseum Kröller-Müller

From 1893 onwards, Karsen regularly exhibited 'gardens'. Some bear the names of the places where he saw them (Kortenhoef, Enkhuizen, Katwijk), others are called *Nightfall*, *Spring* or simply *Garden*. The viewpoint is always similar. Viewed from the

bottom of a garden we see the façade of a modest house, partly obscured by flowering trees or shrubs. Some pictures include the figure of a woman, or a few hens scratching around for food. The motif was used by painters of the Hague School, such as Mauve and Weissenbruch, although they usually introduced more activity. Karsen's main object was to portray the beauty of nature close to home in a humble backyard.

The fruit trees in the sun-drenched garden in the Kröller-Müller canvas look like a vast bouquet, dominating the entire picture. The shrub in the foreground has been kept low, while the line of the roof echoes the triangle of blossom and thus furni-

shes the whole with a fitting frame. Even the woman has paused for a moment so as not to disturb the spectator. The quiet tranquillity of this modern *hortus conclusus* sets off a train of associations, as Karsen probably intended. The trees are ranked in lines ranging from young to old; those in the middle are at their most fruitful.

Karsen based this painting on a photograph. Whether he was in the habit of doing so is uncertain, the only other documented example being the portrait of Joti (private collection), the daughter of his twin brother Henri, who died in childhood. However, he did not simply copy the photograph as it is. A boy in the foreground is not shown in the painting, while a rack of washing has disappeared, to be replaced by a single piece of red cloth hanging over the fence. Moreover, the houses on the right are a little higher in the photograph and have chimneys. Karsen introduced other changes as well, essentially to create a neater composition. In order to obtain a pleasing central axis, he has moved the vantage point slightly to the left, so that the shrub,

which is far larger and wilder in the photograph, is now in front of the blossoming fruit tree. As the sun is directly overhead, the shadow of the low shrub in the foreground does not interrupt the central axis.

Karsen painted the garden once again, using a slightly smaller canvas (private collection; the Rijksbureau voor Kunsthistorische Documentatie in The Hague has a photograph of it annotated 'Katwijk-Binnen'). The garden in this work is not in blossom, but the viewpoint and composition are almost identical.

PROVENANCE: E.J. van Wisselingh & Co., Amsterdam; L.C. Enthoven, Voorburg; acquired at auction Amsterdam (Fred. Muller & Cie.), 18 May 1920, no. 72.

EXHIBITIONS: *Schilderijen door Ed. Karsen*, Amsterdam (E.J. van Wisselingh & Co.) 1895, cat. no. 72 (?).

55

J.E. Karsen
At the IJ, *c.* 1895
Oil on canvas, 30 x 44 cm
Signed lower left: *Ed. karsen*
Otterlo, Rijksmuseum Kröller-Müller

Karsen produced a number of waterscapes with similar titles to the one given to this painting. *At the Zuyder Zee* (fig. 53), which is in a private collection, is one example. The preposition is a subtle indication that it is not the specific location that matters, but the artist's experience of being there. The concept of a 'mood picture' (*stemmingskunst*) is especially apposite in these paintings, where the image perceived is transformed into mood, which in turn determines what is seen, and where time and place are dictated by the observer's frame of mind. Karsen's work thus borders between Impressionism and Symbolism.

At the IJ differs substantially from harbour views by Karsen's contemporaries. A true Impressionist seeks movement in order to capture the single, unique moment before things change position or take on a different appearance. Karsen, on the other hand, completely eliminates time. He portrays his motifs in the morning or at dusk, when there is little human activity and

when contours and colours are hazy. *At the IJ* is devoid of movement. Even the bold cropping on both sides of the image does not transform it into a snapshot. The viewer's gaze moves from the bow of one vessel to the other, always returning to rest on the water. The water is indeed the central theme; not only does the quayside give way to it, but the emphatic use of close-up creates the impression that the boats, too, are giving ground rather than approaching. The sharp contrast between the fishing craft and the steamship *Oranje Nassau* gives the two vessels an extra dimension. Their solemn presence in the foreground endows them with a symbolic value, elevating them to attributes of the river IJ, whether they signify Fishing and Commerce or, more generally, the Old and the New.

PROVENANCE: C. Hoogendijk; acquired at auction Amsterdam (Fred. Muller & Cie.), 21/22 May 1912, no. 39 ('Port d'Amsterdam', *f* 500).

EXHIBITIONS: *Schilderijen door Ed. Karsen*, Amsterdam (E.J. van Wisselingh & Co.) 1895, cat. no. 53.

LITERATURE: *Catalogus van de Schilderijenverzameling van Mevrouw H. Kröller-Müller, 's-Gravenhage, Lange Voorhout 1* [H.P. Bremmer, ed.] 1917, cat. no. 207; A.M. Hammacher 1947, p. 81, fig. 24.

KARSEN, KASPAR

AMSTERDAM 1810 - 1896 BIEBRICH (GERMANY)

Kaspar Karsen belonged to an older, romantic generation, which included artists such as Bosboom and Rochussen. His father, an Amsterdam cabinet-maker, married Helena Westenberg, whose brother, the landscape artist George Westenberg gave Karsen his first lessons in painting. He was also taught by Hendrik ten Cate and studied drawing for two years, from 1825 to 1827, at the Amsterdam Academy. To earn a living, he spent the next four years working as decoration painter under the supervision of D. Vettewinkel, but later in life specialised in townscapes and river scenes. His work reflects a strong feeling for architectural shapes and details within the context of their setting.

Karsen's career initially developed very successfully. In 1834 he was showered with praise by the influential writer, Potgieter, in the periodical *Muzen*. His work was compared to Bosboom's, and he received commissions both in the Netherlands and abroad. He was a keen traveller from an early age, and in 1837 made a journey down the Rhine and the Danube. He visited Vienna, Prague and other cities, and travelled quite extensively throughout Brittany. In 1839 he was accepted as a member of Arti. In 1849, he edited *Pictura*, a bimonthly journal 'for painters and lovers of painting'. It was at this time that he reached the height of his popularity. His artistic talents, however, did not continue to develop as they had done previously. With the occasional exception, his work after 1860 was less interesting. It became somewhat hackneyed, although changing tastes will have played a part in the waning demand for his paintings. He received few commissions, and his financial problems increased, exacerbated by the fact that three marriages had left him with a total of fifteen children to support. His third wife, German-born Johanna Frederica Klueter, bore him the twins Henri Theodoor and Johann Eduard, of whom the latter was to make a name for himself as the painter Eduard Karsen.

Karsen worked as a photographer for a while to supplement his meagre income, but the venture did not prove successful. According to his sons, he was a competent photographer, but lacked business acumen. In 1873 the family had to move to a small apartment in the Haarlemmer Houttuinen. Even in his later years, Karsen continued to give drawing lessons for a living. His pupils included Cornelis Springer and his own son Eduard.

When Karsen was 86, his son Henri enabled him to repeat his never-forgotten journey down the Rhine and Danube. Eduard accompanied his parents. On the return journey, however, Kaspar fell ill, and died of pneumonia in the small town of Biebrich near Wiesbaden.

LITERATURE: G.H. Marius, *De Hollandsche schilderkunst in de negentiende eeuw*, The Hague 1920, p. 62; A.M. Hammacher, *Eduard Karsen en zijn vader Kaspar*, The Hague 1947, pp. 16-24.; J.E. Bokhoven *et al.*, exhib. cat. *De verstilde wereld van Karsper en Eduard Karsen*, Schiedam (Stedelijk Museum) 1976-77; J.F. H[eybroek], 'Topografische aantekeningen over het werk van Johannes Bosboom, Isaac Israëls, Kaspar en Eduard Karsen', *Bulletin van het Rijksmuseum* 36 (1988) 1, pp. 34-36.

56

K. KARSEN
Church in a German Fortification, 1881
Oil on canvas, 72 x 60 cm
Signed and dated in red, centre right: *K. Karsen 1881*
Private collection

Karsen painted this picture in 1881, forty-four years after travelling down the Rhine and Danube. Despite its wealth of detail, the painting does not represent a specific, identifiable structure and is probably a compilation of various architectural elements Karsen had seen on his journey. Like the leading painters of his youth – Josephus Knip, Barend Cornelis Koekkoek and Andreas Schelfhout – Karsen created a world of his own. Working in his studio, he would use his store of drawings and studies like building blocks, from which he would put together views of rivers and landscapes.

His method of painting, with every architectural detail painstakingly recorded, is reminiscent of work from the seventeenth century. Karsen's motif, too, recalls subjects depicted by his great predecessors, such as Jacob van Ruysdael's view of *Bentheim Castle* (Amsterdam, Rijksmuseum). His emphasis on light effects, however, shows him as a true romantic. Patches of light break up the vast expanse of stone. The blue sky stands out in sharp contrast from the rest of the painting, while the reflections in the water help unite the composition. The stretch of gravel in the foreground is beautifully rendered. The paint is thicker and looser, adding a silvery note to the yellow, blue and grey tones that dominate the canvas. The group of people conversing near the cottage by the river, and the fisherman in the foreground lend anecdotal elements. These diminutive figures also heighten the monumental effect of the buildings.

LOOY, JACOBUS VAN

HAARLEM 1855 - 1930 HAARLEM

Jacobus van Looy's youth was anything but privileged or stimulating in comparison to that of some of his artist friends. Orphaned at the age of five, he and his two younger sisters were brought up in the Protestant orphanage in Haarlem, where he lived until 1877. He attended the orphanage school until the age of eleven, after which he was apprenticed to a printer in order to contribute towards his upkeep. This was not successful, however, and after two years he found employment with a decoration painter. In the evenings he studied drawing under J.H. Goteling Vinnes at the public night school and took lessons with the flower and still-life painter, D.J.H. Joosten.

Joosten encouraged Van Looy's artistic development. He gave him lessons in drawing and painting free of charge, introduced him to the club *Kunst Zij Ons Doel* (Let Art Be Our Aim) and advised the orphanage authorities to allow him to train as a drawing master at the Amsterdam Academy. A year later, when sufficient funds had been raised, the talented young man left for Amsterdam. Under the watchful eye of the Academy director Allebé, who had by then replaced Joosten, Van Looy qualified as a drawing master after only two years of study. While continuing his studies at the Academy, where he had his own studio from 1882 to 1884, he supported himself by giving drawing lessons.

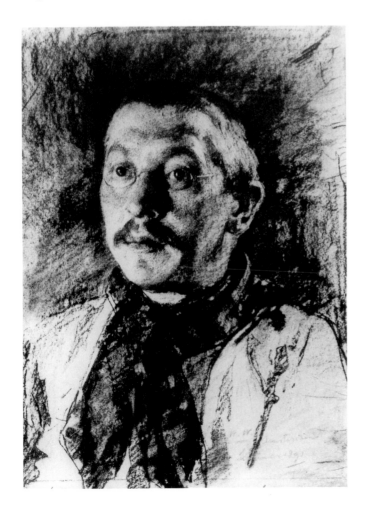

He pursued other interests outside the Academy. With Willem Witsen and Maurits van de Valk, he set up the St Luke's Artists' Association in 1880, and in 1882 visited Paris with Witsen. At the Flanor literary club he met Van Deyssel and various writers associated with *De Nieuwe Gids*, such as Kloos, Paap and Verwey. Inspired by this circle, Van Looy also took up writing. In 1884 he and Jan Dunselman, a student at the Academy in Antwerp, were jointly awarded the Prix de Rome, which gave him an allowance for two years and enabled him to make an extended study trip to Italy, Spain and Tangier. He made his début as a writer for *De Nieuwe Gids* with an article written in Venice. In 1887 he returned to Amsterdam. He became a member of the Dutch Etching Club and again turned to teaching for a livelihood.

Van Looy once described himself as a 'painter by birth and a writer by accident'. His art was regularly exhibited and much of what he wrote was published. His paintings and drawings had a stronger narrative element than those of his friends and contemporaries and his style was quite distinctive. In 1892 he married the recitalist Titia van Gelder and two years later the couple moved to Soest. From this time on, Van Looy withdrew increasingly from the public eye. In 1901 Arti held a retrospective exhibition of his work. From the reviews it was clear that he was considered to be better as a writer than a painter, and Van Looy decided not to exhibit his work again. He and his wife made numerous trips abroad. In 1901/02 they travelled to Tangier. Although it must have seemed to others as if he had put painting aside, in reality he was very much occupied with it. In an interview in 1907 he indicated, however, that he no longer even wished to discuss it. 'If you please, you wished to talk about the writer. We had better say nothing of the painter, as this touches such a private spot, and I should not wish to sound bitter...' In that same year, he and his wife moved to Haarlem, where Van Looy's literary career reached new heights. He produced several superb translations of Shakespeare and wrote books such as the popular trilogy, *Jaapje*, *Jaap*, and *Jakob*, based on memories of his youth.

LITERATURE: G.H. Marius, 'Jac. van Looy', *Elsevier's Geïllustreerd Maandschrift*, 11 (1901) 22, pp. 439-448; G.H. Marius, *Hollandsche schilders van dezen tijd. Jacobus van Looy*, Amsterdam 1912; M.J. Brusse, *Jacobus van Looy over zijn werk*, Rotterdam 1930; M. Augusta Jacobs, *Jacobus van Looy en zijn literair werk*, Brussels 1945; F.P. Huygens, *Jacobus van Looy 'Wie dronk toen water!'. Bloemlezing uit de briefwisseling met August Allebé gedurende zijn Prix de Rome-reis 1885-1887*, Amsterdam 1975; P. Winkels and C. Will, *Jacobus van Looy, Schilder van huis uit, schrijver door toevallige omstandigheden*, The Hague 1982; exhib. cat. *Jacobus van Looy 1855-1930. Schilder van huis uit, schrijver door toevallige omstandigheden* ('Kijken in Haarlem Extra', no. 6), Haarlem (Frans Hals museum) etc. 1982-83; C. Will and P.J.A. Winkels, *De dubbelbegaafdheid van Jacobus van Looy*, Haarlem 1988.

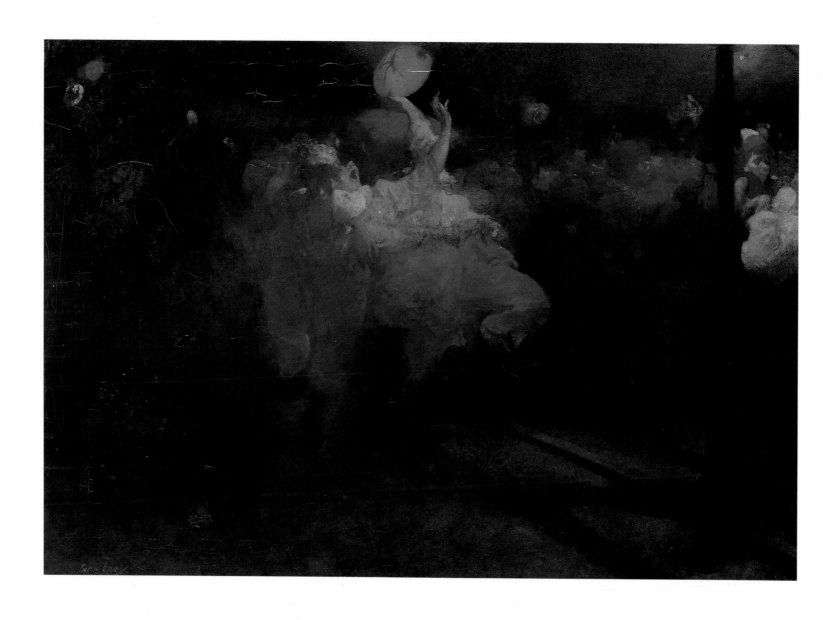

57

J. van Looy
Orange Festival, *c.* 1890
Oil on canvas, 112 x 160 cm
Signed lower left: *Jac. v. Looy*
Amsterdam, Rijksmuseum

Van Looy's large painting of the *Orange Festival*, which Enno Endt contemplates at length in his article in this catalogue, has an interesting history behind it. On 13 April 1887 the *Tachtigers* came together to take part in the festivities that had been organised to celebrate the birthday of William III. The euphoria of the occasion left a deep impression on Van Looy and inspired him to make a large pastel (whereabouts unknown) of the scenes he had witnessed in the streets of Amsterdam. To his great indignation, the work was rejected for an exhibition at Arti et Amicitiae. On 17 November he wrote an angry letter to Van Deyssel: '...the third (a pastel and, according to some acquaintances, the best) has been refused; and it is by *someone* who has been reviewed in *De Nieuwe Gids*. Humph! (...) I think it captures the commotion quite well, but the thing has been refused. A cousin of mine, who likes to air his two words of French and who is a member of some sort of committee in Arti, said it was considered "trop commun". But Arti is holding a viewing on Thursday and I shall try to smuggle it in – having now spent yet another week working on it – and perhaps achieve something in this way. If this fails I shall write my impressions down, about it having been refused repeatedly.' The pastel was indeed rejected once again, an experience which prompted Van Looy to write his novel *De Nachtcactus*.

But the memory of the event continued to preoccupy him. In 1890 he sent the painting of the *Orange Festival* – the version shown here – to Arti, where it was exhibited. The critics, however, found much to malign in his work. *De Amsterdammer* (9 November 1890), for instance, wrote that 'an interesting character among our artists is Van Looy. Not because we could say unconditionally that his work is beautiful, but because he, more than any other, is an artist wrestling to accomplish something great. But his large *Orange Festival* does not ring true. The women, for all their brutishness, are too elegant, and the white clothing is too cool in this type of light. The composition is excellent, although a bit more vitality and fullness would have done no harm.' This final comment and the argument about the women being too 'elegant', are rather surprising. The term 'brutish', however, is an apposite description of the almost inextricable tangle of ecstatic bodies and the open-mouthed animal-like head directly to the left of the figure in the middle.

Orange Festival is less documentary than other of Van Looy's portrayals of dancing revellers, such as *Tango* (fig. no. 24) or *Hartjesdag Celebrations* (c. 1888, private collection). It is not a record of the dancing as such, but rather a representation of the orgiastic climax.

PROVENANCE: A.S. van Wezel, Amsterdam; bequeathed to the museum, 1922.

EXHIBITIONS: *Kunstwerken van leden*, Amsterdam (Arti et Amicitiae), October 1890, (cat. no. 103, 'uit het Oranjefeest').

LITERATURE: G. de V., 'Tentoonstelling in Arti', *De Portefeuille*, 8 November 1890; exhib. cat. 1982-1983, pp. 10-11 (cat. no. 17); Will/Winkels 1982, pp. 82-88; Will/Winkels 1988, pp. 58-62.

58
J. VAN LOOY
The Garden, 1893
Oil on canvas, 97 x 37 cm
Signed lower left: *v Looy*
Amsterdam, F.G. Lauwaars

The Garden is the most impressionistic work Van Looy produced before 1895. The palette is unusually light compared to the often sombre colours of his earlier canvases. It is more lavish than the paintings of kitchen gardens by Anton Mauve (cat. no. 64) and other members of the Hague School, and has more in common with the familiar park and garden scenes by the French Impressionists Monet and Manet, or with some of Verster's still lifes.

Compared with most contemporary Dutch art, Van Looy's treatment of the subject was rather unusual. When the canvas was exhibited at Arti in 1894, an anonymous critic wrote in the *Nieuwe Rotterdamsche Courant* in December that 'it is not really a "painting", a painting that represents something complete in itself. Van Looy could have made his canvas twice as long, or achieved the same unhappy effect with one only half the size. It is a chunk bluntly hacked out of nature', (undated newspaper cutting, Rijksdienst voor Kunsthistorische Documentatie). Van Looy does indeed create the impression of having simply reproduced a patch of garden. The lush profusion of flowers covers almost the entire canvas and conveys the image of nature run riot.

Fellow artist Isaac Israëls did not share the critic's negative view of the piece. 'May I congratulate you on your superb painting at Arti', he wrote, 'it looks wonderful and is by far the nicest work of yours that I know. It is the best painting present, so there is no question but that you should have got the medal' (letter of 21 October 1894, Jacobus van Looy Foundation, Haarlem).

According to his wife, Van Looy painted *The Garden* in the summer of 1893 when they were living just outside Amsterdam in Nieuwer Amstel, and 'sowed' on a small piece of ground in the Rustenburgerstraat. It was painted out of doors, over a period of six weeks (Titia van Looy's notebook, Jacobus van Looy Foundation, Haarlem). Van Looy repeated the same motif on two more occasions, in *Nasturtiums, Soest* from 1895/96 and *Nasturtiums* from 1907, both of which are in private collections. They were painted in his garden in Soest, where 'the dark blooms of the nasturtium trail over the curving path and disappear into the beech hedge', as he wrote in *De wonderlijke avonturen van Zebedeus*, published in 1901.

PROVENANCE: H. Van Booven-Lopez Suasso, 1905.

EXHIBITIONS: Nijmegen (Sociëteit De Vereeniging) 1894 (no catalogue); Amsterdam (Arti et Amicitiae, members' exhibition) November 1894, cat. no. 81 ('Tuin'; ƒ 2,500); *Tableaux [etc.] d'artistes hollandais contemporains, organisé par la société artistique Arti et Amicitiae a Amsterdam*, St Petersburg, November/December 1896, cat. no. 59.

LITERATURE: exhib. cat. 1982-83, p. 11.

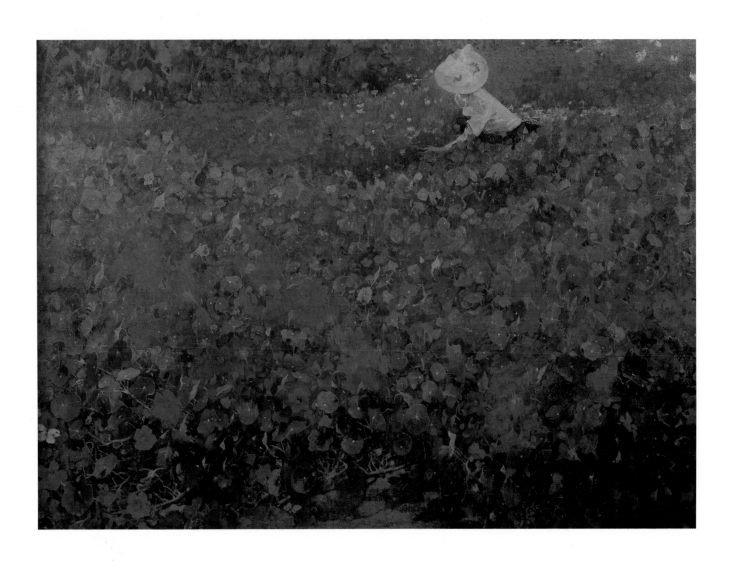

Maris, Jacob

The Hague 1837 - 1899 Karlsbad

Jacob Maris was the oldest of five children in a family which produced no fewer than three painters – Jacob himself and his brothers Matthijs and Willem. They grew up in modest circumstances; their father was a printer, and his wife, Hendrica Maris-Bloemert, a successful herbalist.

Between the ages of twelve and fifteen, Maris studied under the architectural painter Johannes Stroebel, and in 1850 enrolled at the Hague Academy, where he took drawing lessons for three years. In 1853 he was admitted to Huib van Hove's studio to study painting; when Van Hove was forced to flee the country to evade tax debts, Maris followed him to Antwerp. He enrolled at the Royal Academy in Antwerp, where he attended evening classes from 1854 to 1856. When his brother Matthijs joined him in 1855, Jacob left Van Hove's studio and the two young men lived on Mathijs's student allowance, augmenting their income by producing paintings for the American market.

Jacob Maris returned to The Hague in 1857, followed by Matthijs some time later, and from 1859 to 1861 the brothers collaborated on a series of portraits commissioned by the Dutch Royal family. The money they earned enabled them to work in Oosterbeek (1859) and Wolfheze (1860), and in 1861 they set off on a long journey which took them through Germany, Switzerland and France. However, their funds ran out and they finally returned went back to their parents' home. Jacob again enrolled at the Hague Academy, where Johan Philip Koelman had meanwhile become director.

In 1865 he settled in Paris, where he was to remain for six years. At first he worked in the studio of E. Hébert and, like Hébert, concentrated primarily on figure pieces. He maintained a cordial relationship with the art dealer Goupil, which assured him of a good outlet for his work. He married C.H. Horn in 1867, and in 1869 the couple invited Jacob's brother Matthijs to join them in Paris.

After the Franco-Prussian War, Jacob returned to The Hague and settled there permanently. He became a member of the Pulchri Studio and in 1876 of the Dutch Society of Watercolourists. The work he produced in this period, which consisted mainly of landscapes and urban views, clearly reflects the influence of the Barbizon School and his admiration for seventeenth-century Dutch painters such as Ruysdael and Vermeer. Maris maintained contact with Goupil & Cie in Paris, as his work was still unknown in Holland. He only achieved recognition after 1890, but having done so, enjoyed tremendous success. His work was in great demand and attracted buyers from as far afield as Scotland and even the United States. In 1895 Arti et Amicitiae, which he had joined in 1891, organised an exhibition to honour him, and paid a similar tribute after his death in 1899. Maris died in Karlsbad, a health resort in Germany, while following a course of treatment.

LITERATURE: J. Gram, *Onze schilders in Pulchri Studio*, Rotterdam [1880], pp. 92-96; G.H. Marius, 'Jacob Maris', *Elsevier's Geïllustreerd Maandschrift* 1 (1891) 2, pp. 1-13 [reprinted in M. Rooses (ed.), *Het Schildersboek*, Amsterdam 1898, vol. 2, pp. 2-16]; A.C. Loffelt, *Nieuws van de Dag*, 19/20 November 1895 (Jacob Maris I), 2 December 1895 (Jacob Maris II), 3 December 1895 (Jacob Maris III); J. Kalff Jr, 'Jacob Maris', in *Mannen en vrouwen van beteekenis in onze dagen*, 32, Haarlem 1902, pp. 283-308; J. Veth, 'Een studie over Jacob Maris', *Onze Kunst*, 1 (1902) 1, pp. 9-16; 2, pp. 173-175; T. de Bock, *Jacob Maris. Met 90 photogravures naar zijne werken en zijn portret door M. van der Maaten*, Amsterdam [1902]; G.H. Marius, *De Hollandsche schilderkunst in de negentiende eeuw*, The Hague 1903, *passim*; D. Croal Thomson, *The Brothers Maris (James-Matthew-William)*, London/Paris 1907 (Special Summer Number of *The Studio*); Jan Veth, 'De jeugd van Jacob Maris', *Portretstudies en silhouetten*, Amsterdam [1908], pp. 123-175; M. Eisler, 'Jacob Maris in Paris', *Elsevier's Geïllustreerd Maandschrift* 23 (1913) 45, pp. 25-40; M.H.W.E. Maris, *De geschiedenis van een schildersgeslacht*, Amsterdam 1943 (reprinted in 1947); Jos. de Gruyter, *De Haagse School*, Rotterdam 1969, vol. 2, pp. 16-30; exhib. cat. *De Haagse School. Hollandse meesters van de negentiende eeuw*, Paris (Grand Palais) etc., 1983, pp. 200-215 (and bibliography pp. 341-342).

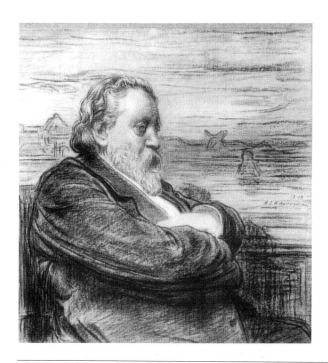

59

J. MARIS

The Arrival of the Boats, 1884

Oil on canvas, 127 x 95 cm

Signed lower left: *J. Maris*

Amsterdam, Rijksmuseum

After his return from Paris in 1871, Jacob Maris concentrated predominantly on city views and landscapes. Figures disappeared almost entirely from his *oeuvre*, apart from a few portraits of his children. *The Arrival of the Boats* is an exception in this respect, since it depicts a large group of people awaiting the return of the fishing fleet. In the centre of the picture are the two

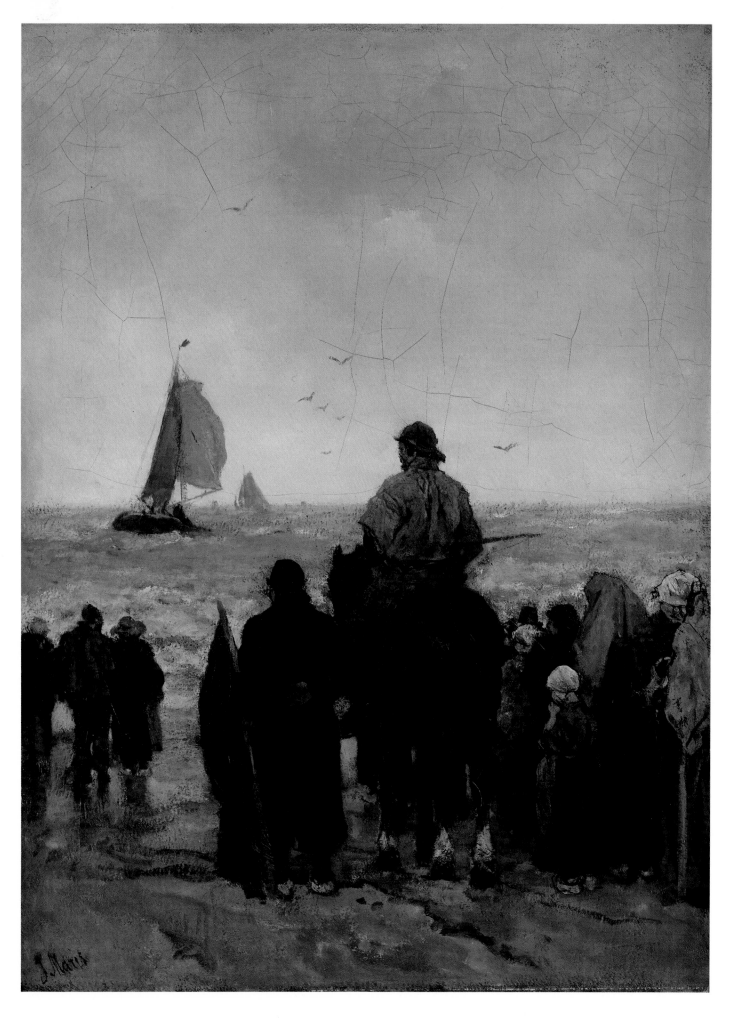

figures who played a key role in bringing the boats safely to shore. The experienced old salt waving a blue flag is guiding the first fishing boat to a landing place on the beach, as Scheveningen had no harbour at the time. Beside him, on horseback, is the line-hauler dressed in yellow oilskins, who is about to ride into the waves to bring in the anchor cable. The people gathered on either side of the two men are preparing to unload the catch as soon as the vessels have landed. Their posture reflects a certain anxiety. Unlike Jozef Israëls, whose fishing scenes had a more sentimental quality, Maris shows the harsh realities of life in a fishing community. The dark brown, ochre and grey tones, applied with a heavily-laden brush, serve to strengthen this mood. Maris's

colours and the contours of his figures recall work by Daumier, who enjoyed great popularity in Holland in the 1880s.

PROVENANCE: J.C.J. Drucker, London, 1896; on loan to the museum, 1904; donated by J.C.J. Drucker-Fraser, 1909-1910.

EXHIBITIONS: *Eere-tentoonstelling Jacob Maris*, Amsterdam (Arti et Amicitiae), 1899, no. 6 ('Aankomst van de booten').

LITERATURE: M. Eisler, 'De collectie Drucker in het Rijksmuseum te Amsterdam', *Elsevier's Geïllustreerd Maandschrift* 46 (1913), pp. 325-326; C.J. Destree, *De Haagse School met Schevenings werk*, exhib. cat. The Hague (Schevenings Museum) 1989, p. 10.

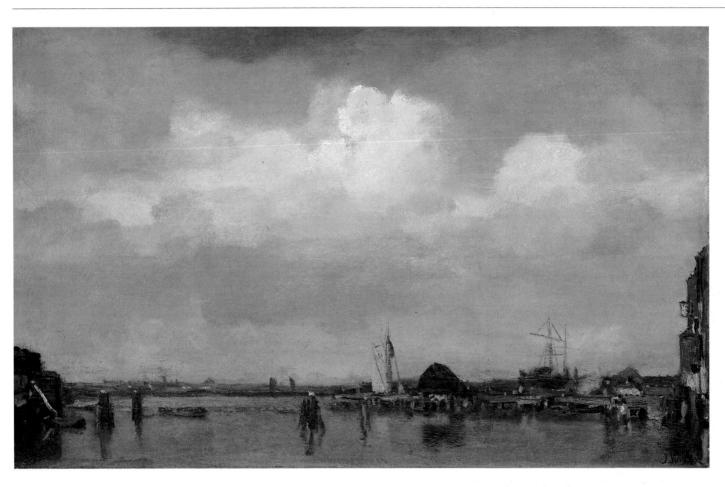

60
J. MARIS
Harbour View, *c.* 1890
Oil on canvas, 51 x 78 cm
Signed lower right: *J. Maris*
Amsterdam, Rijksmuseum

Maris's *Harbour View* is an example of the grey-toned work typical of the Hague School. It is a view over a wharf and harbour, which loom up through the hazy atmosphere. The scene is flanked by warehouses on the right. Clouds have gathered overhead and it is obviously about to rain. Maris never depicts a specific location; his paintings evoke mood and atmosphere, and are not topographical representations. Many of his townscapes and harbour views incorporate elements from different places, and

some are purely imaginary. His colours in *Harbour View* range from white to dark-grey and blue-grey. Although there are no contrasts in the picture, it is far from monotonous. There are traces of red in the warehouses, while subtle hints of green animate the rowing boat bobbing alongside the quay to the left. Maris was a master of 'grey' in all its shades, and he used it to superb effect in his carefully balanced compositions. He received outstanding reviews from around 1890 on, and more than one critic compared him favourably with his illustrious seventeenth-century predecessors, Ruysdael and Vermeer. Indeed, some even considered his freer manner of painting superior to theirs.

PROVENANCE: A. van Wezel; bequeathed to the museum, 1922.

MARIS, MATTHIJS

THE HAGUE 1839 - 1917 LONDON

Following in the footsteps of his elder brother Jacob (born 1837), Matthijs decided early on to train as an artist. In 1852 he enrolled at the Hague Academy as a pupil of I.C. Elink Sterk, and two years later secured a place in the studio of Louis Meijer, a well-known marine painter. A bursary from Queen Sophie enabled him to study at the Academy in Antwerp in 1855, where he received instruction in 'expression' and figure painting. He lodged with his brother Jacob and devoted his free time to portraits, genre pieces and landscapes. As a result of his friendship during this period with Georg Laves from Hannover, he was introduced to the work of German Romantics, such as Richter, Von Schwind and Rethel, who were to exert a strong influence on him. He returned to The Hague in 1858 and became a member of the Pulchri Studio in the same year. The money he and Jacob earned copying portraits of members of the House of Orange enabled them to spend some time in Oosterbeek and Wolfheze in the Veluwe, in 1859/60, and to travel to Germany, Switzerland and France in 1861. Lausanne, in particular, made a deep impression on Matthijs, and its cathedral and castle are recurrent elements in many of his later works. His watercolour, *Christening in Lausanne* (The Hague, Gemeentemuseum) won him honorary membership of the Société Belge des Aquarellistes in Brussels in 1863.

The period that followed was a difficult one. His work was unfavourably reviewed and, with Jacob's departure for Paris in 1865, he was deprived of his brother's moral support. He had some success, however, with works such as *The Bride* (The Hague, Rijksmuseum Mesdag), but in a letter of 1867 he complained of growing disillusionment. He became increasingly withdrawn until, in 1869, he took Jacob's advice and joined him in Paris. Here he struck up what was to prove a lifelong friendship with Elbert van Wisselingh. Van Wisselingh joined the firm of Goupil as an assistant in 1874, later setting up in business on his own. On the outbreak of the Franco-Prussian War (1870/71), Matthijs Maris joined the Garde Nationale and, after the capitulation, the Communards. Jacob and his family decided to return to the Netherlands, but Matthijs remained in Paris. Once again he went through a difficult period, but his productivity did not suffer as a result. Several masterpieces, such as *Souvenir d'Amsterdam* (Amsterdam, Rijksmuseum) and *Butterflies* (Glasgow, The Burrell Collection) date from this time. He absorbed various styles of painting. His views of Montmartre, for example, are impressionistic, while his portraits are smooth and carefully finished, reflecting a deep admiration for sixteenth-century art. From about 1875 onwards his brushwork became more feathery and rather Baroque-like. At the same time his subjects became increasingly unrealistic and he concentrated on fairy-tale images of princes and princesses, and women spinning or tending goats. One of his admirers was the London art dealer Daniel Cottier, a Scot by birth, for whom Van Wisselingh went to work in 1875. Two years later, Maris, too, moved to London, where he was to remain for the rest of his life. He first stayed with Van Wisse-

lingh, but soon afterwards accepted the hospitality of Cottier, who gave him numerous commissions. Maris's inbred distaste for money and trade gradually soured the relationship, and in 1888 their ways parted. Maris came to regard Cottier as the personification of all he despised in a corrupt, materialistic society; this was a lasting source of irritation and became a constant theme in the interminable letters he poured out to a few confidants. Among art dealers, only Van Wisselingh, who supported him financially for the rest of his life, was considered an honorable exception to the rule. Maris increasingly kept to himself and closed his doors to all but a select few.

Besides a series of extremely delicate etchings dating from the early 1880s, he concentrated his efforts during this period on drawings and watercolours, and a few painted portraits of friends and children, elaborating on motifs from his Parisian days. The fairy-tale narrative style of his earlier work gave way to images more like visions or dreams, with enchanted woods and castles and shadowy figures. He continued to work on such themes until the end of his life. None of the paintings he produced after 1890 was 'finished' in the traditional sense of the word.

His sensitive and highly individualistic work, coupled with his non-conformist lifestyle, soon made him into a legend and, even before Van Gogh, he was one of the heroes of the young avant-garde in the Netherlands.

LITERATURE: P. Haverkorn van Rijsewijk, 'Matthijs Maris', *Onze Kunst* XVII (1918) vol. 33, pp. 29-43, 85-90, 122-138, vol. 34, pp. 117-127, XVIII (1919) vol. 35, pp. 33-44, 117-130, vol. 36, pp. 92-102; Ernest D. Fridlander, *Matthew Maris*, London/Boston 1921; W. Arondéus, *Matthijs Maris. De tragiek van den droom*, Amsterdam 1939 [reprinted in 1945]; H.E. van Gelder, *Matthijs Maris*, Amsterdam (Paletserie) [1939]; Jos. de Gruyter, *De Haagse School*, vol. 2, Rotterdam 1969, vol. 2, pp. 31-48; exhib. cat. *Matthijs Maris*, The Hague (Haags Gemeentemuseum) 1974; H.E.M. Braakhuis and J. van der Vliet, 'Symboliek en symbolisme bij Matthijs Maris: 1839-1917', *Tirade* 21 (1977), pp. 335-345; H.E.M. Braakhuis & J. van der Vliet, 'Patterns in the life and work of Matthijs Maris', *Simiolus* 10 (1978-1979), 3-4, pp. 142-181; exhib. cat. *De Haagse School. Hollandse meesters van de 19de eeuw*, Paris (Grand Palais) etc. 1983, pp. 216-225 (with bibliography, pp. 341-344); *Kunstschrift* 34 (1990) 1 (Special edition on Matthijs Maris).

61

M. MARIS
The Enchanted Castle, c. 1884
Oil on canvas, 21.5 x 33 cm
Unsigned
The Hague, Haags Gemeentemuseum

Castles played an important role in Maris's work over a considerable period of time. Those from the 1860s, inspired by the German Romantics, were still clearly distinguishable as medieval constructions, to some extent resembling the castle in Lausanne, which had made a deep impression on him when he visited the city in 1861. In the 1880s, when working in London, he incorporated similar structures in dream-like pictures of towns and forests which have no bearing on reality. *The Enchanted Castle* in The Hague is an example of these paintings. The castles are always situated on a hill in the distance, in thickly-wooded countryside impenetrable to man. Braakhuis and Van der Vliet describe them as romantic visions of a paradise lost. Like *Sleeping Beauty's* castle they are inaccessible, or like the castle of Camelot in Tennyson's *Lady of Shalott* (another recurrent motif in Maris's *oeuvre*), they are cut off by deadly waters.

Recent catalogues have speculated on the dating of *The En-chanted Castle* and of a closely related version at the Jan Cunen-centrum in Oss. However, Haverkorn van Rijsewijk's meticulous provenance shows that Van Wisselingh submitted the slightly more detailed variant from Oss for an exhibition in Edinburgh in 1886. The catalogue published at the time lists the piece as *A fantasy in silver grey: 'A magic wood' with a ghostly castle in the background*, a title more suggestive of Whistler's work. Because of its similarity in terms of atmosphere and rendering to a number of etchings of enchanted castles, forests and towns from 1882/83, the Oss version must have been produced around that time. The Hague canvas might have been made a little later. The foliage is less worked out here, whereas it is possible to identify some of the trees in the Oss variant. Furthermore, the light in the Hague painting is less penetrating and the atmosphere consequently hazier. It is a step closer to the almost abstract forest scene, now in the Mesdag collection, which Maris showed to H.L. Berckenhoff in 1888. Though identical in format and composition – even the solitary figure and the duck are in the same place – the Hague painting is not merely a repetition of the Oss piece, but a work in its own right. The relationship between the two can be compared to Maris's prints of an etching, as he would retouch the sheets in pen or pencil to make each one a unique piece with its own distinctive atmosphere and tone.

PROVENANCE: P.A. Scheen Gallery, The Hague 1955; donated to the museum by P.A. Scheen, 1956.

LITERATURE (for both versions): P. Zilcken, *Les Maris: Jacob-Matthijs-Willem*, Amsterdam [1896], fig. after p. 23; D. Croal Thomson, *The Brothers Maris (James-Matthew-William)*, London/Paris 1907 (*The Studio*, Special Summer Number), p. XXXV, fig. M 2 [= the Oss version, then in the James Crathern Collection]; Haverkorn van Rijsewijk 1919, p. 97; van Gelder 1939, pp. 21, 35, fig. p. 47; Jos. de Gruyter 1969, pp. 43, 48, fig. 55; exhib. cat. *Matthijs Maris* 1974, pp. 24-25; Braakhuis & van der Vliet, 1978-79, p. 178 (note 264); exhib. cat. *De Haagse School 1983*, p. 225 (cat. no. 78).

62

M. MARIS
Barye Swan, 1887
Oil on canvas, 88 x 62.5 cm
Initialled and dated centre right: *MM. 87.*
The Hague, Haags Gemeentemuseum

'No portrait – painted for myself', Matthijs Maris wrote in a letter in 1912 concerning his portrait of Barye Swan (Haarlem, Teylers Museum, no. 149). The child was the son of the animal painter John Macallan Swan, a friend of Maris's. He also painted Swan's little daughter (Glasgow, The Burrell Collection), but from a closer angle and seated, rather than full-length. She, too is wearing a lace frock and holding a lemon. The painting must have been made about the same time, perhaps in Swan's atelier, where Maris sometimes worked. He made numerous drawings and paintings of children, seeking to express the ideal of childhood innocence. His early London *oeuvre* includes portraits of small children, a subject occasionally tackled by his Dutch contemporaries, Jacob Maris, Van Gogh, Jan Voerman and Eduard Karsen. Most are portraits of his friends' children, just as his few portraits of adults were confined to a small circle of family and friends. In 1879/80 he painted three versions of Frederick Lessore, then barely a year old, and in 1887 began a double portrait of the little Westmacott sisters (The Hague, Haags Gemeentemuseum) which he continued to rework for over twenty years, until the figures were barely discernible. These portraits largely resemble the studies of anonymous young girls or the many 'little brides' he produced in the 1880s, though the portraits – the three versions of Frederick Lessore and the portrait of Barye Swan – are more colourful. Barye Swan is delicately painted in colours recalling Whistler, varying from white to soft grey-brown. A contrast is provided by the warm skin tones, the red mouth, the pale blue shoes and shoulder bows, and the yellow lemon. The background is empty; only the tiny feet resting on the base of the canvas dispel the illusion that the child is about to float away. As the observer is not distracted by other details, the eye constantly returns to the boy's face. Scarcely conscious of what is happening to him, he regards us with curiosity. Though the lemon clutched somewhat awkwardly in his little hands may have served as a distraction for the child himself, it also lends a colourful note to the picture. Children in sixteenth and seventeenth-century portraits are often shown holding fruit or toys, but there is no known precedent of a child with a lemon. The position of Maris's monogram and the date placed halfway up the canvas also hark back to an earlier tradition. He seldom signed or dated his work after 1880, and by doing so here he provides a clue to Barye's age, just as the lemon helps give an impression of the child's size.

PROVENANCE: J.M. Swan; donated to Jacob Maris's wife by Swan's brother in 1892; purchased by the museum from Croal Thomson, 1929.

EXHIBITIONS: *Werken van de gebroeders Maris*, Rotterdam (Rotterdamsche Kunstkring), October 1893 no. (?); *Werken door Jacob Maris, Matthijs Maris, Willem Maris*, The Hague (Haagsche Kunstkring), December 1893, no. 55.

LITERATURE: J. Veth, 'Tentoonstelling van werken der Marissen', *De Amsterdammer*, 10 October 1893; E.G.O. (A.C. Loffelt), 'De tentoonstelling der Gebr. Maris', *Het Vaderland*, 22 December 1893; van Gelder 1939, p. 51 with fig.; exhib. cat. *Matthijs Maris* 1974, p. 24; Braakhuis & van der Vliet 1978-79, p. 159 (note 144).

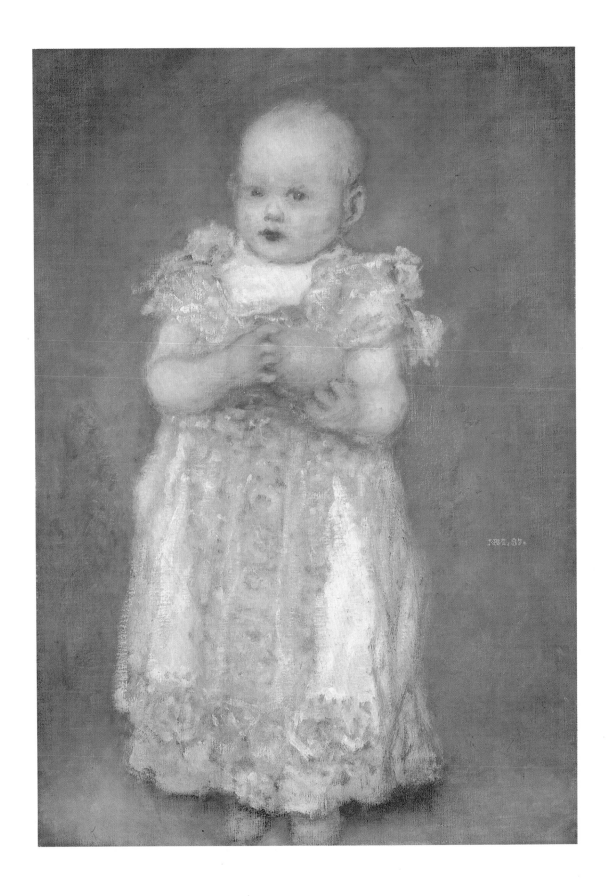

63

M. Maris

The Shepherdess, c. 1885-1890
Charcoal, 47 x 66.7 cm
Initialled lower right: *MM*
Glasgow, The Burrell Collection, Glasgow Museums & Art Galleries

This large charcoal drawing depicts a young woman in a long gown lying outdoors under a clouded sky. Her left arm is resting on a spindle and her right hand is probably clutching a spun thread attached to the skein on the ground. It is impossible to establish exactly who she is or what she is doing. As in most of Maris's paintings and watercolours after 1880 everything is quite vague and there is no reference to any specific time or place. Maris uses his charcoal to blur the contours and remove any contrast between the woman's features and clothing. He has adopted the sfumato technique of Renaissance masters such as Leonardo da Vinci and Andrea del Sarto to envelop the entire figure and her surroundings. We see the image as though through a haze or a misty window that never clears.

The French auction catalogue of 1916 refers to the drawing as *Le génie rompu*, but the caption on an old photograph at the Rijksbureau voor Kunsthistorische Documentatie in The Hague gives the title as *The Shepherdess*. The latter is probably correct, although the French title is more apt. Maris's titles often allude to fairly general themes, even when they give a precise reference, as in the case of *The Lady of Shalott* (fig. 35). He described *The Shepherdess* (c. 1887-1888), at the Rijksmuseum in Amsterdam, which shows a powerful figure kneeling, with arms outstretched

as if to invoke a higher power for the sheep beside her, as an allusion to man's universal, semi-religious need for protection and guidance.

It is not entirely clear how we are to interpret this particular drawing. Maris himself, or his friend Van Wisselingh may have explained the meaning to Hamilton Bruce, the former owner, while the title *Le génie rompu* is undoubtedly significant. The work might be interpreted as autobiographical, in a similar vein to *The Lady of Shalott*, who symbolizes the artist 'living in the realm of shadows, who (...) cannot cease attempting to achieve the impossible' (Braakhuis & Van der Vliet, p. 175). However, this is no more than a hypothesis.

The radically foreshortened pose of the woman, a position sometimes found in pictures of the sleeping disciples in the Garden of Gethsemane, may have been borrowed from sixteenth-century examples. More specifically, it calls to mind an early Raphael panel, *Vision of a Knight*, that Maris would have seen at the National Gallery in London. This depicts a young man in a suit of armour lying on the ground outdoors, with a castle visible on the hill behind him. According to one interpretation, he is dreaming that he faces a choice between earthly pleasures and a chaste life, personified by the two figures on either side of him. Maris would have been inspired not only by the knight's pose but also by the dilemma represented in the scene.

PROVENANCE: R.F. Hamilton Bruce, London; auction Fred. Muller & Cie., Amsterdam, 31 October 1916, no. 219 ('Le génie rompu').

Mauve, Anton

Zaandam 1838 - 1888 Arnhem

Mauve was one of a large family of children; he grew up in Haarlem where his father was a Mennonite preacher. He studied with Pieter van Os between about 1854 and 1857, and a year later under Wouterus Verschuur. From 1858 he spent many summers in Oosterbeek, 'the Dutch Barbizon', where he painted with Paul Gabriël and became friendly with Willem Maris. From Haarlem he travelled to other parts of the country, including Drenthe, Amsterdam and The Hague, where he settled in 1871. In 1874 he married Ariëtte Carbentus, Vincent van Gogh's cousin and a pupil of his. The couple had four children, one of whom was later to become a painter and another an architect. Mauve occupied a prominent position in the artistic circles of The Hague. Together with Willem Maris and Mesdag, he founded the Dutch Society of Watercolourists in 1876, which aimed to promote drawing and especially watercolour as art forms in their own right. Maris also held an administrative position in the Pulchri Artists' Association. From 1882 he regularly worked in Laren, together with Albert Neuhuys. In 1884 he paid his first visit to Ewijkshoeve, the country home of Willem Witsen's family. He maintained close contact with Witsen, as well as with Tholen and Meiners. Mauve lived in Laren from 1885 until his sudden death in 1888, at the age of forty-nine.

A versatile artist, his *oeuvre* includes interiors, figure pieces, portraits, seascapes, shore scenes, and landscapes with peasants at work. He specialised, however, in depicting livestock. Mauve and Willem Maris abandoned the romantic-realistic interpretation of the genre in favour of the more evocative impressionism of the Hague School. Mauve's reputation soared in the 1870s and 1880s. His work was in great demand among Dutch as well as Scottish and American collectors. He produced numerous repetitions as a result, especially in his later years.

Literature: H.L. Berckenhoff, *Anton Mauve*, Amsterdam 1890; L. Bouyer, *Anton Mauve. Sa vie, son oeuvre*, Paris 1898; H.P. Baard, *Anton Mauve*, Amsterdam [1947]; E.P. Engel, *Anton Mauve (1838-1888)*, Utrecht 1967; Jos. de Gruyter, *De Haagse School*, Rotterdam 1969, vol. 2, pp. 61-72; exhib. cat. *De Haagse School*, Paris (Grand Palais) etc. 1983, pp. 232-255, (bibl.) 344-345.

64

A. Mauve
In the Vegetable Garden, c. 1885
Oil on canvas, 55.5 x 75 cm
Signed lower right: *A. Mauve*
Rotterdam, Museum Boymans-Van Beuningen

The picturesque village of Laren had been discovered by Jozef Israëls, Max Liebermann and various other painters before Anton Mauve settled there permanently in 1885. The years that followed saw a veritable invasion of artists, both Dutch and foreign. Though they brought the village fame and prosperity, they also destroyed its character. P.H. van Moerkerken strongly denounced this trend in his novel *De ondergang van het dorp*, published in 1913.

In Laren, Mauve continued to paint the livestock and sheep that had brought him fame and also discovered new motifs, such as peasant women at work in the sheltered privacy of a farmyard, orchard or, as in this case, a kitchen garden. Human figures occupy a more prominent position in these paintings than in his previous work. He also devoted attention to evocative elements, such as plants and trees, though without lapsing into fussy detail. His colours are brighter and more pronounced than in the work he produced in The Hague. These changes reflect his interest in the work of Millet and Bastien-Lepage, which may have been kindled by his frequent contact with young painters such as Tholen and Witsen, whom he met at Ewijkshoeve in the 1880s. Mauve rarely travelled, and would therefore only have known the work of these French artists from reproductions, except for the Millets which he may have seen in Dutch collections. He was probably infected by the enthusiasm Witsen expressed after seeing the commemorative exhibition of Bastien-Lepage's work held in Paris in 1884. This certainly seems to be the case, judging by the colourful and lively treatment of the vegetables which the woman is slicing.

PROVENANCE: G. de Vos, Haarlem (before 1893); auction Amsterdam (C.F. Roos & Co.), 25 April 1893, no. 51 (ƒ 3,025); Goupil & Co., The Hague, 1893; J.P. van der Schilden, Rotterdam, 1895; bequeathed to the museum, 1925.

EXHIBITIONS: *Kunstwerken van levende meesters bestemd voor de tentoonstelling te Antwerpen*, Amsterdam (Arti) 1885, no. 102?; Antwerpen, 1885?; *Internationale tentoonstelling van levende meesters*, Arnhem 1890, no. 297?; *Wereldtentoonstelling van Schone Kunsten*, Antwerp 1894, no. 901; *Mauve-tentoonstelling*, Rotterdam (Rotterdamsche Kunstkring) 1895, no. 56; *Schilderijen van overleden meesters (werkende leden)*, The Hague (Pulchri Studio) 1897, no. 29.

LITERATURE: Engel 1967, pp. 73-74; exhib. cat. Paris 1983, p. 254.

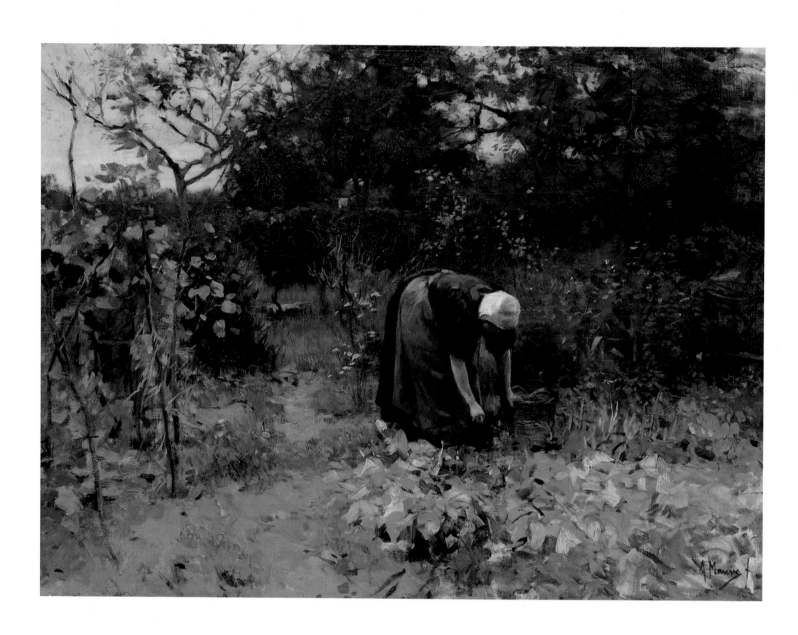

Meiners, Piet

Oosterbeek 1857 - 1903 Lage Vuursche

Piet Meiners first learnt to paint from his father, the landscape artist Claas Hendrik Meiners, who had himself been a pupil of Barend Cornelis Koekkoek. He went on to study under the portraitist, B.L. Hendriks at the drawing academy in Arnhem, and subsequently spent a comparatively long period, from 1876 to 1883, at the Academy in Amsterdam. His fellow-students included Moes, Voerman, Van Rappard, Tholen and Witsen, who was three years his junior. Tholen and Witsen were to become lifelong friends, and the two studied together under Karel Verlat in Antwerp for a few months in 1881.

A reference to Meiners in the register of the Amsterdam Academy describes him as 'conscientious and diligent', although a subsequent entry, dating from 1882/83, adds, somewhat cryptically, that he was 'a singular character'. No further details are given, but he seems to have been a solitary type. After leaving the Academy, Meiners worked near Arnhem, where he painted atmospheric oils and watercolours of subdued evening or night river scenes and landscapes. The few engravings he made probably also date from this period.

At the end of 1886 he settled more or less permanently at Ewijkshoeve, the summer residence of the Witsen family. Although he was considered a 'drifting, idle daydreamer', his output increased and his subject matter became more varied. He painted farm interiors, landscapes, portraits and flower pieces. When the summer guests departed, he stayed on alone at Ewijkshoeve, tending the animals and plants through the winter. It was not until 1896, however, that he registered Ewijkshoeve as his official address.

Meiners was almost impervious to the influence that Ewijkshoeve, 'the garden of the *Tachtigers*', might have had on a young artist. It is interesting to note that, apart from his membership of the St Luke's Artists' Association during his years at the Academy (1880-1882), he was not affiliated to any other organisation until 1897, when he joined Arti. He rarely exhibited, which is possibly why his work, which was sober in style and based on simple, everyday motifs, did not receive general acclaim until the 1890s. On seeing his work at an exhibition in Biesing in 1895, Veth described him as 'a worthy talent who was not destined to be part of the big art parades'. He admired Meiners's 'delicate tones and broadness of vision'. In May 1903 Meiners had a one-man show at the Rotterdam Art Circle. The exhibition was reviewed favourably in the national press and he was especially praised as a still-life artist. A few months later, Meiners died of injuries sustained after a fall from his bicycle, having only briefly enjoyed the growing appreciation for his work.

LITERATURE: J. Veth, *De Kroniek*, 23 June 1895, p. 202; H.F.W. Jeltes, 'Piet Meiners (1857-1903)', *Maandblad voor Beeldende Kunsten*, 22 (1946) 9-11 (September/November) pp. 147-154, 198-208; H.F.W. Jeltes, *Piet Meiners (1857-1903). Zijn leven en zijn werk*, The Hague 1952; Rein van der Wiel, *Ewijkshoeve, tuin van tachtig*, Amsterdam 1988, *passim*.

65
P. Meiners
Les Buveurs d'eau, 1884
Oil on canvas, 74 x 49 cm
Signed and dated lower right: *Meiners 84*
Private collection

Meiners not only signed this painting, but also added the inscription *Les Buveurs d'eau*. A passionate scholar of French literature, he was referring to the novel of the same title by Henri Murger, which appeared in 1853/54. Murger was best known for his *Scènes de la vie de bohème*, published in 1851, which colourfully describes the unconventional lifestyles of artists and writers. The book was extremely popular (Puccini based his famous opera *La Bohème* on it in 1896) and was known to the members of the *Tachtiger* group. Van Deyssel, Kloos and other writers refer to it on several occasions.

Murger's later book describes a small community of artists known as *Les Buveurs d'eau*, who divorced themselves from life in the city, hoping to escape the influence of fashionable trends and the lure of financial gain. Committed to solitude, they wished no more than to lead a life of contemplation. However,

their self-imposed isolation accomplished little, and their idealism, dedication and suffering had no impact beyond the confines of their studio walls.

Meiners probably painted *Les Buveurs d'eau* in Arnhem, where he returned after his turbulent years at the Academy. As far as is known, he had no further contact with his fellow students. This still life seems to convey his sense of isolation at the time, a loneliness he must have thought comparable to that experienced by *Les Buveurs d'eau*. The painting shows the grim reality of life in a garret – a carafe of water, a crust of bread and a depressing view of bare trees and grey roofs. The pipe – an attribute found in many of Meiners's still lifes – shows that he was depicting his own world. His presence is also evident from the 'self-portrait' in the mirror. Like a *buveur d'eau*, Meiners has turned away from the outside world and we see only his back. The painting is thus in effect a double self-portrait.

PROVENANCE: The Hon. Mrs W.E.E. Tholen-De Ranitz, The Hague.

LITERATURE: Jeltes 1946, p. 148; Jeltes 1952, p. 59.

MOES, WALLY

AMSTERDAM 1856 - 1918 LAREN

Etha Fles in 1886. Here she met artists such as Anton Mauve, Jacob Smits, the Italian painter, Grubici, and Max Liebermann. On the advice of Mauve and Gabriël, she started to pay more attention to colour than to detail. This was not her forte, however, and the reviews of her work became increasingly critical. Around 1893 she reverted to her old style. 'My path may not be scenic,' she said, 'but at least I am walking alone'.

After 1900 she turned to writing and in 1911 published the first of three anthologies of fiction about the peasants of the Gooi region. In 1914 she was confined to bed by ill health and was no longer able to paint. With great difficulty, she completed her autobiography in the last years of her life.

LITERATURE: G.H. Marius, *De Hollandsche schilderkunst in de negentiende eeuw*, The Hague 1920, p. 241; Etha Fles, 'Wally Moes', *Elsevier's Geillustreerd Maandschrift*, 41 (1911) 1, pp. 1-13; Wally Moes, *Heilig ongeduld. Herinneringen uit mijn leven*, Antwerp 1961; Jan P. Koenraads, *Gooise schilders*, Amsterdam 1969, *passim*.

Wally Moes was the fourth of six children. Her father was a manufacturer who died when Wally was eight. Her mother, who was of German origin, had spent much of her youth in artistic circles and consequently encouraged her daughter to enrol at the Amsterdam Academy, which she did in 1876. She left eighteen months later, however, objecting to the poor standard of teaching there. After travelling, for some time she returned to the Academy, where Allebé was now director. Her autobiography, *Heilig ongeduld*, mentions his importance to her development as an artist. She painted genre scenes and portraits, which were exhibited regularly at Arti et Amicitiae from 1881. In 1884 she left the Academy with the endorsement 'paints excellently', and travelled to Paris with Thérèse Schwartze, a fellow student. Both worked hard there, painting from Italian models. Moes submitted a number of paintings to the Salon in 1884, but only one, the *Young Italian Smith* (whereabouts unknown), was accepted. To her disappointment, however, it was badly hung and could hardly be seen.

Moes reached the pinnacle of her career around 1885. She received favourable reviews in the press, was awarded the Willink de Collen prize for *Children Playing at Table* (whereabouts unknown), and sold a painting entitled *The Lunch Break* to the Boymans Museum. She was also invited by Jan Veth to become a member of the Dutch Etching Club. She paid regular visits to the picturesque village of Laren, where she settled together with

66

W. MOES

The Lunch Break, 1885

Oil on canvas, 97 x 149 cm

Signed and dated lower left: *Wally Moes. 85*

Rotterdam, Boymans-van Beuningen Museum

The Lunch Break is one of several large figure pieces that Wally Moes made in 1885 after her return from Paris. The Boymans Museum bought it that year at an exhibition in Rotterdam for the substantial sum of 1,500 guilders. Moes's feeling for anecdote and her academic attention to detail reflect the influence of Allebé, although Allebé himself usually worked on smaller canvases.

The painting shows two young basket-weavers taking a break from their work. They have eaten their sandwiches and are sitting quietly, lost in thought. Moes has sought to express the personalities of the two boys; the seated boy seems worried and rather awkward, while his companion looks out at the observer with an aloof and almost insolent air. He is reminiscent of the Italian models Moes painted in Paris, who could be hired cheaply and were available 'in droves', as she wrote in her memoirs. Another source of inspiration may have been Mancini's painting of *The Statue Seller*, which Mesdag bought in 1885. The same blond boy also posed for another ambitious figure piece from

1885, *Interior with Children at Play*, now at the Centraal Museum in Utrecht. In paintings of this type Moes was interested in portraying children as they behave in their own 'natural' surroundings. She would capture a specific moment and record precisely what she saw, without seeking to make a social statement, which in this case might have been an indictment of child labour. Work as such has literally been set aside in *The Lunch Break*, and all attention is focused on the boys themselves. Moes's close observation of children recalls the work of certain seventeenth-century masters such as Murillo, whose painting of the *Young Beggar* (Paris, Louvre) she undoubtedly knew. The casual pose, however, and the air of *dolce far niente* are entirely modern.

PROVENANCE: donated to the museum by the Association of Friends of the Arts (*Vereeniging van Voorstanders der Kunst te Rotterdam*), 1885.

EXHIBITIONS: *Schilderijen en andere kunstwerken van levende meesters*, Rotterdam (Academie der Beeldende Kunsten en Technische Wetenschappen), 1885, no. 297 ('Schaftuurtje').

LITERATURE: Fles 1911, p. 7; J.B. Knipping, *Het kind in Neerlands Beeldende Kunst*, 2, Wageningen 1944, pp. 139-141; Moes 1961, p. 162.

Oyens, David

Amsterdam 1842 - 1902 Brussels

David and his twin brother Pieter came from a wealthy family of Amsterdam bankers. Even at primary school the two brothers showed an interest in drawing, which their parents chose not to encourage. Instead, at the age of fourteen, they went to study agricultural science in Apeldoorn. The rural surroundings merely strengthened their artistic ambitions, and three years later they were sent to Brussels on the advice of the portrait painter Jan Kruseman to study in the studio of Jean Portaels. Three and a half years later they returned to the Netherlands, where they studied together with Allebé under P.F. Greive. In 1866 David married Kruseman's granddaughter and returned to Brussels. Pieter soon joined him, and from the 1870s the two brothers were inseparable, sharing the large studio which had previously belonged to Portaels. They acquired a reputation as genre painters. The ironic undertones of an artist such as Bakker Korff are absent from their work. Their paintings are humorous and good-natured and the brothers became known as the '*bons vivants of painting*'. Though their subject matter frequently has a French tone, it is largely anecdotal and their work shows a strong feeling for mood and colour. Both painted in a loose, impressionistic style from quite early on. David Oyens's *oeuvre* is much larger than his brother's, which suggests that he worked more easily. His brushwork and his interpretation of his subjects are more spontaneous and ambitious. He specialised in genre scenes, painting comparatively few landscapes, portraits or still lifes.

The brothers always maintained close ties with the Nether-lands. Between 1880 and 1895 their work was exhibited almost annually at Arti and the Dutch Society of Watercolourists, and from 1889 it was regularly shown at Pulchri. In 1893 and 1894 they exhibited in Rotterdam and Amsterdam. Much earlier, around 1880, David Oyens was awarded the Leopold Medal for his artistic achievements. Both brothers generally received favourable reviews in the Dutch press, although A.C. Loffelt (E.G.O., *Het Vaderland*, 9 June 1884) was offended by the 'shamelessly' naturalistic side to their work: 'How can someone be an artist and yet have so little taste – or rather, so much taste for the unsightly?' In Loffelt's view, their work was only fit to decorate cafés and alehouses.

LITERATURE: E.G.O. (A.C. Loffelt), *Het Vaderland*, 9 June 1884; E. Wesley, 'David en Pieter Oyens', *Elsevier's Geïllustreerd Maandschrift* 2 (1892) vol. 3 January/July pp. 537-555; G., 'Pieter en David Oyens', *De Nederlandsche Spectator*, 17 February 1894, pp. 60-61; G.H. Marius, *De Hollandsche schilderkunst in de negentiende eeuw*, The Hague 1903, pp. 320-323; R. Jacobsen, 'De gebroeders Oyens', *Onze Kunst* 7 (1908) vol. 13, pp. 89-102; J. Veth, 'David en Pieter Oyens', *Portretstudies en silhouetten*, Amsterdam [1908], pp. 216-218; A. Plasschaert, 'David Oyens', *XIXde Eeuwse Hollandsche Schilderkunst*, Amsterdam [1909], pp. 185-186; H.F.W. Jeltes, 'Notities' (1938, manuscript, Rijksbureau voor Kunsthistorische Documentatie, The Hague); C.J. Kelk, 'De heren David en Pieter Oyens, Kunstschilders eertijds te Brussel. Het tweelingpalet', *De Groene Amsterdammer*, 27 September 1952; Jos W. de Gruyter 'De negentiend'eeuwsche genreschilders David en Pieter Oyens', *Het Vaderland*, July 1942 (Press Documentation Department, Rijksbureau voor Kunsthistorische Documentatie, The Hague).

67

D. Oyens
Dessert, 1882
Oil on canvas, 46 x 38.2 cm
Signed lower left: *David Oyens 1882*
Rotterdam, Boymans-Van Beuningen Museum

This painting has been referred to by various titles: *In the Restaurant*, *In the Café*, *Le déjeuner*. However, the original title under which the canvas was exhibited in 1882, and sold for the sum of 500 guilders, was *Dessert*.

The painting resembles a snapshot – an effect the artist achieved by cropping the picture to correspond to the viewpoint of a chance passer-by. The effect is heightened by way in which the two women are depicted. One is just putting her hand to her mouth to lick something sticky off her finger or to wipe away a crumb, while raising her eyes to her companion, who is speaking and is about to take a mouthful of cake. The artist has neatly captured the intimacy of the moment; it is as if he has caught the two women unawares. Oyens, however, must almost certainly have staged the scene in his studio, using models. The props – piano, chairs and the small table – appear in several of his other paintings. This work places Oyens in the forefront of the young

Dutch painters of the 1880s. In terms of subject matter, and to some extent execution, he has allied himself with French Impressionists such as Renoir and Degas. Degas painted similar café scenes, but Oyens's work is free of the melancholy air which pervades Degas's figures. The painting calls to mind the work of a pupil and friend of Degas, the American artist Mary Cassatt, and in many respects resembles her painting *Le thé*, from 1880 (Boston, Museum of Fine Arts), which captures a similar moment.

PROVENANCE: Van Fokkenberg, Utrecht; auction Amsterdam (Brakke Grond), 1883, no. 227; auction Amsterdam (C.F. Roos & Co) 1912, no. 236; bequeathed to the museum by Justus Schreuder, 1932.

EXHIBITIONS: *Schilderijen*, Rotterdam (Academiegebouw) 1882, cat. no. 311 ('Het dessert', *f* 500); *Schilderijen en andere kunstwerken van levende meesters*, Amsterdam (Arti et Amicitiae) 1882, cat. no. 214 ('Dessert', *f* 500).

LITERATURE: P.A. Scheen, *Honderd jaren Nederlandse schilder- en teekenkunst. De Romantiek met voor- en natijd*, The Hague 1946, p. 231, (fig. opp. p. 113); J. Knoef, *Een eeuw Nederlandse schilderkunst*, Amsterdam 1948, pp. 116-117; H. Gerson, *Voor en na Van Gogh*, Amsterdam 1961, p. 32 (fig. 75).

OYENS, PIETER

AMSTERDAM 1842 - 1894 BRUSSELS

The early years of Pieter Oyens's career were identical to those of his twin brother, David, the elder by five minutes. They completed their art training together, but their paths then diverged temporarily: David settled in Brussels, while Pieter went to Paris in 1869, where he copied numerous works in the Louvre. It is not known why they chose to go separate ways. Pieter may not yet have felt sufficiently confident, and perhaps wanted to devote more time to studying the Old Masters, but other factors, such as his brother's matrimonial plans and the need, commonly felt by twins, to develop an independent personality, may also have played a role. With the outbreak of the Franco-Prussian War in 1870, Pieter Oyens returned to Holland. Shortly afterwards, he settled in Brussels, where his brother had already established his reputation. Pieter's breakthrough came a few years after David's, when he received a number of awards at home and abroad. In 1892, he won a gold medal in Munich, and in 1893 he was received into the Order of Luitpold. In the same year, at the age of 51, he married a German pupil of his, K. Krupp. He was by then apparently suffering from a kidney disease caused by his excessive consumption of beer. He died eight months later, just when the critics were commenting on the greater subtlety and refinement in his work and praising his more judicious choice of subject matter. Unlike David, Pieter concentrated on drawing more than painting. His output was smaller but more varied and he was constantly exploring new fields, rather than confining himself to a single specialism.

LITERATURE: see David Oyens.

68
P. OYENS
La Servante (The Maid), 1881
Oil on canvas, 31,5 x 22 cm
Signed and dated upper right: *P. Oyens. 1881*
Private collection

Pieter Oyens painted *La Servante* in 1881, several years before the theme was taken up by Breitner and Isaac Israëls. It was a subject he returned to on more than one occasion, his intention being to capture a fleeting moment as naturally as possible. Such 'instantanés', in which the artist's eye functions as a photographer's lens, could sometimes produce unusual results, as is the case here in the clumsy rendering of the servant's left hand. The Oyens brothers themselves referred to such mishaps as their '*peccavi*'. Despite this minor flaw, Oyens has admirably succeeded in portraying a woman sitting down briefly to catch her breath. The scene would have been staged and painted in the studio (the sofa and tray feature in other works, as does the model, who posed for both Pieter and David in various guises – maid, pianist, Italian woman), but the overall effect is nevertheless realistic. Oyens has convincingly captured the half-weary, half-alert expression on the girl's face.

The French influence in this painting is clear. The frontal, informal pose is reminiscent of Manet and his circle. The colours, too, are French rather than Dutch. Oyens seems to have delighted in the stark contrasts of the black and white uniform, and in striking colour accents, such as the bright red bow, the blue kerchief and the blue gloss on the girl's hair. The colour of the corsage provides a subtle link between her hands and the complexion of her face, while the sparkling silver tea-tray completes the play of colours. The red, white and blue, and the festive touches in the girl's costume suggest the celebration of some national holiday in France or the Netherlands, both of which have red, white and blue national flags. Pieter Oyens thus achieves an amusing anecdotal effect.

PROVENANCE: 's Hertogenbosch, Borzo Gallery, 1987.

EXHIBITIONS: *Kunstwerken van levende meesters*, Amsterdam (Arti et Amicitiae) October 1887, no. 177 ('Het dienstmeisje', ƒ 650)?

RAPPARD, ANTHON VAN

ZEIST 1858 - 1892 SANTPOORT

The Van Rappard family belonged to the lower ranks of the Dutch aristocracy, and Anthon was accordingly entitled to style himself a *ridder*, or knight. Throughout his childhood, the family of six divided their time between their homes in Zeist and Utrecht, before settling permanently in Utrecht in 1879. Anthon attended high school in Utrecht from 1872 to 1876, and later made a short trip to southern Germany in the company of Johan de Meester. During the journey, he decided to make a career in art. The family approved of his choice, and his father, himself chairman of the Utrecht Artists' Association, welcomed the decision wholeheartedly.

Anthon was accepted at the studio of the Utrecht painter H.E. Grolman, but moved to Amsterdam in the same year and enrolled at the Academy. He left three years later, in 1879, intending to continue his training abroad. He first made a study trip to Belgium and at the end of 1879 went to work at J.L. Gérome's studio in Paris. In 1880 and 1881 he attended painting classes at the Académie Royale des Beaux-Arts and the Académie St Joost-ten-Noode in Brussels. He then returned to Utrecht, and moved back into his parents' home. Van Rappard frequently travelled around the country, visiting Loosdrecht, Drenthe and the island of Terschelling. He returned from these trips with studies of the landscapes and peasants he had encountered on his way.

In 1880 he met Vincent van Gogh in Brussels and the friendship that developed between them was to have a major impact on Van Rappard's artistic development. Although the two men were entirely different in temperament and background, both were profoundly concerned with social issues and the condition of the poor. Inspired by illustrations in English and French journals, they incorporated these themes in their art. Van Rappard made numerous studies at the Institute for the Blind in Utrecht and at the women's almshouse on Terschelling; he also drew factory workers, weavers and peasants. Unlike Van Gogh, he attached great importance to technical proficiency and their disagreement over the matter led to a break in their friendship in 1885. Van Rappard decided to return to the Academy in Amsterdam to improve his technique. His contact with contemporaries working in Amsterdam from 1886 to 1888 had little impact on his choice of subject matter. Although he joined Arti et Amicitiae, he felt a stronger affinity with the Utrecht Art Circle, which he had helped establish in 1883. During this period he also wrote exhibition reviews and essays on art for the *Utrechtsch Provinciaal en Stedelijk Dagblad*. In 1888 he became a member of the Pulchri Studio and made study trips to Heeze in the province of North Brabant and to the Eiffel in Germany.

The following year, Van Rappard married his cousin H.E. Camp del Campo and spent the rest of his life in relative seclusion on a country estate in Santpoort. He joined the nearest local artists' association, 'Kunst zij ons Doel' (May Art Be Our Aim), in Haarlem, but seldom exhibited his work. His late *oeuvre* consists primarily of dune landscapes, portraits of his wife, flower pieces and studies of a cotton-weaving atelier in Haarlem. In 1892 he suffered an attack of pneumonia and died that same year at the age of thirty-three.

LITERATURE: Anonymous, 'A. van Rappard', *Nieuwe Rotterdamsche Courant*, 2 March 1892; G.H. Marius, 'Anthon Gerard Ridder van Rappard', *Onze Kunst* 23 (1913), pp. 189-205; *The Complete Letters of Vincent van Gogh*, New York/London, 1958, reference numbers in square brackets correspond to the letter numbers in this edition; Jaap W. Brouwer *et al.*, *Anthon van Rappard. Companion & correspondent of Vincent van Gogh. His life & all his works*, Amsterdam/Maarssen 1974.

69

A. VAN RAPPARD
The Weaver, *c*. 1883
Oil on canvas, 26,3 x 35,3 cm
Unsigned
Laren, P.H. ter Berg

Paintings of weavers are generally associated primarily with the work of Vincent van Gogh. Nevertheless, apart from a painting by Allebé from 1865, which the younger artists are unlikely to have seen, it was Van Rappard who first explored the theme. This emerges from a letter which Van Gogh wrote from Nuenen in

early January 1884. He enquires whether Theo had seen many drawings of weavers. He himself had already completed three watercolours, but he also refers to a study which Van Rappard had painted earlier in Drenthe, which he especially liked and which he described as 'very gloomy, because these weavers live in poverty' [351].

Van Rappard had spent the late summer of 1883 in Drenthe and although Van Gogh was there shortly afterwards, from mid-September to early December, all his weavers were painted in Nuenen. During a visit to Van Gogh in Nuenen in May 1884, Van Rappard depicted a second weaver which can be identified with our painting [369]. This work, which was in the possession of Van Rappard's sister Wilhelmina in the 1930s, is almost identical to Van Gogh's *Weaver* (Munich, Neue Pinakotek), and must therefore have been painted in May, when the two painters made excursions 'to weavers and other nice things in the countryside' [369]. The daylight pouring through the window illuminates the contours of the figure and casts a soft glow on the fabric in the loom, which is the only object of value in the humble dwelling.

The idea of placing the figure directly in front of the window and thus heightening the chiaroscuro effect may have been in-spired by black and white illustrations in French and English magazines. Like Van Gogh, Van Rappard had a large collection of these prints, many of them concerning social problems and deprivation. Although he seems to have been moved primarily by compassion, the theme undoubtedly offered an interesting pictorial image. Van Gogh lyrically described the looms as 'in themselves so wonderfully beautiful, that old oak against a greyish wall. They should certainly be painted' [367].

PROVENANCE: Wilhelmina Elisabeth van Rappard, 1931; P.H. ter Berg, Laren.

LITERATURE: exhib. cat. *A.G.A. van Rappard: tentoonstelling van zijn werken in Voor de Kunst*, Utrecht (Voor de Kunst) 1931, no. 4; Brouwer 1974, p. 87 (not identified with our picture).

Robertson, Suze

The Hague 1855 - 1922 The Hague

Suze Robertson was the daughter of a merchant and the youngest of a large family of children. The financial support of an aunt enabled her to be sent to a boarding school in Wassenaar, which was run by the prominent educationalist and writer, Elise van Calcar. Although Robertson was both artistically and musically gifted, she chose to study at the Academy in The Hague in 1874, under the director Johan Koelman. Her fellow students included Breitner and De Zwart. In 1877 she qualified as a drawing mistress, and from September of that year taught at a secondary school for girls in Rotterdam. At the same time, she attended evening classes in life drawing at the Rotterdam Academy, while at the weekend she studied painting under Petrus van der Velden, a disciple of Jozef Israëls. In 1882 she moved to Amsterdam, where she again taught at a girls' school. She enrolled for evening classes at the Academy in Amsterdam and was taught by Allebé. There she met the young artists of Amsterdam. In 1883 she gave up her secure job to devote herself entirely to painting. The following year she returned to The Hague, which was then the major centre for artists and art dealers. She became a member of the Pulchri Studio and attended drawing evenings in the company of Breitner, Tholen and De Zwart. Her work was regularly shown in exhibitions. She was admired by artists of the Hague School – Mesdag purchased some of her paintings and watercolours – and by contemporaries such as Breitner, Veth and Witsen. In 1891 she joined the Dutch Etching Club, which had been founded by Zilcken and a number of young Amsterdam artists in 1885. In The Hague she associated mainly with the painters Richard Bisschop and Jacob Smits. Robertson also regularly worked in the Gooi region and in the Brabant hamlet of Dongen, where she found the rather melancholy motifs that interested her – dark interiors with women or children engaged in their daily chores. She also painted a large number of still lifes.

In 1892 she married Bisschop, and two years later gave birth to a daughter, Sara. Robertson produced little work during the next few years, but in the latter half of the 1890s took up painting again with renewed enthusiasm. In the twenty years that followed she produced her most characteristic work. While her motifs remained the same – still lifes, figures in interiors and architectural views – the intensity of colour and her handling of paint became almost Expressionistic. The critical response was mixed. Some reviewers dubbed her work unfeminine; her former teacher Allebé remarked in his notebook (1909) that she belonged to the 'school of justslapitonski', although she 'sometimes produces beautiful work'. Young artists such as Mondrian admired her and were influenced by her work. She received official recognition in the form of awards at international exhibitions, and her work was purchased by museums and prominent collectors. From 1914 Robertson was troubled by ill-health and depression, and seldom painted.

Literature: exhib. cat. *Suze Robertson, Thérèse van Hall*, Rotterdam (Rotterdamsche Kunstkring) 1905-1906; N. van Harpen, *Menschen die ik gekend heb*, Rotterdam 1928, pp. 23-33; A.M. Hammacher, *Amsterdamsche impressionisten en hun kring*, Amsterdam 1941, pp. 72-77; exhib. cat. *Suze Robertson*, The Hague (Haags Gemeentemuseum) 1984.

70
S. Robertson
Girl in Repose, *c.* 1889
Oil on canvas, 77.5 x 60 cm
Signed lower right: *Suze Robertson*
The Hague, Haags Gemeentemuseum

Suze Robertson's *oeuvre* consists of a limited repertoire of schematised images which she reworked in countless variations throughout her life. Her stylistic development has not yet been analysed systematically, but it was probably not an uninterrupted or linear process. Because Robertson rarely dated her work, and as early catalogues give only rudimentary details, it is difficult to determine the date of any given painting.

Girl in Repose, however, was included in the 1905-1906 retrospective exhibition, and Robertson annotated her own copy of the catalogue with the date 1889 (Rijksbureau voor Kunsthistorische Documentatie, The Hague), which is probably the year in which she painted it. The canvas corresponds in style to work that Breitner and De Zwart were producing in the late 1880s, and has features typical of Robertson's early style such as attention to details of clothing and the modelling of the face and hands. It is surprising, however, that the yellow fabric behind the girl is painted so loosely and boldly, particularly in the right half of the picture, where the rough yellow-brown strokes destroy any illusionistic effect. This area is closer in style to Robertson's later

work. Although she may have reworked the canvas at a later date, it is more likely that she handled the paint differently from the outset and that the effect was intentional. Robertson may have been inspired by the Italian, Antonio Mancini, whose work, with similar contrasts and deep black shadows, was admired and collected in the Netherlands at this time, by Mesdag, for example. In terms of subject matter, too, Robertson's painting recalls work by Mancini, such as his *Sick Child* in the Mesdag collection, although Robertson's pieces are less trite and sentimental.

There are several extant variations of the *Girl in Repose*, including a smaller painting (Sotheby-Mak van Waay auction, Amsterdam, 30 October 1979, no. 402) and a panel showing only the girl's head (Brandt auction, Amsterdam, 15/16 June 1954, no. 58). She also depicted the same motif on paper.

PROVENANCE: Van Wisselingh & Co., Amsterdam; H.C. Carsten, Amsterdam; auction Amsterdam (Mak van Waay), 10 June 1952, no. 105; S. van den Berg Jr, Wassenaar; bequeathed to the museum in 1964.

EXHIBITIONS: Schilderijententoonstelling, Middelburg 1889 (*Siska*)?

71

S. ROBERTSON
Girl with Pitcher, *c.* 1891
Oil on canvas, 153 x 84 cm
Signed lower left: *Suze Robertson*
The Hague, Haags Gemeentemuseum (on loan from the Suze Robertson Foundation)

The 'girl with pitcher' is a recurrent theme in Robertson's paintings and drawings, although there are variations in the girl's clothing and pose. These works are all similar in style, unlike Robertson's other repetitions of a motif, and were probably produced in quick succession. The Suze Robertson Foundation (the artist's estate) has three painted versions of the theme. Two sketchier variants depict a girl without a hat, facing right and raising a water jug to pour out the contents, whereas the more finished painting reproduced here shows a girl with a hat, carrying a pitcher. This is one of Robertson's largest known canvases, which suggests that she may have been intending to exhibit it, though it cannot be traced to any specific work she submitted for exhibition in the 1890s. The catalogue of the 1905-1906 exhibitions, however, mentions a *Girl with Pitcher* (225 guilders) and a painting entitled *Fetching Water* (900 guilders), both dated 1891. Judging by the price, the second of these must have been a large work, possibly the canvas shown here, which indeed suggests a girl with an empty pitcher on her way to fetch water. A date of *c.* 1891 is not implausible for this picture. It is less detailed than the *Girl in Repose* of 1889 (cat. no. 70), the composition is tight but the brushstrokes are not as broad and irregular as in her later work. It corresponds in style to the work her contemporaries and former fellow students Breitner and De Zwart were producing around 1890, although Robertson's palette is considerably darker. In terms of subject matter, the painting is typical of the type of figure piece she continued to paint until the end of her career: women and girls from peasant or working-class backgrounds going about their daily tasks. They are shown sometimes in pairs, but more often on their own. Robertson depicts less action, anecdote or picturesque detail than many other nineteenth-century painters in the Netherlands or abroad who dealt with this theme. She concentrates exclusively on the figures, which are placed against an empty background. They are captured with keen sensitivity – hard at work or enjoying a moment of rest.

PROVENANCE: S. Eckhart-Bisschop, The Hague; Suze Robertson Foundation; lent to the museum in 1962.

LITERATURE: exhib. cat. The Hague 1984, no. 30.

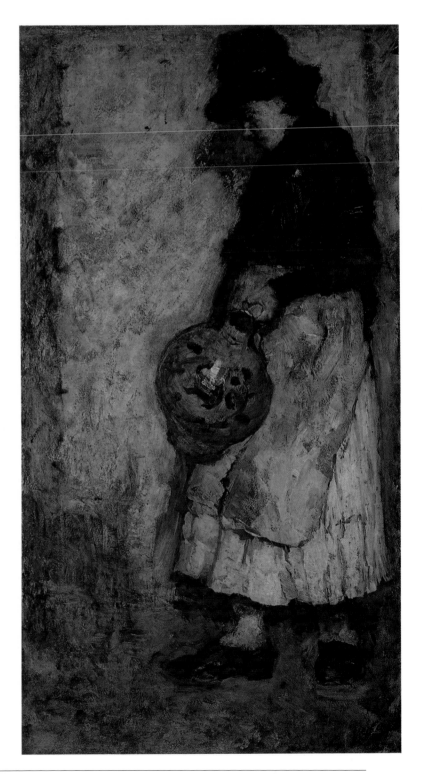

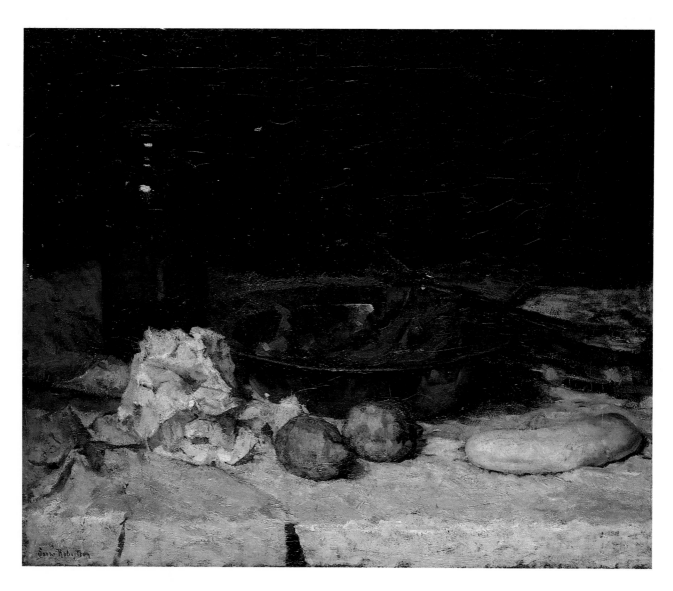

72
S. ROBERTSON
Still Life, *c.* 1892
Oil on canvas, 76.5 x 91.5 cm
Signed lower left: *Suze Robertson*
Amsterdam, Stedelijk Museum (donated by the Association for the Acquisition of a Public Contemporary Art Collection)

In 1913, the Association for the Acquisition of a Public Contemporary Art Collection noted in its annual report for the previous year that 'this powerful *Still Life* is undoubtedly one of the artist's finest works. We purchased it from the lender to ensure that we should not have to relinquish it at some future date'. The lender and previous owner was the collector M.J.J. Thiele, an early admirer of Robertson. His estate, which was auctioned in 1924, included thirteen of her works.

Still lifes form an important part of Robertson's *oeuvre*. She made her début at the International Colonial Exhibition in Amsterdam in 1883 with a piece entitled *Vegetables* (The Hague, Haags Gemeentemuseum), which set the tone for her subsequent work in this genre. These paintings depict only a few objects, all of them commonplace: fruit, a bottle or jug, a dish and a piece of cloth draped over a table. Sometimes, however, the still life is seen as a small part of her studio interior. The canvas reproduced here is one of her most elaborate still lifes. It shows a pewter dish with rhubarb leaves, a green glass jar, a few lemons, a cucumber or large gherkin and a piece of white fabric, set on a table covered with a white cloth. The work is a sonorous harmony of whites and greys, enlivened by a few notes of green, yellow and red. Robertson has managed to capture the texture of the various objects without rendering excessive detail. Her later work shows less concern with the material nature of objects. She seems to have considered still lifes a suitable medium for exploring new artistic avenues. Unlike Verster's still lifes from the same period, Robertson's pieces have no hidden meaning. In terms of composition and technique they rank with the work of French painters of the second half of the nineteenth century, such as Bonvin, Courbet, Fouace and Ribot, all of whom kept alive the tradition of Chardin.

PROVENANCE: M.J. Tiele, The Hague; purchased by the Association for the Acquisition of a Public Contemporary Art Collection, 1912 (*f* 1200); donated to the museum in 1949.

LITERATURE: exhib. cat. The Hague 1984, p. 8.

ROCHUSSEN, CHARLES

ROTTERDAM 1814 - 1894 ROTTERDAM

Charles Rochussen spent his youth at Honingen, a manor-house in Kralingen, near Rotterdam, where his patrician family settled in 1815. Literature and art formed an important part of his education. However, before devoting himself to an artistic career, Rochussen attended the business college in Antwerp and worked in an office for some years. It was only in 1836, when he was already twenty-two, that he moved to The Hague to study under the Romantic painter, Wijnandus Nuyen, and subsequently, after Nuyen's death in 1838, under Anthonie Waldorp. He attended the Hague Academy from 1839 to 1846, before making a series of study trips to Belgium, Germany and France. Later, he also visited Italy and England.

In 1849 Rochussen moved to Amsterdam, where he was to spend the next twenty years of his life. He emerged as a prominent figure in the art world. His entrée to wealthier circles assured him of work, and he was highly regarded by fellow artists and writers. He was elected chairman of Arti et Amicitiae in 1858 and on several occasions subsequently.

His social background inevitably influenced the subjects he chose to depict; he concentrated primarily on historical themes, motifs from the fashionable circles to which he belonged, and images from sports then in vogue. He also played a leading role in Josef de Vos's ambitious 'history gallery', a project undertaken by various artists to illustrate Dutch history through the ages. Rochussen had a sound knowledge of history, which enabled him to advise his colleagues, and he himself produced twenty-seven of the 253 oil sketches made for the project between 1850 and 1863. In the years that followed, he made a number of portraits of actors and actresses, and between 1865 and 1868, some thirty-five posters advertising theatre and ballet productions.

In 1869 he moved to Rotterdam, where he spent the rest of his life as a somewhat reclusive bachelor. He illustrated a large number of books and in 1879 became editor and illustrator of a cultural magazine, *Eigen Haard*. An honorary member of the Dutch Society of Watercolourists, Rochussen caused a minor scandal in 1882 by joining their rivals, the conservative Royal Association of Dutch Watercolourists. As a specialist in history painting and an exponent of a more detailed technique, he probably felt out of place among the masters of the Hague School, who largely comprised the Society of Watercolourists.

Rochussen, who was principally a painter of Dutch history pieces, Alma Tadema, whose main interest was Antiquity, and Ary Scheffer, whose reputation was founded on religious subjects, were the three leading history painters in nineteenth-century Holland. Rochussen's emphasis on historical detail and accuracy reflect the positivist, scientific values that were adopted in educated circles after 1850. He did not lapse into the patriotic idealisation characteristic of the Romantics.

He was greatly admired by younger artists, in particular Breitner, who at first contemplated following in Rochussen's footsteps as a history painter. Indeed, Rochussen was by no means considered a traditionalist. Reviewing a major exhibition of his drawings in the Panorama Building in Amsterdam in 1884, the critic from *De Portefeuille* recalled 'the time when the only important question was whether one was for or against Rochussen, and many people thought it quite daring to be enthusiastic about him or even to admire him.'

LITERATURE: anonymous, *De Amsterdammer* (daily), 26/29 September 1894 (In Memoriam); D. Franken and F.D.O. Obreen, *l'Oeuvre de Charles Rochussen. Essai d'un catalogue raisonné de ses tableaux, dessins, lithographies, eaux fortes*, Rotterdam 1894; C. Veth, *Charles Rochussen*, Rotterdam/Antwerp 1947; J. Knoef, 'Het grafisch werk van Ch. Rochussen', *Van romantiek tot realisme*, The Hague 1947, pp. 95-116; H.C. de Bruyn Jr., 'Charles Rochussen. Grandseigneur onzer 19e eeuwse schilders', *Uitkijk, Christelijk Cultureel Maandblad*, July 1959, pp. 503-507; P. Hoenderdos, *Arie Scheffer, Sir Lawrence Alma Tadema, Charles Rochussen of de vergankelijkheid van de roem*, Rotterdam 1974, p. 27-34; exhib. cat. *Het Vaderlandsch Gevoel. Vergeten negentiende-eeuwse schilderijen over onze geschiedenis*, Amsterdam (Rijksmuseum) 1978, *passim*.

73

C. ROCHUSSEN
Countess Petronella at Egmond Abbey, 1881
Watercolour, 38 x 62 cm
Initialled and dated lower right: *ChR 81*
The Hague, Royal Archives

This watercolour, which depicts Countess Petronella of Holland, her son Dirk VI and her retinue paying a visit to the sculp-

ture studio at Egmond Abbey, was purchased by the Prince of Orange directly from the Academy in The Hague, where it was shown in an exhibition of drawings in 1881. Rochussen's interest in themes from Dutch history brought him into contact with members of the Dutch royal family, and it is possible that his representation of what is ostensibly a purely historical episode in fact contains an implicit statement on contemporary policy on the arts. The government of the day did not support the arts or play any role in cultural life, whereas Rochussen apparently believed that artists working in the Middle Ages had indeed enjoyed the benefit of such patronage.

The watercolour shows a tympanum resting on a large easel. The tympanum depicts St Peter with the founders of the new abbey, Petronella and Dirk, on either side. The abbot is receiving the Countess and her son, who have come to inspect the work they commissioned. Two grand chairs have been set out for them, and the studio floor has been graced with a carpet in their honour. In the background are a number of monks, excited at the pomp and ceremony of the occasion. The tympanum was to be placed above the main entrance of the abbey chapel. The texts inscribed on the moulding read, '*O Deurwachter des Hemels, doe deze met gelovig hart voor u neerknielende Schone binnenkomen en verzoen met haar den koning der Hemelingen*' (O Watchman of Heaven's gate, allow this pure and pious soul to enter and grant her grace before the King of Heaven) and '*Hier bidt Dirk, dit werk is door Petronella versierd*' (Here prays Dirk. This work was decorated by Petronella).

Petronella, however, contributed little – indeed, less than the cost of the material. The tympanum had been hewn from an old tombstone, and records show that the monastery itself covered most of the cost of enlarging the abbey. According to the abbey chronicles, the Countess commissioned the work 'out of greed rather than reverence'. Rochussen could not have known these details, and his interpretation of the story, which was quite different from the situation in his own time, probably seemed to represent the ideal relationship between patron and artist.

For his watercolour, Rochussen presumably consulted various historical works, foremost among them W.J. Hofdijk's complete history of the fatherland, *Ons Voorgeslacht*, published in four volumes between 1859 and 1864. Rochussen had himself contributed some of the illustrations for the book, although the print of the Egmond tympanum, which appeared in Volume III, had been made by Van der Kellen. Rochussen may have drawn the tympanum in the painting after this print, but he is more likely to have studied the actual sculpture in the garden of the Trippenhuis in Amsterdam, where it stood from 1842, if not earlier. The costumes are based on examples he found in books.

Rochussen received outstanding reviews and was acclaimed for his knowledge of history and his 'most spirited rendering'. The importance that was attached to meticulous historical accuracy is evident from a review by A.C. Loffelt, which appeared in *Het Vaderland*. Commenting on Rochussen's watercolour, he said he could understand that people were uncertain whether the tympanum was of sandstone or wood.

PROVENANCE: purchased by the Dutch Royal Family in 1881.

EXHIBITIONS: *Teekeningen door gewone en eere-leden der Hollandsche Teekenmaatschappij*, The Hague (Academie der Beeldende Kunsten), August-September 1881, no. 98 ('Gravin Petronella met haar zoon Dirk bezoeken de werkzaamheden voor de kerk te Egmond (12de eeuw)').

LITERATURE: *De Nederlandsche Spectator*, 20 August 1881, 27 August 1881; E.G.O. (A.C. Loffelt) *Het Vaderland*, 29 August 1881; ibid., 20 November 1894; Franken/Obreen 1894, no. 933; Veth 1947, pp. 5, 8, 59; exhib. cat. Amsterdam 1978, p. 58.

Roland Holst, Richard

Amsterdam 1868 - 1938 Bloemendaal

Richard Roland Holst was born into an affluent family with progressive ideas and an interest in politics. His father, a manufacturer and insurance broker, championed the cause of the Boer Republic in South Africa and was one of the founders of an association of free thinkers. In later life, the artist apparently regretted what he called his 'heathen' upbringing.

Though his flair for drawing was apparent at the age of five, Roland Holst initially failed the entrance examination for the Amsterdam Academy, and was only admitted after a second attempt in 1885. Breitner, who was many years his senior and had a studio at the Academy, was an important influence on him around this time. Even as a student, Roland Holst frequently painted outdoors from nature. He spent part of 1888 with Carl Breitenstein in Breukelen, and several months in 1888/89 with Jan Verkade near Hattem. He then moved to Heerde, where he stayed with the painter H.G. van Rinkhuyzen, before returning to Amsterdam in 1891. In the long run, Impressionism failed to satisfy him, and his interest gradually shifted towards Symbolism.

He produced very few oil paintings after 1892, turning more to graphic and drawing techniques. The studies he made from nature in 1892 and the following years, in Eemnes, Laren and Huizen, are entirely different from the work he had produced previously. They are linear and analytical, rather than evocative of mood or atmosphere. He was strongly influenced by Toorop and Van Gogh, and was one of the organisers of the Van Gogh exhibition in Amsterdam in 1892. He also developed an interest in religion and mysticism, and in 1892 Verkade introduced him to Sérusier. He learned about the theories of Sar Péladan and, shortly after the latter's visit to Holland, Roland Holst joined the Rosicrucians. In 1893, he visited Antwerp, Brussels and Paris, where he met Maurice Denis. He then went to London 'to dabble in the applied arts', as he wrote to Derkinderen, with whom he felt he had much in common (letter from Noordwijk aan Zee, 27 September 1893). Roland Holst, who also wrote art reviews in *De Nieuwe Gids*, was an admirer of Derkinderen, whom he saw as the first painter to consider reality not as an end in itself, but as a means of portraying the abstract concept underlying it. While in England, Roland Holst was deeply impressed by the ideas of Morris, Crane, Ricketts and Shannon.

After a short stay in Amsterdam and Bussum, he settled in Amersfoort and in 1896 married the poet Henriëtte van der Schalk. The couple moved to 's Graveland. Both had socialist sympathies and joined the Social Democratic Labour Party (SDAP) in 1897. Roland Holst began to lose interest in Symbolism in the 1890s as his attention turned to socially-committed, monumental art, which he expounded in lectures, pamphlets and books. Most of the work he produced after 1900 was monumental and generally based on geometrical principles. His murals for the Beurs – the Amsterdam Stock Exchange designed by Berlage – and for the Algemene Nederlandsche Diamantbewerkersbond, headquarters of the diamond workers' union, are

good examples. He also illustrated books and designed stained-glass windows, posters, costumes and stage sets.

In 1903 Roland Holst moved to Laren. In 1918 he was appointed professor at the Amsterdam Academy. A year later, he and his wife moved to Zundert and in 1926 to Bloemendaal. In the same year, he succeeded Derkinderen as director of the Amsterdam Academy, and monumental art came to occupy a prominent place in the curriculum. He resigned in 1934. His last commission was a series of marble decorations for the Supreme Court in The Hague, which was recently demolished to make way for an extension to the parliament building.

LITERATURE: R. Roland Holst, 'Over Derkinderen. De beteekenis van Derkinderens nieuwe muurschildering in onze schilderkunst', *De Nieuwe Gids* 7 (1892) vol. 1, pp. 321-324; A.M. Hammacher, 'Enige beginselen van het werk van R.N. Roland Holst', *Elsevier's Geïllustreerd Maandschrift* 73 (1927), pp. 89-99; R.N. Roland Holst, *Over kunst en kunstenaars. Beschouwingen en herdenkingen*, Amsterdam 1928; H. Roland Holst-Van der Schalk, *Kinderjaren en jeugd van R.N. Roland Holst*, Zeist 1940; R.N. Roland Holst, *In en buiten het tij. Nagelaten beschouwingen en herdenkingen*, Amsterdam 1940; B. Polak, *Het Fin-de-Siècle in de Nederlandse Schilderkunst. De symbolistische beweging 1890-1900*, The Hague 1955, pp. 230-271; exhib. cat. (folder no. 17) *Het legaat R.N. Roland Holst (1868-1938)*, Amsterdam (Rijksprentenkabinet) 1979; Hedwig Saam, 'Roland Holst als reclamekunstenaar. Opdrachten voor de Nederlandsche Oliefabriek', *Jong Holland* 3 (1987) 1, pp. 48-55.

74

R. Roland Holst
Sand Excavation in Amsterdam, 1891
Oil on canvas, 50 x 69 cm
Signed and dated lower right: *R.N. ROLAND HOLST 1891*
Amsterdam, Rijksmuseum

After returning to Amsterdam in 1891, Roland Holst sometimes worked in Witsen's studio near Oosterpark. According to his wife, the *Sand Excavation in Amsterdam* was one of the works

he produced there, and it indeed shows the influence of other artists who were living or working in the neighbourhood. Breitner's impact in particular is apparent in his choice of an urban subject and in the loose, impressionistic brushwork. Sand excavations were a popular motif in the 1880s; De Zwart, Tholen and various other artists interpreted them almost as landscapes. They usually depicted sites on the outskirts of the rapidly expanding city, showing labourers at some distance away. Roland Holst, however, selected a location in the city centre, to some extent anticipating the building-site theme that seems to have intrigued Breitner around 1895. He has taken a low vantage point and placed a boundary of houses at the top of the picture, thus drawing attention to the excavation site itself and the men at work on the site. Van Gogh's influence, which is even more marked in the *Field Sermon* from 1892 (Amsterdam, Rijksprentenkabinet), is already discernible in his treatment of people at work in this canvas. With a trace of Van Gogh's clumsy proportioning, the workmen are dwarfed by the huge mound of earth, as if Roland Holst wanted to emphasise the onerous task facing them. Their

posture, too, strengthens this image. The man in the foreground is struggling to manoeuvre a wheelbarrow, the man left of centre is resting with his head in his hands, and a figure at upper left is leaning on his companion.

The painting is also interesting from a technical point of view. The houses are rendered with fastidious detail, in sharp contrast to the roughly-defined excavation site. Adopting a technique previously used by M. Maris, Toorop and Breitner, Roland Holst used the blunt end of his brush to scratch into the wet paint. Patches of thick, heavy paint, applied almost like cement, contrast with thin layers of colour and rough brushstrokes. Finally, the painting as a whole brings into sharp relief the primness of middle-class respectability and the drudgery of the labourers' work.

PROVENANCE: bequeathed to the State of the Netherlands by the artist in 1938; on loan to the Rijksmuseum in 1979.

LITERATURE: Roland Holst-Van der Schalk 1940, p. 80; Polak 1955, p. 235.

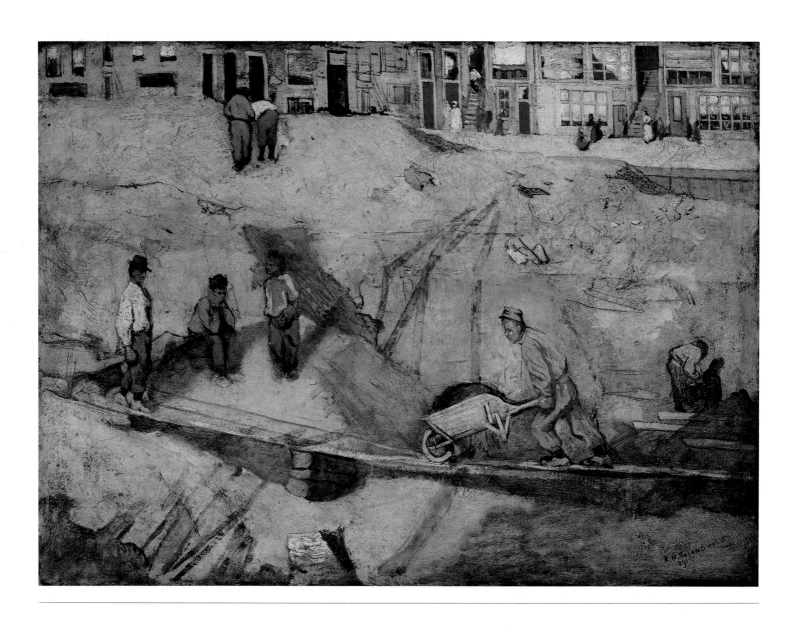

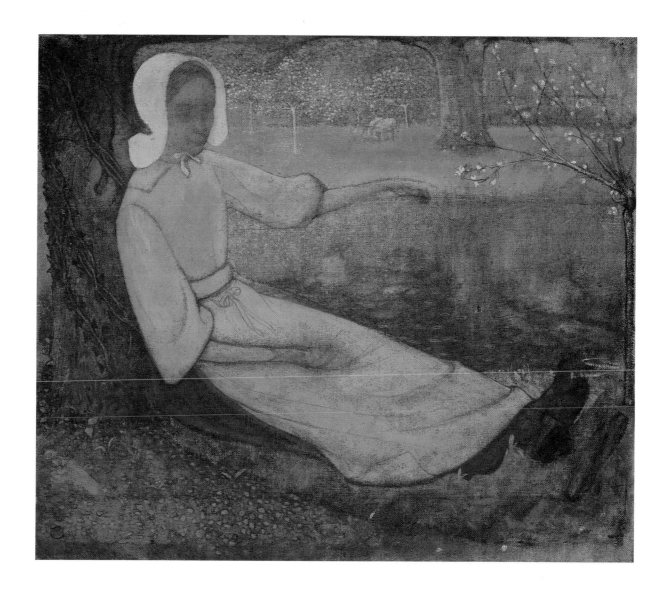

75

R. ROLAND HOLST
Woman from Huizen under a Tree, *c.* 1892/93
Oil on canvas, 54.5 x 64 cm
Signed on the verso: *Roland Holst*
Amsterdam, Rijksmuseum

This portrayal of a girl from the village of Huizen has been rendered in two different styles. The figure is stylised, with heavy contours which give it a flat, almost two-dimensional appearance, whereas the setting is rendered in a fairly naturalistic manner. The ground on which the girl is sitting, the blossoming tree on the right, the orchard and the water behind her form a realistic landscape. Roland Holst may have been dissatisfied with the end result, as he neither completed nor signed the canvas. Though some sections are indeed less successful, the work shows his efforts to find a new direction. This canvas marks his transition from realism to symbolism.

Like Toorop, Thorn Prikker and Veth, Roland Holst was inspired by the Flemish primitives such as Van Eyck, Van der Weyden and Memling, who were active at a time when religion was a more integrated force in society. The Dutch Symbolists replaced the Virgin Marys of their predecessors with young girls in regional dress from the staunchly Protestant villages of Katwijk, Noordwijk, Laren and Huizen. According to his wife, Roland Holst was fascinated by women in 'the silk costume reminiscent of the dress worn in Memling's day'. He first painted this motif in 1892, inspired by Jan Veth, who had shown him a painting of a girl from Huizen called Heintje. Both artists were probably influenced by Jan Verkade's portrayals of Breton peasant girls. For Roland Holst and Veth the country-bred peasants of the Gooi region personified the purity and innocence that Verkade was seeking in rural France. Up until about 1896, Roland Holst depicted the theme several times, mostly in lithograph. These works have a flatter, more decorative quality, and his allusion to the relationship between man and nature is also more explicit. Although these elements are already apparent in the painting shown here, they are understated and rather abstruse.

PROVENANCE: bequeathed to the State by the artist in 1938; lent to the museum in 1979.

LITERATURE: Roland Holst-Van der Schalk 1940, pp. 108-109; Polak 1955, pp. 244-245, 262-263; C. Boyle-Turner *et al.*, exhib. cat. *Jan Verkade. Hollandse volgeling van Gauguin*, Amsterdam (Rijksmuseum Vincent van Gogh) 1989, p. 44.

ROOSENBOOM, MARGARETHA

THE HAGUE 1843 - 1896 VOORBURG

Margaretha Roosenboom received painting lessons from her father Nicolaas Roosenboom and her grandfather, the prominent landscape artist Andreas Schelfhout. She spent part of her youth in Brussels and in 1867 returned to The Hague, where she specialised in fruit and flower still lifes. At the time the genre was still largely the province of women painters. Lodewijk van Deyssel, a member of the *Tachtigers*, was later to remark ironically that 'before the Impressionists, flower painting was a distinct occupation, with a title of its own. One was introduced to Miss So and So, flower painter' (*Verzamelde Opstellen*, Amsterdam 1907, vol. 10, p. 35). The genre acquired a new status in the 1880s, however, through the work of artists such as Verster.

Roosenboom's generation was still largely inspired by seventeenth-century masters. She herself tended to paint roses in predominantly warm colours, imbued with an air of intimacy and dignity. Her work was extremely popular and she received numerous awards, both in the Netherlands and abroad. She was in great demand as a teacher, attracting students from Belgium, England, America and Germany. In 1886 Roosenboom, like so many artists in those years, moved to the Gooi region. She settled in Hilversum and remained there until 1890, when she returned to Voorburg to marry the landscape artist Johannes Vogel in 1892. She died after a fall four years later at the age of fifty-three.

LITERATURE: exhib. cat. *Schilderijen en aquarellen van wijlen mevrouw Margte Vogel-Roosenboom en den Heer J.G. Vogel*, The Hague (Kunstzaal Biesing) March-April 1898; exhib. cat. *Bloemen uit de kelder. Negen kunstenaressen rond de eeuwwisseling*, Arnhem (Gemeentemuseum) 1989, pp. 40-46.

76

M. ROOSENBOOM
Poppies, 1892
Canvas, 92 x 59 cm
Signed and dated lower right: *Margta. Roosenboom 92*
Ede, Simonis & Buunk Gallery

'Vermeer of Delft had his own blue, yellow, azure and white, Rembrandt his golden colour spectrum, and Marg. Roosenboom her various shades of heightening, which gleam like pink pearls', wrote A.C. Loffelt admiringly, after seeing the exhibition held in 1898 as a posthumous tribute to Roosenboom (A.C. Loffelt on the Vogel-Roosenboom Exhibition, 9 April 1898, Rijksbureau voor Kunsthistorische Documentatie). The comparison with celebrated seventeenth-century painters underlines not only her competence but also, whether Loffels intended it or not, her traditional approach to the flower piece. Her bouquet, artfully arranged to look natural, and placed on a stone socle in the centre of the painting, forms the same type of composition as those painted centuries earlier. Like her predecessors, she has depicted the various stages of the flowers' development. The large, full-blown blooms are at their most fragile and liable to change at any moment; some have already lost their leaves and wilted, while a few are still in bud. Illustrations of the life cycle of flowers, sometimes incorporating butterflies or other small insects, were popular in the seventeenth century as symbols of transience; they showed the beauty of life while emphasising its fragility and the briefness of its span. It is uncertain whether Roosenboom intended the piece to represent *vanitas*; there is no explicit indication to this effect. Nineteenth-century painters were generally less concerned with such connotations than with the pictorial qualities of their work.

Roosenboom's painting contains a rich variety of shapes and colours. The poppies in the middle are like pink powder puffs among the various shades of dark pink, purple and green. The strong lighting and thickly applied paint make them almost tangible against the plain background. In the 1880s and 1890s Roosenboom painted mainly large, pale-hued roses, peonies or similar flowers. Here she has opted for the opium poppy, or *Papaver Somniferum*, reflecting the current vogue for showier, more flamboyant blooms. Unlike most of her female contemporaries, she has composed a bouquet of a single species and rendered it with an impasto brush. Her *Poppies*, however, are more conservative than the *Roses after a Banquet* (cat. no. 97) that Verster produced a year later. Verster sacrificed all botanical detail in order to create a deluge of colour.

PROVENANCE: Ede, Simonis & Buunk Gallery.

EXHIBITIONS: *Schilderijen van Gewone en Buiten Leden*, The Hague (Pulchri Studio) 1893, cat. no. 113 ('Papavers').

SANDE BAKHUYZEN, JULIUS VAN DE

THE HAGUE 1835 - 1925 THE HAGUE

As he himself was fond of relating, Julius van de Sande Bakhuyzen was born on 18 June, the anniversary of the battle of Waterloo. He came from a Hague family which had risen to prominence in the arts and sciences. His father, the Romantic landscapist Hendrikus van de Sande Bakhuyzen, had four sons and two daughters, one of whom, Geraldine Jacoba, was later to become a flower painter. Julius was taught the basic principles of drawing from nature by his father. He subsequently studied at the Academy in The Hague, where he excelled at life drawing, although he was primarily interested in landscapes. He painted outdoors almost from the start. He spent eight months in Germany with Philip Sadee in 1866, and some time later visited Norway and Normandy. On the whole, however, these journeys had little impact on his work. He was above all an outstanding exponent of the Dutch landscape, and came to be known as 'the painter of trees'.

Van de Sande Bakhuyzen was one of the first generation of painters of the Hague School who sought to portray the landscape more realistically, in reaction against the contrived studio work of the Romantics. Besides the work he produced in The Hague and its surrounding countryside, he also painted in Gelderland, North Holland and, most often, in Drenthe. He worked in and around Nieuwkoop together with painters such as Stortenbeker, Jan Weissenbruch and Roelofs, and made frequent excursions through the countryside of Drenthe in the company of the French artist, B.A. Stengelin.

In 1895, after the death of his sister Geraldine, with whom he had for many years shared a studio at their parents' home, Van de Sande Bakhuyzen moved to a new house in The Hague. He lived there until the age of ninety, one of the last surviving painters of the Hague School. Until the end of his life, he enjoyed considerable public acclaim and received numerous awards. He also played an active role in the art circles of The Hague. He was a founder member of the Dutch Society of Watercolourists in 1876, and was for many years treasurer of the Pulchri Studio.

LITERATURE: C. Vosmaer, 'Julius Jacobus van de Sande Bakhuyzen', *Onze Hedendaagsche Schilders*, Amsterdam 1883; L. Mulder, 'Julius Jacobus van de Sande Bakhuyzen' in: Max Rooses (ed.) *Het Schildersboek. Nederlandsche schilders der negentiende eeuw. In Monographieën door tijdgenooten* 1898, vol. 2, pp. 61-78; exhib. cat. *Schilderijen en studies door J.J. van de Sande Bakhuyzen*, The Hague (Boussod, Valadon & Cie.) June-July 1905; H. Clewits, 'Schilderkunst in Drenthe', *Maandblad voor Beeldende Kunsten*, 10 (1933) 2, pp. 48-49; anonymous, 'Julius Jacobus van de Sande Bakhuyzen, schilder en etser uit een Haagsch geslacht, 1835 – 18 June – 1935', *Het Vaderland*, 18 June 1935.

77

J. VAN DE SANDE BAKHUYZEN
Landscape in Drenthe (Dusk), 1882
Oil on canvas, 55 x 95.5 cm
Signed and dated lower right: *J. v d Sande Bakhuyzen 1882*
Amsterdam, Rijksmuseum (on loan from the Rijksdienst
Beeldende Kunst, The Hague)

Landscape in Drenthe was bought by the State of the Nether-
lands for one thousand guilders at the Rotterdam Civic Exhibi-
tion in 1882. At the same time the Boymans Museum acquired
Van de Sande Bakhuyzen's *March Showers*, a lesser work, ac-
cording to a critic in *Het Vaderland*. 'Personally,' he wrote, 'I
consider Bakhuyzen's smaller *Landscape in Drenthe* a more
mature example of his poetic brush. The sunlight glides over the
treetops and alights playfully on the road and the placid cows
coming drowsily towards us. The landscape has a beguiling tran-
quillity' (E.O., *Het Vaderland*, 11 July 1882).

In the 1880s and 1890s Van de Sande Bakhuyzen produced
numerous paintings of the Drenthe landscape and regularly ex-
hibited works with titles such as *Rainy Day in Drenthe*, *Autumn
Evening in Drenthe*, and so forth. They reflect a strong feeling
for atmosphere, which he shared with his contemporaries from
the Hague School. His staffage, however, was a little old-fash-

ioned, as in this example of the herder approaching with her dog.
The composition, too, with its cluster of trees on the right,
sooner recalls the early work of J.H. Weissenbruch and Willem
Roelofs, or even the Romantic painter Barend Cornelis Koek-
koek, than mature work by masters of the Hague School.

PROVENANCE: purchased by the Rijksmuseum in 1882; lent to Rijksdienst Beel-
dende Kunst, The Hague, in 1950.

LITERATURE: E.O. (A.C. Loffelt), 'Schilderijen – Tentoonstelling te Rotterdam',
Het Vaderland, 11 July 1882.

SCHWARTZE, THÉRÈSE

AMSTERDAM 1851 - 1918 AMSTERDAM

Thérèse Schwartze started drawing at the age of eight, taught by her father, the portraitist Johan Schwartze. By the time he died, in 1874, she had become a competent artist and was able to support the family. In 1875/76 she enrolled at the Academy in Munich. On Jozef Israëls's recommendation, she contacted F. von Lenbach, who advised her to profit from her year in Germany by copying the Rubens and Velázquez paintings at the Alte Pinakotek. The experience she gained in Munich played an important role in her development of a virtuoso style and rich palette.

From 1878 she attended the Paris Salon every year, sharpening her judgement and taste. During her stay in the city she would also study at the Louvre and the Palais du Luxembourg. At the recommendation of Van Tienhoven, the burgomaster of Amsterdam, she was invited to give lessons to Princess Hendrika at Soestdijk Palace. She also painted a successful portrait of Queen Emma with Princess Wilhelmina in 1881, which resulted in numerous commissions to paint portraits for the well-to-do. Though it was unusual at the time for a woman to pursue a career, Schwartze had no compunction about accepting the public functions she was offered. She held administrative positions in Arti et Amicitiae and the St Luke's Artists' Association, and was a member of the jury of the international painting exhibition in Amsterdam in 1883. She spent several months of 1884 working in a studio in Paris with Wally Moes, and won an award at the Salon. Her reputation firmly established, she exhibited her work in Barcelona, Munich, and Chicago, and in 1887 was honored with an invitation to submit a self-portrait for the portrait gallery at the Palazzo Uffizi in Florence. Many of the portraits she was producing around this time were in pastel.

A fruitful decade was to follow, culminating in an important solo exhibition at the Panorama Building in Amsterdam in 1890. But at this point her work started to come under attack. She displayed a lack of sensitivity and artistic feeling, according to the critics, who felt that she was devoting too much attention to marketing her paintings. Schwartze, however, remained unperturbed. Thanks to her virtuoso technique, she was in great demand as a portraitist up to the time of her death in 1918.

LITERATURE: J.J. Isaäcson, 'Schilderijententoonstelling Thérèse Schwartze', *De Portefeuille*, 26 April 1890, pp. 51-52; H. Leonardsz, 'Thérèse Schwartze', *Elsevier's Geïllustreerd Maandschrift* 3 (1892), pp. 1-26; R.W.P. de Vries jr., 'Thérèse van Duyl-Schwartze 1852-1918', *Elsevier's Geïllustreerd Maandschrift* 29 (1919) 57, p. 144; exhib. cat. *Thérèse Schwartze 1851-1819. Portret van een gevierd schilder*, Zeist (Slot Zeist) 1989.

78

T. SCHWARTZE
Three Girls from the Amsterdam Orphanage, c. 1885
Oil on canvas, 80.5 x 95.5 cm
Signed and dated lower right: *1885 Th. Schwartze*
Amsterdam, Amsterdams Historisch Museum (on loan from the Rijksmuseum, Amsterdam)

Before 1900 Thérèse Schwartze occasionally strayed from the portrait genre and produced a few, mildly sentimental figure pieces. She first tackled the subject of orphans in 1885, returning to it three years later in a painting of *Five Girls from the Maagdenhuis Orphanage, Amsterdam* (Rotterdam, Boymans-van Beuningen Museum). She produced work on a similar theme throughout the 1890s.

Other artists, too, were inspired by the girls in the picturesque uniform of Amsterdam's orphanages; the Amsterdam painter, Nicolaas van der Waay, and the German, Max Liebermann, depicted them on several occasions. Neither they nor Schwartze, however, seem to have been prompted by social conscience, nor were they seeking to draw attention to the plight of these young people. The appeal of the subject lay purely in its pictorial qualities, since the striking red and black uniforms, and white scarves and caps – echoing the colours of the civic coat of arms – lent a colourful note to the city streets.

Schwartze only used two models for the three girls in the painting. The girl depicted on the right and in the middle is one and the same – Elisabeth Vastenhout. The identity of the girl on the left is unknown. The three in the picture are sitting together contentedly; one is doing a piece of needlework (a basket with sewing accessories can be seen at lower left), while the second is reading aloud. Judging by her expression, the literature is of an edifying nature. The third girl is simply listening quietly. The tabby cat behind her on the stool enhances the idyllic atmosphere of the scene. 'A banal, common piece', the art critic Isaäcson expostulated, 'the three orphans displayed at the [Rijks]museum as if it were art...' (*De Portefeuille*, 26 April 1890). Though Isaäcson apparently sought some deeper emotion in art, the charm of the painting lies in the refined technique and richly contrasting colours.

PROVENANCE: purchased by the museum in 1885; lent to the Amsterdams Historisch Museum in 1975.

EXHIBITIONS: *Schilderijen en andere kunstwerken van levende meesters*, Rotterdam (Academie van Beeldende Kunsten en Technische Wetenschappen), 1885, no. 391 ('Drie Burgerweesjes van Amsterdam').

LITERATURE: Isaäcson, 1890, p. 52.

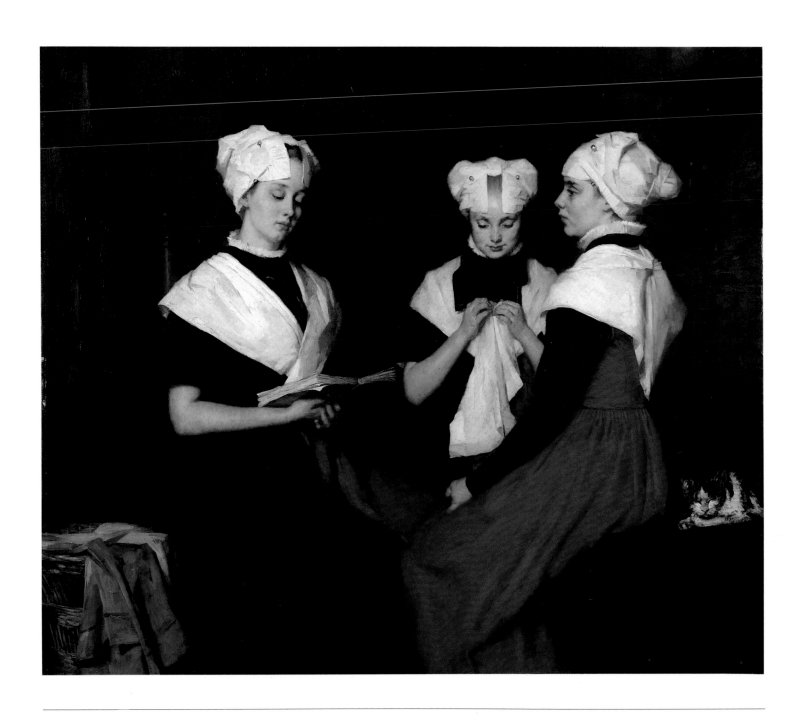

THOLEN, WILLEM BASTIAAN

AMSTERDAM 1860 - 1931 THE HAGUE

Tholen grew up in an artistic environment in Kampen. His father and sister, as well one of his aunts, were all painters. Older artists, such as Gabriël and Kruseman van Elten, were friends of the family. After failing his examinations in the third class of grammar school (a fate shared by his classmate Louis Couperus, who was later to become a distinguished novelist), Tholen enrolled at the Academy in Amsterdam with his childhood friend Jan Voerman. He took this decision on the advice of J.D. Belmer, his drawing master at school, whom Tholen regarded as a key figure in his life. At the Academy (1876-1877) he became friendly with Willem Witsen, while other students in his class included Piet Meiners and Anthon van Rappard. After the Academy he attended Delft Polytechnic for two years and by the age of eighteen he had twice qualified as a drawing master. He subsequently gave evening classes at a secondary school in Gouda, while working from nature during the day. In 1879 he went to Brussels, where he was taught painting by Gabriël, and returned to Kampen in 1880. Once again he divided his time between teaching and working independently as a painter. He frequently worked with Gabriël in the Kampen and Giethoorn area. In 1885 he paid his first visit to Ewijkshoeve, the country residence of the Witsen family. In that same year he, Willem Witsen and a number of other artists established the Dutch Etching Club. In these inspiring circles he met not only painters and writers but also his future wife, Coba Muller, a friend of Witsen's sister. He also began to achieve wider recognition as an artist around this time. After having won several medals at exhibitions abroad he gave up teaching in order to devote himself fully to painting. He married Coba Muller in 1886 and settled first in Voorburg and then, as of 1887, in The Hague, where they shared a house with Witsen's brother-in-law, Bram Arntzenius and his family. Tholen remained there for the rest of his life. After the death of his first wife, he married *Jonkvrouwe* Lita de Ranitz in 1919.

Tholen is usually considered a painter of the Hague School, though he himself rightly objected to this classification. While he was indeed a true *plein air* painter, with a strong feeling for tonality and atmosphere, his motifs prior to 1900 had more in common with those depicted by younger artists. Traces of Gabriël's influence can still be seen in his early work, particularly the colourful landscape impressions he painted in the area around Kampen, Giethoorn and Spankeren. After his stay at Ewijkshoeve, however, he clearly found his own style. Tholen's themes became more varied and his colours more muted. He painted sand quarries and beach and dune scenes in the surroundings of Scheveningen, as well as motifs considered unusual at the time, such as skaters, a slaughterhouse and a cake-stall. After 1895 views of the Zuyder Zee were a recurrent theme in his work. In 1901 he had a small barge built called the 'Eudia', which he sailed to places such as Enkhuizen, Volendam, de Kaag and Zeeland, where he painted numerous harbour views. The colours in his later work are increasingly transparent and the paint is applied more thinly, so that the structure and tone of the canvas are a feature of the work. Using only a thin layer of paint, he produced almost translucent works with a remarkable sense of atmosphere.

LITERATURE: R.S. Bakels, 'W.B. Tholen', *Elsevier's Geïllustreerd Maandschrift* 63 (1922) 1, pp. 1-8; R.S. Bakels, *W.B. Tholen*, The Hague 1930; G. Knuttel Jr., *W.B. Tholen*, The Hague 1944; G. Knuttel Jr., *Het grafisch oeuvre van W.B. Tholen*, The Hague 1950; T. Schulte, *Bilder aus alten Papiermühlen von Willem Bastian Tholen*, s.l. 1958; Rein van der Wiel, *Ewijkshoeve, tuin van tachtig*, Amsterdam 1988, *passim*; Richard Bionda, '"Verschemerd voor ons fel gezicht". Een onbekend portret van W.B. Tholen', *Jong Holland* 5 (1989) 4, pp. 5-7.

79

W.B. THOLEN
The Slaughterhouse, 1889
Oil on canvas, 57 x 71 cm
Signed and dated lower left: *W.B. Tholen; 1889*
Amsterdam, Stedelijk Museum (donated by the Association for the Acquisition of a Public Contemporary Art Collection)

Tholen's choice of subject matter was not only varied, but sometimes also surprisingly original. His slaughterhouse scenes are a good example, as are some of his other rather unpicturesque motifs, such as a brewery, a dairy and a paper factory. The *Tachtigers*, who fervently embraced Zola's naturalism, considered such themes poetic, admiring the way in which the trivia of everyday life could be transformed into art. Others, however, regarded a 'butcher's shop with hunks of meat' as neither aesthetic, nor edifying. *The Slaughterhouse* shows Tholen to be a true naturalist, intent upon showing the world around him in all its facets. He has an eye for people and their surroundings, as can be seen from a preliminary sketch (Amsterdam, Stedelijke Museum) and is a

perceptive observer. But he does not shrink from the brutish side of life and sometimes even seeks it out in its most shocking form. This is evident from his painting of a dead horse being skinned by a group of men (private collection). No other artist of the Hague or Amsterdam Schools depicted motifs of this type. *The Slaughterhouse* recalls the split carcasses of pigs, cows or oxen which were popular themes in the seventeenth century, when they usually served as vanitas motifs or metaphors for prudence after the slaughter which was intended to provide for the winter. Tholen's work, however, is entirely free of any such association. At least two other variants of *The Slaughterhouse* are known, both painted on elongated canvases and also dating from around 1889. One is at Groningen, Groninger Museum voor Stad en Lande, but the whereabouts of the second version are unknown. They depict the carcasses close up with the open door behind them. The butcher is not shown and the representations are therefore almost still lifes.

PROVENANCE: Amsterdam, E.J. van Wisselingh & Co.; purchased by the Association for the Acquisition of a Public Contemporary Art Collection, 1943; donated to the museum, 1949.

LITERATURE: [J.] V.[eth], 'In Pulchri Studio', *De Amsterdammer* (daily), 21 March 1890; 'Tholen in de Kunstzaal Biesing' (cutting 1896, Press Documentation, Rijksdienst voor Kunsthistorische Documentatie, The Hague); Knuttel 1944, pp. 38 (ill. 5).

80

W.B. THOLEN
Fishing Boats on the Beach at Scheveningen, c. 1889
Oil on canvas, 71 x 101 cm
Signed lower right: *W.B. Tholen*
Groningen, Groninger Museum voor Stad en Lande
(R.J. Veendorp Collection, owned by the J.B. Scholtenfonds Foundation)

The theme of fishing boats on the beach immediately recalls painters such as Mesdag, Weissenbruch or Maris. A well-known example is Maris's *Fishing Boat*, painted in 1878 (The Hague, Haags Gemeentemuseum), one of the most classical of the grey-hued works of the Hague School. A decade later, Tholen interpreted the motif quite differently. Instead of showing a wide expanse of sea, he chose to look inland. The background of his painting is largely taken up by the Rauch and Zeerust hotels, two of Scheveningen's leading hotels of the day, and Tholen has thus devised a combination of beach view and townscape. The scene is bustling with activity, unlike the usual landscapes of the Hague School.

The subject of the painting – the maintenance of fishing boats – is a rather unusual one. Of the older generation of Hague School painters, only Mesdag is known to have depicted the theme, although his version has far fewer figures and the scene is viewed from a different direction, looking towards the old fishing village (The Hague, Rijksmuseum H.W. Mesdag). In winter,

when the herring season drew to a close, the fishing boats were hauled onto the beach, as Scheveningen did not yet have a harbour. The boats were then inspected for ship-worm damage and cleared of encrusted seaweed and barnacles. The two men in the foreground to the left are surveying the operation. The boat in the picture is being jacked up. The layers of weed and barnacles often had to be burnt off, which probably accounts for the thick clouds of smoke near the vessels in the background. Tholen made a preliminary study of the painting in black chalk (Groningen, Groninger Museum voor Stad en Lande). The painting, however, has more figures, such as the group on the left, while the smoke has been omitted, probably in order to heighten the sense of activity and strengthen the composition.

PROVENANCE: Amsterdam, E.J. Van Wisselingh & Co.; R.J. Veendorp, Groningen, 1960; J.B. Scholten Foundation, 1968; on permanent loan to the museum.

81

W.B. THOLEN
Sisters, 1895
Oil on canvas, 36.5 x 57 cm
Signed and dated lower left: *WB Tholen 95*
Gouda, Stedelijk Museum het Catharina Gasthuis
(Paul Arntzenius Collection)

This double portrait was originally part of the collection of the painter Paul Arntzenius (a former pupil of Tholen's), which was donated to the Catharina Gasthuis in Gouda in 1964. It shows Arntzenius's two little sisters; on the left is Dora, who was born in 1882, and on the right Elizabeth, born in 1881. In 1885, after their mother's death, their father, Bram Arntzenius, married Cobi Witsen, the sister of Willem Witsen. Tholen, who often stayed at Ewijkshoeve, the Witsen family's summer residence, was married to a friend of Cobi's. In 1887 the two families – the Arntzeniuses and the Tholens – moved into a house together near the White Bridge in The Hague.

Tholen painted the Arntzenius children on a number of occasions, mostly at Ewijkshoeve where they often played in the surrounding woods. From the end of the 1880s Tholen had his own studio there. A photograph of it, which must have been taken around 1895, shows the Gouda painting among other work he produced around this time, predominantly portraits of the Arntzenius children and Paul, but also pictures of Tholen's dog and his boat. They are images of the people and objects that were around him and which he held dear. All his drawings and paintings of the children, whether posed or informal, are superb likenesses. He was obviously sensitive to their moods and had a gift for rendering their astonished, dreamy or wistful faces.

This unusually informal double portrait is like a snapshot of the two sisters, which captures a fleeting moment in their daily lives. Dora is absorbed in her reading, while Elizabeth lounges on the sofa, leafing through a book and looking at an illustration. Unlike the two little boys in Wally Moes's *Lunch Break* (cat. no. 66), they are not posing for a genre piece. In terms of arrange-

ment and composition, Tholen's painting bears a certain resemblance to the *Girl on a Sofa*, Jacob Maris's portrait of his daughter asleep, which dates from around 1875 (Glasgow, Glasgow Museums & Art Galleries). English and French Impressionists, including Manet and Degas, also depicted women or children on a sofa and Tholen may have been inspired by their examples. However, his use of colour and handling of the paint have more in common with the work of his Dutch contemporaries. Using the same device as Breitner, he has worked the colours of the carpet in the background into the overall mass of reds and blacks, which forms a sharp contrast to the girls' white pinafores. The arrangement of the figures also recalls Breitner's portrayal of girls in kimonos (cat. no. oo). Tholen's *Sisters* represents a complete departure from the posed portrait and thus reflects one of the principles of the *Tachtigers*.

PROVENANCE: P. Arntzenius, The Hague; bequeathed to the museum, 1964.

LITERATURE: Knuttel Jr. 1944, pp. 25, 33.

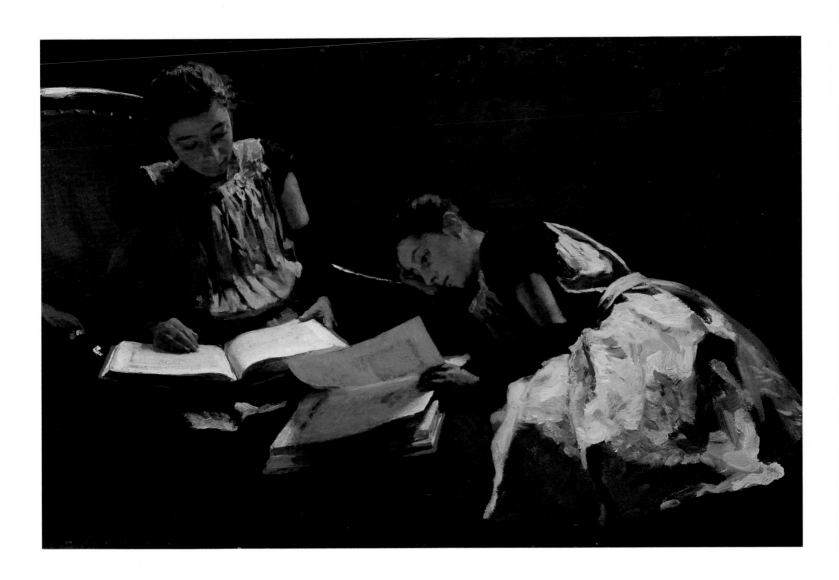

Thorn Prikker, Johann

The Hague 1868 - 1932 Cologne

Johan Thorn Prikker studied at the Hague Academy from 1881 until his expulsion for unruly behaviour in 1887. Accompanied by Edzard Koning, a friend of his from the Academy, he spent the following summer exploring the Meuse valley and the region around Voeren, where he made a number of realistic and finely detailed pencil drawings. He was entranced by the landscape in this border area between South Limburg and Belgium, and was later to pay frequent visits to the region.

On his return to The Hague, he painted landscapes and figure pieces which reflect the influence of the Barbizon painters and of Millet in particular. Matthijs Maris, too, popular among the younger artists, had a substantial impact on his work. He made abstract-looking figure and landscape studies in which colour plays the principal role. Inspired by the Dutch and Flemish primitives and the art of the Middle and Far East, his work shows a marked change from about 1892, when it acquired a distinctly linear quality. Henri Borel, who had visited China, played an important part in fostering his interest in Oriental art.

In 1891 Thorn Prikker became a member of the Hague Art Circle and Pulchri Studio. He met Henri van de Velde in 1892, and subsequently Paul Verlaine and Sâr Péladan. He maintained a close friendship with Van de Velde for many years and the two men influenced each other significantly.

Around 1893 he dissociated himself from artistic life in The Hague and focused his attention abroad. He received favourable reviews at exhibitions of *Les Vingt* in Brussels and l'Association pour l'Art in Antwerp. In the summer of 1893 he spent a month in Visé in Belgium, apparently fascinated by the linear patterns he found in the rocks. Where he had once used colour as a means of uniting man and nature and absorbing them to form a single entity, he now employed expressive lines as the synthesising force. He drew on freely-interpreted Christian imagery and the literature of writers such as Emile Verhaeren and Charles Baudelaire, but most of his contemporaries in the Netherlands failed to grasp the mystical concept of unity he was trying to express, or perceive anything beyond the decorative quality of his art. The absence of narrative detail makes it particularly difficult to penetrate the intrinsic meaning of his work.

Thorn Prikker studied anarchist literature and developed a growing interest in an art for the people, integrated in society as a whole. In 1895, he turned to the applied arts, and was at first especially interested in batik and furniture design. In 1898 he became artistic director of the Arts and Crafts Gallery in The Hague. That same year he married Lena Spree after a thirteen-year engagement. Tragically, she died after a miscarriage only nine months later.

In 1901 Thorn Prikker returned to Visé, where he made a number of chalk drawings with small touches of brilliant colour, reflecting the influence of Van Gogh. Here too he met Bertha Kramer, whom he married in 1903; a year later he left the Netherlands permanently. He first settled in Krefeld, where he took a teaching position at the Kunstgewerbeschule, and also designed textiles and monumental paintings. He joined the Deutsche Werkbund in 1909, and began to design stained-glass windows. A year later he moved to Hagen and made mosaic murals. He moved several more times in Germany, to Ueberlingen (1919-1920), Munich (1920-1923), Düsseldorf (1923-1926) and Cologne (1926-1932), but maintained contact with friends in Holland throughout the years he spent abroad. Both directly and through his former pupil, Heinrich Campendonk, Thorn Prikker's monumental art continued to influence later generations of painters.

LITERATURE: P. Zilcken, 'Johan Thorn Prikker', *Elsevier's Geïllustreerd Maandschrift* 24 (1902), pp. 147-160; H.P. Bremmer, 'Johan Thorn Prikker', *Beeldende Kunst* 7 (1920) 6, pp. 50-60; F.M. Huebner, 'Johan Thorn Prikker', *Opgang* 2 (1922/23), pp. 507-512; M. Creutz, *Johan Thorn Prikker*, München-Gladbach 1925; B. Polak, *Het Fin-de-Siècle in de Nederlandse schilderkunst. De symbolistische beweging 1890-1900*, The Hague 1955, pp. 152-186; A.B. Loosjes-Terpstra, *Moderne kunst in Nederland 1900-1914*, Utrecht 1959, pp. 13-15; exhib. cat. *Johan Thorn Prikker (1969-1932). Schilderijen, tekeningen, litho's, glas-in-lood ramen, mozaïeken, inlegwerk*, Amsterdam (Stedelijk Museum) 1968; J.M. Joosten, *De Brieven van Johan Thorn Prikker aan Henri Borel en anderen, 1892-1904*, Nieuwkoop 1980 (letter numbers cited in text in square brackets); exhib. cat. *Johan Thorn Prikker. Werke bis 1910*, Krefeld (Kaiser Wilhelm Museum), 1982; C. Hoogveld *et al.*, *Glas in Lood in Nederland 1817-1968*, The Hague, 1989, pp. 338-340.

82

J. Thorn Prikker
Cabbage Field, 1891
Oil on canvas, 86 x 145 cm
Signed lower right: *J. Thorn Prikker*
Krefeld, Krefelder Kunstmuseen-Kaiser Wilhelm Museum

The *Cabbage Field* sparked off a violent controversy when it was shown in the members' exhibition at Pulchri Studio in 1891. Objections were raised because Thorn Prikker's work was hung so advantageously, at the expense of more senior and worthier members such as the Maris brothers, Jozef Israëls and Mesdag. The public did not take his work seriously, according to newspaper reports but, on the contrary, ridiculed it. Brilliant yellows, greens, blues and purples are applied in streaks and lively patches. Millet's influence and, closer to home, Willem Witsen's (the *Woman Digging Potatoes*, c. 1885, Amsterdam, Witsenhuis) are apparent in the positioning of the woman in the field of red cabbage. The monumental figure occupies almost half the picture space. The horizon, with a farmhouse silhouetted against the sky on the left and a cluster of trees on the right, is unusually high. Thorn Prikker's work is far more experimental, both in colour and technique, than that of Millet or Witsen. The *Cabbage Field* concludes a series of works designed principally on the basis of colour.

PROVENANCE: Saar de Swart, Paris, 1891.

EXHIBITIONS: *Schilderijen van werkende leden*, The Hague (Pulchri Studio), 1891, no. 98 ('Koolland').

LITERATURE: J. Veth, *De Amsterdammer* (weekly), 14 February 1892; exhib. cat. *Johan Thorn Prikker, Glasfenster, Wandbilder, Ornamente 1891-1932*, Krefeld (Kaiser Wilhelm Museum) 1966, p. 20; Joosten 1980, pp. 68 , 281.

83

J. Thorn Prikker
Christ on the Cross, c. 1891-1892
Oil on canvas, 100 x 70 cm
Unsigned
Otterlo, Rijksmuseum Kröller-Müller

According to H.P. Bremmer, who owned *Christ on the Cross* for many years, Thorn Prikker had been aspiring to the annual Willink van Collen Prize, which was intended to encourage young talent. The prescribed subject in 1891 was an 'expressive head', and the submissions were shown at Arti in January 1892. But Thorn Prikker did not receive the award. The jury was conservative and his entry would probably have been considered too revolutionary. It was unusual in the first place to submit a religious scene, and Thorn Prikker's interpretation was particularly unorthodox.

His Christ is not an idealised figure, but a haunting image of a tortured human being. He is shown from the waist up, close to, on a massive ochre-yellow cross. The cross-beam is cropped abruptly at the frame. Some areas of the flat evening landscape in the background and parts of the body are executed in the Pointillist manner. The physiognomy has not been worked out, and it is this very absence of detail that makes the face so eloquent. Devoid of features, it is little more than a pale patch, framed by blood-soaked hair. The head bowed down to the chest and the torso slumped to one side are reminiscent of medieval devotional pictures.

The critics, though circumspect, were generally favourable. Jan Veth commended the 'unusually powerful yet extremely delicate palette and superb quality' (*De Amsterdammer*) and hailed the work as 'the embryo of an outstanding creation'. According to Isaäcson, the art critic for *De Portefeuille*, Thorn Prikker exemplified a new artistic approach and held out a promise for the future. He was not far off the mark. The style and subject of the painting heralded an important new phase in Thorn Prikker's *oeuvre*.

PROVENANCE: purchased by the museum from the heirs of H.P. Bremmer with the assistance of the Rembrandt Foundation, 1956.

EXHIBITIONS: *Wedstrijd Willink van Collen*, Amsterdam (Arti et Amicitiae), 1892, no. 9.

LITERATURE: W. du Tour (R.N. Roland Holst), *De Amsterdammer* (daily), 15 January 1892; J. Veth, *De Amsterdammer* (weekly), 17 January 1892; J.J. Isaäcson, *De Portefeuille*, 23 January 1892; Bremmer 1920, pp. 52, 53.

84

J. THORN PRIKKER
Descent from the Cross, 1892
Oil on canvas, 88 x 147 cm
Signed lower right: *J. Thorn Prikker*
Otterlo, Rijksmuseum Kröller-Müller

Between 1892 and 1894 Thorn Prikker produced numerous works based on themes from the life of Christ. He was not a Christian himself, but used the traditional imagery to express purity and authentic emotion. His colours and lines were intended to support the symbolic content of his work and convey the emotional message. His paintings, including the canvas reproduced here, are predominantly in shades of ochre, grey-green and purplish-blue, the colours he associated with purity. He would then apply a layer of stippling to create a livelier effect. Lines, he wrote in one of his letters, can express strength, restlessness or holiness. He used decorative linear patterns to fill in the background and empty spaces, and gave the paint surface a smooth finish which looks almost like a glaze. A critic writing under the name of Jasz in *De Portefeuille* of 16 July 1892 suggested that Thorn Prikker might just as well have used mosaic for these mystical representations.

The Descent from the Cross shows St John and the Virgin lowering Christ from the cross. The folds of cloth draped around the cross blend into Christ's arms and, in a single downward sweep, unite the central figures into a sorrowful little group. The billowing robes worn by the bearers fill the foreground with a decorative play of lines. In the background are the two thieves, their bodies merging to form a unity with their crosses. The weeping Mary Magdalene and her female companion are on the right, and on the left are two immense blossoms with long stamens. The flowers, which are on the side of the penitent thief, probably signify Christ's sacrifice and the hope of man's redemption.

Decorative, two-dimensional shapes were used not only in the Netherlands, but also by the circles around Gauguin and Maurice Denis in France, and by the Belgian Henri van de Velde. All were profoundly inspired by Japanese woodcuts and the stylised art of the Middle Ages. Thorn Prikker himself owned a number of Japanese prints and was an ardent admirer of the Flemish and Netherlandish Primitives. He refashioned the idiom to achieve a modern interpretation and to represent of the concept of purity.

PROVENANCE: Van Wisselingh & Co., Amsterdam; private collection Helmond, 1912.

EXHIBITIONS: Haarlem (Kunst zij ons Doel), 1892; The Hague (Haagsche Kunstkring), 1892, no. 14; *Keuzetentoonstelling*, Amsterdam (Arti et Amicitiae), 1892, no. 121.

LITERATURE: H.P. Bremmer, 'Johan Thorn Prikker. Kruisafname', *Beeldende Kunst* 1 (1920) 6, p. 69; Polak 1955, p. 159, 160.

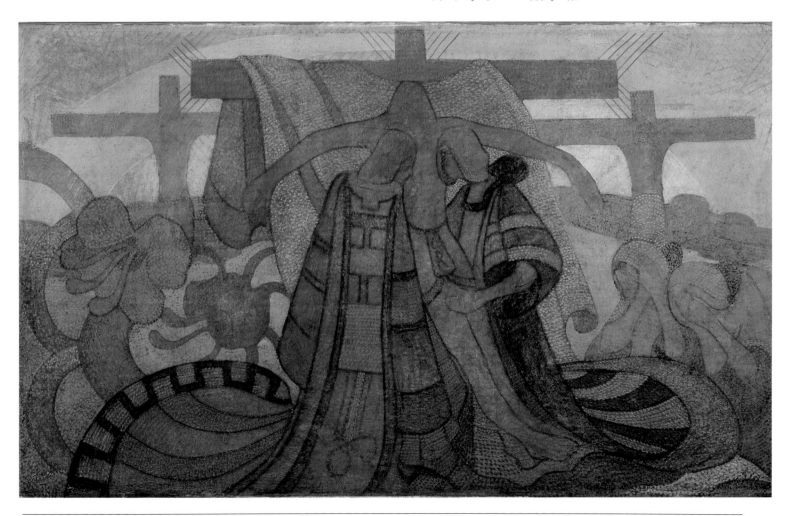

85

J. THORN PRIKKER
Moine Epique, 1894
Indian ink, black chalk and pencil on vellum, 98 x 72.8 cm
Unsigned
Utrecht, Centraal Museum

Le Moine Epique is rendered almost without colour. It is essentially a profusion of lines which cover the sheet to form a pattern rather like the annual rings in a tree trunk, the circles in a fingertip, or the flow of a waterfall. On close inspection, we can just discern the monk's profile, his rosary and the hand in which he is clutching a branch in the shape of a crucifix – an allusion to Christ bearing the Cross. A second monk is kneeling reverently before him on the lower right. This second figure is far smaller than the other, like the portraits of donors in late medieval paintings. The monastery and churchyard on the upper left side are stiff and naïve in comparison with the rest of the picture, as though drawn with a ruler. The contrast between the two styles may be intended to represent culture and nature as opposite poles in religious experience.

Thorn Prikker commented on the drawing in a letter to the writer Henri Borel. 'It is not a figure, nor is it proportion. I have made a giant which, as Verhaeren says, "et seul, et seul toujours avec l'immensité". So there you are; a giant person, which is the same as a rock or a tree' [26]. This was an allusion to the fact that he considered himself a 'mystic' rather than a 'Symbolist'. 'I should like to represent the growth of trees, the unfolding of flowers, anything you can think of, in some specific form, like this or like that, which is certainly not Symbolism in the usual sense, is it?' [23]. Thorn Prikker was referring to the successful Symbolist Toorop, whose work he had recently seen in a solo exhibition at The Hague Art Circle. In his view, it expressed too little 'feeling' and was too theoretical; he worked 'like an illustrator of someone else's ideas' [22]. Thorn Prikker himself sought 'things' in Nature, in the rock formations and trees in Visé in Belgium, for instance. He had made a number of drawings there in 1893, and these, as far as the style is concerned, were probably studies for *Le Moine Epique*.

PROVENANCE: S.H. Obreen, Rotterdam, 1894; H.P. Bremmer; on loan to the museum, 1923 (on loan from the heirs of H.P. Bremmer, 1956); purchased 1964.

EXHIBITIONS: Nijmegen (Sociëteit 'De Vereeniging'), 1894, no. 132 ('Moine Epique, naar Emile Verhaeren'); *Zevende tentoonstelling van de Nederlandsche Etsclub*, The Hague (Pulchri Studio), 1894, no. 90 ('Naar Emile Verhaeren's Moine Epique, afgestaan door den heer S. Henry Obreen te Rotterdam'); *La troisième exposition annuelle de la Libre Esthetique*, Brussels (Musée Moderne), 1896, ('Moine Epique', 1,000 frs.).

LITERATURE: Bremmer 1920, pp. 57, 58; exhib. cat. *Kunstenaren der idee. Symbolistische tendenzen in Nederland c. 1880-1930*, The Hague (Haags Gemeentemuseum) 1978, p. 107 (no. 34); Joosten 1980, pp. 187, 299.

Thorn Prikker made four drawings in 1894, entitled *Le Moine Sauvage* (The Hague, Gemeentemuseum), *Le Moine Epique, Le Moine Doux* (destroyed) and *Une Estampe* (whereabouts unknown). The series was inspired by Emile Verhaeren's anthology of poetry, *Les Moines*. Verhaeren's monks represent primordial values dating back to the heroic Middle Ages, an era he saw as the antithesis of the superficiality and decadence of his own times. Thorn Prikker shared Verhaeren's idealistic view of medieval life and sought a unique visual language to express his ideas. His linear style of drawing, the absence of spatial perspective and his choice of vellum as a support are all features which recall late medieval art.

TOOROP, JAN

PURWOREDJO (JAVA) 1858 - 1928 THE HAGUE

Toorop spent his childhood in the Dutch East Indies; his father held an administrative post in Java and later on the small island of Bangka. After attending primary school in Batavia he was sent to the Netherlands in 1872 to complete his secondary education at boarding schools in The Hague, Leiden and Winterswijk. From 1876 to 1878 he attended the Polytechnic School in Delft, where he received drawing lessons from the Hague painter, Herman van der Weele. In 1880 he enrolled as a student at the Academy in Amsterdam, under Allebé, and struck up friendships with fellow students such as Veth, Witsen and Derkinderen. In 1882 Toorop and Derkinderen left Amsterdam for Brussels. Although they attended classes at the Academy under the director Jean Portaels (a good friend of Allebé), Toorop associated above all with the young painters who, in 1883, established the group known as *Les Vingt*. The group, which organised exhibitions to give extensive coverage to the latest developments at home and abroad, was led by Octave Maus and James Ensor. Other members included Fernand Khnopff and Theo van Rijsselberghe. Several of the artists in this circle had anarchist sympathies, which Toorop shared. In 1885 he was invited to join *Les Vingt*. After his marriage in 1886 to Annie Hall, an Englishwoman, Toorop moved to The Hague, but between 1887 and 1890 he spent much of his time in Brussels or England. He introduced numerous Dutch artists into the circles of *Les Vingt*, and in 1889 organised an exhibition of the group's work in Amsterdam. A year later he settled in Katwijk aan Zee, where his daughter Charley was born in 1891. She, too, was to make a name for herself as an artist.

Toorop was highly susceptible to outside influence, as is evident from the great variety of forms of expression and techniques which he adopted, sometimes consecutively, sometimes over a short period of time, and even within a single work. Having passed through various phases of Realism, Impressionism and Post-Impressionism in the 1880s, he embarked on a more Symbolist course around 1890. He drew his inspiration for such work from literary and musical sources, but above all from the art of different cultures, including non-European civilisations such as those of the Middle East and the Far East, and from different historical periods, from the Flemish Primitives to the English Pre-Raphaelites. His work also reflects the influence of contemporaries such as Ensor, Khnopff, Redon and Van Gogh, whose genius Toorop was one of the first to recognise.

The symbolism in Toorop's work is ambitious but often obscure, his object being to convey his interpretation of the state of the human race and contemporary society. Women occupy a prominent place in his imagery. They appear in various guises – virgin, sphinx, or sensuous seductress – but they feature in a wider context, in which attention is also focused on the role which religion and mysticism, anarchy and socialism, philosophy and art play – or should play – in contemporary life. These all-embracing themes predominated in the period from about 1889 to 1894, when Toorop earned international acclaim and influenced numerous artists, including Thorn Prikker and the Austrian, Gustav Klimt. Thereafter, his work was less encumbered with symbolism, and he produced figure pieces, portraits and also landscapes in a combination of different styles. For example in 1898 he returned once again to the Pointillism of the 1880s and developed it, from 1905 onwards in particular, into an expressive, almost Fauvist style, which served as a model for young artists such as Gestel, Mondrian and Sluyters. Toorop, who converted to Catholicism in 1905, also produced numerous drawings with religious themes. During the last twenty years of his life he assumed an important role in the revival of religious art in the Netherlands.

LITERATURE: W. Shaw Sparrow, 'Herr Toorop's The Three Brides', *The Studio* 1 (1893), pp. 247-248; Julius de Boer, *Jan Toorop*, Amsterdam 1911; Albert Plasschaert, *Jan Toorop*, Amsterdam 1925; J.B. Knipping, *Jan Toorop*, Amsterdam 1947; Bettina Polak, *Het Fin-de-siècle in de Nederlandse schilderkunst. De symbolistische beweging 1890-1900*, The Hague 1955, pp. 87-151, 342-384; R. Siebelhoff, *The early development of Jan Toorop 1879-1892*, Toronto 1973; exhib. cat. *J.Th. Toorop. De jaren 1885 tot 1910*, Otterlo (Rijksmuseum Kröller-Müller) 1978/79; G.W.C. van Wezel, 'Waarde Mejuffrouw Marius. Brieven van Jan Toorop', *Jong Holland* 1 (1985) 4, pp. 2-27; exhib. cat. *Jan Toorop in Katwijk aan Zee*, Katwijk (Katwijks Museum) 1985; exhib. cat. *Jan Toorop*, The Hague (Haags Gemeentemuseum) etc. 1989; Inemie Gerards and Evert van Uitert, 'Jan Toorop. Een "fabuleuze bevattelijkheid": het symbolistische scheppen', *Jong Holland* 5 (1989) 1, pp. 2-17.

86

J. TOOROP
Brussels Students, 1884
Oil on canvas, 172 x 111 cm
Signed and dated lower right: *J. Toorop 1884 Bruxelles*
The Hague, Jan Nieuwenhuizen Segaar

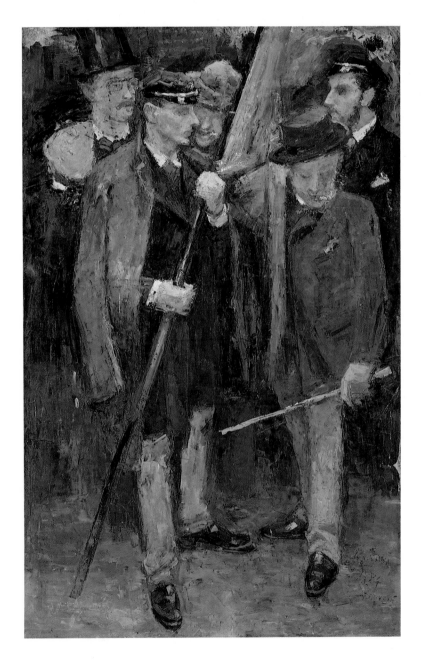

'And then to the Academy in Brussels (...) look over there, said Toorop, I just happen to have it there on the easel. That's something from that period: all of them students at the Université Libre de Bruxelles, demonstrating of course, friends of mine among them, there, with the grey caps on, every one of them a revolutionary!' This was how Jan Toorop described his painting *Brussels Students* in an interview with F.I.R. van den Eeckhout in 1925 (*Jan Toorop*, Blaricum, 1925, p. 17). The painting was probably produced after Toorop's student days (1882-1883), but while he was still living in Brussels. It shows a group of figures, one of them carrying a large blue flag. A gentleman in a top hat can be seen in the midst of Toorop's less formally dressed student friends. It is not immediately clear what they are demonstrating for or against, but it was probably an anti-clerical or anarchist gathering. The Université Libre was a liberal stronghold in the otherwise Catholic city of Brussels, and Toorop is known to have sympathised during this period with the anarcho-socialism of his friend, the Belgian critic Jules Destrée. Toorop accompanied Destrée and his brother Georges, a painter, on a visit to the Borinage region of southern Belgium, where he was struck by the poverty but also the militancy of the miners. The impressions of his visit are recorded in his paintings *Before the Strike* (private collection) and *After the Strike* (Otterlo, Rijksmuseum Kröller-Müller), which date from about 1888.

Brussels Students, like most of Toorop's paintings from the mid-1880s, was painted with a palette knife. The paint, in predominantly grey and brownish tints, against which the blue stands out sharply, is spread roughly on the canvas. All details of costume and, in the case of the figure on the left, even facial features, are sacrificed for the sake of the lively and vigorous effect which can be achieved with this technique. Ensor had popularised the use of the palette knife among the painters in Brussels, Toorop among them, although in a technical sense they were all following the example of Courbet, who had used it to great effect, particularly in his landscapes and seascapes. The subject matter and composition of *Brussels Students* can also be traced to French examples. In the 1925 interview quoted earlier, Toorop remarked that 'it was Manet that I was attracted to at the time. He has in him something of every French painter that came afterwards'. Partly because of the way the figures are cropped, Toorop's painting gives the impression of being a snapshot of modern life, as portrayed by Manet in his early work *La Musique aux Tuileries* and above all his later oil studies of street scenes and guests at a masked ball.

PROVENANCE: Charley Fernhout-Toorop; auction *Atelier Jan Toorop*, Amsterdam (A. Mak), 15 May 1928, no. 18; C. Rezelman, Amsterdam; auction Amsterdam (Sotheby's), 10 November 1986, no. 183.

LITERATURE: P. Zilcken, 'Jan Toorop', *Elsevier's Geïllustreerd Maandschrift* 8 (1898) vol. 16, pp. 115-116; F.I.R. van den Eeckhout, *Jan Toorop*, Blaricum [1925], p. 17.

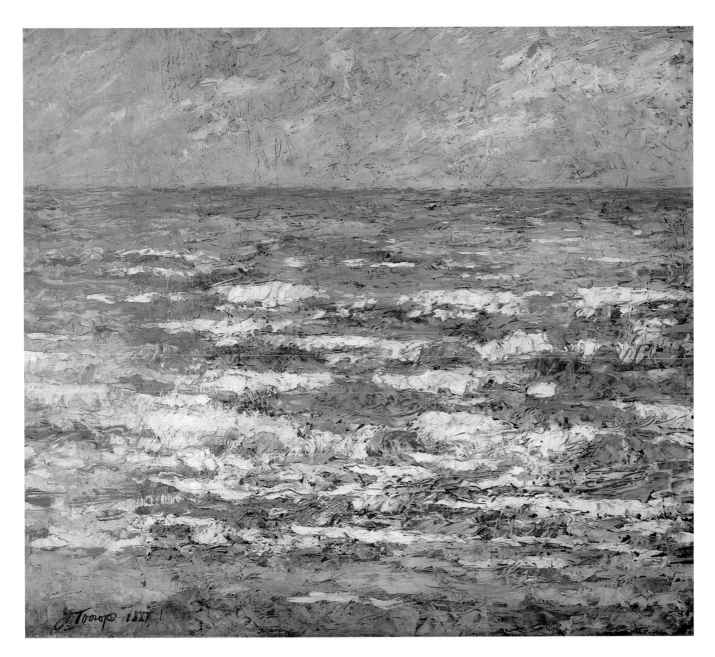

87

J. Toorop
The Sea, 1887
Oil on canvas, 86 x 96 cm
Signed and dated lower left: *J. Toorop 1887*
Amsterdam, Rijksmuseum

In 1886 Toorop left Brussels for The Hague, a city without the attractions of a metropolis, but an important artistic centre none-theless, thanks to the international reputation of the Hague School. For Toorop, like Mesdag, who had arrived in The Hague from Brussels almost twenty years earlier, the move brought a significant change in the subject matter of his paintings. From this point up until the end of his life, the sea is a motif which re-curs with great regularity and in various guises – as an elemental force of nature against which man must pit his strength, as a background pregnant with meaning in symbolic pictures, or, as in this particular case, simply as an image of one aspect of nature under changing atmospheric conditions. This is one of Toorop's first seascapes. It is painted in the technique he favoured during his Brussels years, whereby the paint is applied with the palette knife only. The grey-green water and dirty-white crests of the waves are represented as a regular, almost abstract pattern of horizontal bands. The sea is the only subject; the scene contains no ships or picturesque fishermen, just water and a small strip of sky. Although Mesdag, the most celebrated painter of the marine genre, produced the occasional 'empty' seascape of this sort, Toorop must have based his work primarily on Courbet's *Wave*, one or more versions of which he would undoubtedly have seen in Paris. However, he does not follow Courbet's example of de-picting a single large wave from below, like the chief protagonist in a romantic drama, but adopts instead a raised vantage point, projecting the viewer's gaze over the stormy sea to the calm of the horizon.

PROVENANCE: H. Lohr, Nijmegen; I. Lohr, Basel; donated to the museum, 1973.

88

J. TOOROP
Bridge in London, *c.* 1888
Oil on canvas, 35.5 x 46 cm
Signed lower right: *J. Toorop*
Otterlo, Rijksmuseum Kröller-Müller

This painting is usually dated 1886, on the grounds that a *Bridge in London* was shown at an exhibition of *Les Vingt* in Brussels in that year. However, reviews of the exhibition suggest that Toorop only exhibited paintings executed in his heavy palette-knife technique, so that the picture referred to must have been a different work. Our painting was probably made later, around 1888. There are other examples of uncertainty surrounding the dating of Toorop's early work. He sometimes added the dates later, and his memory was evidently not always reliable. It is not entirely clear, for example, when exactly he began to apply Pointillist techniques. He probably first saw work by Seurat at the Salon des Indépendants during a visit to Paris in 1884, but whether or not he liked it is open to question. In a letter written that year he described the Impressionists as 'too loud'. The French painter he admired most at the time was Manet. It was probably not until 1887 that Toorop was won over to the ideas of the Impressionists and Post-Impressionists. His palette became gradually brighter and he began to apply the paint in stipples, sometimes only in parts of the painting. A similar tendency was apparent among other members of *Les Vingt*, such as Alfred Finch, at about the same time. Seurat was invited to show his work at the group's exhibition in 1887 and Signac did so in 1888. Van Rijsselberghe and Van de Velde also adopted the technique of stippling a short time afterwards, and Seurat thus acquired a considerable following in Brussels.

The Bridge in London is an early, moderate example of Toorop's Pointillist work. The colours are mixed individually and are not applied systematically in stipples, as in some of his later canvases, but in short streaks in different directions, for example diagonally on the piers of the bridge, and horizontally on the water. In terms of technique, the painting is mid-way between Monet and Seurat. The subject matter and composition also suggest parallels with these French artists, whose landscapes are often situated in the suburbs of Paris and contain modern details such as factories (Seurat and Signac) or railway bridges (Monet). Toorop links both these themes in his view of the banks of the Thames, with a railway bridge painted in almost exaggerated perspective to the left. This is one of numerous works from the 1880s inspired by Toorop's regular visits to England, his wife's native country.

PROVENANCE: Douwes Gallery, Amsterdam; Van Es, Amsterdam; auction Amsterdam (Mak van Waay), 21 December 1926, no. 15 (*f* 440); H. Kröller-Müller, The Hague; donated to the museum, 1935.

EXHIBITIONS: The Hague (Haagsche Kunstkring) 1892.

89

J. TOOROP
Environs of Broek in Waterland, 1889
Oil on canvas, 66 x 76 cm
Signed and dated lower right: *Jan Toorop 89*
San Antonio (Texas), Walter F. Brown Collection

As Toorop informed his biographers Zilcken and Marius, this work was painted in Brussels, directly after he had toured North Holland with the poet Emile Verhaeren in February 1889. One of the places they visited was Broek in Waterland, a village to the north of Amsterdam. Although there is no snow or ice to be seen, the bare trunks of the pollard willows show that it is winter, while the greenish-brown tints of the meadows and the cold light reflected in the water heighten the wintry atmosphere.

Having applied Pointillism in parts of some of his earlier paintings (cat. no. 88), Toorop now uses stippling consistently over the entire canvas; the colour contrasts within the individual elements are also stronger than ever before. Thus, yellow and blue stipples are combined in the water in the foreground and green and reddish-brown feature in the meadow, the two latter colours being virtually complementary in the colour circle. Toorop had obviously studied Seurat's work closely when he exhibited with *Les Vingt* in 1887 and Signac's when it was shown in 1888. Toorop's debt to these artists is apparent not only in the technique and use of colour in this painting, but also in the remarkably taut, almost theatrical composition of the landscape. The effect of the bent figures gliding by in a boat is that of a shadow play.

It is tempting to interpret the vertical and receding diagonal composition lines of the painting, the trees, the figures and above all the ditches, as an expression of melancholy, in keeping with the winter season and the harshness of peasant life. Seurat used line direction as a means of expression, drawing on theories which traced their origin via Charles Henry and Charles Blanc to Humbert de Superville. It is quite possible that Toorop was also aware of these ideas when he produced this painting, as he is known to have attributed explicit significance to lines in his Symbolist drawings of a few years later.

PROVENANCE: C. Sijthoff, Rotterdam; C. van Stolk, Rotterdam; Ivo Bouwman Gallery, The Hague.

EXHIBITIONS: *Société des XX te Brussel*, Amsterdam (Kunstzaal Panorama) 1889, no. 4; *Les XX, septième exposition annuelle*, Brussels 1890, no. 3; *Schilderijen, aquarellen en beeldhouwwerken*, The Hague (Haagsche Kunstkring) 1891, no. 73; *Kunstwerken van levende meesters*, Utrecht 1891, no. 131 (ƒ 200); *Jan Toorop*, Rotterdam (Kunstzaal Oldenzeel) 1891; *Jan Toorop*, Leiden (Stedelijk Museum De Lakenhal) 1894, no. 4.

LITERATURE: Jan Veth, 'Schilderkunst in Utrecht', *De Nieuwe Gids* 6 (1890-1891) 2, p. 476; anonymous, *De Opmerker*, 26 (1891) 28, p. 226; H.P. Bremmer, *De Zuidhollander*, 8-15 February 1894; P. Zilcken, 'Jan Toorop', *Elsevier's Geïllustreerd Maandschrift* 8 (1898) vol. 16, pp. 120-121, 123.

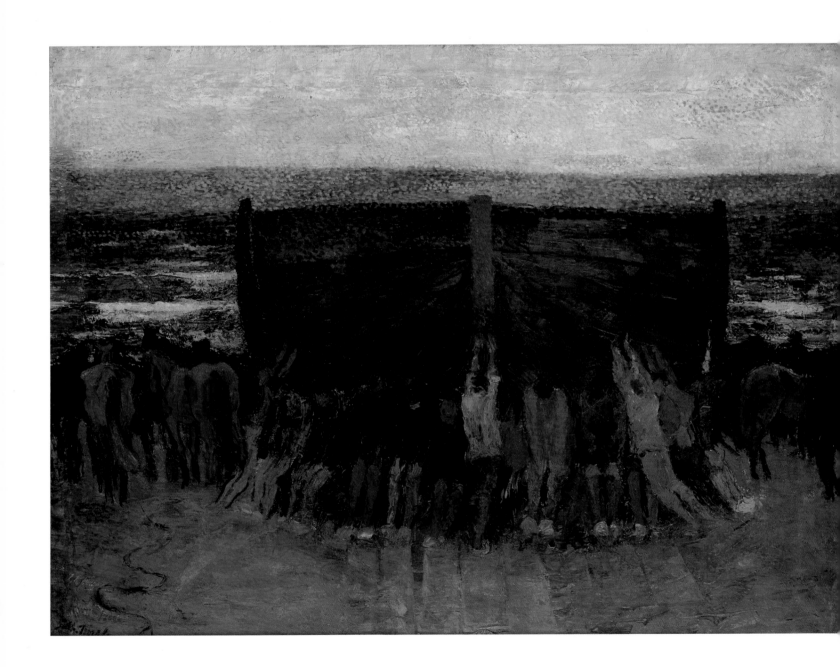

90
J. TOOROP
Transport of a Fishing Boat, *c.* 1890
Oil on canvas, 72 x 97 cm
Signed and annotated lower left: *J.Th. Toorop; Katwijk a/Zee;*
Amsterdam, Stedelijk Museum (donated by the Association for
the Acquisition of a Public Contemporary Art Collection)

This painting must have been produced shortly after Toorop
settled in the small fishing village of Katwijk aan Zee in April
1890. It was included in an exhibition of *Les Vingt* in Brussels in
February 1891. The subject matter is very much in the tradition
of the Hague School. Like Mesdag, Jacob Maris (cat. nos. 59, 60)
and Tholen (cat. no. 80), Toorop was fascinated by the pic-
turesque activities associated with the fishing industry. In places
such as Scheveningen and Katwijk, where there was no proper
harbour, the flat-bottomed boats had to be drawn up onto the
beach by the men and their horses after the catch, and dragged
out to sea again when they departed. It is this moment that
Toorop has chosen to portray.

At about the same time – or perhaps a few months earlier –
he captured the same image in a large, carefully worked out pas-
tel drawing (Otterlo, Rijksmuseum Kröller-Müller). The draw-
ing is like a snapshot of the men and animals at work. The per-
spective and the way the boats are cropped enhance the realistic
effect. In the painting, by contrast, the subject is elevated to a
symbolic level by the deliberate formalisation of the picture.
Stripped of rigging and other detail, the boat has become almost
unrecognisable; its flat bow, occupying the centre of the picture,
is like a vast monolith, almost overpowering the diminutive fi-
gures struggling below like Atlas, or perhaps Sisyphus, or Jesus
on the Road to Calvary. The weight of human suffering seems
also to be expressed in the dark tones and heavy impasto of boat,
men and animals, against which the ethereal sky and sea, in stip-
ples of mother-of-pearl, form a strange contrast, as if they belong
to another world. One can trace a connection between the *Trans-
port of a Fishing Boat* and Toorop's later, more overtly Symbol-
ist works from 1892-1897, such as *The Sphinx* (The Hague,
Haags Gemeentemuseum), which shows people literally and
figuratively bowed under the weight of the mystery of life.

PROVENANCE: J.H. de Bois Gallery, Haarlem; purchased by the Association for
the Acquisition of a Public Contemporary Art Collection Amsterdam in 1939;
donated to the museum in 1949.

EXHIBITIONS: *Schilderijen, aquarellen en beeldhouwwerken*, The Hague
(Haagsche Kunstkring) 1891, no. 72 (*f* 300)?

91
J. TOOROP
Hell and Doubt, *c.* 1892
Black and coloured chalk on cardboard, 68.2 x 78.3 cm
Signed lower left: *Jan Toorop*
Utrecht, Centraal Museum

Toorop's drawing of *Les Rodeurs* from 1891 (Otterlo, Rijksmu-
seum Kröller-Müller) shows a churchyard in which a group of
lascivious young men are reaching out towards an innocent girl.
Two old men are standing impassively to one side, observing
them with indifference. In an exhibition review in 1892, Jan Veth
identified these figures as 'old grave diggers, looking on with the
fixed gaze of impartial observation which attends every drama'
(*De Nieuwe Gids* 6, 1892, vol. 2, p. 455). Almost identical facial
expressions and clothing are worn by the men in the drawing re-
produced here, which Toorop himself referred to as *Les Calvi-
nistes de Katwijck*. Two old fishermen are sitting on top of the
dunes, one with distorted, mask-like features, the other convey-
ing by his posture and facial expression the deepest despair. They
are hell and doubt personified. The mood of the background is
equally sombre. We see a cluster of houses with shuttered win-
dows, huddled together beneath a lowering sky, encircled by
dunes and, on the horizon, a row of church spires. The enclosed
gardens contain a few weeping willows and a blighted tree. The
only living creatures apart from the men on the hill are two wo-
men retreating down an alley or into a doorway, a sinister black
cat and a herd of sheep, grazing on a hillside in the distance to the
right; the shepherd appears to have taken to his heels. Toorop
has used every possible means to convey the oppressiveness of
the stern Calvinism referred to in the painting's title, although
other works from his years in Katwijk present an almost idyllic
picture of life in this isolated village.

Toorop probably modelled the heads of the old fishermen,
with their piercing blue eyes, on Japanese character masks. Simi-
lar allusions to the mysterious cultures of the East are to be found
in his other Symbolic works, associations which Toorop at-
tributed to his non-European origins. However, the overriding
influence in this drawing is that of Van Gogh. Interestingly, it
was Toorop who organised the first retrospective exhibition of
Van Gogh's work, held at the Hague Art Circle in 1892. The
rough treatment of the sheet in *Hell and Doubt*, with harsh,
criss-cross streaks of chalk, and the deliberately clumsy handling
of the anatomy of the figures and the background (a clumsiness
that sits strangely with such an accomplished draughtsman as
Toorop) can all be traced directly to the example of Van Gogh's
first halting steps on the road to artistic achievement – his draw-
ings from the Borinage and from his early days in The Hague.

PROVENANCE: A. Prins, Schiedam; Huynck & Scherjon Gallery, Amsterdam; H.P. Bremmer, The Hague; lent to the museum in 1923; purchased by the museum in 1964 (*f* 3,750).

EXHIBITIONS: *Aquarellen en teekeningen van werkende leden*, The Hague (Haagsche Kunstkring) 1892, no. 81.

LITERATURE: *De Nederlandsche Spectator*, 8 October 1892; W. van Tricht, 'Tentoonstelling van teekeningen van werkende leden van den Haagschen Kunstkring', *De Portefeuille*, 15 October 1892; Ph. Zilcken, 'Jan Toorop', *Elsevier's Geïllustreerd Maandschrift* 8 (1898) vol. 16, p. 123; Polak 1955, pp. 107-108; Carel Blotkamp, *Daubigny, Van Doesburg, Daniels en 88 andere hoogtepunten uit de collectie moderne kunst van het Centraal Museum*, Utrecht 1987, pp. 40-41.

92
J. TOOROP
Apocalypse, 1892
Pen, sepia and white bodycolour on brown paper, 38 x 42 cm
Signed and dated lower right: *J.Th. Toorop 1892*; annotation cited below.
Neuss, Clemens-Sels-Museum

This drawing was intended as an illustration for Lodewijk van Deyssel's *Apokalyps*, an eloquent 'prose poem in ten cantos', which is a vision of the end of the world as it appears in the feverish hallucinations of a dying poet. Van Deyssel, a prominent *Tachtiger*, wrote it in the summer of 1891, and described it in a letter to Albert Verwey as a 'Milton-like fantasy' (*De briefwisseling tussen Lodewijk van Deyssel en Albert Verwey* (ed. Harry G.M. Prick), The Hague 1981, vol. 1, p. 137). While writing it, however, he may also have been influenced by De Lautréamont's *Chants de Maldoror*, which received an outstanding review from Willem Kloos in *De Nieuwe Gids* in April 1891.

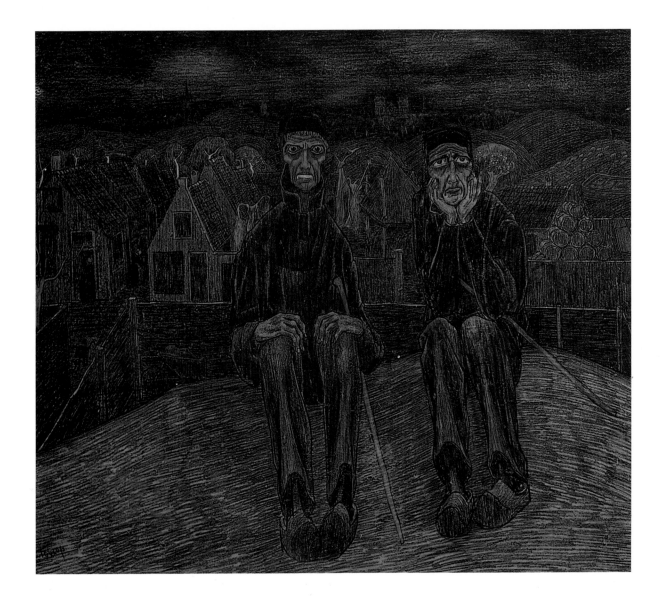

It is not surprising that Van Deyssel wanted the Symbolist Toorop to illustrate his prose poem. Frederik van Eeden requested him to do so, on Van Deyssel's behalf, in February 1894. Toorop apparently consented, and in April 1894 the publication of an illustrated, luxury edition was announced in the press. For a whole year, Van Deyssel sent letters urging Toorop to produce the illustrations, but the project never reached fruition. This is thought to be the only illustration he completed. It probably represents the tenth canto, in which the protagonist dies, 'and out of the head, that had sung great songs, the soul rose like a gold and white kiss through the glowing silence of boundless space towards God' (*Verzamelde werken van Lodewijk van Deyssel. Lyrisch en verhalend proza. Ethiesch-mystische varia. Reis-indrukken. Schetsen en Aanteekeningen*, 2nd impression, Amsterdam, p. 323).

Toorop himself wrote explanatory notes on the drawing, as he did on several occasions. They read as follows: '*Apocalypse* / the two figures at lower right and left are *mortal suffering* / the large figure is *endeavour. The death of the mortal body* / the virgins on the left and right are *the ascent of the soul* after this death, the higher ascents / the flames turning into stone in the background are *the loss of earthly passions*, the process of dying, of hardening.' He probably added these notes later, when he signed the work and dated it, incorrectly, as 1892. The text is in fact more obscure than the drawing in relation to Van Deyssel's prose poem. The lifeless figure in the foreground and the elongated female figures on the left and right of the drawing strongly recall Toorop's *Sphinx* (The Hague, Haags Gemeentemuseum), and particularly a study he made for it (Otterlo, Rijksmuseum Kröller-Müller). He had started his large drawing of *The Sphinx* in 1892, but made major changes to it in 1897, and only completed it in that year.

PROVENANCE: J. Rustige, Amsterdam; L. Bisterbosch, Amsterdam; acquired by the museum.

EXHIBITIONS: *Werken van Toorop*, Groningen (Museum van Oudheden) 1896, no. 52.

BIBLIOGRAPHY: Polak 1955, no. 42; exhib. cat. *Kunstenaren der Idee. Symbolistische tendenzen in Nederland ca. 1880-1930*, The Hague (Haags Gemeentemuseum) etc. 1978, no. 98.

VERKADE, JAN

ZAANDAM 1868 - 1946 BEURON

Jan Verkade and his twin brother Eric spent their early youth in Zaandam. In 1877 the family moved to Amsterdam, and from 1881 to 1883 the mischievous twins were sent to boarding school in Oisterwijk; they subsequently attended the commercial college in Amsterdam. Jan did not complete his education there, as he had decided to become a painter. His father, who had founded the first steam bakery in Zaandam in 1886, had hoped he would succeed him, but did not object to his choice. He, too, enjoyed painting as a hobby. In preparation for the Amsterdam Academy, Jan received drawing lessons from a friend of the family, Hendrik Haverman.

Verkade attended the Academy from 1887 to 1889 and made the acquaintance of Roland Holst and Hart Nibbrig. He spent the summer of 1889 with his brother-in-law, the painter Jan Voerman, in Nunspeet, Haarzuilen and Hattem, and subsequently decided to move to Hattem, where he spent the next two years working on landscapes and figure pieces under Voerman's supervision. After seeing the exhibition of *Les Vingt* in Brussels in 1890, he became fascinated by modern French painting. The following year, he travelled to Paris, where Meyer de Haan introduced him to Gauguin, Sérusier, Bernard and other Nabi artists. He joined the group and was nicknamed *le Nabi obéliscal* – the obelisque prophet – because of his height. He spent the summer and autumn of 1891 in the villages of Pont-Aven, Huelgoat and Le Pouldu in Brittany, and returned to the area for an even longer period the following year to paint Breton peasants, still lifes and landscapes, which in style and colour clearly reflect the influence of Gauguin and the Nabis.

He frequently showed his work in exhibitions at this time, including a group exhibition of the Nabis in Saint-Germain-en-Laye near Paris, and exhibitions in Amsterdam and Brussels. In 1892 Verkade converted to the Catholic faith and his work acquired a religious character. Together with Mogens Ballin, who was a Danish member of the Nabis and likewise a convert to Catholicism, he spent some time in a monastery near Fiesole, and visited Rome and various parts of Tuscany. He studied and copied the Italian trecento painters – Giotto, Duccio, Lorenzetti and Simone Martini – whose religious work was the supreme embodiment of his ideals of community life and spiritual art. Unfortunately, little is known about the work he made in Italy, which includes a number of frescoes.

Early in 1894, Ballin organised a highly successful exhibition of Verkade's work in Copenhagen. However, in that same year, Verkade decided to relinquish his independence as an artist to become a painter-monk at the Benedictine abbey in Beuron in southern Germany. The renowned painting academy attached to the abbey was run by Father Desiderius Lenz, whose pronounced ideas about religious art were based on the canons of Gregorian music and the art and architecture of ancient Egypt and Assyria. Though Verkade accepted these theoretical principles, he soon objected to the impersonal and unemotional nature of the work.

He was nevertheless ordained a priest in 1902, and was subsequently known as Dom Willibrord Verkade. After completing a number of projects, including one in Monte Cassino in Italy and another in Aschhalden in the Black Forest, he spent part of 1907 studying in Munich, turning again to Gauguin, Cézanne and Van Gogh for inspiration. However, disappointed by an unsuccessful project in Jerusalem and unable to resolve his dilemma concerning the respective merits of an objectively 'perfect' art and art as a vehicle for individual expression, Verkade finally decided to give up painting in 1913. He devoted the rest of his life to writing, lecturing and organising exhibitions and other activities for the monastery in Beuron.

LITERATURE: Dom Willibrord Verkade, *Van ongebondenheid en Heilige banden*, 's Hertogenbosch 1920; W. Jaworska, *Gauguin et l'école de Pont Aven*, Neuchatel, 1971, pp. 169-174; exhib. cat. *Jan Verkade. Hollandse volgeling van Gauguin*, Amsterdam (Rijksmuseum Vincent van Gogh) 1989.

93
J. VERKADE
St Sebastian, 1892
Saint-Germaine-en-Laye, Musée du Prieuré

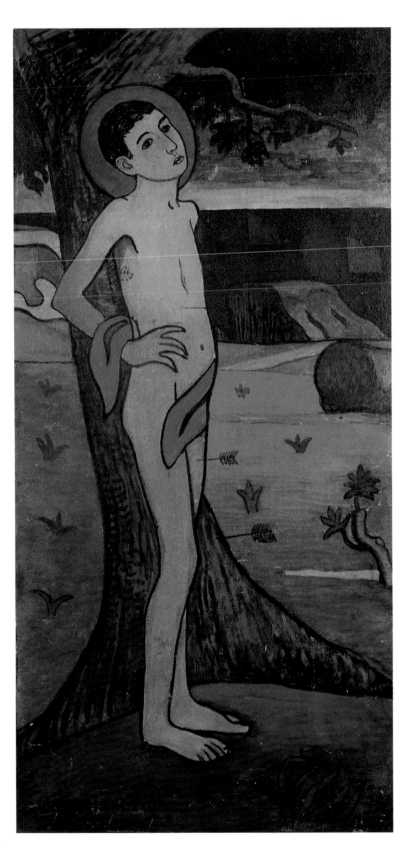

Verkade arrived in Paris in 1891, when French artists and writers were seeking inspiration in mysticism, religion and philosophy. After the hectic 1880s and the emergence of a rapid succession of new styles, they wanted a new framework within which art could serve a cause. Traditional values, themes and forms of expression were examined in a fresh light and reappraised. Gauguin, Bernard and Denis had begun to explore religious themes in 1889, followed soon afterwards by Sérusier, Filiger, Ballin and Verkade. Filiger and Verkade spent part of the summer of 1892 in Le Pouldu, working from the same Bretonnese model, whom Filiger portrayed in *Genius with a Garland* (whereabouts unknown), and Verkade in *Breton Boy on the Beach* (private collection) and *St Sebastian*. The background in both of Verkade's works shows the beach to the south of Le Pouldu, with a few large rocks and a calm sea with small sailing boats in the distance.

St Sebastian was a soldier persecuted for his faith by the Roman Emperor Diocletian, who commanded his men to shoot him with arrows. He is depicted half-naked against a tree in the conventional manner. This image was quite popular with the Symbolists, not only for its religious connotations, but also for the homosexual eroticism evoked by the androgynous figure of Sebastian. Verkade's interpretation of the theme, however, leans more towards the religious significance of the event. He shows Sebastian looking upwards with a serene expression, apparently oblivious to the cruelty to which he is being subjected. Young shoots sprout from the withered branch on the lower right hand side of the picture, symbolising life after death. The sea might be interpreted as an allusion to eternity and to God as the source of life, and the ship, perhaps, to the immortal soul.

The stylised shapes, harmonious colours and bold contours are in the manner of Gauguin and his followers, while the rather clumsy composition recalls medieval representations of saints. In his autobiography Verkade refers to his interest in the Italian Primitives and his special admiration for Fra Angelico, Botticelli and Mantegna, whose religious fervour and artistic eloquence he found deeply moving. He projected his own ideal of the Middle Ages on the peasants of Brittany.

Verkade produced three versions of *St Sebastian*, all of them on paper. He used gold ground in the largest of the three (private collection, 119.5 x 46 cm), which is therefore his most explicit tribute to medieval art. The two smaller drawings (Musée du Prieuré and private collection, 45 x 22 cm) differ from the larger version only in a few minor details, the most conspicuous being the addition of decorative flowers and plants.

It is interesting to speculate on Verkade's reasons for making two copies of the picture, particularly since he made no substantial changes. He himself offers no clues to the answer, but the copies might simply have been intended as gifts for friends. In 1894 the drawing of St Sebastian was published in the Danish journal *Taarnet* to illustrate an article by J. Jörgensen on the Bretonnese mystic Ernest Hello.

LITERATURE: Verkade 1920, pp. 87, 88; Jaworska 1971, p. 172; exhib. cat. Amsterdam 1989, pp. 25, 31, 128-130.

94

J. VERKADE

Décor for *Les Sept Princesses*, 1892

Bodycolour on paper, 137 x 150 cm

Unsigned

Saint-Germaine-en-Laye, Musée du Prieuré

In 1891 Meyer de Haan introduced Verkade to the Nabis, a group of artists working in Paris, and Verkade was soon taking part in their various activities. Every Saturday afternoon the group met at Paul Ranson's studio, which they regarded as their 'temple', to discuss Symbolist literature, theatre and music, as well as religion, philosophy and occultism.

Verkade paid his second visit to Paris in the spring of 1892, when the Nabis were preparing a marionette performance of *Les Sept Princesses*, which the Symbolist playwright Maurice Maeterlinck had written the previous year. Together with *L'Intruse* and *Les Aveugles*, both written in 1890, the play forms a trilogy on the themes of death and despair.

Les Sept Princesses is about a prince who returns to his grandparents' castle after seven years at war, to marry his beloved cousin Ursule, one of the seven princesses. She dies, however, on the day of his arrival. The tale is an allegory based on the paradox that an ideal ceases to exist as such once it has been achieved. In other words, an ideal is by definition elusive and unattainable.

The puppet show was performed at the home of J.C. Coulon, an art connoisseur and member of the Council of State in Passy. According to Verkade's memoirs, he himself painted the screen and worked some of the marionettes, Vuillard and Sérusier provided 'some of the decorations', while Sérusier, his brother Henri and 'the daughter of the director Lamoureaux' narrated the text. It is uncertain what Verkade meant by 'some of the decorations', and this statement may account for the popular but mistaken belief that Vuillard and Sérusier produced the screen. The Nabis, however, would have been little concerned to know the author of the piece, as the salient point in their view was that the production was a *Gesamtkunstwerk*, or collaborative project. And it was indeed extremely successful.

The screen shows the castle of the ageing king and queen, with seven cypresses in front of it. The hilly landscape with a river running through it was based on a drawing Verkade had made in his sketchbook in Brittany (1891, Beuron, Erzabtei St Martin). There is also a lawn in the lower half of the picture, with three flower beds. The screen probably decorated the puppet booth before the performance began, as the story in fact takes place inside the castle. According to the script, the décor consisted of two 'halls', one of which was a large area with marble tiles, where the princess puppets lay on silk-covered steps. Separating them from the king and queen next door was a wall with large panes of glass and a door with a sturdy bolt. The glass, which at first kept the prince from his beloved, while at the same time allowing him to believe her alive, signifies the illusory nature of an ideal.

LITERATURE: J. Veth, *De Amsterdammer* (daily), 3 April 1892; Verkade 1920, p. 117, 120; exhib. cat. Amsterdam 1989, pp. 20, 21, 43.

VERSTER, FLORIS

LEIDEN 1861 - 1927 LEIDEN

Verster showed an aptitude for drawing at a very early age, as we know from extant work he produced in childhood. Encouraged by his father, himself an amateur draughtsman and lithographer, the twelve-year old learned to draw animals at school under the guidance of his art master G.J. Bos. At the recommendation of the painter Herman ten Kate, Verster was removed from school. In the winter of 1878/79 he was enrolled at Ars Aemula Natura in Leiden, where Breitner, four years his senior, taught him perspective. He also studied at the Academy in The Hague from 1879 to 1882. Although the director J.P. Koelman dismissed Verster's drawing as 'angry lines', the budding artist nevertheless won two medals during this period. In 1882, the Leiden artist Alexander Bakker Korff arranged for him to attend the Brussels Academy, where he studied for six months. Verster subsequently returned to Leiden and shared a studio with Menso Kamerlingh Onnes from 1882 until 1892, when he married Kamerlingh Onnes's sister Jenny. The couple went to live in Groenoord, a summer residence near Leiden, where they led a secluded but apparently happy life. Verster produced almost all his work there. In September 1926 his wife died. Deeply upset by the loss and afraid of being forced to leave Groenoord, his health deteriorated. In January 1927 Verster drowned in the pond in his garden.

The work he produced in the 1880s and early 1890s was largely experimental. Up to about 1885 his paintings were essentially in the manner of the Hague School, and the influence of Weissenbruch and Mauve is clearly visible in the evocative landscapes he painted near Leiden, Bergen and Noorden. In 1886/87, when he turned to larger canvases, his talents as a still-life painter began to emerge. The huge flower pieces he produced from 1888 on received wide acclaim, notably from younger artists and critics. After several rejections by the Dutch Society of Watercolourists, he was invited to take part in exhibitions organised by various artists' associations, such as the Dutch Etching Club, Arti and the Hague Art Circle. He was well received in Brussels, too, where he showed his work at exhibitions of *Les Vingt*. Verster excelled as a colourist and achieved a vibrancy reminiscent of old Dutch Masters. His flower pieces, which reveal a passionate sensitivity to colour, are examples *par excellence* of the impressionistic style that the younger painters in Amsterdam and The Hague were trying to achieve.

Around 1893 his work changed quite dramatically. He went back to using smaller canvases and seemed to prefer rather fanciful shapes. He also experimented with techniques other than oil painting. He made crayon drawings, for instance, concentrating mainly on lines and shapes, although colour nevertheless remained important. After 1895 he painted still lifes with simple objects – a few tin jugs or a bowl of eggs – which are more subdued in tone and in some cases deeply spiritual. In one of his few surviving documents, a letter dating from 1895, he wrote, 'I am by nature so happy that I need little distraction from outside; and I could never be a cosmopolitan for my work, I mean travelling and moving around. I am far too dreamy for that. There is so much beauty under a Dutch sky that I had never discovered before, that everything still looks new and unexplored' (exhib. cat. *Floris Verster*, Leiden, Stedelijk Museum De Lakenhal, 1927, p. 7). He continued to paint landscapes, portraits and, most of all, flower pieces.

Verster's *oeuvre* is both emotional and contemplative. In the words of his close friend, the poet Albert Verwey, 'not only his feelings, but his imagination, too, was engaged. He saw an object, but at the same time saw it as an image of something that moved him, as a symbol whose meaning he was perhaps unable to express in words' (*op cit*, p. 9).

LITERATURE: A. Plasschaert, 'Floris Verster (chronologisch en aanteekeningen)', *Neerland's Roem en Grootheid, Meesterwerken in woord en beeld. Verzameling van letterkundige kunstwerken geïllustreerd door Nederlandsche kunstenaars*, vol. XVIII, Amsterdam, 9 (1899), 8, pp. 97-117; A. Plasschaert, 'Floris Verster', *Onze Kunst* 1 (1902) 1, pp. 118-123; A. Plasschaert, *Floris Verster en zijn plaats temidden der schilders, geboren omstreeks 1860*, Amsterdam 1904; A. Plasschaert, 'Rotterdamsche Kunstkring, Floris Verster', *Onze Kunst* 3 (1904) 6, pp. 191-192; Cornelis Veth, *Floris Verster* (in the series Hollandsche Schilders van dezen tijd), Amsterdam 1912; A.M. Hammacher, 'Floris Verster, studie van een ontwikkelingsgang', *Elsevier's Geïllustreerd Maandschrift* 1927 vol. 1, pp. 313-329; Albert Verwey, 'Inleiding', exhib. cat. *Floris Verster*, Leiden (Stedelijk Museum de Lakenhal) 1927; W. Scherjon ed., *Floris Verster. Volledig geïllustreerde catalogus van zijn schilderijen (etc.)*, Utrecht 1928; W.J. Steenhoff, 'Floris Verster en zijn tijd', *Maandblad voor Beeldende Kunsten*, 6 (1929) 11, pp. 331-342; J. Slagter, 'Rede door Albert Verwey te Amsterdam uitgesproken 6 February 1937' *Elsevier's Geïllustreerd Maandschrift*, 47 (1937) 93 pp. 284-288; A.M. Hammacher, *Floris Verster*, Amsterdam s.a.; A.M. Hammacher, *Amsterdamse impressionisten en hun kring*, Amsterdam 1941, pp. 50-52, 89-96; exhib. cat. *Floris Verster, 1861-1927, Schilderijen, Tekeningen en grafiek*, Slochteren (Frayelemaborg) 1977; exhib. cat. *Floris Verster 1861-1927*, Leiden (Stedelijk Museum de Lakenhal) etc. 1986; Aleid Montens, 'Aantekeningen van Jenny Kamerlingh Onnes over Floris Verster', *Jong Holland*, 2 (1986) 3, pp. 42-55.

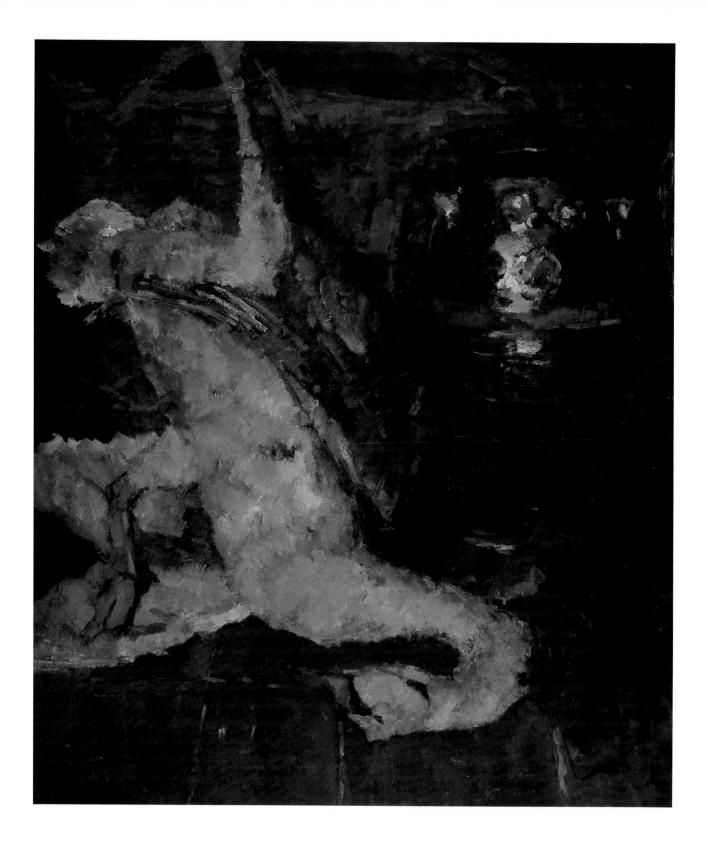

95
F. Verster
Dead Swan, 1886
Canvas, 132 x 116 cm
Signed and dated lower left: *Floris Verster. '86.*
Rotterdam, Boymans-van Beuningen Museum

At the age of twenty-five Verster produced this lifesize rendering of a dead swan, which marked the beginning of his career as a still-life painter. Both the subject and format are surprising, as he had previously painted mainly landscapes of modest dimensions. Like his father and grandfather, Verster was a keen huntsman. The family had a private hunting ground in the dunes and polders around their estate. The bird shown here, which was not a protected species at the time, may have been shot there, probably for the pot. A large preserving jar and a few cabbage leaves are shown beside it; the motif was undoubtedly inspired by hunting tableaux from the seventeenth century, which often depict dead birds hanging up. A comparable, equally large painting of a dead swan by Jan Weenix was displayed at the Boymans Museum in

Rotterdam at the time, and Verster would certainly have seen it. Nevertheless, a conservative critic was quick to comment on the differences between the two. 'What should one say of Floris Verster of Leiden, who shows us a "swan" and a "heron", which appear to be falling out of a copper pan into a plaster porridge. When one thinks of Weenix's swan, it is impossible to suppress a smile' (quoted in exhib. cat. Slochteren 1977, p. 8). The 'plaster porridge' probably refers to the effect of the loose brushstrokes and light grey tints.

The painting differs considerably from its seventeenth-century precursors, both in style and in the fact that it has a simple background rather than a symbolic décor showing the trophies of the chase and attributes of the hunt. In the first instance, the handling of the paint and the muted colours recall Breitner's work. The literature on Verster's early work indeed makes frequent reference to Breitner. And yet the painting has a unique quality of its own. It seems that Verster wants to achieve more than an impressionistic mood, and has endowed the subject with a deeper meaning. The swan is a futile and pitiful presence, a symbol of death and, at the same time, a statement about life.

The *Dead Swan* is one of a series of paintings and etchings of dead birds that Verster continued to make up to 1907. In 1887/88, for example, he painted and engraved several versions of plucked chickens lying on a table, and in 1890, plucked cocks hanging up. These pictures are even less aesthetic than the swan, and it is as though he wanted to represent death ever more explicitly.

PROVENANCE: Van Vloten, Leiden, 1902; L. Warendorf, Utrecht; Amsterdam, Huinck & Scherjon Gallery; purchased by the museum in 1941.

LITERATURE: Scherjon 1928, cat. no. 26; Hammacher 1941, pp. 51-52, 89; exhib. cat. Slochteren, 1977, p. 8.

96

F. VERSTER
Flowers and Foliage, 1888
Oil on canvas, 162 x 100 cm
Signed and dated lower left: *Floris Verster. 1888*
Leiden, Stedelijk Museum de Lakenhal

The flower pieces Verster painted at the end of the 1880s, such as *Flowers and Foliage*, marked his breakthrough as an artist. His colleagues in particular appreciated his work, and Breitner, Bremmer, De Bock, Kamerlingh Onnes and Thorn Prikker were among those who bought his flower still lifes. Critics, on the other hand, troubled by the lack of botanical accuracy, saw them as studies. Van der Kellen, for instance, wrote that '*Flowers and Foliage* undeniably has a pleasant mix and play of colours, but does it bear any relation to reality? No more than in a dream. It is more like a worn, faded tapestry than a painting. One expects more, even of a decoration' (*Nieuws van den Dag*, 16 February 1891). He would apparently have preferred a conventional bouquet with easily identifiable flowers, like those painted by artists such as Margaretha Roosenboom (cat. no. 76).

Verster produced flower still lifes of this unusual format mainly between 1888 and 1890. He may have intended them not as paintings to be hung separately, but as part of a decoration for an interior (which is what Van der Kellen had in mind). These were commonplace in France at the time, and examples are also known in the Netherlands – the work of Josselin de Jong being a case in point. In any event, we know that Verster's *Poppies* (Amsterdam, Rijksmuseum Vincent van Gogh), which was also painted in 1888, hung above the mantelpiece in the home of its first owner.

Verster's still lifes are also unusual because of the way he represents his subjects. His bouquets contain not only cultivated flowers, but also weeds. He ennobles the dandelion, the thistle or the large yellowed or wilted leaves of nondescript plants by incorporating them in his art. The critic Albert Plasschaert, a friend of Verster's, referred to *Flowers and Foliage* in 1902 as *Leaves and Guelder Roses – luxe d'une pauvre*. Kamerlingh Onnes, with whom Verster shared a studio in the 1880s, often gave his still lifes symbolic titles, such as *Les fleurs du Mal* (cat. no. 52). Verster, however, did so only rarely. In 1891 he dubbed a still life *Fairy Tale*, but soon changed it to the neutral *Flowers in a Conservatory*. Another piece, which he only produced in 1921, is subtitled *Peasant Wedding*. In general he kept such associations to himself. However, *Leaves and Guelder Roses – luxe d'une pauvre* is a title he might have thought of himself, and it is certainly appropriate for this 'poor man's bouquet' of fanciful leaves with no more than a few wild flowers in their midst. He draws attention to simple shapes in nature, which are often dismissed as banal, and exalts them to monumental effect. The vivid greens, yellows and browns of the leaves stand out in sharp contrast to the dark background. Other flower pieces from the same period likewise reflect Verster's fascination with the natural process of growth, flowering and decay.

PROVENANCE: Widow Hubrecht, Leiden, 1902: bequeathed to the museum by Miss L.S.P. Hubrecht in 1940.

EXHIBITIONS: *Schilderijen, tekeningen en etsen van Nederlandsche schilders*, Leiden (Lakenhal) 1890, cat. no. 86 ('Bloemen en Bladen'); *Tentoonstelling van kunstvoorwerpen door nederlandsche artiesten*, Amsterdam (Arti et Amicitiae) March 1891, cat. no. 158.

LITERATURE: D. van der Kellen, *Nieuws van den Dag*, 16 February 1891, p. 110; Plasschaert 1902, p. 122; Plasschaert 1904, p. 191; A.M. Hammacher, (Paletserie) s.a., p. 24; Scherjon 1928, cat. no. 39; exhib. cat. Leiden 1986, pp. 48 (note 18), 49.

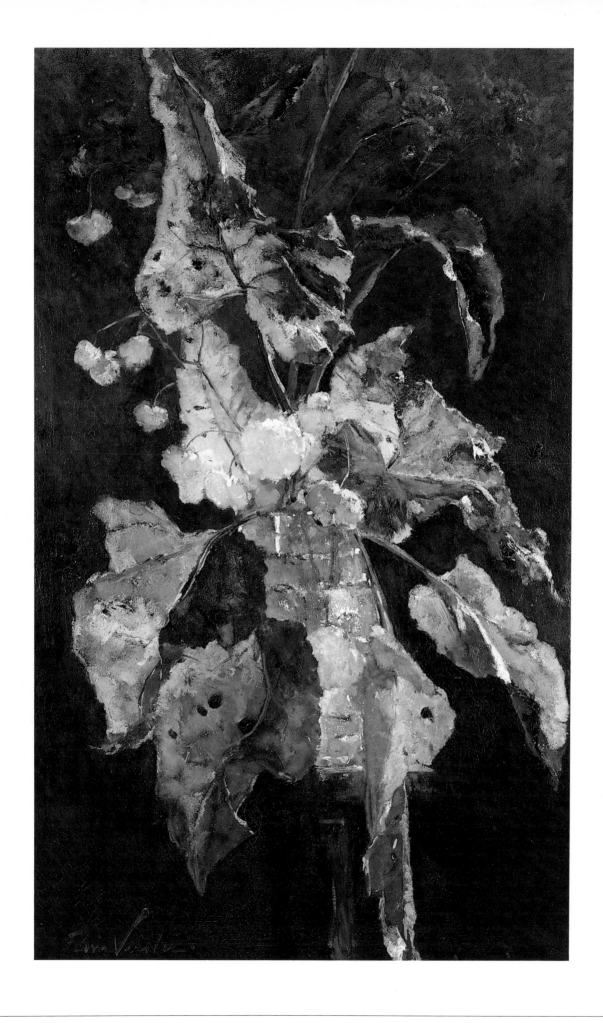

97

F. Verster
Roses after a Banquet, 1893
Oil on canvas, 57 x 74.5 cm
Signed and dated lower right: *Floris Verster '93*
Groningen, Groninger Museum voor Stad en Lande (R.J.
Veendorp Collection, lent by J.B. Scholtenfonds Foundation)

Verster took his experiments with artificial effects to extremes in his still lifes from 1893, sacrificing representation in order to make an impact through colour. The various sections of the painting erupt in an overwhelming explosion of pinks, reds, purples and greens. *Roses after a Banquet* is one of the few works to which he has given an evocative title, designed to elicit specific associations. The overblown roses, the sparkling crystal and the empty bottles in the background are the only tangible remains of the festive banquet, but the mood lingers on in the intoxicating, sumptuous colours of the painting. The result is a decadent, almost un-Dutch emphasis on the beauty of overripeness heralding the onset of decay.

Verster's work from this period – reviewers spoke of 'visions' – has a degree of abstraction, which he achieved partly through his style of painting. Rough brushstrokes and the movements of the palette knife are clearly visible in the impasto in his *Roses after a Banquet*. However, his interest in this type of painting and the visual impact of light and colour seems to have been short-lived. Soon afterwards he began to produce work with more emphasis on form, although he lost none of his brilliance as a colourist.

PROVENANCE: Widow Hubrecht, Leiden; H. Tutein Nolthenius, Delft; The Hague, Nieuwenhuizen Segaar Gallery; R.J. Veendorp, Groningen, 1953; J.B. Scholtenfonds Foundation, on permanent loan to the museum, 1968.

EXHIBITIONS: *Schilderijen en beeldhouwwerken van werkende leden der eerste afdeling en van werken van Claude Monet, Renoir, Sisley en C. Pissarro*, The Hague (Haagsche Kunstkring) October/November 1893, cat. no. 37, ('Rozen').

LITERATURE: Hammacher s.a., p. 33; Scherjon 1928, no 83; G. Knuttel, 'Floris Verster (1861-1927)' (cutting dated 23 January 1927, Rijksdienst voor Kunsthistorische Documentatie, The Hague; Montens 1986, p. 53.

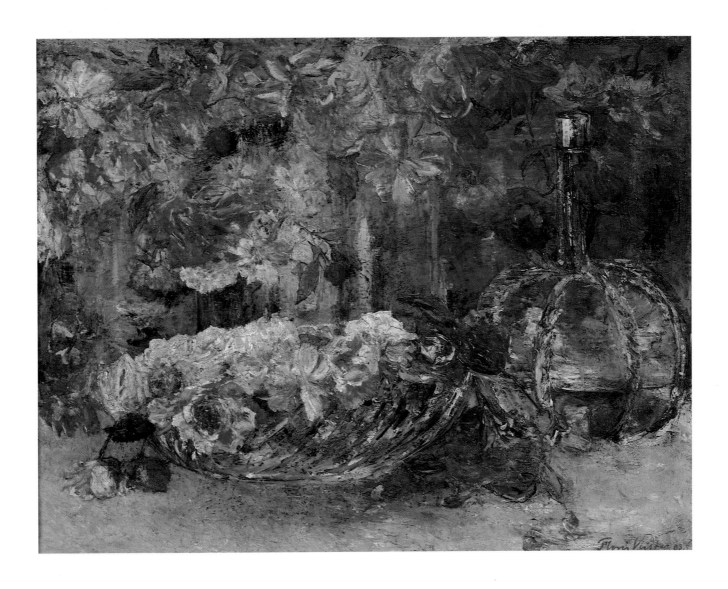

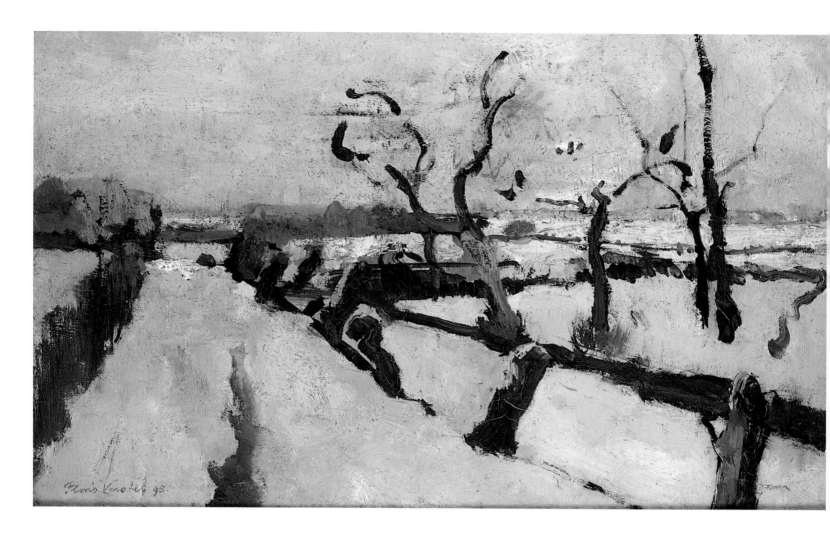

98

F. Verster
Snow, 1895
Oil on canvas, 30 x 50.5 cm
Signed and dated lower left: *Floris Verster '95*
Otterlo, Rijksmuseum Kröller-Müller

This snow-covered landscape was painted somewhere near Leiden in the winter of 1895. A country road, lined with pollard willows and flanked by a ditch and a field with fruit trees, leads to a few barns and some farmland in the distance. Reversing the conventions for colour perspective, Verster has used bright red and orange for the buildings, a light purplish hue for the horizon, and grey-blue in the foreground. The brushwork is broad and steady with looser strokes in some parts, such as the trees on the right.

Probably painted *en plein air*, the canvas served as a study for a slightly larger, more detailed drawing in crayon, which Verster completed that same year (private collection). He also made a charcoal drawing of the subject (Otterlo, Rijksmuseum Kröller-Müller), which focuses more on the trees. Interestingly, he used oils during this period rather than chalk or pencil, to capture his impressions of landscapes illuminated by the setting sun. It was a medium in which he had more than adequately demonstrated his skills as a colourist.

Provenance: L.C. Enthoven, Voorburg; auction, Amsterdam (Frederik Muller & Cie.) 18 May 1920; purchased by the museum.

Literature: Plasschaert 1902, p. 120; Scherjon 1928, cat. no. 96; Hammacher 1941, p. 95.

Veth, Jan Pieter

Dordrecht 1864 - 1925 Amsterdam

Jan Veth grew up in a liberal, intellectual family. His mother was the daughter of the Dordrecht painter Jacob van Strij, and his father, an ironmonger, published several articles on politics and eighteenth-century art. Jan Veth's ambition to become a painter was therefore fostered at home, and he received drawing lessons from Johannes Rutten. In 1879 he studied under H.J. Terwen in order to prepare himself for the Academy. At the same time, he joined the Pictura Drawing Society in Dordrecht. He then enrolled at the Academy in Amsterdam, where he remained from 1880 to 1885, studying together with Toorop and Derkinderen. He became friendly with Witsen and was often invited to Witsen's country house Ewijkshoeve. Mauve, too, was a frequent guest from 1884 on, and Veth benefited from his advice, as he was contemplating becoming a landscape painter.

In 1885 Veth, Witsen and Derkinderen founded the Dutch Etching Club. Veth also started to publish controversial art reviews and essays in *De Nieuwe Gids* and various other journals and newspapers. For some years after leaving the Academy, he was undecided about choosing a genre in which to specialise. He visited Dongen and Laren on numerous occasions and also travelled to London and Paris. In 1888, the year of his marriage to Anna Dirks, he decided to devote himself completely to portraiture. Though it was indisputably his forte, he was also motivated by financial considerations. His series of lithographed portraits of prominent contemporaries, which first appeared in *De Amsterdammer* and subsequently in *De Kroniek*, assured him of a steady income and numerous further commissions. Moreover, publishing his work in the press corresponded with the ideal of art for the people, which he had cherished since around 1890. Jan Veth was instrumental in promoting Art Nouveau, and advocated its underlying collectivist principles through his writings. He also translated Walter Crane's *Claims of Decorative Art*, which appeared in Dutch as *Kunst en Samenleving* in 1893 (fig. 58). Yet in his own portraiture and in his experience as an artist, Veth was drawn mainly by the quality of individuality. The examples on which he based his work were principally fifteenth and sixteenth-century masters such as Dürer, Holbein and Jan van Scorel. He wrote two important books on Rembrandt and Dürer.

LITERATURE: E., 'Portretten van Jan Veth in het Museum te Dordrecht', *De Amsterdammer* (daily), 1 May 1891; J. Huizinga, *Leven en Werk van Jan Veth*, Haarlem 1927; W.J. Steenhoff, 'Jan Veth als conterfeiter en als schilder', *Elsevier's Geïllustreerd Maandschrift*, 75 (1928) 1, pp. 1-13; W.J. Steenhoff, 'Jan Veth als schrijver', *Elsevier's Geïllustreerd Maandschrift*, 75 (1928) 6, pp. 378-387; C. Veth, 'Hoogtepunten in het werk van Jan Veth', *Maandblad voor Beeldende Kunst*, 16 (1939) 1, pp. 11-18; A.J. Vervoorn, 'Het grafisch werk van Jan Veth', *Antiek* 16 (June/July 1981) 1, pp. 11-22; 4, pp. 255-264; Peter J.A. Winkels *et al.*, *Ten tijde van de Tachtigers*, The Hague 1985, *passim*; F. Bijl de Vroe, *De schilder Jan Veth 1864-1925. Chroniqueur van een bewogen tijdperk*, Amsterdam/Brussels 1987; Rein van der Wiel, *Ewijkshoeve, tuin van tachtig*, Amsterdam 1988, *passim*.

99

J.P. VETH

Portrait of Frank van der Goes, 1887

Oil on canvas, 108.3 x 87.5 cm

Signed and dated lower right: *Jan Veth '87*; annotated upper right: *Aet. 28*

Dordrecht, Dordrecht Museum

Jan Veth first met the lawyer Frank van der Goes at the Flanor Literary Society in 1884. Their contact became more frequent the following year, when Veth started writing reviews for *De Nieuwe Gids*, a journal which Van der Goes had helped establish and to which he contributed political and social commentaries. The painters and writers associated with the journal formed a close circle. In 1885 Veth painted portraits of the poets Albert Verwey, Frederik van Eeden and Willem Kloos, in 1886 of the painter Mau van der Valk, and in 1887 of Van der Goes and the poet Hein Boeken. He then submitted the latter two works for the Exhibition of Living Masters at Arti. The committee rejected the fresh, rather loosely rendered painting of Boeken – 'ostensibly for lack of space', according to Veth – but accepted the more muted portrait of Frank van der Goes. Veth's opinion of the painting, as he wrote to his friend Anna Dirks, was that 'however weak it may be and whatever is said of it, I am not ashamed of it hanging there. I am fully aware of its shortcomings, but know that it was a worthy attempt.' Others, too, however, were aware of its shortcomings, and Van der Goes later regretted having placed himself at the mercy of Veth's green-grey paint. Nevertheless, encouragement came from an unexpected quarter. Com-

menting in *De Amsterdammer*, the conservative Alberdingk Thijm lavished praise on Veth's portrait, which he considered an excellent likeness of the sitter and an outstanding pose.

Van der Goes is shown in an evenly-lit room in his own home, since Veth believed that a sitter's personality was best expressed in familiar surroundings. He is leaning back in his chair, observing us with an earnest expression, a lean hand draped over his elegantly crossed legs. The large moustache, the high white collar and bow-tie, and the pale purple forget-me-nots in his buttonhole distinguish him as *un homme cultivé*. The frame in the background contains an illegible postcard and a small portrait of the writer and critic, Busken Huet, who had died in 1886. He was one of the few members of the old guard whom the younger generation held in esteem, and the discerning Van der Goes may have wanted to be associated with him.

The composition and predominantly grey tones in the portrait recall Whistler's famous *Arrangement in Black and Grey: The Artist's Mother* from 1871 (Paris, Louvre). Whistler, who visited the Netherlands in the autumn of 1887 when Veth was preparing his painting, was extremely popular with Dutch artists. The main difference between the two works is that Veth's is a *portrait*, while Whistler's painting is first and foremost an exercise in harmonious composition.

PROVENANCE: donated to the museum by A. Veth-Dirks in 1929.

EXHIBITIONS: *Kunstwerken van levende meesters*, Amsterdam (Arti et Amicitiae), 1887, no. 255 ('Mansportret').

LITERATURE: J.A. Alberdingk Thijm, *De Amsterdammer* (weekly) 13 November 1887; Huizinga 1927, p. 24, cat. no. 79; Steenhoff 1928, pp. 6, 7, fig. 2; Veth 1939, pp. 14, 15; Bijl de Vroe 1987, pp. 127, 156; Van der Wiel 1988, pp. 118, 121.

Voerman, Jan

Kampen 1857 - 1941 Hattem

Jan Voerman came from a large farming family. After primary school, he followed evening classes in drawing together with his friend W.B. Tholen. They also received painting lessons from a local art teacher J.D. Belmer, who strongly encouraged them. With financial assistance from an uncle, Voerman, like Tholen, enrolled at the Academy in Amsterdam, where his contemporaries included Meiners, Van Rappard and Witsen. In 1880 he went to study life painting at the Antwerp Academy, returning to Amsterdam a year later. He was allowed the use of a studio at the Academy until 1883, when he became a member of Arti et Amicitiae.

Besides working in and around Amsterdam, Voerman spent many of his summers painting in Kampen. The work he produced in this period include rapidly-executed studies of landscapes with cattle, as well as ambitious genre pieces of Jewish themes. The latter, which were very much in the academic tradition, earned him well-deserved recognition, and in 1884 he was awarded a royal bursary. The following year he moved into Jozef Israëls's old studio on the Rozengracht in Amsterdam, where he became friendly with Isaac Israëls and Albert Verwey, who introduced him to Breitner, Karsen and Verster. These new contacts left their mark on his work and his subsequent flower pieces, landscapes and townscapes were painted with a bolder, looser hand. In 1886 Voerman was awarded the Willink van Collen Prize for a picture of cows he painted in Kampen (Amsterdam, Stedelijk Museum). In 1889 he married Anna Verkade, the sister of the painter Jan Verkade. The couple settled in Hattem, where they raised five children.

By the time of his marriage Voerman had already acquired a considerable reputation, notably as a watercolourist, and he became a member of the Dutch Society of Watercolourists (1889) and Pulchri Studio (1891) shortly afterwards. After 1890 his work gradually became less Impressionistic. Inspired by the French Nabis, with whom his brother-in-law Jan Verkade maintained close ties, he adopted a taut, simplified style and clear, pure colours. The technique he used in his watercolours – the medium he favoured at that time – changed dramatically. In an earlier series of paintings entitled *Houses in Epe* he had already experimented with new materials which created a dry, pastel-like effect. He now used a bodycolour technique to paint fairly uniform decorative surfaces, against which the meticulously-observed plants and animals stand out as though rendered in appliqué. The critics and public had reservations about his new style. The colours were considered too hard, while his Amsterdam art dealer Buffa commented on a general 'lack of movement and vitality'. Voerman took exception to this criticism. 'It is precisely the tranquillity and stillness of Nature that strikes me, and this is what I wished to express', he replied in a letter of 23 November 1892 (Blaricum, Voerman archives).

In 1894 Buffa organised the first of a series of solo exhibitions. Two years later, Voerman moved into a new house on the Geldersedijk in Hattem, which commanded a beautiful view of the river IJssel and meadowland from the front, and of the town of Hattem from the back. The two subjects became recurring themes in his *oeuvre* from then onwards. Two further solo exhibitions in 1897 and 1898 brought him universal acclaim. Around this time his colours once again became richer and more naturally variegated. In about 1904 he returned to oil painting after a long interval. In order to obtain the transparent effect of watercolour he diluted the paint with oil and applied several thin coats of varnish. He would sometimes let the thin paint trickle over the panel or canvas before modelling it with the brush. These later works have a smooth, enamel-like surface, as though covered with Japanese lacquer, and recall Jan van Goyen's thinly-painted panels. The compositions of Voerman's river views resemble those by seventeenth-century Dutch painters; to a slightly lesser extent the same is true of his atmospheric skies, some of which are imbued with an almost religious sense of drama. In the 1920s he rendered more abstract views in fantastic colours, which recall the Romantic work of the English painter William Turner. Failing eyesight put an end to Voerman's painting in the early 1930s.

Literature: A. Plasschaert, 'J. Voerman', *Elsevier's Geïllustreerd Maandschrift* 15 (1898), pp. 1-22; Anna Wagner, *Jan Voerman. IJsselschilder*, Wageningen 1977; Leo Boudewijns and Henk van Ulsen, *Broeden op een wolk. Jan Voerman, Schilder 1857-1941*, Veenendaal 1987.

J. VOERMAN
The Seven Days of Mourning, *c.* 1884
Oil on canvas, 74.2 x 99.2 cm
Signed lower right: *J. Voerman*
Amsterdam, Joods Historisch Museum

In the early 1880s, Voerman concentrated on animal paintings, studies of peasants and genre pieces. He found the subjects for many of these works in the Jewish quarter of Amsterdam. In 1883, the year in which he left the Academy and became a member of Arti, he exhibited *Scene in the Jewish Quarter* at the Amsterdam 'Triennial'. This was followed soon after by *A Widow at the Rag-and-Bone Shop* (private collection) and *The Seven Days of Mourning*. The latter in particular received enthusiastic acclaim at an exhibition in 1884. *De Nederlandsche Spectator* spoke of a 'highly original and remarkable work of lasting value'. *De Amsterdammer*, too, was full of praise; it was regarded as one of the best works of 'the new school' for its fine tone, the style of painting and the superb rendering of facial expression.

Voerman's meticulous concern with detail and his subtle handling of light and colour – qualities much admired by the public and critics alike – are still very much in the academic manner of Allebé. On the other hand the frontal view and the grouping of the figures in the centre, with a large window behind them, recall many of Jozef Israëls's interiors; Voerman seems to have borrowed the valance from him, too. Israëls, however, would not have placed a figure with his back to the viewer in such a prominent position in the centre. Voerman introduces greater variation in his arrangement of the figures and in their individual expressions. He continues to observe the established classical rules, even in the handling of the grieving widow. This was a popular motif since the second half of the eighteenth century, and one which Jozef Israëls had tackled in his celebrated paintings of fishing people.

The widow and her child are on the right-hand side of Voerman's painting. The woman's pose recalls the work of French Classical painters, such as Greuze or David, or, in the more distant past, the style of Poussin or Dürer's *Melancholia*. We see her after her husband's funeral, at the start of a period of mourning which will last for a year. The *shivah* has now begun, the traditional seven days of mourning, during which the Jewish com-

munity organises prayers at the home of the bereaved, who sit on low benches as a sign of mourning. The men in Voerman's painting have prayer shawls draped over their heads and shoulders. Around the left hand and on the forehead each wears the phylacteries prescribed for morning prayers. The tiny case, clearly visible on the forehead, contains four biblical texts. Voerman includes many other details, such as the table laid with a white cloth, traditional on the Sabbath and other remembrance days, on which is a collection box for alms for the needy; on the sideboard to the left is the memorial candle (the *ner-tamid*), which must be kept burning throughout the year of mourning; to the left of the clock a plaque inscribed with the Hebrew text *mizrah*, or 'east', hangs on the eastern wall of the room, in the direction of Jerusalem. The sunlight confirms that even the clock has been set correctly – in Voerman's picture it is ten to seven in the morning.

According to a manuscript catalogue of Voerman's work, the artist produced a second version of *The Seven Days of Mourning* in 1886 on a slightly smaller canvas (whereabouts unknown).

PROVENANCE: M.J. Bielders, bought at the Triennial in The Hague, 1884 (*f* 500); M.C. Lebret, Dordrecht, bought at auction at Bielders (*f* 825); acquired by the museum in 1978 with the assistance of the Friends of the Joods Historisch Museum.

EXHIBITIONS: *Schilderijen en andere kunstwerken van levende meesters*, The Hague (Academiegebouw) 1884, no. 440 ('Treurdagen'; *f* 800).

LITERATURE: *Het Vaderland*, 29 May 1884; *De Nederlandsche Spectator*, 14 June 1884; Anna Wagner, *Jan Voerman* 1977, p. 21.

101

J. VOERMAN
Cattle beside the IJssel near Hattem, *c.* 1895
Watercolour, 63 x 82.5 cm
Signed lower right: *J. Voerman*
Amsterdam, Henk van Ulsen

1891/92 marked the beginning of what Voerman referred to as a 'theoretical period' in his work. In a letter to G.H. Marius he later wrote: 'As time went by I understood more and more clearly that the work of Dutch painters collectively was not pure enough in its colour (...); my studies had already become much brighter, but at that time I realised that I would have to work quite differently' (letter of 18 July 1903, The Hague, Municipal Archives). Voerman wanted to get away from the Impressionist style of painting which could all too easily degenerate into something resembling 'dirty dishwater'. Encouraged by what he had learnt from his brother-in-law Jan Verkade about the work of the Nabis in France, he began to use bold outlining and pure colours. *Cattle beside the IJssel near Hattem*, once owned by the poet P.C. Boutens, is a typical example of this style. Using a combination of watercolour and gouache, he painted flat, contained surfaces, which he sometimes outlined in the same fashion as a Japanese woodcut. The billowing cumulus clouds are given volume, but other parts, such as the houses and the two cattle in the foreground, seem to have been superimposed like appliqué forms. The line of the ground and the houses simply continues through the wafer thin row of cows in the distance. Everything, down to the churning of the water, gives the impression of being frozen in the carefully balanced composition. It is as if Voerman respects only the form, not the substance. The colours and the harsh transitions from water to land or from the cows in the foreground to the deep spinach-green field, look unnatural. After the exceptionally delicate flower pieces of a few years earlier, the critics saw this more contrived approach as a retrograde step. Looking back over this period, Loffelt wrote that 'Voerman later began to draw or rather paint with some sort of bodycolour and sought to achieve his effect more through the purity of his contours and the decorative, monotonous, flat patches in his landscapes. A meadow was represented by a homogeneous grass-green, without any nuance; the sky took on the appearance of wallpaper, a chalkiness, with the occasional fluffy cloud, sometimes stereotyped, looking like cotton wool (...). To my mind there is too little in this of the thinking, feeling, living artist, the sensitive human being. This art smacks too much of technique.' Many of his fellow artists, however, were enthusiastic about his new approach. It conveyed a highly personal message and a sense of the 'tranquillity and stillness' of the countryside around Hattem, which made such a deep impression on Voerman, according to a letter to the art dealer Buffa (letter of 23 November 1892, Blaricum, Voerman archives).

PROVENANCE: F. Buffa & Sons, Amsterdam (?); P.C. Boutens, The Hague.

WEISSENBRUCH, JOHANNES HENDRIK

THE HAGUE 1824 - 1903 THE HAGUE

Johannes Weissenbruch grew up in a family of modest means, who were interested in art and owned work by Andreas Schelfhout and Bartholomeus van Hove. He was one of six children and chose to be a painter, while a younger brother became an engraver. His father, a chef, was also an amateur painter. A cousin of his, Jan Weissenbruch (1822-1880), was at first the more popular of the two artists. His townscapes are more detailed and his approach more academic, while the overall effect of his style was described as "calligraphic", compared with Johannes's more expressive painting. As personalities they were also quite different; Johannes was of a cheerful disposition, whereas his cousin was a quieter, more composed type.

From 1840 to 1843 Johannes received drawing lessons from J.J. Löw and subsequently attended evening classes under Bart van Hove at the Hague Academy. Like Bosboom, he probably worked in Van Hove's studio during the day. His superb early landscapes of rolling dunes betray Schelfhout's influence, and although he admired seventeenth-century painters such as Potter and Ruysdael, he wanted nature itself to be the inspirational force behind his work. The watercolours he produced around 1850 show the same broad, flowing brushwork as Bosboom's. He joined the Societé Belge des Aquarellistes in 1866 and the Dutch Society of Watercolourists ten years later. In the 1860s Weissenbruch often worked near Nieuwkoop and Noorden in the fenlands around Gouda and Boskoop, an area which was also popular with Gabriël, Stortenbeker, Van de Sande Bakhuyzen and Roelofs. His style gradually became looser, and his carefully rendered panoramas gave way to more atmospheric landscapes.

Although Weissenbruch's talent for composition had long been recognised and appreciated by his fellow artists, it was only after 1880 that his portrayals of the countryside around Noorden and Nieuwkoop gained wider popularity. The Pulchri Studio organised a party to celebrate his 75th birthday in 1899, while the Buffa Gallery in Amsterdam mounted a major exhibition – warmly commended by Jozef Israëls in *De Nederlandsche Spectator* – to mark the occasion. It is uncertain what the younger generation thought of his work; in contrast to Jozef Israëls, Jacob Maris and Mauve, few references are made to Weissenbruch. He, on the other hand, was one of the first to appreciate Van Gogh's talent, and even rallied to his defence against an attack by Mauve in 1882.

Weissenbruch made his first trip abroad late in life, visiting Fontainebleau and Barbizon in 1900. He returned with several beautiful studies.

LITERATURE: F.A.E.L. Smissaert, 'Jan Hendrik Weissenbruch', *Elsevier's Geillustreerd Maandschrift* 2 (1892) 3, pp. 425-440 [reprinted in M. Rooses (ed.), *Het Schildersboek* 1 (1898), pp. 122-138]; J. Havelaar, 'J.H. Weissenbruch', *Maandblad voor Beeldende Kunst* 1 (1924), pp. 165-172; H.E. van Gelder, *J.H. Weissenbruch*, Amsterdam (Paletserie) [1940]; Jos. de Gruyter, *De Haagse School*, Rotterdam 1968, vol. 1, pp. 60-75; exhib. cat. *De Haagse School. Hollandse meesters van de 19e eeuw*, Paris (Grand Palais) etc. 1983, pp. 274-288 (with bibliography p. 348).

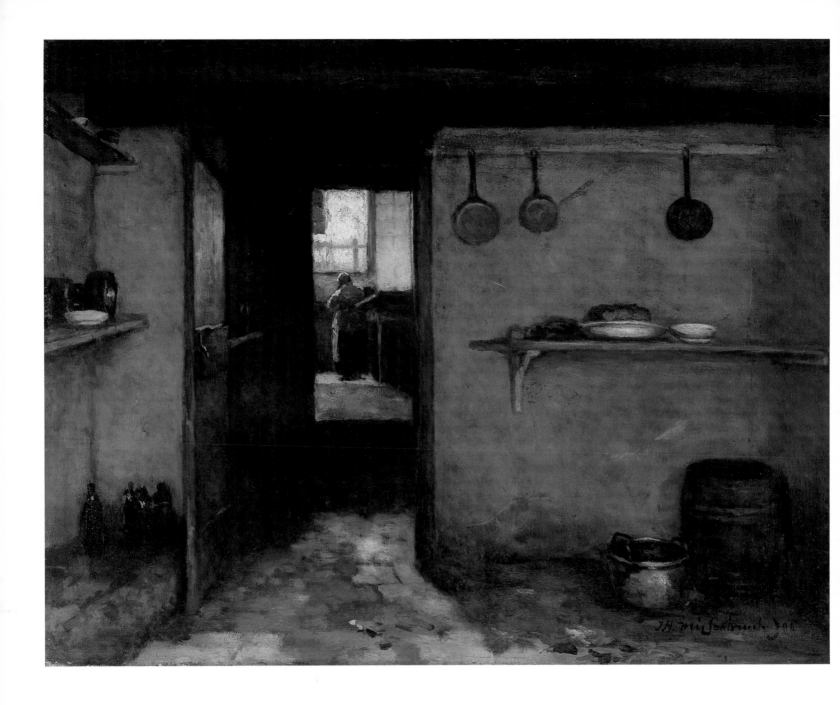

102

J.H. WEISSENBRUCH
Basement Interior, 1888
Oil on canvas, 39 x 51 cm
Signed and dated : *J.H. Weissenbruch f 88*
Amsterdam, Rijksmuseum

The painting shows the basement room in Weissenbruch's house in Kazernestraat in The Hague. According to one of his contemporaries, it was a home that exuded the quiet serenity of a seventeenth-century Old Dutch interior. Weissenbruch's painting evokes a similar atmosphere and gives the same feeling of spatial depth as interiors by Johannes Vermeer and Pieter de Hoogh. The genre motif in Weissenbruch's picture, however, is not a focal point. The woman has been placed in the background so that all attention is drawn to the space. Weissenbruch made another version of the painting in watercolour (The Hague, Ge-meentemuseum). The differences between the two are minor, but nevertheless significant, since he added a wall on the right side of the watercolour version, which changes the perspective entirely and gives the illusion of looking through a tunnel. The spatial effect without the wall is more imposing and monumental. The addition of a few, simple kitchen utensils enhances the air of domestic tranquillity. As A.C. Loffelt observed some years later, it is the portrayal of 'an interior as a still life'.

PROVENANCE: lent to the museum by J.C.J. Drucker-Fraser in 1919; bequeathed to the museum in 1944.

EXHIBITIONS: *Schilderijen, schetsen, teekeningen en etsen der werkende leden*, The Hague (Pulchri Studio), 1888, no. 325 ('Binnenhuis').

LITERATURE: Van Gelder 1940, p. 50; De Gruyter 1968, p. 66; exhib. cat. Paris 1983, p. 282.

WITSEN, WILLEM ARNOLD

AMSTERDAM 1860 - 1923 AMSTERDAM

Willem Witsen came from a patrician Amsterdam family and was the youngest of six children. His father was a prosperous businessman with a stake in the newly developed iron industry. The family occupied a large house on the Prinsengracht and spent the summers at their country home near the river Vecht. Music played an important part in the life of the household; the family hosted musical soirées to which well-known performers and composers, including Johannes Brahms, were invited. All the children sang or played musical instruments, in Willem's case the cello. His mother died when he was thirteen, and his eldest sister took charge of the household. In 1876 Witsen enrolled at the Academy in Amsterdam, where he was officially registered until 1884, although he was absent for prolonged periods. In 1881, for example, he and Piet Meiners studied under Karel Verlat in Antwerp for several months. From 1882 onwards he did much of his work at Ewijkshoeve, his family's country residence near Den Dolder. During his years at the Academy, Witsen became friendly with many of the painters who were to set the tone of Dutch art in the 1880s and 1890s, such as Derkinderen, Karsen, Van Looy, Tholen, Toorop and Veth; later his acquaintances included Breitner and Isaac Israëls (who moved to Amsterdam from The Hague).

Witsen and his fellow students embarked energetically on a succession of new ventures. In 1881, dissatisfied with the apathy of Arti, they founded an artists' association called St Luke's. Witsen also became a member of Flanor, another club founded in 1881, where he met young writers and poets such as Van Eeden, Kloos and Verwey. It was here that the idea for *De Nieuwe Gids* was born, a review launched in 1885 with financial backing from Witsen, which became the most important mouthpiece for the new generation of writers and painters. Witsen himself published a number of reviews in the magazine. He was very much at the centre of this circle of friends; he was a generous host, first at Ewijkshoeve, later in London (1888-1891), in Ede and in his studio home overlooking Amsterdam's Oosterpark, where he received Paul Verlaine in 1892. Sometimes he would take his painter friends with him on his trips abroad. The *Nieuwe Gids* circle gradually disintegrated in the 1890s because of internal conflicts, and as one member after another married and settled down to family life. Witsen himself married Betsy van Vloten in 1893, which made him brother-in-law to Van Eeden and Verwey. The marriage ended in divorce, and in 1907 he remarried. His second wife was Marie Schorr.

As a student, Witsen had primarily devoted himself to figure studies and portraits, but in the course of the 1880s landscapes and paintings of peasants at work became prominent themes in his work, reflecting the influence of French painters such as Bastien-Lepage, Breton and Millet, but above all of Mauve, who was a close friend of his. Towards the end of the 1880s he turned to sombre townscapes, which became his speciality. In contrast to Breitner and Isaac Israëls, who depicted the hustle and bustle of modern urban life, Witsen saw the city as a monument of timeless beauty. The geometric order of façades and bridges, represented *en face*, is crucial to the tightly structured composition of his paintings, watercolours and etchings. The human figure plays only a minor role. In addition to his townscapes, however, he continued to paint landscapes and the occasional still life or portrait.

Witsen was one of the leading graphic artists of his generation. He was a founder member of the Dutch Etching Club, set up in 1885, which organised exhibitions aimed at fostering the art of printmaking as opposed to graphic reproductions which, though technically advanced, often lacked vitality. Witsen had begun etching around 1882, and experimented with every possible technique, including aquatint, soft-ground etching (*vernis mou*) and colour etchings. Over 220 of his prints are known.

After his death, Witsen, like Breitner, also acquired a fair reputation as a photographer. His first photographs probably date from 1891. However, while Breitner primarily documented Amsterdam city life, Witsen's photographs provide a lively record of his family and friends. As far as we know, he made only occasional use of photographs for his paintings and graphic work.

LITERATURE: N. van Harpen, *Willem Witsen*, Amsterdam 1924; A.M. Hammacher, *Amsterdamsche impressionisten en hun kring*, Amsterdam 1941, pp. 57-58, 61-65; A.M. Hammacher et al., *Witsen en zijn vriendenkring*, Amsterdam [1947]; Charles Vergeer, *Willem Witsen en zijn vriendenkring. De Amsterdamse bohème van de jaren negentig*, Amsterdam/Brussels 1985; Rein van der Wiel, *Ewijkshoeve, tuin van tachtig*, Amsterdam 1988.

103
W.A. WITSEN
Gathering Wood, 1885
Oil on canvas, 79 x 94 cm
Private collection (formerly P.B. van Voorst van Beest Gallery,
The Hague)

Around 1882, while still enrolled at the Academy, Witsen began to paint landscapes incorporating human figures at work or, less frequently, animals. Like many artists of his generation, he was inspired by painters of the Barbizon and Hague Schools. In addition, he had left Amsterdam in 1882 to live at his family's estate at Ewijkshoeve. The country house was to be a source of inspiration and a welcome retreat for artist friends such as Derkinderen, Meiners and Tholen (cat. no. oo) for the following two decades. The most famous of the artists who stayed at Ewijkshoeve was Anton Mauve, Witsen's senior by over twenty years, who first visited the estate in 1884. He advised Witsen to include large figures in his landscapes, advice which Witsen took to heart. Mauve's influence is apparent in a number of ambitious paintings that Witsen exhibited in 1884-1886. They include *Moorland Worker* (private collection), *The Shepherd* (The Hague, Rijksdienst Beeldende Kunst) and *Gathering Wood*, the painting reproduced here. He made quick preparatory oil studies and drawings for large elaborate works such as this. The smaller oil study of *Gathering Wood* is one example (Mak van Waay auction, Amsterdam, 25 May 1971, no. 630). The figures in *Moorland Worker* and *The Shepherd* protrude far above the horizon, like monuments in the flat landscape. Witsen depicts them from a low vantage point, undoubtedly following the example of Millet, who was extremely influential at the time. In *Gathering Wood*, however, he has opted for a raised viewpoint. The horizon is high and the figures are enveloped in the wood. Witsen had explored this type of image in the *Boy in a Wood near Ewijkshoeve*, painted in 1884 (private collection), but the effect then had been rather contrived and posed. In *Gathering Wood* the figures are painted with greater assurance and blend more naturally with their surroundings. The canvas still betrays a certain dependence on Mauve and French artists such as Jules Breton and Bastien-Lepage. The handling of the main figure and the vegetation in the foreground, in particular, is reminiscent of Bastien-Lepage, whom Witsen greatly admired. He had visited the exhibition held in Paris in 1884 to commemorate the artist, who had died at the age of only thirty-six.

Witsen entered *Gathering Wood* for the competition organised by the Willink van Collen Foundation, which was intended to encourage young artists, but it received no more than an honorable mention. In a short review in *De Nieuwe Gids*, Jan Veth called the painting 'a little masterpiece' and criticised the jury's decision to award the first prize to Hoynck van Papendrecht whose faces, according to Veth, were 'like putty' (*De Nieuwe Gids* 1, 1885, vol. 1, p. 507).

PROVENANCE: Van Voorst van Beest Gallery, The Hague; private collection.

EXHIBITIONS: Willink van Collen Fonds, Amsterdam (Arti) 1886.

104

W.A. WITSEN
Montelbaanstoren, Amsterdam, 1887
Oil on canvas, 40 x 55 cm
Initialled and dated lower left: *W.W. '87*
Amsterdam, Stedelijk Museum

In April 1887 Witsen took over Breitner's studio at 5 Oude Schans in Amsterdam, and subsequently divided his time between the city and his family's estate at Ewijkshoeve. *Montelbaanstoren, Amsterdam* marks Witsen's transition from rural to urban themes. It is one of his earliest paintings of Amsterdam, and the townscape was to be the genre on which, more than any other, his reputation was founded. The painting shows the view from the studio, but Witsen has clearly manipulated the scene. He has cropped half the tower and the bridge, possibly following the example of Jacob Maris's famous painting *The Truncated Mill*, dating from 1872 (Amsterdam, Rijksmuseum). He has also brought his subject closer, as if he were using a zoom lens. Breitner had in fact taken this approach a step further, shortly before, in a large watercolour of the same spot (Amsterdam, Stedelijk Museum) which shows only the bottom of the tower and the boats moored up against it. The differences between these two works – leaving aside the medium – are typical of the two artists. The watercolour bears the mark of Breitner's rapid,

nervous way of capturing an image, whereas Witsen's work is carefully composed and painted layer by layer, as if he only gradually achieved the proper balance between the components of the picture. It is also characteristic that Breitner should show an interest in human activity (the watercolour contains a man rowing and two men carrying out repairs to a boat), whereas the chief protagonist in Witsen's painting is the city itself. The canvas owes all its atmosphere to the mass of masonry of the tower and the houses, the smooth surface of the water, and the light that seems to rise from it like a mist. The figures on the bridge, diminutive though they may be, nevertheless play a more important role here than in most of Witsen's other townscapes. Japanese woodcuts enjoyed a vogue among Amsterdam artists in the 1880s, and he may have been emulating Hokusai's famous series of woodcuts of bridges, in which small figures under parasols are contrasted with the vast expanse of water and land.

Long after he had given up the studio on Oude Schans, Witsen continued to seek subjects for his work in that quarter of the city. The Montelbaanstoren, seen from different perspectives, features in a whole series of paintings, watercolours and etchings.

PROVENANCE: J. van Eck, Amsterdam, 1937; donated to the museum, 1939.

105

W.A. WITSEN
The Thames at London, *c.* 1895
Oil on canvas, 79 x 100 cm
Signed lower left: *Willem Witsen*
Otterlo, Rijksmuseum Kröller-Müller

The Kröller-Müller Museum catalogue dates this river view around 1900, which would imply that Witsen did not paint it while living in London (1888-1891), but either during a subsequent visit to the city or in the Netherlands, using studies he had made on the spot. The latter hypothesis is not implausible; other cases are known where studies which he had made on his travels were only developed into paintings, watercolours or etchings at a much later date, in the calm of the studio. In any event, he was little concerned about spontaneity in his work. The technique he used in this particular river view suggests a date after 1891; the paint is applied relatively loosely and thinly, using an *alla prima* technique, which contrasts with the rather stiff work from his London period. The canvas certainly dates from before 1896,

however, because it is known to have been in an exhibition in Amsterdam in January that year.

Of all his paintings with a London theme, this comes closest to the work of Whistler. There are similarities in the manner of painting and the fine silvery tone, but also in the choice of subject and the delineation of the picture: from the 1870s onwards, Whistler painted numerous views of the Thames in which a dark band, a bridge or a distant bank, forms a boundary high up in the picture. There are ships in some of these *Nocturnes*, looming like dark shadows with little substance to them. Witsen has tried to achieve the same effect, at least in the background of his painting. The only objects with any solidity are the two freighters and the tug in the foreground, whose wash cuts through the murky grey surface of the river stretching out to either side.

PROVENANCE: C.M. van Gogh Gallery, Amsterdam, 1895; H. Kröller-Müller, The Hague, 1916 (*f* 900); donated to the museum, 1935.

EXHIBITIONS: *Schilderijen, teekeningen, etsen enz. van de firma C.M. van Gogh,* Amsterdam (Arti) 1896, no. 33.

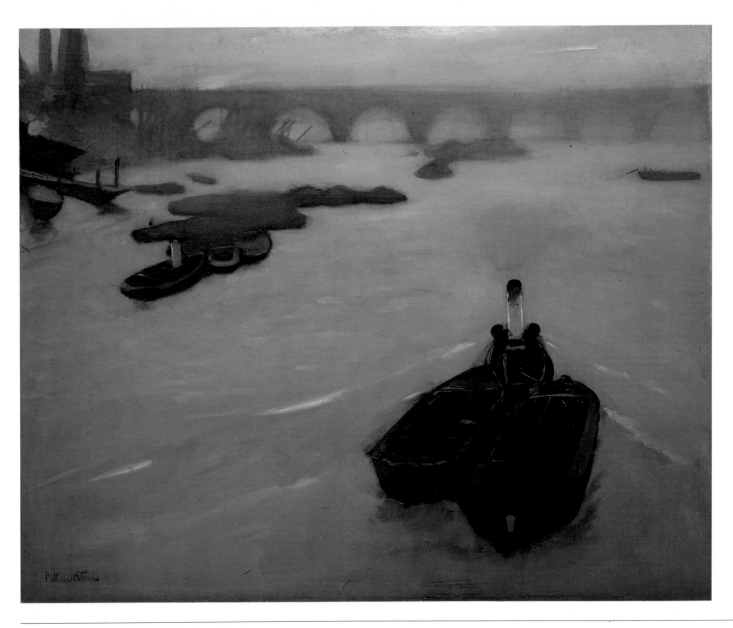

106
W.A. Witsen
Self-Portrait, *c.* 1889
Watercolour on paper, oiled, 33.5 x 29 cm
Unsigned
Amsterdam, Witsenhuis (on loan from the Rijksdienst
Beeldende Kunst, The Hague)

The period between October 1888 and February 1891, which Witsen spent in London, was possibly the most important in his life. He discovered an abundance of new motifs in the city, and developed to the full his unique way of looking at urban life. His main reason for going there, however, was probably of a more personal nature. He had met an English artiste performing in one of the *cafés-chantants* in the Nes district in Amsterdam and had decided to follow her to England, partly in order to escape the pressures exerted on him by his family, and also to take some distance from the problems that had arisen among the writers and artists associated with *De Nieuwe Gids*.

He painted this unusual *contre-jour* portrait in London. Its precise date is uncertain, but it is believed to have been made in 1889 or 1890, when he was about thirty years old. His earnestness, the air of intense concentration and his steady gaze reveal a man preoccupied with the meaning of his life, as a human being and an artist. His introspection is likely to have been prompted to some extent by the fact that his sister Anna, to whom he was deeply attached, had committed suicide in March 1889.

Apart from a few drawings and photographs, it is the only self-portrait Witsen is known to have made. He painted it in watercolour, but later applied a layer of oil and varnish to it, giving it the appearance of a painting in thin oil paint.

PROVENANCE: M. Witsen-Schorr, Amsterdam; bequeathed to the State of the Netherlands in 1943.

LITERATURE: Hammacher 1941, pp. 121-122, fig. 10.

ZWART, WILLEM HENRICUS DE

THE HAGUE 1862 - 1931 THE HAGUE

Willem de Zwart grew up in The Hague, the eldest of eight children in a Roman Catholic family of modest means. His father was a decoration painter. In about 1877 he was apprenticed to Jacob Maris, who set up still lifes for him to paint and encouraged him to copy Old Masters and work *en plein air*. From 1876 to 1880 De Zwart took evening classes in drawing at the Hague Academy, under the direction of Johan Philip Koelman and Fridolin Becker. He was called up for military service in 1880 but, with the help of friends, managed to buy himself out soon afterwards. His work from about 1881 to 1884 consisted mainly of faithfully rendered still lifes, studies of animals, and small landscapes after the style of Maris. He also copied many works from the Mauritshuis. A royal bursary in 1883 provided a brief respite from financial cares, but from 1884 to 1886 he was forced to earn a living painting tiles for the Rozenburg delftware factory in The Hague.

In 1885 he became a member of Pulchri Studio and the Dutch Etching Club. He soon gained a reputation, notably for his etchings, most of them produced around 1886 while he was living in a community of artists, including the graphic artist Philippe Zilcken, in Het Kleine Loo, a country house on the outskirts of The Hague. Like the rest of his work, the etchings were mainly portrait studies, girls or women in interiors, views of dunes or other landscapes, farms, sand excavations and harbour scenes with people at work. His paintings from this period, particularly the still lifes and figure pieces, bear a striking resemblance to work by Breitner, who was a close friend of his. They would occasionally pass on commissions to one another, and in 1885 they visited Drenthe together. Although the two artists often depict the same subjects, De Zwart's work tends to be less daring, more sombre and, partly because of his smaller canvases, more intimate.

Around 1889, the year of his marriage to Maria Reevers, his themes became bolder and his formats more ambitious. His large views of The Hague and the series of girls in kimonos date from these highly productive years (1889-1892), referred to as his 'Beeklaan' period (after the street in which he lived). In 1891 De Zwart joined the Hague Art Circle and paid a brief visit to Paris. Three years later he moved to Het Gooi, a wooded area to the southeast of Amsterdam, where his work changed dramatically.

In addition to his well-known paintings of livestock markets, he began to depict the themes generally associated with the Laren School. Moreover, the sombre tone of his earlier work gave way to bright, variegated colours which, as time went on, became increasingly harsh. His work assumed an anecdotal quality, perhaps as a result of his commercial association (1892-1910) with the art dealer Van Wisselingh.

From 1900 to 1905 De Zwart lived in Amsterdam, moving from there to Bloemendaal (1905), Scheveningen (1906) and a year later to Leidschendam (1907-1917). At the height of his popularity, from about 1900 to 1912, his letters constantly complained of the deteriorating quality of his work. He had difficulty restraining his colours, and his compositions became 'shaky'; this decline was depicted symbolically in *The Fallen Angel*, painted in about 1916 (Amsterdam, Rijksmuseum). His work suffered as a result of the depressions he experienced with increasing frequency after 1905. A brief stay in a psychiatric clinic (Oud Rosenburg, The Hague, 1906/1907) produced little improvement. In 1910 De Zwart severed his connection with Van Wisselingh, and the following year his wife obtained a divorce. He continued to work after his return to The Hague in 1917, where he remained until his death, living at a succession of addresses, but without completing many paintings. Besides a number of curious screens decorated with exotic birds or naked figures, he produced paintings harking back to compositions from before 1890. Most were weak imitations which he sought in vain to modernise by means of a nervous touch and a palette suggestive of French Post-Impressionism. He donated his painting entitled *The Tormentors*, dating from 1924, to the Gemeentemuseum in The Hague, to show the cause of his decline. The best work of his final years are his drawings and pastels on plywood. Most of them depict birds in the Hague zoo and are executed rapidly and with assurance.

LITERATURE: A. de Meester-Obreen, 'Willem de Zwart', *Elsevier's Geïllustreerd Maandschrift* 19 (1909), pp. 145-156; G.H. Marius, 'Willem de Zwart', *Onze Kunst* 9 (1910), pp. 13-28; J.H. de Bois, *De etsen van Willem de Zwart; introducties & aanteekeningen over kunst*, Bussum [1911]; A. Brunt, 'Willem de Zwart', *Eigen Haard* 1911 (June-July), pp. 533-538; Jos. de Gruyter, *De Haagse School*, Rotterdam 1969, vol. 2, pp. 73-81; Richard Bionda, *Willem de Zwart 1862-1931*, Haarlem 1984 (with complete bibliography and a catalogue of the etchings).

107

W.H. DE ZWART

Young Man in Spanish Costume Playing a Musical Instrument, 1889

Oil on canvas (*marouflé*), 42 x 23 cm

Signed upper left: *W. de Zwart*

Zwanenburg, Mr and Mrs B. Biesheuvel

De Zwart almost certainly painted the *Young Man in Spanish Costume* in 1889. He also produced a dated variant of the canvas, in which the man is depicted standing, staring straight out of the picture, and holding a cigarette instead of a musical instrument (private collection). In this case De Zwart did not work directly from a model, but used studies drawn on virtually the same scale as the final painting. The panel shown here was probably also painted from preliminary drawings, although none have come to light. We may assume, therefore, that the spontaneity which the work exudes was in fact carefully planned. As in other early works, De Zwart first experimented with various possibilities before rendering the final composition in oils. The short, restrained brushstrokes are also indicative of his cautious approach to his work. He took none of the risks courted by painters of the same school, such as Breitner and Isaac Israëls, who applied the paint with swift sweeping strokes; in his case the form dictated the speed and motion with which he applied the paint. His warm, often sombre palette, and the small formats he generally used, make his paintings seem more intimate than those of the other Impressionists. The mood is enhanced when, as in this case, he depicts his model turned slightly away from the viewer, as if caught in a moment of mild embarrassment. The frontal depiction in the other version of this painting, and in the *Girl with a Japanese Parasol* (cat. no. 109), is unusual in De Zwart's early *oeuvre*. Both the frontal pose and the 'Spanish' motif may have been inspired by Manet, many of whose works were shown at the World Exhibition in Paris in 1889. It is uncertain, however, whether De Zwart had seen Manet's work, particularly his pictures of Spanish models playing musical instruments. He may have heard about them from Breitner, who had a copy of Manet's *Olympia* hanging in his studio. Whatever the case, the *Young Man in Spanish Costume* was regarded by conservative critics as symptomatic of the pernicious 'Manetism' which had become evident in the Netherlands around 1885.

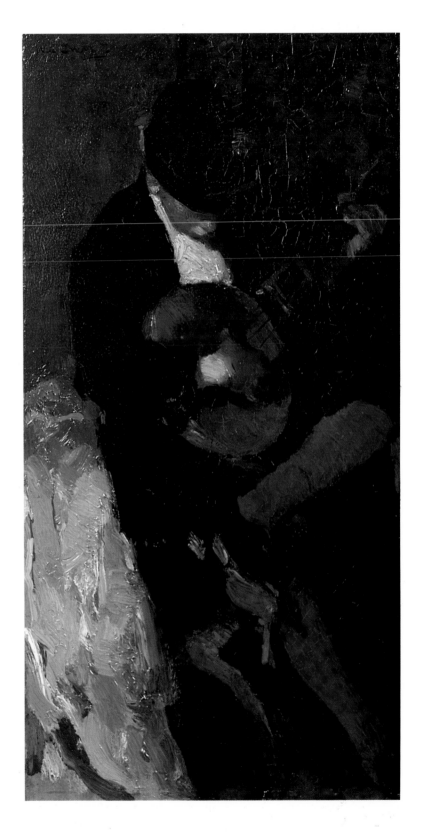

LITERATURE: Bionda 1984, p. 26 with fig.

108

W.H. DE ZWART
The Wagenbrug in The Hague, *c.* 1890
Oil on canvas, 48 x 101 cm
Signed lower right: *W. de Zwart*
Amsterdam, Stedelijk Museum (donated by the Association for the Acquisition of a Public Contemporary Art Collection)

De Zwart produced numerous townscapes in his early years in The Hague. At first he used only small formats, but around 1890 he occasionally experimented with work on a much grander scale. *The Wagenbrug in The Hague* is one of the largest and also the most successful of his pictures in this genre. It was bought in 1915 by the Association for the Acquisition of a Public Contemporary Art Collection for the substantial sum of 5,500 guilders. De Zwart was not interested in the fleeting, chaotic street scenes favoured by Breitner or Isaac Israëls. Like Witsen, he preferred to seek out the city's tranquil spots – carriages and horse-drawn trams waiting on the Buitenhof or at one of The Hague's stations. He often depicted wet or wintry scenes with an anonymous figure hurrying home or a cab-driver with his horses. He generally succeeded in creating atmospheric scenes which were well-received by the critics.

The composition of *The Wagenbrug in The Hague* is perfectly balanced; the horizon is high and the roofline of the row of houses on the right is neatly placed just within the frame. The dimensions of the painting make it possible to leave an open space on the right, a bold formula which provides a visual counterpoint to the compact group of coachman, horses and tramcar in the left foreground. The firm, resolute style of painting is typical of De Zwart and serves to enhance the introverted effect of the groups of figures and buildings. Nothing is left to chance, nothing can move even slightly from its appointed place without disturbing the balance. The various elements are sited wherever the composition demands their particular shape or colour. The billowing skirt of the woman battling against the wind on the bridge, for example, is first and foremost a useful device for providing visual relief in a rather flat setting. The grey is chosen to avoid monotonous repetition of the colour of the horses; it also brings out the figure of the coachman and reduces the monolithic effect of the tramcar.

One would expect such a considered composition to have been based on numerous preliminary studies, or at least on sketchbook jottings of figures or fragments of buildings. However, no studies have ever been found for any of De Zwart's early townscapes. Nor, as far as we know, did he work from photographs, a single exception being his *Porte St Denis in Paris* dating from 1892 (The Hague, Haags Gemeentemuseum), which he based on a postcard bought in Paris. There is, however, a highly developed watercolour of the *Wagenbrug* (private collection), although the format is narrower, and the result less exciting.

PROVENANCE: Bought by the Association for the Acquisition of a Public Contemporary Art Collection from Krüger Gallery, The Hague 1915; donated to the museum, 1949.

LITERATURE: *Jaarverslag van de Vereeniging van Hedendaagsche Kunst*, 1915, pp. 2-3; de Gruyter 1969, pp. 75-76 (with fig.); Bionda 1984, p. 29 with fig.

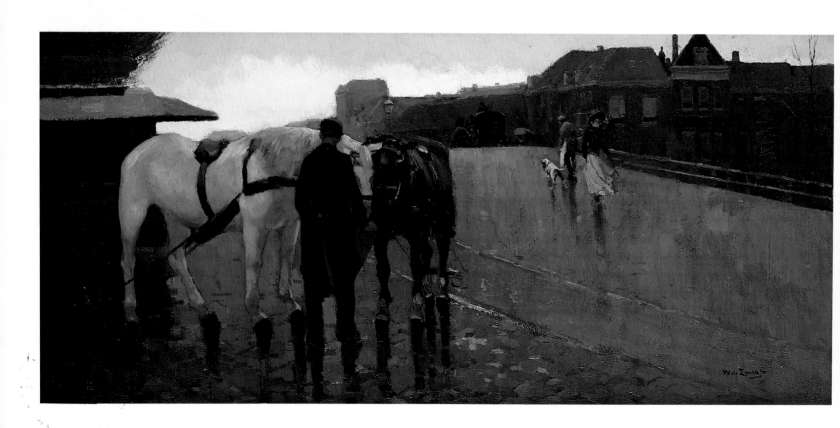

109

W.H. DE ZWART

Girl with a Japanese Parasol, c. 1890

Oil on canvas, 82.5 x 51 cm

Signed upper left: *W. de Zwart*

The Hague, Haags Gemeentemuseum

De Zwart's work is usually described as 'late Hague School'. The classification is inappropriate, however, particularly for his work from 1880-1890, as is apparent from the *Girl with a Japanese Parasol*, which, by De Zwart's standards, is a large canvas. This work and another painting of the same model dressed in a white kimono and lying down, filling the entire breadth of the picture, are among a small group of figure pieces (all at the Gemeentemuseum, The Hague) in which he comes closest of all the Hague artists to Breitner.

De Zwart is at his most exuberant in *Girl with a Japanese Parasol*. The burst of colour in the parasol, which is lit from behind like a stained glass window, is unusually bold, and puts him briefly on a par with the leading colourists of the day, Verster and Breitner. The rough manner in which he has applied the paint in some parts is also very much in the style of these two artists. This is apparent in the still life in the foreground, placed there specifically to counterbalance the glimmering parasol, but it is even more conspicuous in the large leaves looming against the dark background to the right.

Compared with the 'Japanese girls' (cat. no. 13) that Breitner painted slightly later, who are depicted, after the fashion of Whistler, in an exotic setting embellished with carpets and screens, De Zwart's girl is no more than a costumed model surrounded by appropriate attributes. Breitner also made the setting more one-dimensional, by painting the objects around the model without depth and adding decorative, semi-abstract patterns. Breitner's hand is surer, his brushstrokes broader. De Zwart paints more stiffly and with less ease; the paint has been applied much more heavily, with the result that the skin in many places looks kneaded or treacly.

The *Girl with a Japanese Parasol* is undeniably one of De Zwart's most powerful works. It is surprising, therefore, that there is no record of its having appeared in an exhibition before 1900. The same is true of the other figure pieces in the group. Perhaps a buyer was found immediately, or it is equally possible that De Zwart, who did not regularly submit work for exhibitions during this period, kept them back for one reason or another. The *Girl with a Japanese Parasol* was first shown in 1903, in De Zwart's first comprehensive exhibition at Van Wisselingh's in Amsterdam, where it was the first work listed in the catalogue. By this time he had acquired a reputation as 'late Hague School' thanks to his large output of landscapes in the intervening years.

PROVENANCE: purchased by the museum in 1932 from C.F.L. de Wild.

LITERATURE: Bionda 1984, p. 28 with fig.

Select bibliography

See biographies for literature on individual artists. Only monographs containing relevant information about the period are listed.

Blotkamp, Carel. 'Art Criticism in De Nieuwe Gids', *Simiolus* 5 (1971), pp. 116-131.

De Bodt, Saskia. 'Pulchri Studio. Het imago van een kunstenaarsvereniging in de negentiende eeuw', *De Negentiende Eeuw* (Documentatieblad Werkgroep 19e eeuw), 14 (1990), no. 1, pp. 25-42.

Braches, Ernst. *Het boek als Nieuwe Kunst 1892-1903. Een studie in Art Nouveau*, Utrecht 1973.

Brom, Gerard. *Schilderkunst en litteratuur in de 19e eeuw*, Utrecht 1959 (revised edition of *Hollandse schilders en schrijvers in de vorige eeuw*, Rotterdam 1927).

The Complete Letters of Vincent van Gogh. New York/London 1958.

Colmjon, G. *De Beweging van Tachtig, een cultuurhistorische verkenning in de 19de eeuw*, Utrecht 1963 (revised edition of *De Renaissance der cultuur in Nederland in het laatste kwart der negentiende eeuw* (1941).

Derkinderen, A.J. *De Rijks-Academie van Beeldende Kunsten te Amsterdam*, Haarlem 1908.

Diepenbrock, Alphons. *Brieven en documenten*, compiled and with an introduction by Eduard Reeser, 6 vols., 1962 etc.

Erens, Frans. *Vervlogen jaren* (ed. Harry G.M. Prick), The Hague 1982.

Gans, L. 'Het "onhollandse" in de kunst van Isaac Israëls', *Museumjournaal* 4 (1958), pp. 144-149.

Gans, L. *Nieuwe Kunst. De Nederlandse bijdrage tot de Art Nouveau*, Utrecht 1966.

Van Gelder, H.E. *Honderd jaar Haagsche Schilderkunst in Pulchri Studio*, The Hague 1947.

Gerson, H. *Voor en na Van Gogh*, Amsterdam 1961.

Giltay, Jeroen. 'De Nederlandsche Etsclub (1885-1896)', *Nederlands Kunsthistorisch Jaarboek*, 27 (1976), pp. 91-125.

Gram, J. *Onze schilders in Pulchri Studio*, Rotterdam [1880].

Gram, J. *Onze schilders in Pulchri Studio (1880-1904)*, Leiden [1904].

Van der Grinten, H.F.A.M. *Nederlandse aesthetica in de negentiende eeuw*, Helmond 1947.

De Gruyter, Jos. *De Haagse School*, 2 vols., Rotterdam 1968-69.

Haagse Kunstkring: werk verzameld, The Hague 1977.

Hamilton, George Heard. *Painting and Sculpture in Europe 1880-1940*, Harmondsworth 1967.

Hammacher, A.M. *Amsterdamsche Impressionisten en hun kring*, Amsterdam 1941.

Hammacher, A.M. 'De ontmoeting van Van Gogh en Breitner 1882', *Museumjournaal* 3 (1957), pp. 89-94.

Hammacher, A.M. 'Isaac Israëls – Liebermann en het Franse Impressionisme', *Museumjournaal* 4 (1958), pp. 142-143.

Hefting, P.H. *Breitner in zijn Haagse tijd*, Utrecht 1970.

Heij, J.J. (ed.). *Een vereeniging van ernstige kunstenaars. 150 jaar Maatschappij Arti et Amicitiae 1839-1989*, Amsterdam 1989.

Heijbroek, J.F., and A.A.M. Vis. *Verlaine in Nederland. Het bezoek van 1892 in woord en beeld*, Amsterdam 1985.

Heijbroek, J.F. 'Werken naar foto's. Een terreinverkenning. Nederlandse kunstenaars en de fotografie in het Rijksmuseum', *Bulletin van het Rijksmuseum* 34 (1986), pp. 220-236.

Imanse, Geurt, and Tilman Osterwold, John Steen. *Van Gogh tot Cobra. Nederlandse schilderkunst 1880-1950*, Amsterdam (1981).

Jaffé, H.L.C. 'Breitner tussen de schilders van Amsterdam', *Museumjournaal* 3 (1957), pp. 94-99.

Jaffé, H.L.C. 'Vincent van Gogh en G.H. Breitner, een parallel?', in *Miscellanea Joseph Duverger, Bijdragen tot de Kunstgeschiedenis der Nederlanden*, vol. I, Ghent 1968, pp. 383-387.

Joosten, J.M. 'De eerste kennismaking met het werk van Vincent van Gogh in Nederland', *Museumjournaal*, 14 (1969), pp. 154-157; 'De Vincent van Gogh-tentoonstellingen bij de kunsthandels Buffa in Amsterdam en Oldenzeel in Rotterdam in februari-maart 1892', pp. 216-219; 'De tentoonstelling van werken van Vincent van Gogh bij de Haagsche Kunstkring van 17 mei tot 6 juni 1892', pp. 260-273.

Van Kalmhout, Ton. 'Tempels aan de muzen gewijd. Multidisciplinaire kunstkringen in Nederland tussen 1880 en 1914', *De Negentiende Eeuw* (Documentatieblad werkgroep 19e eeuw), 14 (1990) 1, pp. 95-110.

Karsen, Eduard. *Een droom en een scheidsgerecht. Een relaas* (ed. Rein van der Wiel), Amsterdam 1986.

Knoef, J. *Een eeuw Nederlandse schilderkunst*, Amsterdam 1948.

De Leeuw, Ronald. 'Nederlandse oriëntalisten', *Jong Holland* 1 (1985) no. 3, pp. 10-37.

Leids Kunst-legaat. *Kunst en historie rondom 'Ars Aemula Naturae'*, Leiden 1974.

Marius, G.H. *De Hollandsche Schilderkunst der XIXde eeuw*, The Hague 1903 (English edition *Dutch Painters of the 19th Century*, edited by Geraldine Norman, London 1973).

Moes, Wally. *Heilig ongeduld: herinneringen uit mijn leven*, Amsterdam etc. 1961.

Plasschaert, A. *Floris Verster en zijn plaats temidden der schilders*, Amsterdam 1904.

Plasschaert, A. *XIXde Eeuwsche Hollandsche schilderkunst*, Amsterdam [1909].

Plasschaert, A. *Korte geschiedenis der Hollandsche schilderkunst van af de Haagsche School tot op den tegenwoordigen tijd*, Amsterdam 1923.

Polak, Bettina. *Het Fin-de-siècle in de Nederlandse schilderkunst. De symbolistische beweging 1890-1900*, The Hague 1955.

Rosenblum, Robert and H.W. Janson. *Art of the Nineteenth Century. Painting and Sculpture*, London 1984.

Van Schendel, Elie. *Museum Mesdag. Nederlandse negentiende-eeuwse schilderijen, tekeningen en grafiek*, The Hague 1975.

Sillevis, John with Roland Dorn, Hans Kraan (ed.). *De Haagse School. De collectie van het Haags Gemeentemuseum*, The Hague 1988.

Thorn Prikker, Johan. *De brieven van Johan Thorn Prikker aan Henri Borel en anderen 1892-1904*, ed. J.M. Joosten, Nieuwkoop 1980.

Thijs, Walter. *De Kroniek van P.L. Tak. Brandpunt van Nederlandse cultuur in de jaren negentig van de vorige eeuw*, Amsterdam/Antwerp 1956.

Tibbe, Lieske. 'Les XX en de Nederlandse schilderkunst (1883-1893)', *De Negentiende eeuw* (Documentatieblad Werkroep 19e eeuw), 5 (1981) no. 3, pp. 115-147.

Vergeer, Charles. *Willem Witsen en zijn vriendenkring. De Amsterdamse bohème van de jaren negentig*, Amsterdam/Brussels 1985.

Verwey, A. 'Breitner, Karsen en Verster', in *Proza* IX, Amsterdam 1923, pp. 25-32.

Veth, Jan. *Gedenkboek der Hollandsche Schilderkunst uit het tijdperk 1860-1890*, Amsterdam 1898.

Veth, Jan. *Portretstudies en silhouetten*, Amsterdam [1908].

Veth, Jan. *Hollandsche teekenaars van dezen tijd*, Amsterdam 1905.

Vosmaer, Carel. *Onze Hedendaagsche Schilders*, The Hague 1881.

De Vries, R.W.P. Jr. *Nederlandsche grafische kunstenaars uit het einde der 19de en het begin der 20ste eeuw*, The Hague 1943.

Van der Wiel, Rein. 'Beelden van '80. Het oog van Joseph Jessurun de Mesquita (1865-1890)', in *De Revisor* 8 (1981), no. 3, pp. 42-48.

Van der Wiel, Rein. *Ewijkshoeve, tuin van tachtig*, Amsterdam 1988.

Winkels, Peter J.A. et al. *Ten tijde van de Tachtigers, rondom de Nieuwe Gids 1880-1895*, The Hague 1985.

Van Wisselingh, E.J. *Half a century of picture dealing, an illustrated record*, Amsterdam 1923.

Zemel, Carol M. *The Formation of a Legend. Van Gogh Criticism 1890-1920*, Ann Arbor 1980.

Zilcken, P. *Peintres Hollandais Modernes*, Amsterdam 1896.

Zilcken, P. *Moderne Hollandsche Etsers*, Amsterdam [1896].

Zilcken, P. *Au jardin du passé. Un demi-siècle d'art et de litterature. Lettres à une amie*, Paris/The Hague 1930.

Exhib. cat. *Tijdgenoten van Verster*, Leiden (Stedelijk Museum De Lakenhal) 1957.

Exhib. cat. *Het symbolisme in Europa*, Rotterdam (Museum Boymans-Van Beuningen) etc. 1975/76.

Exhib. cat. *Licht door kleur. Nederlandse luministen*, The Hague (Haags Gemeentemuseum) 1976/77.

Exhib. cat. *Kunstenaren der idee. Symbolistische tendenzen in Nederland ca. 1880-1930*, The Hague (Haags Gemeentemuseum) 1978.

Exhib. cat. *Dutch Painting of the Century of Van Gogh*, Tokyo (Odakyu, Grand Gallery) etc. 1979.

Exhib. cat. *Post-Impressionism. Cross Currents in European Painting*, London (Royal Academy of Arts) 1979/80.

Exhib. cat. *De tijd wisselt van spoor*, Laren (Singer Museum) 1981.

Exhib. cat. *The Hague School. Dutch Masters of the 19th Century*, London (Royal Academy of Arts) etc. 1983.

Exhib. cat. *Stemmingen. Realisme, Impressionisme en hun nawerking in Amsterdam 1870-1940*, Amsterdam (Museum Fodor) 1988.

Exhib. cat. *Neo-impressionisten: Seurat tot Struycken*, Amsterdam (Rijksmuseum Vincent van Gogh) 1988.

Exhib. cat. *Bloemen uit de kelder. Negen kunstenaressen rond de eeuwwisseling*, Arnhem (Gemeentemuseum) 1989.

Colophon

This catalogue is published to coincide with the exhibition on *The Age of Van Gogh. Dutch Painting 1880-1895*, at The Burrell Collection in Glasgow from 10 November 1990 to 10 February 1991.

A more comprehensive Dutch version of the catalogue will subsequently be published for the exhibition at the Rijksmuseum Vincent van Gogh in Amsterdam from 1 March to 26 May 1991.

EDITORS
Richard Bionda, Carel Blotkamp

GENERAL EDITOR
Yvette Rosenberg

ENGLISH TRANSLATORS
Martin Cleaver, Jane Hedley-Prôle,
Mary Maclure, Andrew McCormick

GENERAL COORDINATION
Ineke Middag, Aly Noordermeer, Louis van Tilborgh

DESIGN
Harry Veltman & Jaap Hofman, Amsterdam

PRINTING
Waanders Printers, Zwolle

PHOTOGRAPHS
All photographs have been provided by the Museums or owners of the works unless otherwise stated. Photographs of catalogue numbers 11, 16, 27, 41, 43, 48, 50, 53, 55, 56, 58, 65, 69, 83, 98, 103, 105, 106 and 107 by Thijs Quispel.

© Copyright 1990: Uitgeverij Waanders bv, Zwolle
Rijksmuseum Vincent van Gogh

Cover illustration:
Vincent van Gogh, *Still Life with Irises* 1890 (detail). Amsterdam, Rijksmuseum Vincent van Gogh (Vincent van Gogh Foundation)

CIP-GEGEVENS KONINKLIJKE BIBLIOTHEEK, DEN HAAG

ISBN 90 6630 128 7